D1449659

THE NEW MIDDLE A

BONNIE WHEELER, *Series Editor*

The New Middle Ages is a series dedicated to transdisciplinary studies of medieval cultures, with particular emphasis on recuperating women's history and on feminist and gender analyses. This peer-reviewed series includes both scholarly monographs and essay collections.

PUBLISHED BY PALGRAVE:

VISUAL CULTURE AND THE GERMAN MIDDLE AGES

Edited by

Kathryn Starkey and Horst Wenzel

VISUAL CULTURE AND THE GERMAN MIDDLE AGES
© Kathryn Starkey and Horst Wenzel, 2005.

First published in 2005 by
PALGRAVE MACMILLAN™
175 Fifth Avenue, New York, N.Y. 10010 and
Houndmills, Basingstoke, Hampshire, England RG21 6XS
Companies and representatives throughout the world.

PALGRAVE MACMILLAN is the global academic imprint of the Palgrave Macmillan division of St. Martin's Press, LLC and of Palgrave Macmillan Ltd. Macmillan® is a registered trademark in the United States, United Kingdom and other countries. Palgrave is a registered trademark in the European Union and other countries.

ISBN 978-1-4039-6444-1

Library of Congress Cataloging-in-Publication Data

Visual culture and the German Middle Ages / edited by Kathryn Starkey and Horst Wenzel.
 p. cm.—(The new Middle Ages series)
 Includes bibliographical references and index.
 ISBN 1-4039-6444-0 (alk. paper)
 1. Illumination of books and manuscripts, Medieval—Germany.
2. Illumination of books and manuscripts, German. 3. Manuscripts, Medieval Germany. 4. Visual communication—Germany. 5. Art and literature—Germany. I. Starkey, Kathryn. II. Wenzel, Horst, 1941–
III. New Middle Ages (Palgrave Macmillan (Firm))

ND3151.V57 2004
302.2'0943'0902—dc22 2004059353

A catalogue record for this book is available from the British Library.

Design by Newgen Imaging Systems (P) Ltd., Chennai, India.

First edition: May 2005

10 9 8 7 6 5 4 3 2 1

Printed in the United States of America.
Transferred to Digital Printing in 2009.

CONTENTS

LIST OF ILLUSTRATIONS

LIST OF ABBREVIATIONS

AGN	*Anzeiger des Germanischen Nationalmuseums*
ATB	Altdeutsche Textbibliothek
DTM	Deutsche Texte des Mittelalters
DVjs	*Deutsche Vierteljahrsschrift für Literaturwissenschaft und Geistesgeschichte*
FSt	*Frühmittelalterliche Studien*
GAG	Göppinger Arbeiten zur Germanistik
MGH	Monumenta Germaniae Historica
PBB	*Beiträge zur Geschichte der deutschen Sprache und Literatur*
WJfK	*Wiener Jahrbuch für Kunstgeschichte*
WSt	*Wolfram-Studien*
ZfdA	*Zeitschrift für deutsches Altertum und deutsche Literatur*
ZfdPh	*Zeitschrift für deutsche Philologie*

ACKNOWLEDGMENTS

This volume has grown out of an ongoing discussion on media and visuality in which we often found ourselves comparing the scholarly discourse in Germany with that in North America. Although a wide variety of aspects of medieval visual culture, such as memory, text and image, mysticism, and religious drama, have been the focus of debates in both North America and Germany, there has been little sustained intellectual exchange across the language barrier. Fortunately, in recent years, several of our colleagues have made the effort to bridge this gap between Europe and North America by organizing small conferences that rotate between Germany and the United States, bringing scholars together and creating a forum for an international exchange of ideas. These colleagues include Arthur Groos, Hans-Jochen Schiewer, and Volker Mertens (Berlin-Cornell), and Stephen Jaeger, Wolfgang Harms, and Peter Strohschneider (Munich-Urbana/Champaign-Berlin). In fact, we first came up with the idea to publish this collection of essays on visual culture at a conference organized by Arthur Groos at Cornell University in September 2000. We hope that this volume will foster scholarly debate on visual culture in the German Middle Ages on both sides of the Atlantic.

In the preparation of *Visual Culture and the German Middle Ages*, we have accumulated numerous debts to friends and colleagues. While it would be impossible to list everyone whose goodwill and generosity we have enjoyed, we would like to single out a few individuals here. We would like to thank Edward Potter, who devoted many hours carefully translating several of the essays in this volume. We are also grateful for the editorial expertise of Jonathan Hess, who enthusiastically supported this collection of essays and offered insightful critiques and advice that helped to make it a better book. We would also like to thank all of the contributors for their timely response to our sometimes hasty requests for additional information and documentation. In particular, we are grateful for their understanding when the press required us to cut the number of images in half.

The publication of this book would not have been possible without generous support from the Deutsche Forschungsgemeinschaft and the University of North Carolina at Chapel Hill. A research fellowship from the

Alexander von Humboldt Foundation allowed us to put the finishing touches on the volume at the Humboldt University in Berlin.

It has been a real pleasure to work with Bonnie Wheeler and Farideh Koohi-Kamali, and we are grateful to them and to the editorial staff at Palgrave Press for all the work that they have put into this book. The anonymous readers of the manuscript made extremely helpful comments and criticisms, and we thank them for the time and effort that they put into their detailed reports.

Kathryn Starkey and Horst Wenzel

CHAPTER 1

VISUAL CULTURE AND THE GERMAN
MIDDLE AGES

Kathryn Starkey

swer niht fûrbaz chan vernemen,
der sol da bi ouch bilde nemen [. . .].
swer niht enchan
versten, daz ein biderb man
an der schrift versten sol,
dem si mit den bilden wol.
der pfaffe sehe die schrift an.
so sol der ungelerte man
die bilde sehen, sit im niht
die schrift zerchennen geschiht.

—Thomasîn von Zerclaere, *Der Welsche Gast*, 1984, 1703–1704; 1711–1718

[Whoever is unable to comprehend otherwise should learn by looking at images [. . .].
Whoever cannot understand what a good man should understand from writing is well
served by images. Just like the priest looks at words, thus should the unlearned man
look at images, since writing does not reveal itself to him.] [Translations my own unless
otherwise noted.]

This multidisciplinary collection of essays draws on various theoretical
approaches to explore the highly visual nature of the German Middle
Ages and to expose new facets of old texts and artifacts. The term *visual
culture* has been used in recent years to refer to modern media theory, film,
modern art, and other contemporary representational forms and functions.

Recent volumes on visual culture, such as the collections of essays edited by Chris Jenks and Nicolas Mirzoeff, regard the privileging of sight as one of the markers of modernity.[1] The contributions to this anthology challenge the notion that visual culture is a modern paradigm. In fact, the visual culture paradigm is highly pertinent to premodern culture, which not only privileged sight and visual perception over other forms of reception and cognition but also gave rise to numerous discourses on visuality that may be found in the works of medieval secular poets, theologians, and scholastics alike. A number of recent books, articles, and conferences have examined various aspects of premodern visual culture, such as clothing, gesture, memory, word and image, and manuscript design and compilation.[2] These works have revealed medieval society to be a highly visual one in which images, objects, and performances play a dominant, communicative, and representative role in both secular and religious areas of society.

From the perspective of the medievalist, understanding visual communication and concepts of perception in the Middle Ages is crucial to understanding medieval culture. There appears to be a visual turn at the end of the twelfth and the beginning of the thirteenth century when we find the overt development of a courtly culture that goes hand in hand with innovations in architecture, fashion, literature, and literary transmission.[3] From the perspective of the modernist, studies on medieval visual culture provide a crucial historical perspective for understanding our own highly visual society, in which computers offer us guidance in the form of icons, and in which the visual media of the Internet, films, and television are the dominant cultural transmitters of information. The essays in this volume present various perspectives on medieval visual culture and provide a critical historical basis for the study of visuality and visual processes. The reader will find that visual culture in the Middle Ages is at once familiar and alienating to modern sensibilities.

Paradigmatic for the Middle Ages is the broad notion of the image that we find in the immensely popular book of conduct, the *Welsche Gast* ("The Italian Guest" [1215]), cited earlier. The *Welsche Gast*, the first treatise on conduct composed in the German vernacular, covers such topics as courtly manners, comportment, spiritual guidance, the liberal arts, and the rules of self-representation and leadership. It is directed explicitly at a mixed court audience comprised of "fruome ritter und guote vrowen und wise pfaffen" [pious knights and good women and wise clerics] (15, 349–50). Although conceived as a written text from the start, Thomasîn von Zerclaere emphasizes, in the brief excursus on learning and perception cited above, the importance of images, of *bilde*, for someone who cannot read. While he seems to present his audience with a bipartite structure of learning that involves reading for the educated cleric and looking at images for the layperson, in fact, Thomasîn's notion of images is a broader one that

incorporates memory, visualization, description, and example.[4] Thomasîn employs the term *bilde* (image) on numerous occasions throughout the text to refer to different kinds of visual perception, including description, role models or examples, scenarios, memories, and imagination. Thomasîn's form of presentation is designed for an audience that learns not only by looking at but also by envisioning images, working with concrete ideas, and making visual connections. Whereas we might think of an "image" as a pictorial representation on parchment, Thomasîn uses the term *bilde* not to refer to pictorial reproduction or illustration per se, but rather to a more encompassing notion of images that even includes writing. He therefore does not simply make a distinction in the excursus cited above between reading words and looking at illustrations, as some scholars have assumed; rather, he refers to different kinds of perception. On the one hand, the cleric might look at and ruminate on the word, on the other, the layperson focuses on images that may be textual or pictorial, real or imagined.

As the essays in this volume indicate, the notion of the visual was broadly conceived in the Middle Ages, encompassing images, objects, and performance. The term *image* is used in this collection of essays, as it is by medieval authors, to refer not only to pictures or illustrations but also to descriptive textual passages, such as ekphrasis, memorial strategies, imagination, and visions both sacred and secular. The term therefore denotes pictures that are real and imagined. Of great importance, in both the secular courtly society of the Middle Ages and in the religious sphere, were material *objects*, such as sculpture, tapestry, frescoes, manuscripts, relics, and other artifacts, that bear testimony to the various forms of medieval perception and representation. Finally, *performance* refers to the dramatic enactment of scenes, the choreography of rituals, and the presentation of music, texts, and entertaining acts. The reception of images, objects, and performance involved writing, reading, seeing, watching, visualizing, and imagining—processes that were not perceived as mutually exclusive but as intersecting and influencing one another as modes of visual perception.[5] *Visual culture*, therefore, in the broadest sense, refers to images, objects, and performance and the processes of visually perceiving them.

New Visions in Medieval Studies

As the passage from the *Welsche Gast* implies, already in the Middle Ages, the visual was the focus of various scholarly and theological discussions about literacy and the laity, reception, imagination, representation, and memory. Several of the essays in this volume harken back to Gregory the Great's famous letter to Bishop Serenus of Marseille (ca. 600) in which he chastises the bishop for removing all the images in his church, thus

alienating his congregation. Gregory informs the bishop that images are like writing for the illiterate.[6] Traditionally, as Norbert Ott's essay (chapter 2) reminds us, scholars drew on this statement to justify regarding the study of art and literature as mutually exclusive disciplines. Since art historians regarded images as texts for the illiterate, they tended therefore to study images in manuscripts as discrete narratives independent perhaps not of the text, which becomes part of the visual layout of the page, but of the word. Literary scholars, on the other hand, tended to give primacy to the written text, regarding the images as informative illustrations and interpretations of the text, but derivative of and therefore secondary to the word. This perceived dichotomy is particularly apparent in early scholarship on word and image. Recently, however, scholars have reevaluated Gregory's comment both against the material evidence provided by manuscripts and in light of other medieval comments and discussions on perception. Thanks to the work of Mary Carruthers and others, Gregory's letter is no longer regarded as proof that words and images should be considered mutually exclusive, but that the processes for perceiving words and images were deemed to be similar.[7] Both involved reading (aloud), thought, and visualization. Images and texts thus functioned similarly and were perceived as complementary means by which one might achieve the same results.[8] The relationship between text and image or word and image is now regarded by many scholars as discursive, indeed symbiotic.

Along with these developments in our understanding of the visual processes of reception in the Middle Ages have come new efforts to approach the material in an interdisciplinary manner.[9] In this volume, Norbert Ott's essay examines the development of an interdisciplinary approach to the study of word and image. As a discussion of methodology rather than specific texts or visual processes, Ott's essay stands on its own. The other contributions to this volume provide examples of how productive such an interdisciplinary approach can be for understanding perception and visuality.

While the scholars represented in this volume contribute to ongoing debates in the field of medieval studies, this collection of essays differs from most current anthologies in its cultural perspective: the contributions are united by their emphases on German material and/or German-speaking territories. The field of Medieval Studies in North America is currently dominated by Romance and Anglo-Norman scholarship.[10] Most recent English-language publications on aspects of visual culture ignore the German tradition. Yet German medieval culture and the scholarship that has been done on it have much to offer the scholarly debates on visual culture in North America.[11] The contributors to this anthology place their studies within the larger framework of ongoing debates, thus bridging the cultural gap and making "new" material accessible to a wider audience.

In part, a linguistic barrier has caused the obvious bias in Medieval Studies. Many North American medievalists are not familiar enough with the German language to incorporate German scholarly work into their studies, and relatively little work on German medieval culture has been published in English. Thus, although many important studies in the field of visual culture, particularly on word and image, have appeared in German, these remain untapped by most scholars working in North America.[12] This volume seeks to bridge this gap by making available to an English-speaking audience the work of several eminent German scholars. Even within the field of German Studies, it is too often the case that there is little interaction between European and North American scholars. By transcending linguistic and geographic boundaries, it is the goal of this volume to raise new questions for the field of Medieval Studies while offering a new cultural perspective and enlivening scholarly debates across the Atlantic. Finally, this anthology offers an interdisciplinary perspective on visual culture of the Middle Ages. The contributors include both art historians and literary scholars, each of whom examines the ways in which ideas, acts, and processes were visualized in the Middle Ages.

Norbert Ott's polemic (chapter 2) from a European perspective on the development of word and image as a field of study suggests guidelines for further inquiry into the relationships between word and image, suggesting above all that interdisciplinarity is the key to understanding medieval visual culture. His essay, in a sense, sets the stage for this volume by providing a brief history of the intersection between literary and art historical studies, contrasting the traditional German resistance to an interdisciplinary discourse to the more inclusive approach prevalent in North America. Only now, he maintains, have German scholars started to embrace the interdisciplinary possibilities inherent in the study of word and image. To use Ott's metaphor, we are still in the process of polishing and identifying pieces of the mosaic, but we do not yet have a complete picture of the ways in which word and image worked together in medieval society. Implicit in his essay is the notion that in order to develop a better understanding of word and image, we must take into consideration scholarship across national boundaries.

Intermediality

Characteristic of many medieval German texts is a tension and interplay between word, image, and performance. This interplay becomes particularly apparent in manuscripts that attempt to meld the visual conventions of the Middle Ages with a developing secular understanding of the possibilities afforded by the written text. Three essays in this volume successfully isolate moments in vernacular texts in which this intermediality is particularly

tangible. As the term *intermediality* implies, these essays are concerned with the ways in which verbal and visual representation function together in the production of meaning for a medieval audience.

Jan-Dirk Müller's essay (chapter 3) addresses the visual nature of courtly culture depicted in literary texts, which are replete with descriptions of clothing, choreographed ceremonies, and gesture. Several scholars have recently focused on this aspect of court society, creating an image of a culture that relied primarily on a visual language of communication, rather than a verbal one. Müller challenges this scholarship by taking issue with the notion that courtly interaction can be reduced to representational visual signs. Looking at the ambiguities of visual communication in courtly literature, he demonstrates that gestures and other visual cues are not self-evident, but rather that medieval literature is replete with missed or misinterpreted visual signs. Indeed, the more the courtly world is visually codified, he argues, the more these signs are manipulated and misconstrued. Citing several literary examples, Müller demonstrates that poets resort to placing verbal clarifications of visual signs into the mouths of their characters or narrators. According to these literary texts, visual and verbal modes of expression intersect and rely on one another in the process of courtly communication.

Haiko Wandhoff (chapter 4) similarly exposes the interdependence of verbal descriptions and visual cues in literary texts. Focusing on ekphrastic passages describing decorated shields in epic texts from antiquity through the Middle Ages, Wandhoff demonstrates that these verbal representations are a strategic means of helping audiences to visualize poetic works of art. Emblems, symbols, and pictorial stories are projected onto the shield's surface, the detailed description of which serves as a commentary on the story. Drawing on the language of computer technology, Wandhoff describes the shield as an interfacing screen that navigates the reader's perspective of the verbal text. As Wandhoff shows, the motif of the shield is a key to understanding word-image interactions and particularly the verbal-visual qualities of literature in high and late medieval court society.

Ulrich Ernst's essay (chapter 5) focuses similarly on the intersection of the verbal and the visual. Drawing on an extensive corpus of vernacular texts and their redaction in illustrated manuscripts, Ernst argues for an intermedial form of reception that acknowledges both oral performance and the written word. He identifies a secular discourse on writing that is expressed both in the written texts and the illustrations that portray authors writing texts, messengers transporting written missives, and letters, for example. Ernst demonstrates how this discourse became widespread by the late Middle Ages, appearing in all genres of vernacular literature including the heroic epic, conduct literature, and romance. These pictorial and textual references to writing bear testimony to the intersection between writing and oral performance in the secular society of the Middle Ages.

Rethinking Manuscript Culture

Traditionally, scholars of orality and literacy set up a clear dichotomy that corresponded to the perceived dichotomy between the religious and scholastic Latin culture and the secular vernacular culture.[13] This division was thought to be reflected in the texts produced for the two groups: while the clerics read Latin books, the laity listened to performed vernacular texts. But, as scholars have recently shown, orality and writing existed side by side throughout the Middle Ages, intersecting and influencing one another.[14] As Dennis Green argued in his seminal study on primary reception of Middle High German literature, vernacular literary texts were composed with an eye to two-fold reception, that is, by listening to an oral performance or by reading.[15] More recently, Horst Wenzel's seminal comprehensive study of media in the Middle Ages has broken down these dichotomies to present a more complex and diverse image of medieval reception that involves all the senses, but places particular emphasis on the medieval discourse of reception by listening and seeing.[16] Although all the contributions to this volume deal in some sense with manuscripts, three essays in particular engage in recent debates on manuscript culture.

James Rushing (chapter 7) explores the manuscript evidence for an intersection and coexistence of oral performance and writing, of listening and reading. Examining the development of secular manuscript illustration in the context of orality and literacy, Rushing focuses on medieval redactions of the legend of Roland, one of the most frequently pictorialized nonbiblical story materials in the Middle Ages. Rushing puzzles over the fact that the two defining manuscript versions of the story, the Old French *Chanson de Roland* and the Latin *Pseudo Turpin* are barely touched by pictorial traditions. In answer to the question where the material finds its ways into the visual arts, Rushing suggests that pictorialization of the Roland material generally takes place at the interface of the oral and literate epistemes.

Joachim Bumke (chapter 6) argues that manuscript variation in the transmission of the courtly epic at the beginning of the thirteenth century reflects different versions of texts that coexisted orally. Whereas traditional scholars assumed that manuscript variation represented contamination of a fixed original text, Bumke's reassessment of the evidence suggests that different versions of a text bear testimony to a dynamic and discursive storytelling culture. His essay further argues that, as the concept of the text is reconceived in the course of the thirteenth century, the epics start to incorporate visual markers that help a reader to navigate the text, but they also become fixed in their transmission, so that we find relatively little variation in these texts from the end of the thirteenth century on.

Volker Mertens (chapter 8) also expands the traditional notion of the manuscript. Mertens interprets neumes, medieval musical notation, as

a visual representation of a musical text's realization in oral performance. Unlike modern musical notation, he argues, which is used to help an initiate learn the melody and tone of a particular song, neumes were intended as mnemonic aids. They served as a gloss or commentary on the text, helping a viewer to recall a melody with which he or she was already familiar and to envision a specific oral realization of a given song. The musical text was written down and viewed with voice and performance in mind. Moving from liturgical and scholarly texts to vernacular epics and poems, Mertens further demonstrates that neumes were visual markers of a text's importance, underlining the value of a codex and the centrality of a given song or section of a song.

Spiritual Visions

Among medieval religious communities, oral performance in the form of sermons and religious plays played a crucial role informing practices of devotion. In part 4 of this volume on spiritual visions, Jeffrey Hamburger and Niklaus Largier (chapters 9 and 10) demonstrate to what great extent religious practices rely on the visual to illuminate the word. These essays deal with spiritual texts, devotion, and the representation of God's word. Jeffrey Hamburger examines a remarkable sermon by Johannes Tauler (ca. 1300–1361) that was delivered to the Dominican nuns of St. Gertrude in Cologne in 1339. The sermon takes as its point of departure a copy in the nuns' refectory of one of the illustrations to Hildegard of Bingen's celebrated *Liber Scivias*. At issue, however, is more than an early and intriguing episode in the reception of Hildegard's most celebrated work. Hamburger considers Tauler's sermon in the context of other German sermons addressing images, including some by Meister Eckhart and others attributed to the so-called St. Georgener Prediger, and concludes that the sermon offers a very personal reading of Hildegard, consistent with Tauler's mystical theology and linking his insight to her visionary powers. At the same time, Tauler tailors Hildegard's prophecy, written some two hundred years earlier, to the requirements of the contemporary *cura monialium*, the pastoral care of nuns. The sermon testifies in uncommon detail to the importance of images in the mystical piety and the interaction of word and image in the visual culture of the German Middle Ages.

Niklaus Largier argues that both religious plays and visions represent in similar ways a desire for the enactment of the hidden, spiritual meaning of the Scriptures. Plays and visions use narrative, visual, and allegorical strategies to insist on the theological fact that the hidden meaning of the Scriptures can never be represented but that they have to be understood in terms of performance and of spiritual excitement. Thus, the staging of the gospel and of other

religious narratives in the shape of arousing images, theatrical plays, and vision-
ary experiences defines the concept of faith and conversion in specific ways,
turning conversion and union with the divine into emotional events that have
their origin within the logic and the structure of the visual display and that
compensate for the lack of our understanding with regard to the divine.

Word, Image, and Technology

This reliance on the visual, articulated already in Pope Gregory's famous
letter, was often perceived as problematic, particularly by theologians who
maintained the primacy of the word and saw images as seductive and
potentially sacrilegious. The relationship between the image and the word
remained a topic of lively debate among theologians and Church fathers
dating from Gregory up through the Middle Ages.

In part 5 of this volume, Horst Wenzel and Thomas Cramer (chapters 11
and 12) consider religious texts in the context of information technology
and genre. Whereas most cultural historians see the development of infor-
mation technology, such as the printing press, as a reflex of social history,
Wenzel argues that technological breakthroughs are often the result of fantasy
and imagination. He draws connections between the development of the
printing press, Christian iconography, and the notion of a communicative
network that spreads the word of God. Wenzel traces the iconographic
tradition of Christ in the wine-press to demonstrate that the technology of
the printing press is prefigured in these images. The printing press is seam-
lessly incorporated into the traditional religious iconographic tradition of
the body of Christ and its relationship to the word of God. The new tech-
nology is represented as a medium of communion.

Moving to the late Middle Ages, Thomas Cramer's essay deals with the
way in which book compilers solved the tension between words and images
in the Bible. The numerous picture bibles that start to appear after 1560, in
which images dominate the page, were highly problematic for Protestant
theologians who were concerned with the status of images in representing
God's word. Cramer's essay first examines justification strategies in Jos
Amman's picture bibles, published by Siegmund Feyerabend in 1564 and
1579. It then looks at the solution to the problem provided by Tobias
Stimmer and Johann Fischart, who develop a theory of art and signs that
ultimately frames their picture bible as a book of emblems.

Goals of this Volume

These essays explore a broad spectrum of questions and a wide range of
texts from the high to the late Middle Ages to engage in cultural studies in

the widest sense. By presenting a cohesive albeit heterogeneous understand-
ing of visual culture in the German Middle Ages, these essays shed light on
a central aspect of medieval culture that is currently the focus of scholarly
debate in a wide variety of disciplines falling within the rubric of Medieval
Studies.

By presenting new scholarship by leading authorities on early German
art and literature from both sides of the Atlantic, these essays further provide
a snapshot of the current state of German Medieval Studies. While the work
of some authors (Rushing, Hamburger, Largier, Bumke, and Wenzel) is
available in English, this collection of essays places the research of others
(Cramer, Ernst, Mertens, Müller, Ott, and Wandhoff) at the disposal of
an English-reading audience for the first time. While these scholars have
been in active exchange with American colleagues for some time, they are
for the most part undeservedly unknown outside the field of German
Medieval Studies. *Visual Culture and the German Middle Ages* should remedy
that situation.

Notes

1. Chris Jenks, ed., *Visual Culture* (London: Routledge, 1995); Nicolas Mirzoeff,
 ed., *An Introduction to Visual Culture* (London: Routledge, 1999); Mirzoeff,
 ed., *The Visual Culture Reader* (London: Routledge, 1998). See also Martin Jay,
 Downcast Eyes: The Denigration of Vision in Twentieth-Century French Thought
 (Berkeley: University of California Press, 1993).
2. See, for example, the work by Michael Camille on manuscripts and their
 illustrations including: Camille, "The Book of Signs: Writing and Visual
 Difference in Gothic Manuscript Illuminations," *Word and Image* 1 (1985):
 133–48; "Seeing and Reading: Some Visual Implications of Medieval
 Literacy and Illiteracy," *Art History* 8 (1985): 26–49; *Mirror in Parchment: The
 Luttrell Psalter and the Making of Medieval England* (Chicago: University of
 Chicago Press, 1998); and Mary Carruthers's work on memory: *The Book of
 Memory: A Study of Memory in Medieval Culture* (New York: Cambridge
 University Press, 1990); *The Craft of Thought: Meditation, Rhetoric, and the
 Making of Images, 400–1200* (New York: Cambridge University Press, 1998).
3. See Joachim Bumke, *Courtly Culture: Literature and Society in the High Middle
 Ages* (1991; repr. Woodstock, NY: Overlook Press, 2000), who discusses many
 of these changes and innovations.
4. See Kathryn Starkey, "From Symbol to Scene: Changing Models of
 Representation in Thomasîn von Zerclaere's *Welsche Gast*," in *Beweglichkeit
 der Bilder: Text und Imagination in den illustrierten Handschriften des "Welschen
 Gastes" von Thomasin von Zerclaere*, ed. Horst Wenzel and Christina
 Lechtermann (Cologne: Böhlau, 2002), pp. 121–42. See also the other essays
 in this volume for the most recent scholarship on Thomasîn's *Welsche Gast*.

5. See Horst Wenzel, *Hören und Sehen: Schrift und Bild* (Munich: C.H. Beck, 1995).

6. Pope Gregory I, *Gregorii I papae Registrum Epistolarum*, ed. Ludwig Hartmann, MGH: Epistolae, vol. 2, no. 270 (Berlin, 1899).

7. On medieval discourses on perception, see Carruthers, *Book of Memory*; Wenzel, *Hören und Sehen*. See also Norbert Ott, "Texte und Bilder: Beziehungen zwischen den Medien Kunst und Literatur in Mittelalter und Früher Neuzeit," in *Die Verschriftlichung der Welt: Bild, Text und Zahl in der Kultur des Mittelalters und der frühen Neuzeit*, ed. Horst Wenzel et al. (Vienna: Kunsthistorisches Museum, 2002), pp. 105–43.

8. Carruthers, *Book of Memory*.

9. Some of the most important collections of essays in German are as follows: Christel Meier and Uwe Ruberg, eds., *Text und Bild: Aspekte des Zusammenwirkens zweier Künste in Mittelalter und früher Neuzeit* (Wiesbaden: Reichert, 1980); Wolfgang Harms, ed., *Text und Bild, Bild und Text, DFG Symposium 1988* (Stuttgart: Metzler, 1990); Klaus Dirscherl, ed., *Bild und Text im Dialog* (Passau: Wissenschaftsverlag Rothe, 1993). Two important studies that served as touchstones for a previous generation of scholars are Wolfgang Stammler, *Wort und Bild: Studien zu den Wechselbeziehungen zwischen Schrifttum und Bildkunst im Mittelalter* (Berlin: Schmidt, 1962) and F.P. Pickering, *Literatur und darstellende Kunst im Mittelalter* (Berlin: Schmidt, 1966). See also F.P. Pickering, *Essays on Medieval Literature and Iconography* (Cambridge: Cambridge University Press, 1980).

10. There are a few exceptions, such as: Sarah Westphal, *Textual Poetics of German Manuscripts, 1300–1500* (Columbia, SC: Camden House, 1993); Joan A. Holladay, *Illuminating the Epic: The Kassel Willehalm Codex and the Landgraves of Hesse in the Early Fourteenth Century* (Seattle: University of Washington Press, 1996); James A. Rushing, Jr., *Images of Adventure: "Ywain" in the Visual Arts* (Philadelphia: University of Pennsylvania Press, 1995). Joachim Bumke's seminal study of courtly culture (*Courtly Culture*) has recently been translated into English and has already found tremendous resonance in the scholarly community. The work of C. Stephen Jaeger and Jeffrey Hamburger has also crossed disciplinary divides and been widely recognized in the field of Medieval Studies.

11. Important essays include: Norbert H. Ott, "Epische Stoffe in mittelalterlichen Bildzeugnissen," in *Epische Stoffe des Mittelalters*, ed. Volker Mertens and Ulrich Müller (Stuttgart: A. Kröner, 1984), pp. 449–74; Ott, " 'Pictura docet': Zu Gebrauchssituation, Deutungsangebot und Appellcharakter ikonographischer Zeugnisse mittelalterlicher Literatur am Beispiel der Chanson de geste," in *Grundlagen des Verstehens mittelalterlicher Literatur: Literarische Texte und ihr historischer Erkenntniswert*, ed. Gerhard Hahn and Hedda Ragotzky (Stuttgart: Kröner, 1992), pp. 187–212; Michael Curschmann, "Hören—Lesen—Sehen: Buch und Schriftlichkeit im Selbstverständnis der volkssprachlichen literarischen Kultur Deutschlands um 1200," *PBB* 106 (1984): 218–57; Curschmann, "Der Berner *Parzival* und

seine Bilder," *WSt* 12 (1992): 153–71; Curschmann, " 'Pictura laicorum litteratura'? Überlegungen zum Verhältnis von Bild und volkssprachlicher Schriftlichkeit im Hoch- und Spätmittelalter bis zum Codex Manesse," in *Pragmatische Schriftlichkeit im Mittelalter: Erscheinungsformen und Entwicklungsstufen*, ed. Hagen Keller et al. (Munich: Fink, 1992), pp. 211–29; Volker Schupp, "Pict-Orales oder Können Bilder Geschichten Erzählen?" *Poetica* 25 (1993): 34–69; Schupp and Hans Szklenar, *Ywain auf Schloß Rodenegg: Eine Bildergeschichte nach dem Iwein Hartmanns von Aue* (Sigmaringen: J. Thorbecke, 1996); Eckart C. Lutz, "Verschwiegene Bilder—geordnete Texte: Mediävistische Überlegungen," *DVjs* 70 (1996): 3–47; Lieselotte Saurma-Jeltsch, "Textaneignung in der Bildersprache: Zum Verhältnis von Bild und Text am Beispiel spätmittelalterlicher Buchillustration," *WJfK* 41 (1988): 41–59; Saurma Jeltsch, " 'Zuht und wicze': Zum Bildgehalt spätmittelalterlicher Epenhandschriften," *Zeitschrift des deutschen Vereins für Kunstwissenschaft* 41 (1987): 41–70; Saurma-Jeltsch, "Zum Wandel der Erzählweise am Beispiel der illustrierten deutschen *Parzival*-Handschriften," *WSt* 12 (1992): 124–52; Nikolaus Henkel, "Titulus und Bildkomposition: Beobachtungen zur Medialität in der Buchmalerei anhand des Verhältnisses von Bild und Text im *Bamberger Psalmenkommentar*," *Zeitschrift für Kunstgeschichte* 62 (1999): 449–63.

12. This unfortunately includes the work of Princeton professor Michael Curschmann, who has published numerous important essays in German. His work is central to the debates on word and image in Germany, and it also plays a prominent role in this volume as several of the authors draw on his essays.

13. See, for example, Herbert Grundmann, "Litteratus-illitteratus: Der Wandel einer Bildungsnorm vom Altertum zum Mittelalter," *Archiv für Kulturgeschichte* 40 (1958): 1–65.

14. For two recent studies on the two-fold reception of medieval English literature, see Joyce Coleman, *Public Reading and the Reading Public in Late Medieval England and France* (New York: Cambridge University Press, 1996); and Nancy Mason Bradbury, *Writing Aloud: Storytelling in Late Medieval England* (Urbana: University of Illinois Press, 1998).

15. Dennis Green, *Medieval Listening and Reading: The Primary Reception of German Literature, 800–1300* (Cambridge: Cambridge University Press, 1994).

16. Wenzel, *Hören und Sehen.*

PART ONE

NEW VISIONS IN MEDIEVAL STUDIES

CHAPTER 2

WORD AND IMAGE AS A FIELD OF RESEARCH: SOUND METHODOLOGIES OR JUST A FASHIONABLE TREND? A POLEMIC FROM A EUROPEAN PERSPECTIVE

Norbert H. Ott

> *Literature [. . . is] the bearer of thought [. . .]; art is not. [. . .] A book is, above all else, a "text."*
> *One understands it, or one does not understand it. [. . .] One needs a technique in order to unlock*
> *[the text]. This [technique] is called philology. Since the field of literary studies deals with texts, it is*
> *helpless without philology. [. . .] It is easier for scholars of art. They work with pictures—and*
> *photographs. There is nothing incomprehensible there. One must rack one's brains in order to*
> *understand Pindar's poems; this is not the case with the frieze on the Parthenon. One finds the same*
> *relationship between Dante and the cathedrals, etc. The study of images is effortless compared to the*
> *study of books.*

This statement, which is simultaneously naive and arrogant, was made by one of the most famous literary scholars of his century—no less a personage than Ernst Robert Curtius—and it appears in the introduction to his equally famous book *European Literature and the Latin Middle Ages.*[1] He even dedicated this book (and one is tempted to regard this as an intended insult) to Aby Warburg, that same Aby Warburg who, already at the beginning of the twentieth century and long before it became fashionable, practiced an integrated form of cultural studies that organized "the rest of the so-called 'humanities' around the focal point of pictorial art, thereby creating an

overall program of cultural history" and demonstrating the ways in which art is indeed the bearer of thought.[2]

One could, in good conscience, toss Curtius's dictum onto the trash heap of scholarly history, except that it reanimates a pronouncement that was once meant in a completely pragmatic sense: Gregory the Great's famous assertion that *pictura* were the *laicorum litteratura*. Over the course of a thousand years, this pronouncement did more to distort reflections on the relationship between the media of art and literature than it did to stimulate them. Even now, it still exerts a determining influence on the discussion.[3] The naive statement by the great philologist Curtius clearly highlights the fact that even modern literary scholars have yet to liberate themselves from the traditional school of thought regarding the Latin culture of writing in the Middle Ages. While many scholars accord the image merely the function of a substitute for writing, medieval practice constantly calls this assessment into question. Transposing their own methodological discourse onto other disciplines without having been invited to do so, scholars of texts tend to claim interpretative supremacy for themselves: the text is seen as that which precedes the image, as that which exists prior to the images, and the image is presumed to accompany the text only as a secondary element.

This type of methodological egotism is, however, not limited to textual scholars. Recently, Michael Curschmann has not only drawn attention to the statement by Ernst Robert Curtius cited earlier but he has also described a meeting with Erwin Panofsky, who was one of Warburg's methodological heirs, in which he asked Panofsky why professorships in art history but not in literary studies had been established at the Institute for Advanced Study in Princeton, New Jersey.[4] Panofsky answered, "That is because we have a method and you don't."[5] He was correct in that scholarship in art history, with its iconographic-iconological approach—and it was this approach that Panofsky had in mind—has a clearly defined, theoretically sound methodology at its disposal, which is practiced successfully in the treatment of objects, whereas philologists and literary scholars are much more likely to define themselves in terms of a variety of often conflicting methods, or, to state it in a more positive way, in terms of methodological pluralism. Moreover, iconology, which provides an experimental framework for tracking down the content, message, and thematic statement of artworks, in other words, the "thoughts" that Curtius claimed were missing, is an interdisciplinary method that was developed and tested above all on medieval and Renaissance objects, that is, on objects from eras in which the topics of art dealt almost exclusively with the Christian history of salvation and with classical mythology. These objects, therefore, correspond to material that is also presented in the textual medium that has been passed down to us either orally or in writing. Thus, art historians had already integrated texts, Curtius's literary studies, into their own methodology. This is precisely

the accusation and criticism that has been leveled at iconology by other schools of thought within the discipline of art.

Given the manner in which individual academic disciplines tend to remain, at times stubbornly, wed to the methods handed down to them, it is somewhat surprising that *one* interdisciplinary topic has already been attracting the passionate attention of various disciplines within the humanities for some time now: the topic of "word and image." Interest in this area has seen a rapid increase over the past twenty years, particularly in the field of medieval German literary studies in German-speaking countries. With this interest has grown the amount of material that has been the subject of research and/or discussion. The topics and perspectives have become broader as well, yet one cannot completely fend off the impression that, in all their naive joy over the new area of study, scholars are failing to reflect on the goals of the endeavor and especially on its methodological requirements. Particularly for one who was trained as a scholar in an environment of intellectual exchange in which interdisciplinarity was put into practice daily, it is odd to hear the mere study of texts and images praised lavishly as the very latest innovation, when these reflections upon a cultural–historical constant, reflections that began in the late sixties and early seventies, are really nothing more, as far as the history of scholarship is concerned, than the resumption of something that had already been practiced for a long time yet had been forgotten. It is, if you will, a question of a "secondary interdisciplinarity."[6] It is as though the field, which, of course, views itself as a historical discipline, had forgotten its own history. New labels such as *cultural studies* or *media studies* are falsely considered to denote new areas of inquiry on the academic market.

Studies in the broad field that is only rather hazily defined by terms such as *text and image, word and image, literature and art* have not only failed to disappear, but instead they have also almost come into vogue. The German language does not possess the terminological clarity of the English language, which draws a strict distinction between, on the one hand, *word and image*—the media-specific semiotic structures, the relationship of both media "in and of themselves"—and, on the other hand, *text and picture*—the manifestation of the media in concrete relationship to one another. Ultimately, this is precisely the reason for the terminological vagueness within the German academic community, both in discussions within the individual disciplines and in the dialogue between the disciplines. As a result, there is more talking at cross-purposes than any real discussion. A quite alarming example of this dialogue gone wrong is the volume containing the conference proceedings of the Deutsche Forschungsgemeinschaft (DFG) Colloquium on *Text und Bild, Bild und Text* ("Text and Image, Image and Text") in 1988.[7] Many of the contributions in this volume are remarkable for their lack of thorough theoretical and methodological reflection; equally remarkable is the accidental manner in which

the contributions, some of which were quite innovative, were brought together in the collection. The absence of either an interdisciplinary overview or a consciousness of methodology finally materializes in the bibliography appended to the volume, which includes more than eight hundred titles and was, according to the editor's introduction, meant to "establish [itself] as a central point of reference for future research"[8]—a threat that one can only hope will not be realized. In addition to the special interests of the bibliographers, another principle behind the compilation and organization of this bibliography was most likely pure coincidence, which, it must be admitted, may certainly lead to new discoveries. Nonetheless, the bibliography contains considerable gaps, especially concerning the literature on art history: Fritz Saxl, John Fleming, Lieselotte Saurma-Jeltsch, Hella Frühmorgen-Voss, Michael Camille, and Karl-August Wirth, for example, are each represented by only one of their early works. Others, particularly non-German scholars who have been making crucial contributions to the field of text-image research for a long time, such as Hugo Buchthal, Madeline Caviness, Chiara Settis-Frugoni, André Grabar, Sylvia Huot, Verdel A. Kolve, Elizabeth Sears, and Alison Stones, are completely ignored, which is a revealing commentary on the level of international and interdisciplinary exchange that is to be found among a good number of scholars who are engaged in the text-image discussion in Germany.

This is the very problem that plagues the field of text–image research even today, especially in Germany, despite considerable progress in various instances. The field of study termed *text-image* stretches between an ancient slogan and a medieval one—between Horace's *ut pictura poesis* and Gregory's *pictura laicorum litteratura*—and the subjects of research within this field of study are subdivided into two large areas: on the one hand, there are illustrations of manuscripts and printed texts, which are by their very nature closely intertwined with the text, and, on the other hand, there are objects that have customarily been described rather awkwardly as "pictorial representations of literary subject matter." These are images of literary subject matter, motifs, and narrative plotlines that existed independent of the medium of the book and were created in textile, painted, sculpted, or produced by other means on a variety of material objects. The literary subject matter had previously been or was concurrently passed down in a linguistic medium as well, either orally or in written form. It must be granted that some progress has been made in the field of text-image, at the very least in the following instances: first, library catalogs or descriptions of manuscripts in studies on the history of the manuscript tradition now at least mention whether a piece of textual evidence is illustrated or not; second, today's monographs on authors, genres, groups of texts, and the like can hardly make do any more without a chapter on the pictorial layout of the texts in question; and third, in numerous articles in handbooks of literary studies, the iconography of the subject matter is

also mentioned. In short, word has gotten around about how inextricably intertwined the media text and image were in the Middle Ages, and it has also become known that a literary scholar does not convey the whole truth if he or she ignores the iconography of the subject matter. Yet we have a long way to go before we can achieve fundamental methodological agreement, or reach an understanding regarding the goals of this endeavor, or are able to situate this area of study within the history of the discipline or in terms of its current topicality. Nevertheless, scholars could and should at least inform themselves about what needs to be done by, first, acquainting themselves with the history of the discipline (and also with the history of art scholarship in the first third of the twentieth century) and second, by following more systematically what has been happening recently in the academic community working in this area, especially in North America. Here, scholars of texts and scholars of images, if one prefers to use these terms, participate equally in the interdisciplinary dialogue, whereas in Germany, working with this double subject still remains, to a large extent, the domain of German literary studies. The few art historians who attended the DFG conference mentioned earlier found themselves in the roles of exotic outsiders or of guest lecturers who were invited in order to round out the program; otherwise, the "book scholars," many of whom were only dabbling in art history, remained among themselves. This state of affairs, which has continued, to a great extent, to the present, has very much to do with the development of both disciplines on both sides of the Atlantic, and with their permeating influence on one another, which has been determined by history.

German literary scholars of the early twentieth century, such as Burdach, Panzer, Walzel, and von der Leyen, were already making ambitious attempts to uncover the elements of structural commonality among literature, art, architecture, and music in comparisons of style and analogy under the heading of the so-called mutual elucidation of the arts.[9] These attempts were indebted to the intellectual-historical optimism of the beginning of the century, and soon caused art historians such as Dagobert Frey to call for methodological circumspection.[10] Several scholars were working concurrently, albeit unconnectedly and without any desire for discussion on either side, with the endeavors associated with the name of Aby Warburg to place art history in the service of an "integral" discipline of cultural studies and, in this way, to include all forms of cultural expression within a given period by making use of the content, that is, iconology.[11] These endeavors soon became obsolete, since the Warburg scholars disregarded the concrete physicality and the cultural context of the objects that they studied and compared to one another. The older, aestheticist and formalistic art history scholars were, in turn, suspicious of the Warburg School, not least because of its inclusion of pictorial evidence that was of inferior quality and that was used

for primarily pragmatic purposes, and the Warburg School (Erwin Panofsky, Fritz Saxl, and others) was ultimately driven out of Germany. The Warburg method used by German art history scholarship that was the most suitable means of studying the similarities and the differences of both media of representation and transmission, that is, art and literature, found its home in England and in the United States. The scholars who remained behind—and consequently "lagged behind" intellectually as well—busied themselves with such projects as discovering what was German about the Bamberger Reiter (Bamberg Horseman), or practiced their craft on garment pleats and produced innocuous critiques of style; in other words, they, like a fair number of their colleagues in literary studies, withdrew and turned to the immanent method; one could even say that they underwent the academic equivalent of the inner emigration. After the war, German art historians were faced not only with the ruin of their objects of study but also with the ruin of the fundamental principles of their methodology.

It is obvious that this situation was not conducive to interdisciplinary scholarship. In the United States, on the other hand, a form of art history had developed in productive dialogue with the discipline that had already been established there that regarded the knowledge and use of texts or indeed the interconnectedness of image and text as self-evident. This previously established discipline had already operated for a long time along the boundaries between the art of the image and the art of the word, whether in more methodological experiments such as Heckscher's *Studies in Relationship* or in large-scale studies supported with material such as Roger and Laura Loomis's book on the iconography of Arthurian subject matter, which appeared in 1938 and is indispensable even today. Roger and Laura Loomis were, incidentally, both literary historians who successfully trained themselves in the methodology of the neighboring discipline.[12]

Another literary scholar, Wolfgang Stammler, was connected with a revival of interest in the field of text-image in Germany, although this revival had a completely different emphasis than its intellectual-historical origins at the start of the century and the initial work of the iconological school. Using the subjects of his own field, German philology, as a point of departure, Stammler, with his neopositivist interests, made the inclusion of nontextual forms of the reception of vernacular literature, tapestries, frescoes, sculptures, as well as the iconography of the text-bearing manuscript "acceptable, so to speak" in postwar German studies, as Michael Curschmann once commented, and one should not underestimate this contribution.[13] He was, above all, interested in making materials available; but he was little interested in the theoretical or methodological problems of the interrelationship of the media. Nor did he engage in a dialogue with either the transatlantic communications community made up of art historians and literary historians

or with German art historians, although Stammler, as several of the places
of publication of his works testify, certainly had contacts within these
groups. The interdisciplinary discussion that never took place was certainly
not the result of an attitude of ignorance on the part of Stammler; it
reflected, instead, the desolate situation of postwar German art history.
Scholars who were interested in crossing the boundaries of the disciplines
and who had reflected on the methods needed for an integrated approach
to their mutual subject, such as the Byzantinists Hugo Buchthal and Kurt
Weitzmann, the art historian Hellmut Lehmann-Haupt (one of the first
who had, after Rudolf Kautzsch, produced important detailed studies on the
illustration of German-language manuscripts); and the historian Gerhart
Ladner, had been, as was mentioned above, driven out of the country.[14] This
desolate situation, among other things, led the editors of the seminal refer-
ence book for art historians, the *Reallexikon zur Deutschen Kunstgeschichte*
("Encyclopedia of German Art History"), to employ Stammler, who had
no background in the field, as the author of articles on the iconography of
Aristotle, Dietrich and on the illustration of vernacular epics.[15] It is charac-
teristic that the compendia that are so rich in material and that provide a
reappraisal of the iconography of secular subject matter—Loomis on the
Arthurian material, Ross and Settis-Frugoni on Alexander the Great,
Lejeune and Stiennon on Roland—were not produced in Germany.[16] The
few German art historians who studied illumination, for example, were still
primarily concerned with criticizing style and were, for the most part, only
interested in Latin or French masterpieces. They largely ignored the
German-language illuminated manuscripts, which were, according to their
standards, "inferior," although these manuscripts had been a central field of
research for scholars of the Warburg School, such as Fritz Saxl. These
German scholars almost entirely skirted questions concerning the complex
network of interrelationships between the illustrations and the illustrated
text. This was even the case with the great Otto Pächt, who did, in fact,
contribute pioneering research that led to important insights into illumina-
tion and yet who lacked the insight that, in the end, illuminations and illus-
trated texts all interconnected.[17]

Why then, one might ask oneself in view of this rather discouraging
situation in the 1960s, is there such an incredible boom in the text-image
field today, especially in medieval German literary studies in Germany? This
is so much the case nowadays that almost all literary scholars seem compelled
to include at least a few sentences about the iconography of their literary
subjects, even when their work has a completely different orientation. The
scholarship that has appeared on this topic in the last twenty-five years is
not yet overwhelmingly vast, yet it has certainly become more diverse. It
is becoming increasingly extensive, and it has begun to distinguish itself

in terms of its relevance and its methodology. At times, however, the scholarship has remained disparate and, occasionally, even muddled. In some cases, it has been methodologically unsound. The recent preoccupation in both German art history and German literary studies with this area of study probably owes more to the special interests of individual scholars or even to coincidences and lucky circumstances than to systematic methodological considerations. Here, one could name the following (and this list is certainly not all-inclusive): the art historian Christian von Heusinger, whose 1953 dissertation dealt with late medieval illumination in the Upper Rhine region; Lilli Fischel with her 1963 study on the illustration of incunabula; Leonie von Wilckens, who has written numerous articles on the illustration of manuscripts and on textile art, many of which arose from the author's daily practical work at the Germanisches Nationalmuseum; or Gerhard Schmidt with his many contributions on the illustration of vernacular manuscripts, among other things, on the *biblia pauperum*, which was, incidentally, a subject that, up until Karl-August Wirth's article in the *Verfasserlexikon* ("Lexicon of Authors"), had been studied almost exclusively by art historians.[18] This exclusivity resulted, for example, in a lack of attention to the fact that variations in the text, the so-called German narrative model, had provoked changes in the pictorial models resulting in typological illustrations being abandoned in favor of new iconic narrative series. These initially isolated studies converged, in the end, into a network of debates within the discourse on art history that has become ever denser so that, today, the study of vernacular illuminated manuscripts and of pictorial representations of literary subject matter has become a matter of course among art historians as well; Lieselotte Saurma-Jeltsch is one such scholar who works on the boundary of pictorial art and literature.[19]

Literary studies, on the other hand, did not enter into the dialogue until later, and even today, scholars of literature prefer to speak amongst themselves than to engage in a dialogue with their colleagues in the neighboring discipline. Indeed these scholars have hardly taken note of the discussion that has been taking place for some time now among art historians regarding the narratology of the image, a discussion that is associated primarily with Wolfgang Kemp and his associates,[20] nor has literary studies paid sufficient attention to interdisciplinary projects such as the Münster research group "Cultural History and the Theology of the Image." Incidentally, it is possible to pinpoint almost the exact moment of the sudden outbreak of enthusiasm for the iconographic dimension of literature that views pictorial representations predominantly as a previously neglected means of transmission for literary texts or literary subject matter: this moment is marked by the discovery of the *Iwein* frescos at Rodenegg Castle in Southern Tyrol in 1972. Shortly after the publication of Niccolò Rasmo's reports on the uncovering

and restoration of the frescos, literary scholars pounced almost breathlessly on this earliest pictorial evidence of secular subject matter that had been passed down in the vernacular,[21] and from the very beginning, the discussion then took place under the primacy of (Curtius's) literary studies, or to speak in Gregory's categories: under the primacy of the *litterati*. It also took place without adequate familiarity with the system of methods, categories, and terminology used in the neighboring discipline of art history, indeed, without even sufficient knowledge of the material.[22] Interdisciplinarity does not, after all, mean merely introducing entities that are usually dealt with by another discipline into one's own process of investigation. I do not necessarily mean to place blame on scholars of the word: philology's claim to interpretative supremacy is extremely old and can even be supported with quotations from the Bible. The practice of explaining an image, the *imago*, by means of language is equally old, going back at least as far as the scholarly culture of medieval Latin literacy: art theory has become, to a certain extent, obscured by "poetics" or "semiotics" as the metadiscipline of cultural studies. Since then, the conviction that "the meaning both of texts and of images [. . . can] be demonstrated adequately and with ultimate authority only by texts," has defined, in either expressed or unexpressed form, the discussion taking place among Germanists on this subject.[23] Philologists have only rarely considered the fact that the pictorial medium indeed possesses its own system of categories, its own structure, and its own truth quite apart from the structure, the categories, and the truth of texts. Hopeful and expectant philologists are then disappointed when they fail to recognize their own interpretation of a work, derived from a text, when they are confronted with the structure and choice of scenes in pictorial representations or with the specific emphases of illustration cycles in manuscripts that reflect the same work in the medium of the image. Philologists are then, indeed, quick to accuse medieval artists of a lack of familiarity with the text, or they hypothesize about a gap in the transmission of the object or text. Mistaken conclusions such as these are not only, however, the result of a philologist's lack of familiarity with the methods of art history—art historians are, of course, often similarly unfamiliar with philologists' methods—but are often also the result of studies based on too narrow a range of material.

As far as the topic text-image is concerned, we still basically find ourselves in the phase of collecting and preparing materials, if one overlooks the discussion regarding requirements, goals, and methods that has yet to reach its conclusion, especially in Germany, where interdisciplinary work is not, by any means, a matter of course and is often not institutionally recognized. Already Stammler realized this, and it was also one of the reasons that persuaded Hugo Kuhn to plan a *Katalog der deutschsprachigen illustrierten Handschriften des Mittelalters* ("Catalog of the German-Language Illustrated

Manuscripts of the Middle Ages") when the Commission for Medieval German Literature of the Bayerische Akademie der Wissenchaften was founded in 1959,[24] long before those kinds of research projects or fields of study had even begun to be considered elsewhere. His methodological approach involved seeking out literature and the use of literature in transmission, and as far as this approach was concerned, it was a matter of course to include manuscript iconography in the investigative process. Indeed, Kuhn made use of an expanded conception of literature, which at that time was not at all self-evident and which, possibly even unintentionally, corresponded to the expanded conception of art held by the Warburg School. Hella Frühmorgen-Voss took over the project. Frühmorgen-Voss, a scholar trained as both a literary scholar and an art historian, was predestined not only to take the interdisciplinary discussion and interdisciplinary practices seriously but also to lend the project its first, decisive contours. Even with such a "positivist" undertaking as a catalog, one must, after all, be fairly clear about the research goals, the requirements, and the methods already before starting one's work, since, as we all know, even the most wonderful material does not organize itself. Without going into this catalog of illustrated manuscripts and its possible influence on the intermedial discussion of methods in more detail, it must, nonetheless, be emphasized that this undertaking, which up until now is the only one of its kind within the realm of the European vernacular languages, has simplified the premises for a dialogue between the disciplines concerning texts and images. It should be noted that certain completely unplanned and unexpected results have come to light as a by-product of the work of cataloging. For example, during the preparation of the material, it became clear that there were considerably more manuscripts that derive from printed texts than had previously been presumed: the new medium of transmission did not, as a matter of course, supersede the old medium of transmission; instead, both media existed for a considerable time in an interrelationship that was, most certainly, productive for both.[25]

Several methodological observations and studies extending beyond the positivist collection of material have arisen from working on the "Catalog," including some beginning efforts to catalog pictorial representations that are not found in manuscripts.[26] Even in this area, despite the works of Loomis, Ross, Settis-Frugoni, Lejeune-Stiennon, Frühmorgen-Voss, Fouquet, Rushing, and others, the process of collecting pieces and preparing material has by no means been completed.[27] What is particularly needed is at least a preliminary attempt to proceed from the floor exercises of the "positivist" accumulation of facts, which is the necessary basis for all higher acrobatics. Indeed, one must first methodologically structure one's exercises before venturing onto the high wire of comprehensive overviews. This

endeavor would involve considering the following, as a kind of framework:[28]

1. in the context of orality and literacy, the instances of mediation between text and image;
2. combinations of various literary subjects in an iconic medium (Dietrich-Alexander-Roland, for example, on a series of capitals or on facades);
3. the principles according to which individual scenes and narrative plotlines are selected for the pictorial medium from the available material in the literary "source" and the issues that seem to lie behind these principles of selection;
4. the locations of the images and the materials used that had a considerable influence on the use of the pictorial literary narratives;
5. the function of artifacts that condense all of the literary subject matter available for a given story into a single scene (for example, the orchard scene in *Tristan*), and the types of images used in these instances;
6. the principles of form that are intrinsic to the medium of pictorial art: series, oppositions, symmetries, repetitions, frontality; and any elements in the structure of the text that might correspond to them;
7. the pictorial elements beyond the texts, or in other words, motifs, such as nine heroes, the castle and the tournament of courtly love, slaves to courtly love, wild people, and fountains of youth, that are also passed down via the medium of text but are to be found much more often and far more independently in the medium of image; and
8. the changes in the structure of the pictorial artifacts and in the situation in which they were used in their historical context, which allows one to draw conclusions about the lives of the texts themselves.

It is, however, doubtful that the time has yet arrived for us to incorporate the insights gained from the numerous individual studies on cycles of illustrations in manuscripts or on manuscript-independent pictorial representations into the systematic writings on literary history. Various recent studies, such as Michael Curschmann's several seminal articles, Horst Wenzel's 1995 book, James Rushing's book on *Iwein*, and several other works as well, have, hopefully, made it clear to many people that the relationship between art and literature played no less a role in the construction of the German vernacular secular culture and secular culture of writing (*Literarizität*) in the Middle Ages than the relationship between the vernacular and Latin, which scholars have known about for quite some time.[29] It is, however, not yet a matter of course that scholars take the iconographic dimension of a literary work into account before venturing to make fundamental statements about a medieval text or genre from the perspective of literary history or literary sociology. Perhaps, as we are still in the process of preparing the material, it

really is too early for that just yet. In spite of the great progress that has been made and the insights that have been gained, there have only been a few breakthroughs in the thicket of images and texts, oral and gestural performances, and written and iconic representations, even taking into consideration works of such an extensive scope as Wenzel's *Hören und Sehen, Schrift und Bild* ("Hearing and Seeing, Writing and Image"). Michael Curschmann, for one, is aware of this as well. He qualified the groundbreaking research contained in his substantial article "Wort—Schrift—Bild" ("Word—Writing—Image") with the introductory remarks that he only "selected a few aspects and attempted to gain insights," and that "the book that should be written might, perhaps, be written in ten years."[30]

Such comprehensive overviews of the complementary and complex relationship between literature and art in their respective manifestations and in the respective situations of their usage, whether these overviews are about the illustration of vernacular manuscripts or about pictorial representations or whether they are more general in nature (and this should actually be the goal), are only truly useful and promising when they are based on a broad range of material. This means that in addition to the vernacular German sources, one must consult the illustrations of Latin literature,[31] and above all, the neighboring vernacular literatures, most especially French literature, where the situation regarding the preparation of the material is even more desperate.[32] For the time being, we will have to content ourselves with collecting bits of the mosaic in individual paradigmatic studies that can then be brought together to form a complete picture, albeit a picture formed by precisely considered, complex methodological processes. This methodological transformation can, however, in conjunction with the occasionally deprived, unspectacular, yet direly necessary "positivist" preparation of materials, only come into being through interdisciplinary work in art history and literary studies, through the mutual and patient listening and the integrated cooperation of scholars in both, as well as other, disciplines. It is not my place to decide whether or not it is reasonable to demand that every scholar doing research in this interdisciplinary field be well versed in the varying methodological and material tools of the individual disciplines before he or she is tempted to draw any conclusions about his or her research. Nonetheless, it should go without saying that one should at least attempt to gain a familiarity with the fundamental methodological categories of the neighboring disciplines that are involved, so that one does not merely respond to the material with astonishment, even if it is interested astonishment. Instead, one should be equipped with a capacity for critical evaluation when one is working on material that "belongs" to the neighboring discipline.

If taken to its logical conclusion, this demand would have consequences for academic policies: academia would at last have to break with that

"awkward policing of the boundaries" of the individual disciplines that Aby Warburg criticized as far back as 1912,[33] and it would have to push ahead with (and this is also a question of the organization of scholarship and of institutions of higher learning) an interdisciplinary, comprehensive medieval cultural studies program; in this program, the respective disciplines would, on the one hand, have their own place but, on the other hand, would be integrated within the context of a common research interest to make our knowledge about this period and its achievements broader, more profound, and more subtly differentiated. These disciplines would include the philological and literary studies programs of all of the medieval languages; the history of art and the history of law; theology and philosophy; music, nature, and technology studies; historical studies in the narrow sense of the term; in short, every discipline that relates in some way to the Middle Ages and that, up until now, has been atomized. In Germany at present, the official definition of the type of research that is considered deserving of financial support is admittedly more likely to leave one skeptical about whether such interdisciplinary models have any chance of ever being realized. These models, namely, require stamina, which means concretely the organization of long-range projects that are kept going by scholars who are not being rushed from one project to the next but have instead acquired their skills by means of old-fashioned "experience," which they must acquire by dealing extensively with the objects of their study. These scholars would not be performing so-called marketable research and would, as a result, not be secure in a system of universities that are meant to conduct only research that will immediately make itself felt in the balance of trade. The distinctive image of such a discipline would be more similar to the highly complex organizing principle of the Early Modern cabinet of curiosities, which referred one both forward and backward at the same time and in which usefulness was not yet misunderstood to mean merely something that may be put to use. If we were to sacrifice this goal, we would, in the end, indeed produce a so-called knowledge-based society, but it would be one without a memory.

Notes

Translated by Edward T. Potter.

1. "Die Literatur [. . .ist] Träger von Gedanken [. . .], die Kunst nicht. [. . .] Ein Buch ist, abgesehen von allem anderen, ein 'Text'. Man versteht ihn oder man versteht ihn nicht. [. . .] Man braucht eine Technik, um [ihn] aufzuschließen. Sie heißt Philologie. Da die Literaturwissenschaft es mit Texten zu tun hat, ist sie ohne Philologie hilflos. [. . .] Die Kunstwissenschaft hat es leichter. Sie

arbeitet mit Bildern—und Lichtbildern. Da gibt es nichts Unverständliches. Pindars Gedichte zu verstehen, kostet Kopfzerbrechen; der Parthenonfries nicht. Dasselbe Verhältnis besteht zwischen Dante und den Kathedralen usw. Die Bilderwissenschaft ist mühelos, verglichen mit der Bücherwissenschaft." Ernst Robert Curtius, *Europäische Literatur und lateinisches Mittelalter*, 2nd edn. (1948; repr. Bern: Francke, 1954), p. 24.

2. "um das Zentrum der Bildkunst herum den Rest der sog. 'Geistes'-Wissenschaften zu einem kulturhistorischen Gesamtprogramm." Michael Curschmann, "Wolfgang Stammler und die Folgen: Wort und Bild als interdisziplinäres Forschungsthema in internationalem Rahmen," in *Das Mittelalter und die Germanisten: Zur neueren Methodengeschichte der Germanischen Philologie; Freiburger Colloquium 1997*, ed. Eckart Conrad Lutz (Freiburg, Switzerland: Universitätsverlag, 1998), p. 116.

3. See also Michael Curschmann, "Pictura laicorum litteratura? Überlegungen zum Verhältnis von Bild und volkssprachlicher Schriftlichkeit im Hoch- und Spätmittelalter bis zum Codex Manesse," in *Pragmatische Schriftlichkeit im Mittelalter: Erscheinungsformen und Entwicklungsstufen*, ed. Hagen Keller, Klaus Grubmüller, and Nikolaus Staubach (Munich: Fink, 1992), pp. 211–29.

4. I owe most of what I say here to articles by Michael Curschmann as well as to conversations with him. It will not be difficult for readers who are familiar with his work to recognize what I have borrowed from him in my text, even if these elements have not been explicitly noted in every case when they go beyond the mere quotation: my contribution largely retains the form of a lecture and therefore intentionally dispenses with the usual academic window dressing. This is not meant to offend; instead, it is meant to provide the impetus to a possible discussion.

5. Curschmann, "Wolfgang Stammler," p. 116.

6. Curschmann, "Wolfgang Stammler," p. 116.

7. Wolfgang Harms, ed., *Text und Bild, Bild und Text: DFG-Symposion 1988* (Stuttgart: J.B. Metzler, 1990). The DFG is the central organization for the support of research in Germany. In addition to supporting young scholars and providing scientific counsel to political committees, it also finances research projects at universities, independent research institutions, and scientific academies, and supports academic conferences and publications.

8. "als zentraler Bezugspunkt künftiger Forschung etablieren." Compare the review by Michael Curschmann in *PBB* 115 (1993): 314–27.

9. Konrad Burdach, *Nachleben des griechisch-römischen Altertums in der mittelalterlichen Dichtung und Kunst und deren wechselseitige Beziehungen* (1895); repr. in *Vorspiel: Gesammelte Schriften zur Geschichte des deutschen Geistes*, vol. 1, part 1: *Mittelalter*, ed. Konrad Burdach (Halle: M. Niemeyer, 1925), pp. 49–100; Friedrich Panzer, "Dichtung und bildende Kunst des deutschen Mittelalters in ihren Wechselbeziehungen," *Neue Jahrbücher für das klassische Altertum, Geschichte und deutsche Literatur* 13 (1904): 135–61; Oskar Walzel, *Wechselseitige Erhellung der Künste: Ein Beitrag zur Würdigung kunstgeschichtlicher Begriffe* (Berlin: Reuther & Richard, 1917); Friedrich von der Leyen, "Deutsche Dichtung und bildende Kunst im Mittelalter," in *Abhandlungen zur deutschen*

Literaturgeschichte: Franz Muncker zum 60. Geburtstage dargebracht, ed. Eduard Berend et al. (Munich: C.H. Beck, 1916), pp. 1–20. See also Max Hauttmann, "Der Wandel der Bildvorstellungen in der deutschen Dichtung und Kunst des romanischen Zeitalters," in *Beiträge zur Kunst- und Geistesgeschichte: Festschrift Heinrich Wölfflin* (Munich: H. Schmidt, 1924), pp. 63–81.

10. See the introduction in Dagobert Frey, *Gotik und Renaissance als Grundlagen der modernen Weltanschauung* (Augsburg: Dr. B. Filser, 1929), pp. xvii–xxxi.

11. On Warburg, see Ernst H. Gombrich, *Aby Warburg: Eine intellektuelle Biographie* (Frankfurt am Main: Suhrkamp, 1984).

12. William Heckscher, *Art and Literature: Studies in Relationship*, ed. Egon Verheyen (Baden-Baden: V. Koerner, 1985); Roger Sherman Loomis and Laura Hibbard Loomis, *Arthurian Legends in Medieval Art* (1938; repr. London: Kraus Reprint Corp., 1966).

13. Curschmann, "Wolfgang Stammler," p. 119. The most important essays of Wolfgang Stammler are collected in *Wort und Bild: Studien zu den Wechselbeziehungen zwischen Schrifttum und Bildkunst im Mittelalter* (Berlin: E. Schmidt, 1962). See also Stammler's *Der Totentanz: Entstehung und Deutung* (Munich: C. Hanser, 1948); and *Frau Welt: Eine mittelalterliche Allegorie* (Freiburg, Switzerland: Universitätsverlag, 1959).

14. Hellmut Lehmann-Haupt, *Schwäbische Federzeichnungen: Studien zur Buchillustration Augsburgs im XV. Jahrhundert* (Berlin: W. de Gruyter, 1929).

15. "Aristoteles," in *Reallexikon zur deutschen Kunstgeschichte*, vol. 1 (Stuttgart: J.B. Metzler, 1937), cols. 1027–40; "Dietrich von Bern," in *Reallexikon*, vol. 3 (Stuttgart: J.B. Metzler, 1954), cols. 1479–94; "Epenillustration," in *Reallexikon*, vol. 5 (Stuttgart: J.B. Metzler, 1967), cols. 810–57.

16. See Loomis and Loomis, *Arthurian Legends in Medieval Art*; David J.A. Ross, *Illustrated Medieval Alexander-Books in Germany and the Netherlands: A Study in Comparative Iconography* (Cambridge: Modern Humanities Research Association, 1971); Chiara Settis-Frugoni, *Historia Alexandri elevati per griphos ad aerem: Originbe, iconografia e fortuna di un tema* (Rome: Istituto storico italiano per il Medio Evo, 1973); Rita Lejeune and Jacques Stiennon, *La légende de Roland dans l'art du Moyen Âge* (Brussels: Arcade, 1966).

17. See Otto Pächt, *Buchmalerei des Mittelalters: Eine Einführung*, ed. Dagmar Thoss and Ulrike Jenni (Munich: Prestel-Verlag, 1984); see particularly the bibliography in that volume listing all of Pächt's works on book illustration (pp. 214–15).

18. See respectively Christian von Heusinger, *Studien zur oberrheinischen Buchmalerei und Graphik im Spätmittelalter* (Diss., Freiburg i. Br., 1953); Lilli Fischel, *Bilderfolgen im frühen Buchdruck: Studien zur Inkunabel-Illustration in Ulm und Straßburg* (Konstanz: J. Thorbecke, 1963); Leonie von Wilckens: "Regensburg und Nürnberg an der Wende vom 14. zum 15. Jahrhundert: Zur Bestimmung von Wirkteppichen und Buchmalerei," *AGN* (1973): 57–79; Wilckens, "Salzburger Buchmalerei um 1400: Was charakterisiert und was trennt sie von der donaubayerischen?" *AGN* (1974): 26–37; Wilckens, "Nürnberger Bildteppiche um 1460–65," *AGN* (1976): 31–38; Wilckens, "Buchmalerei um 1410–1440 in Heidelberg und in der

Kurpfalz," *AGN* (1980): 30–47; Wilckens, "Die Bildfolge von Gawan auf dem gestickten Behang in Braunschweig," *Niederdeutsche Beiträge zur Kunstgeschichte* 33 (1994): 41–56; Wilckens, "Das Mittelalter und die 'Wilden Leute,' " *Münchner Jahrbuch der bildenden Kunst* 3, Folge 45 (1994): 65–82; Gerhard Schmidt, *Die Armenbibeln des XIV. Jahrhunderts* (Graz: H. Böhlaus Nachf., 1959); Karl-August Wirth, "Biblia pauperum," in *Die deutsche Literatur des Mittelalters: Verfasserlexikon*, 2nd edn., vol. 1, ed. Kurt Ruh et al. (Berlin: de Gruyter, 1978), cols. 843–52.

19. I cite here only a few of the numerous articles by Lieselotte E. Saurma-Jeltsch: "Zuht und wicze: Zum Bildgehalt spätmittelalterlicher Epenhandschriften," *Zeitschrift des Deutschen Vereins für Kunstwissenschaft* 41 (1987): 41–70; "Textaneignung in der Bildersprache: Zum Verhältnis von Bild und Text am Beispiel spätmittelalterlicher Buchillustration," *WJFK* 41 (1988): 41–59, 173–84; "Neuzeitliches in einer mittelalterlichen Gattung: Zum Wandel der illustrierten Handschrift," in *Hours in a Library* (Frankfurt am Main: Zentrum zur Erforschung der frühen Neuzeit der Johann Wolfgang Goethe-Universität, 1994), pp. 70–112; *Spätformen mittelalterlicher Buchherstellung: Bilderhandschriften aus der Werkstatt Diebold Laubers in Hagenau*, 2 vols. (Wiesbaden: Reichert, 2001).

20. Compare, for example, Wolfgang Kemp, ed. *Der Text des Bildes*, Literatur und andere Künste 4 (Munich: Edition Text + Kritik, 1989).

21. These works can be found in the bibliography of Volker Schupp and Hans Szklenar, *Ywain auf Schloß Rodenegg: Eine Bildergeschichte nach dem "Iwein" Hartmanns von Aue* (Sigmaringen: J. Thorbecke, 1996).

22. I include here my first discussion of the subject with Wolfgang Walliczek in Norbert H. Ott and Wolfgang Walliczek, "Bildprogramm und Textstruktur: Anmerkungen zu den 'Iwein'-Zyklen auf Rodeneck und in Schmalkalden," in *Deutsche Literatur im Mittelalter: Kontakte und Perspektiven; Hugo Kuhn zum Gedenken*, ed. Christoph Cormeau (Stuttgart: Metzler, 1979), pp. 473–500.

23. "die Bedeutung sowohl von Texten als auch von Bildern [. . .] in letzter Instanz und adäquat nur durch Texte abgebildet werden [kann]." Michael Titzmann, "Theoretisch-methodologische Probleme einer Semiotik der Text-Bild-Relationen," in Harms, *Text und Bild*, p. 376 [368–84].

24. Kommission für Deutsche Literatur des Mittelalters der Bayerischen Akademie der Wissenschaften.

25. Compare for example, Norbert H. Ott, "Von der Handschrift zum Druck und retour: Sigismund Meisterlins Chronik der Stadt Augsburg in der Handschriften- und Druck-Illustration," in *Augsburg, die Bilderfabrik Europas: Essays zur Augsburger Druckgraphik der Frühen Neuzeit*, ed. John Roger Paas (Augsburg: Wissner, 2001), pp. 21–29.

26. Hella Frühmorgen-Voss, Norbert H. Ott et al., eds., *Katalog der deutschsprachigen illustrierten Handschriften des Mittelalters*. The following volumes have appeared in print thus far: vol. 1: *1. "Ackermann aus Böhmen"— 11. Astrologie/Astronomie* (Munich: C.H. Beck, 1991); vol. 2: *12. Barlaam und Josaphat—20 Anton von Pforr, "Buch der Beispiele der alten Weisen"* (Munich: C.H. Beck, 1996); vol. 3: *21. Johann von Neumarkt, "Buch der Liebkosungen"—26*.

Chroniken (Munich: C.H. Beck, 2003); vol. 5:1–2: *43. Gebetbücher* (Munich: C.H. Beck, 2002). For a catalog of images not found in manuscripts, see Norbert H. Ott, "Katalog der Tristan-Bildzeugnisse," in *Text und Illustration im Mittelalter: Aufsätze zu den Wechselbeziehungen zwischen Literatur und bildender Kunst*, ed. Norbert H. Ott (Munich: C.H. Beck, 1975), pp. 140–71.

27. See the works cited in note 16; Hella Frühmorgen-Voss, "Tristan und Isolde in mittelalterlichen Bildzeugnissen," in Ott, *Text und Illustration*, pp. 119–39; Doris Fouquet, *Wort und Bild in der mittelalterlichen Tristantradition: Der älteste Tristanteppich von Kloster Wienhausen und die textile Tristanüberlieferung des Mittelalters* (Berlin: E. Schmidt, 1971); Fouquet, "Die Baumgartenszene des Tristan in der mittelalterlichen Kunst und Literatur," *ZfdPh* 92 (1973): 360–70; James A. Rushing, *Images of Adventure: Ywain in the Visual Arts* (Philadelphia: University of Pennsylvania Press, 1995).

28. See Norbert H. Ott, "Literatur in Bildern: Eine Vorbemerkung und sieben Stichworte," in *Literatur und Wandmalerei I: Erscheinungsformen höfischer Kultur und ihre Träger im Mittelalter. Freiburger Kolloquium 1998*, ed. Eckart Conrad Lutz, Johanna Thali, and René Wetzel (Tübingen: Niemeyer, 2002), pp. 153–97.

29. See, for example Michael Curschmann, *Vom Wandel im bildlichen Umgang mit literarischen Gegenständen: Rodenegg, Wildenstein und das Flaarsche Haus in Stein am Rhein* (Freiburg, Switzerland: Universitätsverlag, 1997): Curschmann, "Wort—Schrift—Bild: Zum Verhältnis von volkssprachlichem Schrifttum und bildender Kunst vom 12. bis zum 16. Jahrhundert," in *Mittelalter und frühe Neuzeit: Übergänge, Umbrüche und Neuansätze*, ed. Walter Haug (Tübingen: M. Niemeyer, 1999), pp. 378–470; and other of Curschmann's works cited earlier; Horst Wenzel, *Hören und Sehen, Schrift und Bild: Kultur und Gedächtnis im Mittelalter* (Munich: C.H. Beck, 1995); Rushing, *Images of Adventure*.

30. "ein paar Aspekte ausgesondert und Durchblicke versucht. [. . .] Das Buch, das zu schreiben wäre, kann vielleicht in zehn Jahren einmal geschrieben werden." Curschmann, "Wort—Schrift—Bild," p. 381.

31. A review of the *Katalog der deutschspachigen illustrierten Handschriften des Mittelalters* ("Catalog of the German-Language Illustrated Manuscripts of the Middle Ages") remarked that the limitation of the catalog to German-language manuscripts and the exclusion of Latin manuscripts in particular was a "fundamental and serious conceptual deficiency of the catalog." This remark indicates, on the one hand, insufficient familiarity with the specific characteristics of the iconography of German-language literature and, on the other hand, naive illusions about the feasibility of this type of "compilation of information" within the context of publicly funded research (see Nikolaus Henkel in *Germanistik* 32 [1992], no. 3829). It is, however, correct that one can only make informed statements about iconographic contexts that extend beyond the subject matter when one takes the entire European situation into account.

32. The two-volume compilation *Les Manuscrits de Chrétien de Troyes / The Manuscripts of Chrétien de Troyes*, ed. Keith Busby, Terry Nixon, Alison Stones,

and Lori Walters (Amsterdam: Rodopi, 1993) that, for the first time, presents the manuscript iconography of Chrétien's epics in a systematic manner, was, typically enough, the result of the initiative of American scholars.

33. Aby M. Warburg, "Italienische Kunst und internationale Astrologie im Palazzo Schifanoja zu Ferrara," in *Aby M. Warburg: Ausgewählte Schriften und Würdigungen*, ed. Dieter Wuttke in collaboration with Carl Georg Heise (Baden-Baden: V. Koerner, 1979), p. 185 [173–98].

PART TWO

INTERMEDIALITY

CHAPTER 3

WRITING—SPEECH—IMAGE:
THE COMPETITION OF SIGNS

Jan-Dirk Müller

> Die Gebäude der Sprachwelt, in der wir jetzt noch wohnen, werden bald schon
> weitgehend verlassen und unter dem Sand der Bilderwelt begraben sein. Sprache—
> eine verlassene Provinz—nicht mehr der universale Code, der die Welt aufschließt. Oft
> stelle ich mir die blinkende und tönende, sprachlose Bilderwelt vor, die einmal Natur
> hieß und die nun wuchernd wiedererscheint in Form der neuronalen Datennetze, in
> denen das Selbstgespräch dieses Planeten längst stattfindet.
>
> —Thomas Hettche, *Animationen*, 1999, p. 12;
> Hettche's book provides the best denial of this vision.

[The edifices of the world of language in which we now live will soon be largely deserted
and buried under the sand of the world of images. Language—a deserted province—no
longer the universal code that unlocks the world. I often imagine the flashing and
resonating, speechless world of images, once called nature, that is now rampantly
reappearing in the form of the neuronal data networks in which this planet has been
talking to itself for a long time.]

Prophecies such as the one cited above are more and more common now
that the electronic communications media have set off on their triumphal
march, no longer transporting only a limited linguistic code (such as Morse)
or only spoken or written language (such as radio or fax) but instead trans-
porting images and sounds as well. In fact, these types of multimedia commu-
nication are no longer only used by big institutions that have access to the
necessary technology (such as television) but can be produced by anyone

with access to the "net." In modern forms of communication, the word is more and more often supplemented or replaced by iconic signs. Indeed, a world without books seems to be one of the less threatening visions of the future, when some people even envision a world without writing, or perhaps without language, looming on the horizon. Yet, ever since Malthus predicted that humanity would die of starvation, such predictions have never proven trustworthy, and now, too, one should wait first and observe carefully, especially since futuristic visions of this sort reflect, to a considerable extent, fantasies of retrogression. It is telling that, in the words of Hettche cited earlier, "nature" is to "reappear" in that future world of images, apparently a Rousseauian world "before" the differentiation of language. Is it the return to a space beyond language, a homecoming into the romantic phantasm of unmediated presence? One must remember that this so-called nature, this world of images, is one that is conveyed solely by digital means and that the use of nonanalog linguistic signs, and particularly, nonanalog metalinguistic signs has not declined, but rather increased. Thus, this putative return to nature is, in reality, a departure into a world in which a "natural" physical experience and sensory perception are possible only in a virtual sense, as simulation. One should not confuse a world of images that is digitally produced with one that is not.

Yet the comparison of the digital with the nondigital has generated a good deal of current interest in the question of how such a world of images might function. The secular society of the Middle Ages, which was gradually acquiring writing skills and whose members were still predominantly illiterate when courtly literature was beginning to flourish, provides us with illustrative material. Only a small part of society, the clergy, could write, but this clergy was connected to the secular world and placed its skills at the disposal of the illiterate. Scholars coined the term *vocality* to describe this interaction of speech and writing, that is, of literate and illiterate forms of communication.[1] But speech was always accompanied by visual signs: on the one hand, gestures, gesticulations, stances, and movements in space, and on the other hand, body language, attributes, clothing, props, and accoutrements. These visual signs compete with linguistic ones by supplementing, supporting, or thwarting them. Taken together, speech and visual signs all make up communication.

This view has no doubt become the consensus. But Hettche's reflections contain a much farther-reaching supposition, and this supposition, too, has been applied to the Middle Ages: namely, that it is possible to think not only of a world without writing but also of one without language. This is suggested, for example, in one scholar's statement "that, in the largely illiterate culture of the nobility, from which the courtly epic takes its origin, the body is the central medium for the realization of collective knowledge."[2] The voice is, of course, part of the body as well, but the statement refers to the many visual signs that can be perceived on the body. Although this

comment may be only a hasty formulation, it can, in my opinion, be regarded as symptomatic of certain trends within the general discussion in which "speech" plays only a subordinate role compared to pictorial or written signs and in which visual signs are supposed to be self-evident. One reason for this may be that pictorial and written signs are transmitted in manuscripts, for "the body is accessible to us in written sources and, as a result, in the written tradition,"[3] while oral communication vanished as did the visual reality in which it was embedded. When scholars consider only the opposition of writing and image, therefore, they fail to comprehend communication in a preliterate society. We have to distinguish different levels of analysis and, when dealing with medieval culture, we have to describe the interaction of speech and visual signs on the one hand and the representation of both by written or pictorial texts on the other.

Visual Signs

In a culture of visuality, the world is suffused with signs. To a far greater extent than in the modern era, visual perceptions can be "read."[4] An abundance of examples can be cited to demonstrate that social learning is transmitted for the most part by means of imitating, that is, without writing and even without language; that courtly behavior adapts itself to visible models; that visible rituals express religious or political meaning; that social structure as well as religious truths are represented in images; that nature itself is understood as an inventory of signs referring back to God's act of creation. But if we regard all these different phenomena, *visuality* appears as a generalized term for diverse relationships of signs—between allegorical images and involuntary body language—and the "reading" of these signs requires very different skills. Visuality means encoded actions, stances, gestures, insignia, objects of material culture, configurations in space and time, "traces" of the divine Creator in nature, and the like. Scholars tend to bundle together extremely heterogeneous phenomena, both in terms of intellectual history as well as in terms of the pragmatics of communication, and subsume them under the term *visuality*.

Of greatest importance are iconic signs that have been explicitly coded (for example, coats of arms, allegories, and the like); here, each sign is accorded a specific meaning. These signs function in a manner that is analogous to verbal language. The same is true of the implicit codification of concretely visible actions or objects (for example, the liturgy, legal procedures, and the like). Their range of meaning is more open, and the interpretative leeway that they afford is broader, yet they, too, have been more or less conventionalized and can be "learned" like a language.

It should, therefore, be no surprise that the considerable number of images that have come down to us in medieval manuscripts, especially in

religious ones, are just as elaborate and complex as writing, and indeed are often motivated by the tradition of writing.[5] However, scholars have often neglected this fact when comparing the culture of visuality to the culture of writing: allegorical representations of religious truth very often presuppose the most complex theological speculations, as the Ohly school has repeatedly demonstrated. Contrary to what one might think, the "book of nature" is not accessible to every human being; it does not present meaning in a clear, unmediated fashion; instead, it is a highly differentiated text that requires instruction and scholarly knowledge in order to "read" it correctly. Visuality does not mean self-evidence.

These pictorial signs or series of signs are accessible to us only if we know the code. In these instances, images compete with writing as a medium of storage. Like written signs, they can convey meaning, even when they are removed from the situation in which they were originally used or to which they originally referred. Visual codes are transmitted either by means of writing (for example, in the allegorical interpretations of the Mass, in legal books) or by means of pictorial representations (for example, pictorial inventories, heraldic books, and the like), but we only have access to what has survived in the form of writing or iconic representation. Their transmission, therefore, does not differ fundamentally from that of linguistic communication.

There is also a more informal practice of visually encoding actions and events by using, for example, gestures of petition or inquiry, gestures of subservience, colors, different kinds of clothing, and the like.[6] In general, the degree to which these signs can be regulated is much lesser than in the examples of visual encoding discussed earlier, resulting in a greater chance of misunderstanding.[7] However, by primarily communicating via visual codes, medieval culture was able to develop a greater repertory of such signs than we moderns can appreciate, as well as establish conventions regarding the meanings of those signs. These signs could therefore be used and interpreted with much more certainty in the Middle Ages than today.

Yet, scholars assume that the visual culture of the Middle Ages was "legible" in an even more extensive sense. Visible reality as a whole is accorded significance not only in the case of implicit or explicit encoding. It is correct that a preliterate or semiliterate culture directs its attention to a greater degree toward the many visible details involved in the face-to-face processes of everyday communication such as stances, gestures, clothes, spatial distribution of the interacting partners, and the like. (Even today, these elements play an important role in oral communication.) Much of what is considered informal or insignificant in literate cultures, as far as these visible details are concerned, is meaningful in the social dynamics of the Middle Ages, even when its significance is not codified anywhere.[8] But

it would be wrong to conclude that the visible world is symbolic in all of its elements. There are only rare cases of this, such as in the totally allegorical interpretation of nature (*Omnis mundi creatura*). Exceptions such as this represent the clerics' desire to invest the visual world beyond Scripture with religious meaning. Originally, the creation means nothing in and of itself; instead, it is constituted as a visual sign only in the scholarly, religious discourse.

This is often overlooked because scholars in medieval studies deal with texts and sometimes with iconic representations, but not with the visual world represented by them.[9] In the secondary system of the text (and *a forteriori* the literary text), everything is a (written) sign and is, as a result, a potential bearer of meaning. It is not possible, however, to draw conclusions from the written text, for the same is not true about the primary system. In other words, the elements that have a symbolic character in the literary text do not necessarily have one in the everyday world; elements that must be deciphered in the one may lack significance in the other. In comparison to the everyday world, literary texts are overdetermined. Reading visually perceptible elements in a literary text and reading them in the everyday world are not the same thing. Every word of what Wolfram narrates of Parzival battling with Ither, for example, is charged with meaning; it does not, however, follow that participants in a similar scene in the everyday world would read it in the same way, that is, as meaningful in every respect. Similarly, when one learns by copying and imitating in the real world, he or she selects only a part of a variety of perceptions; the pupil judges some things to be signs, and others not.[10] In a literary or iconic allegory, on the other hand, one expects everything to be significant.[11] Therefore, one should not speak generally of the "encoding" of the visual world. "Encoding" presupposes one who encodes and thus the conscious organization of visible reality as an ensemble of signs. This, however, apparently only occurs in special cases—although it is prevalent in the Middle Ages. But, even in the Middle Ages, the visible world is not totally invested with meaning, for not everything that is visible has a communicative function, neither from the point of view of the observer nor from the point of view of the observed.

Expressiveness and clarity differ with the degree of conventionalization. In general, visual signs are less arbitrary than linguistic ones and depend, therefore, to a lesser degree upon a particular culture. Whereas language, apart from a few borderline cases, is an arbitrary system of signs, there are varied degrees of arbitrariness within the realm of the visible world. The least culturally specific signs are the instinctive expressions of the body that are understandable transculturally without needing to be encoded. Even gestures, stances, and processes that are determined in a culturally specific (for example, ritual) manner can include a large number of nonarbitrary signs. Gestures of mourning, for example, are less extensively conventionalized

and are therefore, as a whole, if not in all their details, comprehensible across different cultures. By contrast, legal gestures can be subject to particular rules in medieval society that are incomprehensible elsewhere: one has to learn their precisely established form in order to take legal action properly, so that the judge, the jurors, and the bystanders understand what is happening (and, correspondingly, the modern observer must know their meaning in order to interpret them as in, for example, the illustrated manuscripts of the legal treatise, the *Sachsenspiegel* ["Saxon Mirror"]).[12]

On the whole, one may say that conventionalization prevails in an institutionalized framework such as the court trial or the liturgy. Here, one can speak of a "vocabulary" that is more or less consciously used, a vocabulary with conventional, and to a large extent, arbitrary signs. This similarity to language does not, however, characterize the visual as a whole; encoded iconicity is a special case that can not be generalized.

Reading the Visible

Signs exist only for readers. Even visual signs are not self-evident. The visual world, like the written text, is an ensemble of signs only if someone deciphers it. In this respect, visual and written signs are akin to one another; they differ only in the knowledge that they presuppose.

Of course, scholarship has concentrated on the explicitly encoded forms of visual communication, for instance, in the realm of religion (the attributes of the saints, the liturgy, the representation of the unseen, and the like) in the legal sphere (for example, the gestures enacted during the handling of a case or the completion of a contract), in political representation (signs of sovereignty, indications of hierarchy, rituals, and so on), at the court (objects, clothes, attributes), and last but not the least the *proprietates* in the "book of the world." This pictorial "language" requires a certain competence just as the written text does, and this competence is often no less sophisticated than writing and reading.

A second type of sign is based on the social knowledge of everyday behavior, a knowledge of how something must look or take place or how something normally looks or takes place. This type leaves greater leeway for interpretation than the first type does. It seems that this kind of social knowledge was more important in the Middle Ages than it is in modern times. Nonetheless, since it is, for the most part, informal, there exists an asymmetrical relationship between the "transmitter" and the "receiver": signs are ambiguous, they can be misunderstood, or the observer can understand something as a sign that was not intended as such.

A third type of visually perceptible sign is the involuntary expression of the body. Here, one should not speak of a "use" of signs at all, even if those signs are "read" by an observer, for example, blushing as a sign of shame,

distortion of the face as a sign of rage. What is "read" is not necessarily intended as a sign. On the contrary, a person who sends a "message" with this type of sign may have intended to suppress it. An outbreak of pain does not have to be rehearsed, nor is its expression arbitrary: its meaning is directly visible to the eyewitness. But the person suffering may not want to show that he or she suffers.

Finally, it is possible that something visual has no particular meaning within a given culture itself, and only later, from the perspective of a different culture, becomes legible as a "sign": for instance, a sign of certain intellectual or social configuration. Only the historian is able to "read" it as a more or less culturally specific convention. People are habituated unconsciously to those conventions and therefore do not realize that they exist; they are meaningful only to the scholar of later generations.

These various readings of signs can compete with one another in one and the same situation. For this reason, one and the same phenomenon may not only be significant for one observer and insignificant for another, but it can also convey different meanings according to the context and the code that the observer applies to the phenomenon. A famous example of this is the incident of the raised spear in Wolfram von Eschenbach's *Parzival* in the scene in which Parzival is mesmerized by three drops of blood in the snow:[13] for Parzival himself, his raising of the spear is meaningless. It is certainly not a sign of aggression that is directed at an opponent, but rather the expression of his engrossment. For a moment he loses control over his body and his weapons and forgets that they are possible signifiers to be guarded against misinterpretations.[14] For Segremors, Keie, and the other Arthurian knights, on the other hand, the spear is—within the context of a conventionalized chivalric code and in a situation in which everybody expects hostilities to break out—a sign of aggression. This interpretation is incorrect. Gawan, too, interprets Parzival's appearance as a sign. For him, Parzival's behavior as a whole (including the raised spear) is a sign of his mental absence. Realizing that the drops of blood in the snow on which Parzival fixes his gaze are the reason for this absence, Gawan is able to understand the scene and to liberate Parzival from his embarrassment. He interprets the situation correctly, but without Parzival having given him any sign. These interpretations all make do without language.

For the medieval or modern recipients of the text, it is different. In Wolfram's narrative, they receive a verbal explanation of Parzival's motives along with the description of his strange behavior. The recipients can, therefore, immediately understand the sign correctly. Parzival's behavior is not only a sign of courtly lovesickness (as Gawan realizes), but also a reflective pause that already signals the impending crisis. Thanks to language—to Wolfram's words—the audience also understands the interpretations of the sign by the

participants in the scene. Last but not least, the modern reader is informed about signs of aggression in the warrior society of the Middle Ages.

The gesture of the raised spear is at once devoid of meaning, (incorrectly) interpreted as a sign of aggression, correctly understood as a symptom of a psychological state (which obviously has not been explicitly encoded), and a symbol of the crisis that is looming, and it is finally a piece of evidence for the universal encoding of visuality in the Middle Ages. Only in the second case is the gesture supposed to be "encoded": it is read as an element of a chivalric code.[15] It can, however, also be "read" when no cultural encoding exists: not everything that is read presupposes a code. Often something only becomes a sign if it is interpreted by someone who—like Segremors or Gawan—can be a participant in the narrated situation or—like the audience or the modern scholar—is an outside observer.

Visual signs thus vary in scope, but they only function within certain contexts, and for certain observers. They create a space for interpretation that is far more extensive than that of speech. Many medieval narratives revolve around the ambiguity of signs. Different sign systems—verbal and nonverbal, symbolic and iconic—can stimulate or negate one another. In the following case studies, I explore these hypotheses: First, one must examine the performance and specialization of visual codes in their relation to language. Second, it is apparent that the inferiority of visual signs to speech was a source of reflection already during the Middle Ages.[16] Third, when visual signs are narrated, we ultimately have to distinguish between the producer and the recipient of visual signs. Fourth, the distinction between producers and recipients becomes much more complex when we are dealing with visual signs in a text.

The Sign of Tears: The Interpretable Symptom

In the *Nibelungenlied*, when Kriemhilt insults Prünhilt in the famous quarrel between the queens that takes place in front of the Cathedral of Worms, the latter bursts into tears (843, 1; 850, 3). This is an appropriate emotional response to the damage done to her honor (*êre*, 849, 2; 853, 1). The public (*offenlîche*, 851, 4) insult and her crying before everyone's eyes concerns Gunther's entire court: "daz muose vreischen Gunther und aller Burgonden man" [Gunther and all of his people had to learn of this] (850, 4). Crying is not only Prünhilt's concern, but it is also a visible sign that peace has been disrupted: "ich muoz unvroelîche stân" [I must exclude myself from the joy of the court] (852, 4). Gunter's intervention does not succeed in reinstating harmony. Instead, the visible damage continues: "dô trûret' alsô sêre der Prünhilde lîp / daz ez erbarmen muose die Guntheres man" [then Prünhilt mourned so much that Gunther's followers had to feel pity for her] (863, 2–3).

This disruption becomes visibly legible on the queen herself. Prünhilt does not have to do or say anything. Her tears, perceivable to all, indicate what must be done: Hagen questions her—"weinende er si vant" [he found her in tears] (864, 2)—and vows to her that he will avenge her on Sivrit. Others follow him, and Sivrit is murdered. After vengeance has been exacted, one reads: "Prünhilt diu schoene mit übermüete saz" [the beautiful Prünhilt lived in the elation of her victory] (1100, 1): her capacity for courtly interaction (*hôher muot*) has not only been restored to a far greater extent, but it is also visible in her appearance.[17]

When later on Kriemhilt celebrates her wedding with Etzel and has obviously reacquired all of her earlier honors, she nevertheless bursts into tears when she recalls "wie si ze Rîne sæze [. . .] bî ir edelen manne" [how she lived on the Rhine with her noble husband] (1371, 1–2). Her crying is, once again, a sign that order is disrupted and, in the context in which it occurs, it is a sign that could arouse suspicions of revenge. This is why Kriemhilt hides her tears: "si hetes vaste hæle daz ez iemen kunde sehen" [she hid them carefully so that no one could see them] (1371, 3). Even later, when Kriemhilt wants to lure her brothers to Etzel's court, she explicitly forbids the messenger to say in Worms, "daz ir noch ie gesâhet betrüebet mînen muot" [that you have ever seen me saddened] (1415, 3). It is not until they arrive at Etzel's court that the Burgundians learn that "Kriemhilt noch sêre weinet den helt von Nibelunge lant" [Kriemhilt still weeps bitterly for the hero from the land of the Nibelungs] (1724, 4), and "ich hoere alle morgen weinen unde klagen / mit jâmerlîchen siten daz Etzelen wîp" [every morning, I hear Etzel's wife weeping and lamenting in a pitiful manner] (1730, 2–3).

Kriemhilt's tears have to remain a secret because it would be devastating if someone were to draw any conclusions from them. Her secretive tears are not uncovered until it is, in fact, too late. Crying is the expression of pain. Prünhilt and Kriemhilt do not use crying as a sign; they do not cry because they intend to inform someone about their feelings, but because they have experienced *leit* (pain). But, their environment is able to interpret crying as a sign, or more precisely, as a symptom of pain and much more. For them, this crying is by no means a purely private phenomenon, but a sign of disorder. The disruption is visually perceptible in their tears. As a sign, crying indicates a desire for vengeance. So, in the one instance (Prünhilt) it triggers action, in the other (Kriemhilt), it has to be dissimulated, for nobody is supposed to suspect that action is already underway. The hearer or reader of the *Nibelungenlied* recognizes crying as the symbolic omen or foreshadowing of that which is to come: the murder of Sivrit and the betrayal of the Burgundians. The modern scholar recognizes the public meaning of individual emotions in the medieval culture portrayed in the *Nibelungenlied*.

What seems to be (1) an involuntary yet visible sign of an emotional experience proves to be (2) a sign of a social condition, (3) a sign of future events, and (4) a datum for historical anthropology. Crying is not primarily an element of a code, but it is, on a secondary level, able to be read like the element of a code, since courtly society pretends to live under the norm of "joy," and a violation of this norm indicates disruption. Crying is both audible and visible.

What Prünhilt Sees: The Misunderstood Code

Crying is not explicitly encoded. Sivrit's and Gunther's appearance when they arrive in Isenstein on their wooing expedition, however, is. Here, two "languages" compete, but the language of the visible lacks clarity, so the meaning must be established by means of linguistic signs. First, Sivrit and Gunther stage a ritual of subordination and superiority before the eyes of Prünhilt and her court. Sivrit performs a service for Gunther: he helps Gunther to mount his horse, takes the horse by the reins, and leads it onto the beach. In the political semantics of the twelfth century, this is an unambiguous performance expressing the social and political relations between Gunther and Sivrit, and Gunther, therefore, feels *getiuret* (glorified [396, 4]) by the performance.[18] Accordingly, when Prünhilt welcomes them, Gunther stands one step before Sivrit: he "has precedence" (420, 3). Yet, none of these performances helps at all because Prünhilt holds Sivrit to be the leader of the small group and the one who is challenging her to become his bride (416), and so she welcomes him first.

The staging of their entrance in Isenstein is meant to represent a difference in rank between Gunther and Sivrit that coincides with their roles in the contest for the bride. Sivrit's extraordinary strength, which qualifies him as the only possible challenger of Prünhilt, has to be concealed behind a pretense of vassalage to Gunther that completely reverses the relation of upper and lower, of first and second. The staging seems necessary (see 386) in order to make Gunther appear to be a plausible suitor for Prünhilt. Movements and configurations in space are "encoded" in this "staged" entrance. It is obvious, however, that the visual code is not understood in Isenstein, for Prünhilt greets the wrong man first. Doing so, she acts in accordance with what she sees. She welcomes the man whose physical appearance stands out from the other foreigners, the one who [is] "gelîche Sîfride" [looks like Sivrit] (411, 3), the "starken Sîfrit" [strong Sivrit] (416, 2).[19] Prünhilt "reads" in Sivrit's body that he is stronger than Gunther and, as a result, that he will be the challenger, and she also "reads" in his clothing, which is the same quality and color as Gunther's, that he is not of a lesser rank than the Burgundian lord. In contrast to the encoded performance on the beach

of Isenstein, these signs of physical superiority lack anything that is arbitrary or conventional. To use Augustine's terminology, Prünhilt responds to a symptom (*signum naturale*) rather than an explicit signal (*signum datum*). The courtly code of the visible, which the people in Isenstein do not understand, conflicts with another interpretation of the visible world that is plausible to an archaic warrior society and therefore accepted by Prünhilt and her companions.

Two differently elaborated interpretations of the visible compete here with one another. In comparison to the service that Sivrid performs for Gunther, and the enactment of courtly precedence, the physical sign of superior strength is less complex. In the former, the participants have consciously engaged in encoding their actions; their code is conventionalized, which, however, also means that it is not necessarily comprehensible anywhere beyond the world of Worms. In a less subtle system of signs, physical strength indicates political power and political power indicates strength. The significance of the visually perceptible has, in both cases, a limited scope; it is valid only "regionally" and suggests results that contradict each other.

The conflicting statements of the visible are finally resolved by means of language, that is, in Sivrit's words to Prünhilt explaining to her what she sees: according to Sivrit, Gunther, who is standing before him (code of staged visibility) is his lord, and Gunther has forced Sivrit to support him in the dangerous adventure (equation of authority and power, contrary to the visible impression of physical superiority). Sivrit makes the "valid" meaning clear using words. Language overrides the visible signs. However, in this case, language, like the visually encoded actions of the two men, is sending a false message. This double lie suppresses what Prünhilt thought she could read in Sivrit's physique directly. The evident nature of Sivrit's appearance contains the true message, whereas speech as well as gestures distort reality. It is the narrator's voice that tells the audience what really happens in this complicated competition of signs.

Der Stricker, *Der nackte Bote* ("The Naked Messenger"): The Symptom as Code

The complementary nature of visual communication and language (and, once again, the possibility of the misinterpretation of the former) is presented in the *Maere vom nackten Boten* ("Tale of the Naked Messenger").[20] As often happens in the work of the Stricker, this tale deals with the misunderstanding of a situation and the warning that one should practice clever circumspection.[21] Over and above that, the text also problematizes the visually perceivable.

A lord sends a messenger to one of his vassals, at whose home he would like to spend the night. A mentally challenged *kint* (child) directs the

messenger to the vassal, telling him that he is to be found in the heated bathing room. The messenger "sees" (l. 18) that his informant, the child, is witless but does not inquire any further. Instead, he understands that the vassal is taking a bath ("wânde" [believed], l. 22; "gedâhte" [thought], l. 25). In fact, however, the vassal has withdrawn with his family to the only room that is heated in the in-between season, a custom that the narrator calls "hövischeit" [appropriate behavior] (l. 55). Since the messenger wants to adapt his conduct to the place he is visiting, he takes off his clothing. The child remains silent, as children should do, according to the narrator ("als ein kint sol" [as a child should], l. 38). The cause of the ensuing confusion is thus a situation in which there is a lack of linguistic communication: the messenger does not inquire, and the child does not warn him.

The messenger picks up a bundle of twigs at the entrance to the bathhouse in order to cover his private parts, but he is attacked by a watchdog and has to use the bundle to protect himself. For this reason, he enters the bathing room backward ("hinder sich" [l. 77]), and, of course, naked. Up to this point, the bathing room has been a site of courtly order: "man mohte dar inne schouwen / vil manigen wünneclîchen lîp" [one could see many beautiful women there] (l. 60 f.). But now, the messenger bursts into the circle with his naked rear end:

> als in dô die vrouwen
> sô blôz begunden schouwen,
> sie erkômen vor schanden
> und dâhten mit den handen
> die ougen al gemeine. (ll. 81–85)

[when the ladies caught sight of him there so naked, they were beside themselves with shame, and all of them covered their eyes with their hands.]

To greet someone with one's naked rear end is a coarse and insulting gesture. The chapbook *Ulenspegel* alludes to this in the protagonist's name— Ulenspegel is an outlaw and an outrageous troublemaker. As a gesture, greeting someone with one's naked rear end can probably be understood transculturally; it does not need to be formally "encoded," for its meaning appears to be clear. In the Stricker's narrative, too, no one doubts the insulting character of the gesture. This is why the landlord reacts in an outraged fashion: "der erzeicte im schiere sînen haz" [he immediately demonstrated his enmity toward him] (l. 87); or perhaps a better translation would be: "he showed him instantly that he felt he was being attacked." What happened by accident is interpreted as a meaningful gesture that does damage to the host's *êre* (honor).[22] As a result, the vassal wants to avenge himself for

the insult by killing the messenger. The messenger flees back to his lord, and it is only thanks to the lord's intervention that a bloodbath is avoided.

The intervention succeeds because of words: the servant is permitted to "sagen, waz diu rede sî" [say how he justifies himself] (l. 169); "herre, lât in sagen, / warumbe er ez tâte" [my lord, listen to the reason why he did it] (l. 172). The visual sign is certainly unambiguous, but when it is decontextualized, it is misunderstood. The messenger must recontextualize it by using speech to explain it. Only then does it become apparent that the messenger's naked rear end was not intended as a sign even if it was understood as such. Once more, the nature of the sign varies from the perspective of the transmitter to that of the receiver. The deficient visual sign requires a linguistic context, the context of a story. The narrative moves from one type of sign to the other. In the first section, in which a vocabulary of visual perception prevails,[23] the lack of verbal language results in incorrect interpretations of the situation.[24] Even when the messenger's lord attempts to find an explanation for his strange appearance, his attempts fail at first because no one speaks.[25] It is not until people speak that everything becomes clear.[26]

Repeatedly, appearances are deceptive, yet the epimythion takes up only the messenger's false assumption (wân); he should have informed himself more thoroughly (bedæhticlîche) about what the child really meant. Language caused the first misinterpretation and the following misinterpretations were caused by judging only appearances. The vassal's honor (êre) seems at first to depend completely upon what one sees. This is why the lord threatens his messenger—ius talionis—in the end with the punishment of blinding.[27] Yet, this punishment would have been inappropriate for the mistake because the insult that the land lord sees is the result of two rationally practical considerations of the messenger. First, one does not enter a bathhouse dressed, and second, if one wants to defend oneself against a dog, one has to face it. In terms of Augustinian linguistic theory, we have an interpretation functioning as a *signum naturale* that is competing with one that is functioning as a *signum datum*. Agreement is not possible on the level of the visual signs, but only in verbal communication—by means of symbols—that locates the visual signs within the discursive context of a story. The Stricker's tale plays with precisely this discrepancy and demonstrates the deficiency of an interpretation of signs that remains fixated on visual appearances.

Herrand von Wildonie, *Der nackte Kaiser* ("The Naked Emperor"): The Code as Symptom

Herrand's *nackte Kaiser* seems to contradict these results.[28] In this text, it is not language that resolves ambiguities and misunderstandings, but rather God's arrangement of the visible world. In this tale, disruption and reestablishment of

order are symptoms of an improper inner attitude and of its correction, respectively. The emperor is introduced as presumptuous and as challenging the divine order. Therefore, he has to be punished by God. As he is taking a bath and resting in the heat, another person, who is later revealed to be an angel of God (l. 537), takes his shape and his clothes and leaves the baths as the emperor. Now, the real emperor is nothing, for he is naked. Only, he himself knows who he is, the others take him—without his clothing—for a rogue. Since appearances constitute social rank, he rejects the shabby clothing offered to him in order to cover his nakedness. Such poor garments would not have made him back into what he knows himself to be. But he is then thrown out of the baths. After he has covered himself in a makeshift manner and returned to his palace, he is chased away by the gatekeeper, and even one of his trusted counselors does not recognize him, though he detects his physiognomic "similarity" to the emperor. This similarity ("sît ir im aber gelîche sît" [since you are similar to him] [l. 340]) at least earns the naked man some decent clothing, albeit only the clothes of a servant. As such, he must find his place among the other servants, where he is ridiculed and mocked as a "fûler vrâz" [lazy glutton] (l. 367). They ask him scornfully: "oder sît ir dâvon muotes rîch, / daz ir dem keiser sît gelîch" [or are you so conceited because you look like the emperor] (l. 371). The next day, he has to watch from the crowd as the imposter dispenses justice in the rôle of the emperor. At this moment, he must acknowledge to himself "daz er im was sô gar gelîch, / als er sich selben het gesehen" [that the other man was so similar to him that it was as though he had seen himself] (l. 454 ff.). He understands "daz in daz lantvolc het für in" [that the people believed the other man to be him] (l. 459). He also recognizes that the false emperor performs his duties better than he himself would have done. This is the turning point at which he repents. The other man gives back the "keisers kleit" [emperor's clothing] (l. 538) to him and he returns with his crown and his regalia to the judge's bench as the emperor (ll. 550–51). He can once again be what he indeed is: the emperor. In the future, he is humble and just, and no one rebels against him (ll. 565–72).

Unquestionably, the visual signs provide irrefutable evidence of one's identity; they are unambiguously encoded to convey social rank, and speech is incapable of affecting them. The emperor, who had trusted that his rank made him independent from all external vicissitudes, is taught by God that, on the contrary, his position depends upon convention, that is, upon certain external signs such as clothing and the insignia of power. Whatever case he attempts to make verbally against the evident nature of these signs is ignored. Der nackte Kaiser seems to be proof of the fact that visual signs such as clothing constitute the human being and, further, that words can not achieve anything in the face of what one can see.

It is, however, not only the code of clothing that catapults the emperor out of his inherited position, but the misreading is also manipulated by

God's intervention. Those to whom the emperor turns base their judgment just as much on conventionalized signs as they do on the miraculous doppelgänger. The man who appears as the emperor's double at the baths "was completely identical to the emperor, his build, his authoritative voice, just as though he were the emperor himself" [was dem keiser gar gelîch, / sîn lîp, sîn stimme hêrlîch, / als ez der keiser wâre] (ll. 171–73); he is similar to him "in build, hairstyle, conduct" [an lîbe und an hare / und an aller der gebâre] (ll. 314–16). Only for this reason, it is possible to mistake them for each other, and this is why the real emperor is not recognized by his closest friends (l. 228). Even the emperor himself has to admit that the other man is completely identical to him. What can be seen is ambiguous. It is true that, as far as the people in the story are concerned, clothing makes the emperor, but the audience and the emperor know that that is not quite true. It takes the narrator to explain that the people's false assumption about the identity of the naked emperor is not a misreading, but instead represents a spiritual truth.

Disrupted perception is a symptom of the disrupted order. The nakedness of the emperor is a sign, too, but a sign of his rotten nature as a sinful creature. He cannot be reinstated as emperor until the messenger of God has demonstrated his religious failings to him and he has repented of his behavior and decided to change his life. Comparing his superficial similarity to the internal dissimilarity between himself and the ideal sovereign, he realizes why he is being punished: "dar zuo sô ist sîn sin / sô edelîch für mich gestalt, / daz ers genôz und ich engalt" [the nobility of his way of thinking is so superior to my own that he received the reward and I the punishment] (ll. 460–62). The other man is justly entitled to bear the external signs of the imperial office. When the true emperor has "read" his nakedness to represent his sinful status, he can once again be the emperor, without anyone noticing the difference, "wan er was als der getân, / der ê an sîner stat dâ saz" [for he was identical to the one who had previously sat in his place] (ll. 568–69). His clothing indicates his rank beyond a doubt, but it is, above all, a sign of the restoration of order.

At the end of the tale, the angel offers words of explanation and the emperor confesses, so that the visible phenomena may be deciphered and proven to be vehicles for spiritual truth. Only words can express this truth. Once again, the visible sign is, in the end, ambiguous and in need of supplementation, yet this time, it is God himself who brings to light the true state of things by throwing the external signs into confusion. All human sign systems, linguistic as well as extralinguistic, prove to be susceptible to errors and have to be corrected by God.

Conclusion

Each of these four examples demonstrates possibilities of communication via visual signs within secular medieval society. They also show, however,

that there exist various visual sign systems and that these signs are by no means self-evident. One must distinguish not only between conventional-ized and nonconventionalized signs but also between the observer and the observed, and even between the different points of view of different observers. When their meaning is contested, visual signs must rely on speech, either the speech of the participants or the voice of the narrator, to clarify their meaning.The more thoroughly encoded the visible world is, that is, the more closely its structure resembles that of language, the more its decoding becomes susceptible to manipulation. In this way, visuality and language approach each other. It is precisely when visual perception is confronted with encoding that its ambiguity is brought to light.

Notes

Translated by Edward T. Potter.

1. Ursula Schäfer, *Vokalität: Altenglische Dichtung zwischen Mündlichkeit und Schriftlichkeit* (Tübingen: Narr, 1992).
2. "daß der Körper in der weitgehend schriftlosen Adelskultur, der die höfische Epik entspringt, das zentrale Medium der Aktualisierung kollektiven Wissens ist." Silke Philipowski, "Rezension zu Franziska Wenzel: *Situationen höfischer Kommunikation*, Frankfurt am Main, 2000," *Arbitrium* 19 (2001): 35.
3. "der Körper uns wiederum in schriftlichen Quellen und damit in der schriftlichen Vermittlung zugänglich ist." Philipowski, "Rezension," p. 35.
4. A standard work on this subject is Horst Wenzel, *Hören und Sehen, Schrift und Bild: Kultur und Gedächtnis im Mittelalter* (Munich: C.H. Beck, 1995).
5. Jan-Dirk Müller, "Ritual, pararituelle Handlungen, Geistliches Spiel: Zum Verhältnis von Schrift und Performanz," in *Audiovisualität vor und nach Gutenberg*, ed. Horst Wenzel, Wilfried Seipel, and Gotthart Wunberg (Vienna: Kunsthistorisches Museum, 2001), pp. 63–71.
6. These stand in contrast to Gerd Althoff, *Spielregeln der Politik im Mittelalter: Kommunikation in Frieden und Fehde* (Darmstadt: Wissenschaftliche Buchgesellschaft, 1997). Althoff estimates the degree of encoding as well as the binding nature of encoding to be very significant.
7. Examples of the failure of rituals can be found in Gerhard Wolf, "Inszenierte Wirklichkeit und literarische Aufführung. Bedingungen und Funktionen der 'performance' in Spiel- und Chroniktexten des Spätmittelalters," in *"Aufführung" und "Schrift" in Mittelalter und Früher Neuzeit: DFG-Symposion 1994*, ed. Jan-Dirk Müller (Stuttgart: Metzler, 1996), pp. 381–405.
8. Thus, the color of a garment worn by a ruler or a member of the nobility at a public appearance can be significant; the color of the tie worn by the German Chancellor or the American President does not, as a rule, carry any significance. Yet there are, even here, more affinities than one would think: an appearance wearing a crown and driving up in a black limousine with dark tinted glass function in a comparable manner.

9. See also Philipowski, "Rezension."
10. A standard work on this subject is Horst Wenzel, "Partizipation und Mimesis: Die Lesbarkeit der Körper am Hof und in der höfischen Literatur," in *Schrift*, ed. Hans Ulrich Gumbrecht and Karl Ludwig Pfeifer (Frankfurt am Main: W. Fink, 1988), pp. 178–202.
11. This can be observed in the illustrations of Thomasîn von Zerclaere's *Der Welsche Gast* ("The Italian Guest"). The didactic images focus "meaning" in allegorical figures (which are, for the most part, even labeled with inscriptions) when, in the text, Thomasîn refers vaguely to impractical learning. Even when scenes are depicted, they are not scenes of learning in the everyday world. On the illustrations in the *Welsche Gast*, see Horst Wenzel and Christina Lechtermann, eds., *Beweglichkeit der Bilder: Text und Imagination in den illustrierten Handschriften des "Welschen Gastes" von Thomasin von Zerclaere* (Cologne: Böhlau, 2002); see also *Der Welsche Gast des Thomasin von Zerclaere: Codex Palatinus Germanicus 389 der Universitätsbibliothek Heidelberg* (Wiesbaden: Reichert, 1974); *Thomasin von Zerklaere: "Der Welsche Gast"; Farbmikrofiche-Edition der Handschrift Ms. Hamilt. der Staatsbibliothek zu Berlin—Preußischer Kulturbesitz*, introduction by Horst Wenzel (Munich: H. Lengenfelder, 1998).
12. On the illustrations of the *Sachsenspiegel*, see Madeline H. Caviness, "Putting the Judge in His P(a)lace: Pictorial Authority in the *Sachsenspiegel*," *Österreichische Zeitschrift für Kunst und Denkmalpflege* 54 (2000): 308–20, and Caviness and Charles G. Nelson, "Silent Witnesses, Absent Women, and the Law Courts in Medieval Germany," in *Fama: The Politics of Talk and Reputation in Medieval Europe*, ed. Thelma Fenster and Daniel Lord Smail (Ithaca, NY: Cornell University Press, 2003), pp. 47–72.
13. When Parzival approaches King Arthur's court, he sees three drops of blood in the snow that remind him of his wife, Condwiramurs, whom he left long ago to pursue his quest to find the grail. He forgets everything around him and is unaware that he holds his spear raised. King Arthur's knights notice the spear and believe that the foreign knight is challenging them to a fight. Segremors and Keie attack him, but Parzival is able to defend himself only because his attention is momentarily drawn away from the drops of blood. Finally, Gawan discerns the reason for Parzival's mental absence. He covers the blood, and Parzival regains his presence of mind. Since the example has been taken from a literary text, it must be stressed that its symbolic elements are not necessarily identical to elements of the cultural codes of the society to which it belongs. This is, incidentally, an important criterion that differentiates literary texts from other texts that refer to extratextual phenomena, such as chronicles.
14. A recent work dealing with this scene is Joachim Bumke, *Die Blutstropfen im Schnee: Über Wahrnehmung und Erkenntnis im "Parzival" Wolframs von Eschenbach* (Tübingen: Niemeyer, 2001).
15. The gesture could also be interpreted as element of other codes, but not in medieval culture: The loss of control over the body, for instance, could be read as an element of a "language of feeling" or of a "code" of melancholia. Yet, such a reading would in fact be more appropriate for a modern text.

16. It is obvious that the efficiency of sign systems differs: semaphore and Morse code are, for example, inferior to ordinary linguistic encoding; they are therefore limited to abbreviated messages, although it is, in principle, possible to express every situation, albeit somewhat laboriously, with each of these sign systems. This is demonstrated in a comical fashion in Monty Python sketches portraying Caesar's assassination, or a key scene from *Wuthering Heights*, with the aid of a flashlight sending Morse code, or by means of waving flags.

17. On *übermuot* (arrogance), see Jan-Dirk Müller, *Spielregeln für den Untergang: Die Welt des Nibelungenliedes* (Tübingen: Niemeyer, 1998), pp. 237–42. Text according to *Das Nibelungenlied*, based on the edition of Karl Bartsch, ed. Helmut de Boor, 15th rev. edn (Wiesbaden: Brockhaus, 1959).

18. It is true that, in the political quarrels of the twelfth century, especially between the pope and the emperor, this staging became more or less a mere demonstration of honor that had little to do with actual power relations (Gerd Althoff in a letter; see also Müller, *Spielregeln für den Untergang*, pp. 171–72 and 268–69). Yet it seems to me not very likely, as far as the conception of the character of Prünhilt is concerned, that her reaction is the result of such an "enlightened" judgment.

19. On this logic, see Silke Philipowski, "Geste und Inszenierung: Wahrheit und Lesbarkeit von Körpern im höfischen Epos," *PBB* 122 (2000): 458–60 [455–77]; see also Müller, *Spielregeln für den Untergang*, p. 268; and especially Müller, "Visualität, Geste, Schrift: Zu einem neuen Untersuchungsfeld der Mediävistik," *ZfdPh* 122 (2003): 118–32.

20. Der Stricker, *Verserzählungen I*, ed. Hanns Fischer, 4th rev. edn., Johannes Janota (Tübingen: Niemeyer, 1979), pp. 110–25.

21. Hedda Ragotzky, *Gattungserneuerung und Laienunterweisung in den Texten des Strickers* (Tübingen: Niemeyer, 1981).

22. See lines 89, 92, 106, 109, 137, 171, as well as the epimythion once again.

23. See lines 8 ("tet. . .schîn" [made visible]); 11 ("sach" [saw]); 12 ("vant" [found]); 18 ("sach" [saw]); 60 ("schouwen" [view]); 70 ("sach" [saw]); 82 ("schouwen" [view]); 84 ff. ("dahten. . .diu ougen" [covered. . .their eyes]); 87 ("erzeicte" [demonstrated]); 91 ("sach" [saw]); 103 ("gesach" [saw]); 122 ("gesach" [saw]); 127 ("sihe" [see]); 195 ("ensach" [did not see]). Of course, these terms appear in varying situations and contexts, yet their accumulation is nonetheless striking.

24. See lines 22 ("wânde" [believed]); 25 ("gedâhte" [thought]); 68 ("dûhte" [seemed]); 105 ("hâte. . .gesworn" [would have. . .sworn]); 185 ("wânde" [believed]); 203 ("wân" [belief]) as well as the epimythion.

25. See lines 124–30: "wolt. . .hân vernomen" [wanted to hear]; "sage" [say]; "getorste. . .niht gesagen" [did not dare to say]; "sweic" [was silent].

26. See lines 169, 172, 176, 177.

27. At first, he threatens him with death (l. 146), then with mutilation (l. 165), and finally with blinding (l. 178 ff.).

28. Herrand von Wildonie, *Vier Erzählungen*, ed. Hanns Fischer (Tübingen: Niemeyer, 1959), pp. 22–43.

CHAPTER 4

THE SHIELD AS A POETIC SCREEN: EARLY BLAZON AND THE VISUALIZATION OF MEDIEVAL GERMAN LITERATURE

Haiko Wandhoff

Elaborately decorated shields are a remarkable literary motif that one finds in texts from antiquity, throughout the Middle Ages, and into the Early Modern period.[1] The poetic device of shield-description reflects a social practice, for premodern warriors and knights not only valued their round or oval shields, usually made of wood, for protection, but also used them to indicate visually the social and genealogical status of their bodies that they shielded. Indeed it is in this context, as easily accessible visible displays of personal data, that painted shields became privileged objects of poetic representation. Rooted in the rhetorical technique of *enargeia* (*evidentia*), which was developed to bring before a reader's eyes what is in fact merely a verbal report, rounded shields associated with significant bodies provided ideal graphic surfaces on which poets could project different kinds of visual data. The decorated shield thus executes what Murray Krieger calls the "ekphrastic principle" of literature, that is, the desire of the verbal arts "to do the work of the visual sign" and convert readers into eyewitnesses.[2]

My purpose in this chapter is not to give a full account of shield-descriptions in Middle High German literature, but rather to discuss the motif as a key to the understanding of word-image interactions in the highly visual culture of medieval court society. Considering poetic shields from Homer to 1300, I focus on strategies of visualizing verbal works of art. By juxtaposing *ekphrastic* and *heraldic* shield-descriptions, it is possible to distinguish the different techniques that ancient and medieval poets used to navigate the reader's inner gaze into and through their texts.

Ekphrasis, or the Ancient Invention of the Poetic Shield

The emergence of poetic shield-descriptions is closely connected to the origins of a poetic device that is the subject of much recent scholarship, *ekphrasis*. While in antiquity the term *ekphrasis* occurs as part of Greek *progymnasmata*, meaning a rhetorical exercise to provide vivid descriptions with the goal to establish "unmediated access to visual phenomena," today it is usually limited to the description of a work of visual art, "the verbal representation of visual representation."[3] There is a long tradition of describing visual works of art that goes back to ancient Greek and Latin literature. The description of Achilles' shield in Book 18 of Homer's *Iliad* (18, 468–608) is the *locus classicus* for the common feature of *ekphrasis* as well as the touchstone for all ancient descriptions of shields, and has inspired many imitators such as pseudo-Hesiod, Euripides, Virgil, and Silius.[4]

The *Iliad* depicts in detail the god Hephaestus skillfully engraving a complete representation of the world on the Greek hero Achilles' weapon: the earth, the sky, and the sea, framed by the stars and the Ocean River. Within this cosmic setting, the shield displays a representative sample of human affairs including a wedding procession, a lawsuit, a ploughing scene, the harvest, music, dance, and a city at war. This emerging image of the world is so universal that the "relation of epos to *ekphrasis* is thus turned inside out: the entire action of the *Iliad* becomes a fragment in the totalizing vision provided by Achilles' shield."[5]

It is significant, though, that after Thetis has handed the shield over to her son, its decoration is not mentioned again, nor is anybody except Achilles reported to look at the marvelous pictures. And even his gaze seems to focus more on the armor made by Hephaestus as a whole than on the shield's decorations in particular (19, 16–20). The lack of narrative context leaves it up to the text's user to decipher the meaning of the ekphrastic description. Is Achilles carrying the whole of Greek culture on his shoulders? Is he bearing a "sanctified icon" to ward off all enemies by means of the invulnerable material as well as the emblematic decoration?[6] Or are the peaceful scenes from human life that dominate the shield meant to serve as a contrast to the war theme of the proper epic; that is, does, as Mitchell suggests, the *ekphrasis* call to mind the "Other" of the *Iliad*?[7]

Whatever the answers to these questions might be, it seems obvious that the graphic display of the shield's surface makes visible the larger cosmological frame of the narrated actions within the epic. This pictorial information, however, is seemingly not transmitted to any of Achilles' enemies, but rendered almost exclusively to the readers or listeners of the text "who are given time, by virtue of *ekphrasis*, to look at its production and appearance in detail."[8]

It must have seemed strange for the audience of the *Iliad* that Achilles' shield was lacking an essential characteristic of "real" contemporary shields. Although manufactured by Hephaestus for military use, the shield did not bear any of the usual apotropaic figures on its surface, as did, for instance, Agamemnon's shield: "And circled in the midst of all was the blank-eyed face of the Gorgon with her stare of horror, and Fear was inscribed upon it, and Terror" (11, 36–37).[9] Within the verbal arts, this terrifying face on the shield's surface, its military gaze intended to deflect and deter the opponent, is inappropriate, for literature as a medium of the imagination needs to keep its readers and listeners engaged in its verbal-visual discourse. To accomplish this, that is, to enhance the user's attachment to the text, the surface of the *poetic* shield is changed into an instrument of visual *attraction*. Ekphrastic shields compared to their apotropaic counterparts thus reveal a significant shift from the *protective* to the *projective* mode. The reader's inner gaze is forced to enter the verbal-visual space of the epic in order to scan extensively the different sections of the marvelous picture that has lost its offensive quality.

The fact that there is no archaeological evidence for the existence of a "cosmological shield" like the one described in the *Iliad* further underlines the argument that Homer invented it for a particularly literary purpose. While some ancient Greek vases, cups, or other "peaceful" indoor objects contain single elements of the Homeric shield-decoration, no shields have been found depicting these scenes.[10] By transferring familiar iconographic features from cups and vases onto the rounded surface of a shield, Homer creates a *poetic shield*. This poetic shield is conceived as a "window" through which the audience looks into other text-worlds, both verbal and visual, which reveals the cultural foundations of the epic.

In the *Aeneid*, Virgil both imitates and adapts the Homeric model. He imitates it by decorating the shield of his hero with a series of scenes from the future of Roman imperial history up to Augustus, a series of events still unknown to Aeneas but familiar to both the author and the audience of the epic (VIII, 626–728).[11] It is thus Roman imperial history that is deployed as the larger historical frame of the narrated actions. As in Homer, the shield's surface is mentioned only once in the text. But Virgil does not only alter the poetic shield by replacing Homer's cosmological design with a historical one, but he also describes the pictures through the eyes of an internal beholder, for it is Aeneas himself whose amazed gaze mediates the audience's perusal of the shield's surface.

To sum up, the common feature of ekphrastic shield-descriptions in Greek and Latin literature appears to lie in this extension of the hero's body to a pictorial representation of a larger cultural frame that provides cosmological or historical guidelines for understanding the texts in which they

occur. The form of signification can thus be called *allegorical*. "Homer's description of the shield of Achilles lays down the pattern for all later uses of the dress, the costuming and the armoring of the human body as allegorical symbols for a larger system of ideas and things."[12]

From *Ekphrasis* to Heraldry: Decorated Shields in Twelfth-Century Literature

It is significant that in the Middle Ages, at least in German and French vernacular literature, classical *ekphrasis* and shield-descriptions develop in different directions. On the one hand, we still find a lot of *ekphrastic* passages, but there are no shield-descriptions like those by Homer or Virgil, in which the surface of the weapon bears a complete cosmological or historical system. Instead, we find other surfaces of the body illustrated with the visual data provided by clothing and jewelry. Well-known examples are the detailed descriptions of Erec's cosmic cloak and emerald scepter in Chrétien's *Erec et Enide* (6682–747), Enite's horse and saddle in Hartmann's *Erec* (7290–757), or Helmbrecht's cap in Wernher's *Helmbrecht* (14–103).[13] On the other hand, the shields of heroic or courtly warriors bear testimony to a different kind of pictorial decoration that has more in common with the burgeoning heraldic arts.

Let us look briefly at the origins of heraldry. Probably initiated during the crusades by the necessity to distinguish several national contingents within the international army of crusaders, the number of aristocratic coats of arms increased throughout Europe from the second quarter of the twelfth century on. From this period on, shields, helmets, and banners contain different kinds of charges, ordinaries, and lines. In the beginning, however, the use of these badges was far from fixed or even hereditary. For over one hundred years, we have no written documentation about early heraldry and its rules, although it is likely, as Brault suggests, that there was some kind of oral tradition.[14] Only in the middle of the thirteenth century do we find written and iconographic documentation and transmission of heraldic knowledge. The first rolls of arms written or painted on parchment appear in England and France at almost the same time, about 1250. These early heraldic documents were probably a kind of "mnemonic system" for the heralds who had to develop a new and international language of arms across Europe.[15] What is established here, that is, the "classical" form of heraldry that stays more or less unchanged for the next two hundred years, can be defined as "the systematic use of hereditary devices centered on the shield."[16]

This increased importance of visible signs attached to the bodies of warriors, knights, and noblemen as a means of representing aristocratic status

and social identity leads to a new and quite distinct form of poetic shield in vernacular literature. It takes some time, however, for coats of arms to become a common feature in medieval German court epic. With the exception of several heraldic shields that appear in the *Kaiserchronik*, such as the boar carried by the Romans—the oldest heraldic insignia in medieval German epic literature, according to Zips[17]—most of the precourtly and even courtly epics up to 1200 contain very few decorated shields at all. Several isolated coats of arms are mentioned in the German *Rolandslied*, *König Rother*, Veldeke's *Eneas*, and Hartmann's *Erec*—mostly related to the protagonists. Others such as Lamprecht's *Alexander*, Eilhart's *Tristrant, Herzog Ernst B, Oswald*, or even Hartmann's *Iwein, Gregorius*, and *Armer Heinrich* do not display any painted shields at all.[18] It seems to me that in these texts, the shields' surfaces are *no longer* used as ekphrastic "windows" to draw the reader's or listener's inner eyes into the work of verbal art. At the same time, however, the poetic shields are *not yet* used as displays for symbolic or hereditary information later characterized as heraldic.

While aristocratic shields in early medieval German narratives are mostly blank, and we are given very little information about their form, color, or charge, the situation in twelfth-century Latin literature as well as in the Northern vernaculars is quite different. Here the ancient patterns of ekphrastic shield-description live on, and in a couple of texts, such as Walther von Châtillon's *Alexandreis* or Ulfr Uggason's *Husdrapa*, richly decorated shields still serve as ekphrastic "windows" that offer the audience insight into the historical or biblical backgrounds of the epics.[19]

If we look at Achilles' famous shield in the medieval German epics of Troy, by contrast, we find that there is not much to see at all. There is no cosmological or even decorated shield of Achilles in Herbort von Fritzlar's *Liet von Troie*, even though there is strong evidence that the motif was well known throughout the Middle Ages.[20] Although several other shields decorated with pictures are mentioned in Herbort's text, we rarely learn anything about *what exactly* is represented on their surfaces. One of the few exceptions to this rule is a red-and-white lion in a field *von lasure* (1328) carried by the Greek warriors that is, as Frommann points out, the old heraldic symbol of Hessen and Thuringia.[21] Herbort thus provides the Hessian-Thuringian earldom with ancient Greek predecessors, and by doing so, he offers us one of the earliest examples of "heraldic flattery" in medieval German literature.

Interestingly, almost one century later, Konrad von Würzburg, one of the main promoters of epic heraldry, envisions a new pictorial shield for Achilles in his *Trojanerkrieg*. Konrad's shield of Achilles portrays a completely new design that is apparently more suitable to medieval knights and clearly indicates a change from *ekphrasis* to heraldry: "ûz silber was ein blanker

swane / ûf sînen brûnen schilt geworht" [a white swan was worked in silver on his dark shield] (39316–17).[22]

The vernacular adaptation of Virgil's *Aeneid* is a somewhat different case. While the shield of Virgil's protagonist shows the crucial events of Roman imperial history in a series of "moving" images, the Old French *Roman d'Eneas* turns this historical display into a showpiece of early courtly heraldry. Fabricated by Vulcan, the field is red with a border and three bends of gold that carry no charges: "D'or fu toz li escuz orlez, / de treis bendes parmi listez" [The whole shield was framed with gold and striped with three diagonal bends in the center] (4457–58).[23] Gems are spread all over the surface of the shield, which carries a boss with a bright and shiny topaz at its center.[24] In his medieval German adaptation of the *Roman d'Eneas*, Heinrich von Veldeke once again changes the design of the shield: in a field of gold with a boss made of white silver and decorated with eight different kinds of gems, he blazons a lion that is "betalle rôt" [completely red] (161, 6–162, 3).[25] Veldeke, like his anonymous source, replaces the ekphrastic "window" of Virgil's shield with decisively heraldic imagery. Remarkably, both texts adhere to the rule later found in heraldry that metal may not appear on metal, nor color on color.[26]

Constituting one of the main differences between *ekphrastic blazon* and *heraldic blazon* is the possibility of easy transformation of the latter from the verbal into the visual medium. The heraldic blazon, the verbal representation of the visual image, has to be so precise, "that an accurate drawing may be made from the description."[27] In contrast to the weapons of their ancient predecessors, Achilles and Aeneas, the shields in the *Roman d'Eneas* and in Veldeke's *Eneas* could certainly be painted according to their verbal description. Both authors use clear terminology—Old French *bende* means a bend from the right upper part to the left lower part of the shield[28]—and a compact emblem that can be identified at first sight; only the different gems signifying aristocratic splendor might pose a problem for a painter.

Heraldry thus marks a particular moment in the history of text-image relationships: It is conceived as a bi-medial art that employs verbal texts as well as paintings and needs the content of both media to be exactly convertible into one or the other. It is obvious that this close cooperation between the verbal and visual arts, based on a rigid canonization of heraldic colors, ordinaries, charges, and even gems, marks a crucial development in ekphrastic imagery. If one looks at the several failed attempts to "translate" the verbal description of the shield of Achilles into a painting, it soon becomes evident that this is an impracticable task. Every attempt to draw the shield produces a completely different picture.[29] *Ekphrasis* from antiquity on participates in the *paragone*, the contest between the verbal and the visual arts, and it is this very rivalry that stimulates poets to "paint" better

pictures than the visual artists. By evoking complex mental images for our *inner* eyes that can hardly be converted in drawings, the verbal arts thus celebrate "the power of words to encompass any other art."[30] Because the verbal image contains a surplus as well as a certain fuzziness that resists its extramental visualization, the *ekphrastic* shield-picture, as Heffernan puts it, "is shielded by the very language that purports to reveal it to us."[31]

New Forms of Poetic Heraldry in the First Half of the Thirteenth Century

From the beginning of the thirteenth century, poetic shields in the vernaculars tend to provide more and more visual information. Apart from the type of early heraldic shields described above, I consider here two other kinds of coats of arms. First, there are a lot of knights, especially in Arthurian romances, who bear plain arms, "i.e. a shield consisting of a single tincture."[32] Red, green, black, blue, golden, or white knights with no apparent significance being attached to their armor inhabit the universe of the romances, although from the beginning of heraldry, this was a rarity in actual practice. As Brault succinctly comments, "Though no rule of heraldry forbids it, few historical personages have borne plain arms."[33] Brault's explanation for the emergence of plain arms in French literature is that they "served in most cases to create an atmosphere suggesting a time long since past and the opulence and splendour of the universe of epic and romance."[34] This impulse to show a splendid and, above all, colorful world is also characteristic of the German court epics, but the number of plain arms seems to be smaller than in Old French epic literature.[35]

Chrétien de Troyes introduces a more specific use of plain arms that becomes more and more important in German Arthurian romances as well: plain arms as a means for remaining incognito while fighting in public. In Chrétien's *Cligés*, the hero enters the lists of tournaments on three successive days, bearing first plain black, then plain green, and finally plain red arms to defeat Sagremor, Lancelot, and finally Perceval. Similar constellations appear in the *Charrette*.[36] In medieval German literature, for instance, the hero in Ulrich von Zatzikhoven's *Lanzelet* defeats a couple of famous Arthurian knights bearing plain green (2868–3079), plain white (3080–268), and plain red (3269–423) arms on the first, second, and third day, respectively.[37] Unknown knights emerging from the forest to challenge the court of Arthur often bear plain arms, too. Parzival, probably the most famous plain knight in medieval German literature, remains incognito during his quest for the grail. Appearing as the Red Knight, his identity is unknown to his opponents as well as the other characters in the story, while the readers of the text are aware of his true identity.[38]

Second, some so-called symbolic or canting arms (*armes parlantes*) are decorated with symbols and charges revealing their bearer's character, for example, by displaying a pun on the knight's name or occupation.[39] In Wolfram von Eschenbach's *Parzival*, for example, Parzival's father Gahmuret bears anchors both on his shield and on his *kovertiure*. This device explicitly denotes Gahmuret's social status as a *chevalier errant*. After the death of his father and his older brother's inheritance of title, property, and power, Gahmuret decides to leave the family's territory and give up his hereditary arms. In their place, he chooses the anchor as a symbol for his quest for solid ground (14, 12): "der anker ist ein recken zil" [the anchor is a symbol for the errant warrior] (99, 15),[40] and, as the text informs us, he has to carry "disen wâpenlîchen last" [this burdensome symbol] (15, 3) throughout his adventures. When his brother dies and the power transfers to Gahmuret, he relinquishes the anchor and finally accepts the hereditary arms of his family: "dez pantel, daz sîn vater truoc, / von zoble ûf sînen schilt man sluoc" [they hammered the sable panther, which his father had carried before him, to his shield] (101, 7–8). Canting arms, such as those in *Parzival*, bear a close relationship to religious or symbolic arms like the cross of the crusaders, the wheel of Fortune, or Venus, the goddess of love, worn by knights fighting in love's service.

In *Wolfdietrich* D VIII, a painted shield reminds Ortnit's widow of her dead husband. Two figures are painted on this "schilt schoene und niuwe: daz eine was Ortnît, daz ander ir gelîch / swenn sie daz an blicte, sô weint diu keiserinne rîch" [beautiful and new shield: one was Ortnit, the other was her likeness; whenever she looked at it, the noble empress cried] (15, 1–2).[41] The commemorative character of this device is akin to the siege of Belakane in Wolfram's *Parzival*, where the reason for the war is projected onto the banners of both parties. While Isenhart's troops, seeking revenge for their dead king, bear "ein durchstochen rîter" [a knight pierced through] (30, 26; cf. 42, 28) as their heraldic insignia, Belakane's besieged troops carry on their banners a figure of the queen who swears that Isenhart's death is her deepest sorrow (30, 24–31, 16).

Compared to the two other kinds of armorial bearings in medieval German literature, that is, "heraldic" and plain arms, canting arms exhibit the closest relationship to *ekphrasis*, in that they often contain micronarratives, albeit abridged to a single emblem. Their symbols, like the complex picture-stories on ancient shields, not only function as individual charges, but also represent a text within the text that unfolds visually on the screen provided by the shield. These emblems fulfill a commemorative purpose, for they remind the reader of the bearer's occupation and its significance to the text, and they may even recall a leitmotif of the entire work. This *intrinsic* focus constitutes the main difference between canting arms and ekphrastic

shields, which generally project cosmological or historical, that is, *intertextual* discourses, onto the arms of their protagonists. The anchor-device of Gahmuret, for instance, reminds us visibly of the leitmotif of the Gahmuret books themselves. The same model is at work in the French and German *Lancelot en prose*: Here, the adulterous love between Lancelot and queen Ginevra, the nucleus of the entire text, is painted onto the surface of a cracked shield that is split right between the two figures. Only when their secret love is realized does the crack disappear and the two lovers appear undivided (I, 342–43; I, 462).[42]

Analogous to Gahmuret's canting arms, epic heraldry in the *Lancelot en prose* mirrors the structure of the narrative in which it is found. In the text, Lancelot paints the story of his love to Ginevra onto the walls of his prison at Morgane's, using the pictures to remind him of his absent lover. In these paintings as well as in the cracked shield, the readers encounter a visual interface that directs their eyes further into the text itself, rather than, as in classical *ekphrasis*, into the intertextual universe beyond.

All three kinds of poetic shield-devices described above, namely, "heraldic," plain, and canting arms, participate in a particularly courtly desire to "paint" with words a rich, splendid, and, above all, colorful world of chivalry in its three-dimensional extensions. In this respect, they are a crucial part of what Bumke calls the "höfischen Beschreibungsstil" [courtly style of description] of Middle High German epic literature.[43] In contrast to ancient shield-descriptions, this style lends the depicted objects a more plastic, three-dimensional quality while at the same time the complex picture-stories disappear from the "poetic screens." The red knight Ither's description of Gaheviez's plain arms in *Parzival*, for example—which Parzival later steals—conceives a mental image of the knight's whole body including his horse, rather than focus on the flat symbols or devices on his shield or banner (145, 17–146, 4). The same applies to the canting arms carried by Gahmuret, which are embedded into a rich surrounding of noble fabrics and contain several spatial elements. On the shield's surface there is "ein tieweriu buckel drûf geslagn" [a priceless boss was riveted to it] (70, 29; cf. 36, 22–37, 9), and Gahmuret also carries a famous diamond helmet that is also decorated with an anchor, but ornamented with other gems as well (70, 20–26). In his *Eneas*, Heinrich von Veldeke depicts the shield of his hero first from the inside. He describes the splendidly upholstered straps of the weapon in detail, even mentioning that they are gentle on the skin, before he turns the object around to make the outside visible to the reader (161, 24–39).

Thus, contrary to classical heraldry, epic shield-descriptions in the twelfth and thirteenth centuries deal with a mixture of amazing colors, stylish outfits, and splendid fabrics as well as other rich materials that combine visual,

acoustic, tactile, and even olfactory data. These descriptions amount to an "epic gaze" at shields and other courtly objects that differs from *ekphrasis* as well as from heraldry in its classical form. The latter aims at the instant identification of a particular armor by offering a precise and, above all, concise description of the shield-devices without mentioning the boss, the decorated edge, or other spatial forms. This tendency of heraldry to replace spatial objects with flat surfaces is reflected by the transformation into simple colors of furs, charges, and gems, which, in the beginning, were objects appended to the shield. Middle High German *zobel*, for instance, originally meant the black fur of the sable, but over the course of time it comes to indicate the color black. The same applies to the gems, which come to represent heraldic tinctures, and even the charges are transformed from objects into flat paintings.[44] The sleeve that Erec carries on his shield in Hartmann's Arthurian romance still seems to be an object, for the text reads: "diu [*mouwe*] was geworht" [the sleeve was fashioned] (2299) and buckled to the wooden surface of the shield.

The fact that even almost a century later Konrad von Würzburg still seems to describe actual fur instead of simple colors,[45] suggests that the "epic gaze" into chivalric worlds of the past conserves the three-dimensional objects much longer than heraldry does in the extratextual, "real" world of tournaments. While the romances try to create a virtual world that contains three-dimensional objects and persons—in particular, armored knights and beautiful ladies—the objects of the "heraldic gaze" are decisively two dimensional. Whereas the *heraldic* blazon is supposed to identify the charges at a glance and neglect other qualities of the described object, the *poetic* blazon in courtly literature navigates the reader's inner gaze slowly and in several sequences over surfaces, curves, and elevations of the armor, over "real" gems, "real" furs, and "real" charges. By initiating this kind of slow *high-definition* scanning, the vernacular poetic shields of the twelfth and thirteenth centuries still participate in the "*ekphrastic* principle" of literature, even though they carry more and more heraldic devices: They perform the desire of the verbal arts to create "a total verbal form, a tangible verbal space."[46]

The Text as a Shield-Device, or the "Heraldization" of Poetry in the Late Thirteenth and Early Fourteenth Centuries

While in the beginning of heraldry the terminology and forms of shield-devices were derived "for the most part, from the specialized language of the artists,"[47] the practice of painting and blazoning shields became so important fewer than a hundred years later that around 1200 the Middle

High German term *schiltaere*, originally meaning "painter or manufacturer of shields," could refer to a painter in general as, for instance, in *Parzival* (158, 15). The heraldic painting of shields had apparently become a dominant discipline of the secular visual arts that then affected the concepts of visuality in courtly literature on more than just descriptive levels. From the second half of the thirteenth century on, one notices a remarkable expansion not only of heraldic motives, but also of heraldic "style" in medieval German romances.

First, there are many more heraldic devices depicted in the texts than before. These are primarily fictitious arms, as in the Arthurian romances of the Pleier, heroic romances such as *Walberan, Rosengarten, Biterolf und Dietleib*, and *Virginal*, as well as *Reinfried von Braunschweig* and *Wilhelm von Österreich*.[48] Second, we find a rising number of historically "correct" arms in literary texts, such as the golden lilies in a blue field carried by the French king or the three golden leopards in a field of red indicating the king of England.[49] One can observe a seeming breakthrough of epic heraldry in medieval German literature in Ulrich von Liechtenstein's *Frauendienst*, written about 1250. Ulrich blazons numerous genuine arms of Austrian noblemen, while the plot of his text probably remains almost completely fictitious.[50] Moreover, there develops a stronger adherence to the heraldic rules in epic literature. Konrad von Würzburg is, without doubt, a touchstone in this development, as it is his *Turnier von Nantes* that establishes the genre of heraldic poetry (*Wappendichtung*) in Germany. This text consists entirely of a tournament description in which the German king Richard of Cornwall and several other well-known historical personages are blazoned in their historical arms before they enter the tournament. But in his courtly romances, too, Konrad adheres more strictly to the heraldic rules than his predecessors. Besides blazoning numerous common charges, he especially pays attention to the six canonized tinctures of heraldry, that is, gold or yellow (*or*), silver or white (*argent*), red (*gules*), blue (*azure*), black or brown (*sable*), and green (*vert* or *sinople*). In his *Partonopier und Meliur*, for instance, we find the heraldic colors mentioned in a conventional manner:

mit schilten rôt, grüen unde blâ
wîz, gel und gebriunet,
wurden si beziunet
und umbeslozzen allenthalp. (14383–51)[51]

[They were all attired in and covered with red, green, and blue, white, yellow, and brown shields.]

Konrad von Würzburg almost never forgets to tell his audience the tinctures of his arms, whereas in former courtly epics, the charges were sometimes

described without the colors, as in the *Nibelungenlied* manuscript B in which Siegfried is told only to carry a crown as a shield-device (215).[52] Or the colors might change within a given text, as in the case of Gahmuret's anchors that are first "hermîn" [white] (14, 17) and on another occasion "zobelîn" [black] (71, 3). Similarly, in Hartmann von Aue's *Erec*, Erec carries three shields with the sleeve as device, "doch schiet si diu varwe" [but they were distinguished by their colors] (2289): one is silver, the other red, and the third golden (2285–323).

Heraldry, however, did not only alter the design of epic shields, but also influenced the text-image relationship in the vernaculars in another respect. Already in Gottfried von Strassburg's *Tristan*—where the epic poets are emphatically referred to as *verwaere* (colorers)—we find the poetic colors to be influenced by the six tinctures of heraldry, for example, in the description of King Marke's festival in May: "man sach dâ [. . .] manege decke snêwîze, / gel, brûn, rôt, grüene unde blâ" [one saw there (. . .) many a blanket (that was) snow white, yellow, brown, red, green, and blue] (666–67).[53] Konrad von Würzburg, as mentioned earlier, uses the six canonized colors of heraldry time and again in his romances and even lyric. He does so not only to put before the reader's eyes "diu wâpenkleit rôt unde blâ, / grüen, gel, brûn unde wîz" [the heraldic coverings red and blue, green, yellow, brown, and white] as in his *Partonopier und Meliur* (15506–07), but also to "paint" objects that have no genuine relationship to heraldry at all such as a landscape:

> man siht dur grünez gras ûf gân
> gelwe zîtelôsen;
> bî den rôten rôsen
> glenzent vîol bla;
> durch die swarzen dorne lachet
> wîziu bluot vil manecvalt:
> die sehs varwe treit der walt,
> der von doenen crachet
> unde ûz loube machet
> cleider wol gestalt. (7, 23–32)[54]

[One sees yellow crocuses blooming through the green grass; blue violets shining next to red roses; innumerable white blossoms laughing through the black thorns: bearing these six colors the forest cracks with sound and creates well-formed clothing from its leaves.]

The forest here is "bearing" the six colors of heraldry and is described as a tournament. The verbal art thus "paints" the colors of natural objects as well as the courtly world using the tinctures of the *schiltaere* (shield maker). This

becomes increasingly common from the late thirteenth century on, when a certain "heraldization" of literature can be observed.

The *Minneburg* ("Castle of Love"), for instance, is a remarkable allegorical poem that portrays a battle over the castle in which several allegorical warriors are depicted with their coats of arms. The shield-devices found in this text can be called canting or symbolic insofar as the charges indicate the bearers' characters:

> Jecklich nach sinem nennen
> Und siner art und sinem leben
> Ist im die visament gegeben. (2696–98)[55]
>
> [Each is given a heraldic symbol according to his name and his nature and his life.]

But in the *Minneburg* there is also a wonderful, decisively "heraldic" description of a beautiful lady:

> Dich haben an alle selbe
> Und auch an wandels narbe
> Beluchtet die sehs varbe:
> Die will ich hie visiren,
> Gar weppenlich gloyren
> Reht in dines antlutz schilt;
> Wann sie sint eben dar gezilt
> In dines antlutz forme. (2408–15)
>
> [Without any make-up and without the scars of change, the six colors have illuminated you: I will depict them here, praising them in the manner of heraldry on the shield of your countenance; for there they have found their goal in the form of your face.]

The six tinctures of heraldry, represented here by the names of six precious stones, are found in the appearance of the beautiful lady, and her face is blazoned as if it were a shield.[56] "The shield of your face" [dines antlutz schilt], as the text reads, consists first of the skin that is imagined here as a white field made of "Parellen und perlin wiß" [beryl and white pearls] (2418). The poet, therefore, adheres to the heraldic principle that the field is to be blazoned first before proceeding with the charges: "Dar in verstrawet rosenbleter, [. . .] Und von rubin ein pflaster" [therein are strewn rose petals, (. . .) and a band of ruby] (2424–26), meaning the lady's cheeks and lips ("muendelin" [2433]); her black eyelashes are "von dyamant" [diamond]; contrary to expectations, the tincture blue is represented in the lady's face not by her

eyes, but by her veins shimmering through the white skin:

> Von saphir cleine geeder,
> Daz durch ir veles duennes leder
> Sich in dez schildes ecken
> Let ein wenig erblecken,
> Daz man ez kaum erkuset. (2443–47)

[Small veins of sapphire appear faintly through the thin leather of her skin in the corners of the shield so that one barely notices them.]

Her hair is "Gel sam ein thopasius / und glichet sich auch strangolde" [yellow like a topaz and similar to strips of gold] (2450–51); finally the shield as well as the face is crowned ("gekronet" [2458]) with a green "schapel" [garland] that shines "von jacincten fine / Und von smaragden schin" [with fine garnets and glowing emeralds] (2455–56).

What can be "seen" here in a single fascinating description is the verbal representation of a beautiful face that takes shape as a heraldic shield. Transformed into a mental image, the face dissolves into a shield and vice versa, forming a hybrid, oscillating image that cannot be fixed by the observer. Moreover, it is noteworthy that although the eyes are mentioned in the description, they are not used for the heraldic image. It is odd that the color blue is represented by shimmering veins rather than by eyes. In accordance with classical ekphrastic shields, the "shield of the face" has no eyes that could look back at the reader, and no gaze projects from it that could meet, irritate, or even deter the gaze of the beholder.

Johann von Würzburg similarly but much more extensively describes nonheraldic objects metaphorically using heraldic colors and gems, forms and vocabulary in *Wilhelm von Österreich*. Throughout the entire romance, he presents the reader with many rich descriptions of shields and banners. But at the same time, the narrator also takes up the common notion of *colores rhetorici*, the colors of rhetoric, and asks the "schepfer aller aventiur" [the creator of all adventures] (2435) how these colors may be painted onto the surface of his narrative so that they are not bleached by the heat of the summer (2441–43). The romance-painting is thus represented as an outdoor object—indeed the romance-painting is a shield. This becomes clear in another poetological reflection in the text in which the author/narrator declares his ambitions:

> ich wil von grozer triwe
> kluoge rede niwe
> velden und visieren,

bluemen und florieren
mit wilder rede spruechen. (1451–55)

[I will order and organize, embellish, and decorate an innovative new tale about great faithfulness with wondrous words.]

Whereas *bluemen und florieren* belong to the well-known terminology of rhetoric, indicating a certain style (*geblümte Rede*, "flowery speech"), the terms *velden und visieren* are obviously derived from heraldry. MHG *velden* or *velten* applies to the field (*velt*) of the shield and means "to divide into fields, as in heraldic devices";[57] MHG *visieren* is closely related to *velden* and means "to divide a shield and bring the figures in the heraldic device into order, and then describe it in an artistic manner."[58] Thus, *visieren* has a double meaning insofar as it marks the drawing of a shield-device as well as the verbal description of a given shield. This term, therefore, underlines the close relationship between the visual and the verbal arts: painting with a brush and painting with words converge in heraldry. *Rheinhardts Wappenbuch* ("Rheinhardts Book of Heraldic Devices") later tries to distinguish clearly between *visieren* in the sense of drawing a shield-device and *blasonieren* in the sense of describing a given shield-device. The insistence on this distinction, however, further indicated that these terms have long overlapped.[59]

For my purpose, it is crucial here to note that by replacing the *colores rhetorici* with the *colors of heraldry*, Johann von Würzburg raises the "heraldization" of poetry to another level. He relies on heraldry not only to stimulate highly visualized descriptions in epic poetry, but also much more broadly as a source of poetic coloring and image making. By conceiving his romance as a heraldic *visament* or blazon, that is, the painting or description of a shield according to the rules of heraldry, Johann's narrative becomes analogous to a heraldic shield-device itself. At least in the readers' imagination, his *Wilhelm von Österreich* as a whole is projected onto the flat "screen" of a shield-surface so that the entire romance becomes part of a visual interface.[60] In *Wilhelm von Österreich*, there is no longer any difference between *ekphrasis* and romance. The poetic text itself becomes "the ultimate shield beyond shields."[61]

What we see in both the *Wilhelm von Österreich* and the *Minneburg* is that the phenomenon of the tremendous expansion of heraldic imagery in MHG poetic texts eventually turns out to be fundamentally ekphrastic. Literature does not constrain itself to imitating the "heraldic gaze," but reworks it according to its own poetic, that is, metaphorical and allegorical, principles. It adopts the virtual "screen" of the shield's surface in order to deploy a particularly poetic gaze that meets with emblematic descriptions as well as new forms of metaphors and allegories. The heraldic impact of the twelfth and thirteenth centuries is integrated into what seems to be the timeless "ekphrastic principle" of literature.

Notes

1. I want to express my gratitude to the Alexander von Humboldt foundation for a scholarship at the University of Washington, Seattle (1998–1999), where most of the research for the present essay was done. An abridged German version of this essay was presented at the 10th Congress of the International Association for Germanic Studies (IVG) in Vienna (September 2000).

2. Murray Krieger, *Ekphrasis: The Illusion of the Natural Sign* (Baltimore: Johns Hopkins University Press, 1992), p. 4. See also Haiko Wandhoff, "Velden und visieren, blüemen und florieren: Zur Poetik der Sichtbarkeit in den höfischen Epen des Mittelalters," *Zeitschrift für Germanistik* N.F. 9 (1999): 586–92 [586–97].

3. Andrew Sprague Becker, *The Shield of Achilles and the Poetics of Ekphrasis* (Boston: Rowman and Littlefield, 1995), p. 25; James A.W. Heffernan, *The Museum of Words: The Poetics of Ekphrasis from Homer to Ashbury* (Chicago: University of Chicago Press, 1993), p. 3. Heffernan cites W.J. Thomas Mitchell, "Ekphrasis and the Other," *South Atlantic Quarterly* 91 (1992): 696 [695–719]. See also Becker, *Shield of Achilles*, p. 2.

4. Homer, *Iliad*, trans. Richmond A. Lattimore (Chicago: University of Chicago Press, 1951).

5. W.J. Thomas Mitchell, "Ekphrasis and the Other," *Picture Theory: Essays on Verbal and Visual Representation* (Chicago: University of Chicago Press, 1994), p. 180 [151–81].

6. Krieger, *Ekphrasis*, p. xv.

7. Mitchell, "Ekphrasis and the Other," p. 180.

8. Mitchell, "Ekphrasis and the Other," pp. 176–77.

9. See Mitchell, "Ekphrasis and the Other," pp. 176–77. There is also archaeological evidence about the existence of those kinds of apotropaic shields, see Erika Simon, "Der Schild des Achilleus," in *Beschreibungskunst—Kunstbeschreibung: Ekphrasis von der Antike bis zur Gegenwart*, ed. Gottfried Boehm and Helmut Pfotenhauer (München: Fink, 1995), pp. 128–29 [123–41].

10. Simon, "Schild des Achilleus," pp. 128–33.

11. Virgil, "Aeneis," in *P. Vergili Maronis Opera*, ed. R.A.B. Mynorsa (Oxford: Oxford University Press, 1969), pp. 103–424.

12. Angus Fletcher, *Allegory: The Theory of a Symbolic Mode* (Ithaca, NY: Cornell University Press, 1964), p. 116.

13. Chrétien de Troyes, *Erec et Enide*, ed. and trans. Albert Gier (Stuttgart: Reclam, 1987); Hartmann von Aue, *Erec*, ed. Albert Leitzmann, Ludwig Wolff et al. (Tübingen: Niemeyer, 1985); Wernher der Gärtner, *Helmbrecht*, ed. and trans. Fritz Tschirch (Stuttgart: Reclam, 1974). See Haiko Wandhoff, *Ekphrasis: Kunstbeschreibungen und virtuelle Räume in der Literatur des Mittelalters* (Berlin: de Gruyter, 2003).

14. Gerard J. Brault, *Early Blazon: Heraldic Terminology in the Twelfth and Thirteenth Centuries with Special Reference to Arthurian Heraldry*, 2nd edn. (Woodbridge, Suffolk: Boydell Press, 1997), p. 8.

15. Brault, *Early Blazon*, p. 7.

16. Anthony Wagner, *Heralds and Heraldry in the Middle Ages*, 2nd edn. (1959; repr. New York: Oxford University Press, 2000), p. 12.

17. Manfred Zips, *Das Wappenwesen in der mittelhochdeutschen Epik bis 1250* (Ph.D. diss., Vienna, 1966), p. 1.

18. A comprehensive survey about heraldic and preheraldic devices on shields and banners in MHG epic poetry up to 1250 is found in Zips, *Wappenwesen*, pp. 1–63.

19. For Walther von Châtillon, see Christine Ratkowitsch, *Descriptio picturae: Die literarische Funktion der Beschreibung von Kunstwerken in der lateinischen Großdichtung des 12. Jahrhunderts* (Vienna: Verlag der Österreichischen Akademie der Wissenschaften, 1991), pp. 135–48; for the Northern vernaculars, see Hellmut Rosenfeld, "Nordische Schilddichtung und mittelalterliche Wappendichtung," *ZfdA* 61 (1936): 235–48 [232–69].

20. Bebius's *Ilias latina*, which was an integral part of school education in the twelfth century, showed the cosmological shield of Achilles in full detail. Bebius Italicus, *Ilias latina*, ed. Marco Scaffai (Bologna: Petrón, 1982), pp. 862–91. The main sources for medieval Troy narratives, however, were Dares Phrygius and Dictys Cretensis. See Ratkowitsch, *Descriptio picturae*, pp. 319–22.

21. Herbort von Fritzlar, *Liet von Troye*, ed. G. Karl Frommann (Quedlinburg: Basse, 1837), commentary to the edition, p. 233.

22. Konrad von Würzburg, *Der Trojanische Krieg*, ed. Adelbert von Keller, G. Karl Frommann et al. (Stuttgart: Litterarischer Verein, 1858).

23. *Le Roman d'Eneas*, ed. and trans. Monika Schöler-Beinhauer (München: Fink, 1972).

24. The topaz in later heraldry becomes a symbol for the color of gold. See Guy Cadogan Rotherty, *Concise Encyclopedia of Heraldry* (London: Senate, 1994), p. xv. Brault, *Early Blazon*, does not mention this early heraldic showpiece in his groundbreaking book.

25. Heinrich von Veldeke, *Eneasroman*, ed. and trans. Dieter Kartschoke (Stuttgart: Reclam, 1986).

26. See Brault, *Early Blazon*, p. 18.

27. James Parker, *A Glossary of Terms Used in Heraldry* (Rutland: Tuttle, 1970), p. 64.

28. Brault, *Early Blazon*, pp. 120–27.

29. Krieger, *Ekphrasis*, p. vii; and Heffernan, *Museum of Words*, p. 15, give several examples.

30. Marianne Shapiro, "Ekphrasis in Virgil and Dante," *Comparative Literature* 42 (1990): 97 [97–113].

31. Heffernan, *Museum of Words*, p. 14.

32. Brault, *Early Blazon*, pp. 29–35, this quote p. 29.

33. Brault, *Early Blazon*, p. 29.

34. See Brault, *Early Blazon*, p. 29, with regard to Geoffrey of Monmouth and his *Historia regum Britanniae*.

35. See Zips, *Wappenwesen*, pp. 138–46.

36. See Brault, *Early Blazon*, p. 30.

37. Ulrich von Zatzikhoven, *Lanzelet*, ed. Karl A. Hahn (1845; repr. Berlin: de Gruyter, 1965).

38. See Zips, *Wappenwesen*, pp. 139–41; and Heiko Hartmann, "Heraldische Motive und ihre narrative Funktion in den Werken Wolframs von Eschenbach," *WSt* 17 (2000): 157–81.

39. See Brault, *Early Blazon*, pp. 23–28, this quote p. 23. See Zips, *Wappenwesen*, pp. 118–20.

40. Wolfram von Eschenbach, *Parzival*, ed. Karl Lachmann and Bernd Schirok (Berlin: de Gruyter, 1998).

41. "Wolfdietrich D," in *Deutsches Heldenbuch IV*, vol. 2, ed. Arthur Amelung and Oscar Jänicke (Berlin: Weidmann, 1873), pp. 11–236.

42. *Lancelot: Nach der Heidelberger Pergamenthandschrift Pal. Germ. 147*, ed. Reinhold Kluge, DTM 42, 47, 63 (Berlin: Akademie-Verlag, 1948, 1963, 1974).

43. Joachim Bumke, *Geschichte der deutschen Literatur im hohen Mittelalter* (Munich: Deutscher Taschenbuch Verlag, 1990), p. 103. See also Haiko Wandhoff, *Der epische Blick: Eine mediengeschichtliche Studie zur höfischen Literatur* (Berlin: Erich Schmidt, 1996), pp. 134–44 and 169–79.

44. See n. 24.

45. Arnold Galle, "Wappenwesen und Heraldik bei Konrad von Würzburg," *ZfdA* 53 (1912): 223–32 [209–59].

46. Krieger, *Ekphrasis*, p. xvii.

47. Brault, *Early Blazon*, p. 5.

48. See Zips, *Wappenwesen*, pp. 14–16.

49. See the French arms, for example, in Der Pleier, *Meleranz*, ed. Karl Bartsch (Stuttgart: Litterarischer Verein Stuttgart, 1861), ll. 3348, 11923; Konrad von Würzburg, "Das Turnier von Nantes," in *Kleinere Dichtungen II*, ed. Edward Schröder (1959; repr. Zürich: Weidmann, 1970), l. 534 [pp. 42–75]; Johann von Würzburg, *Wilhelm von Österreich*, ed. Ernst Regel (1906; repr. Dublin: Weidmann, 1970), l. 17012. For the English arms, see Konrad von Würzburg's, "Turnier," l. 310; or *Reinfried von Braunschweig*, ed. Karl Bartsch (Tübingen: Litterarischer Verein Stuttgart, 1871), p. 328.

50. Ulrich von Liechtenstein, *Frauendienst*, ed. Franz V. Spechtler (Göppingen: Kümmerle, 1987).

51. For example, "diu banier gel und grüene, / wîz, rôt, brûn unde blâ gevar" [the banners colored yellow and green, white, red, brown, and blue] (21342–43); "diu wâpenkleit gel unde rôt, / grüene, brûn, wîz und blâ" [the yellow and red, green, brown, white, and blue heraldic cloaks] (21700–01). In one passage, the six colors are expanded to seven by gray, which is also a well-known practice of heraldry: "wîz, rôt, gel, grüene, swarz, grâ, blâ / was ir wünneclîcher schîn" [its wonderful appearance was white, red, yellow, green, black, grey, blue] (12448–49). Konrad von Würzburg, *Partonopier und Meliur*, ed. Karl Bartsch (Vienna: Braumüller, 1871).

52. See Zips, *Wappenwesen*, p. 139; and Galle, "Wappenwesen und Heraldik," p. 215. *Das Nibelungenlied*, ed. and trans. Helmut Brackert, vol. 1 (Frankfurt: Fischer, 1970).

53. Gottfried von Strassburg, *Tristan*, ed. and trans. Rüdiger Krohn, 3 vols. (Stuttgart: Reclam, 1980).

54. Konrad von Würzburg, "Lied 7," in *Kleinere Dichtungen III*, ed. Edward Schröder, 3rd edn. (Dublin: Weidmann, 1970), pp. 23–24.

55. *Die Minneburg*, ed. Hans W. Pyritz (Berlin: Akademie-Verlag, 1950).

56. The representation of colors by stones is an essential part of classical heraldry; see Rotherty, *Concise Encyclopedia*, pp. xv–xvi.

57. Matthias Lexer, *Mittelhochdeutsches Taschenwörterbuch*, 34th edn. (Stuttgart: Hirzel, 1976), p. 265. There is no entry in Georg F. Benecke, Wilhelm Müller, and Friedrich K.T. Zarncke, *Mittelhochdeutsches Wörterbuch*, vol. 3 (Leipzig: Hirzel, 1861).

58. "einen schild eintheilen und die wappenfiguren in gehöriger ordnung und stellung einrichten, dann in kunstgerechter weise beschreiben." Benecke, Müller, Zarncke, *Mittelhochdeutsches Wörterbuch*, p. 330.

59. Michael Schroeder, *Kleine Wappenkunst* (Frankfurt am Main: Insel, 1990), p. 152.

60. See Wandhoff, "Velden und visieren," pp. 594–97.

61. Krieger, *Ekphrasis*, p. xvii.

CHAPTER 5

WRITTEN COMMUNICATION IN
THE ILLUSTRATED EPIC POEM

Ulrich Ernst

Introduction

In recent years, analyses of medieval literary works by literary scholars have set in motion a wide variety of research on orality and literacy in the period between late antiquity and the modern era.[1] New findings have emerged particularly within the context of the medieval culture of writing: studies on the long-neglected genre of the Latin figural poem, for example, have moved previously neglected artistic scriptographic practices into medieval scholarship's field of vision, causing scholars to regard medieval scriptography in a different light.[2] In a recent study on the forms of writing in the vernacular epic, I attempted to adjust the dominant view that medieval texts are principally unstable by pointing out examples of systems of textual stabilization, such as that represented by acrostics identifying the author. This study also critically questioned the deep-rooted conception of the supposedly illiterate author by examining an image of Wolfram that is characterized by references to literacy and also cited numerous examples of reading and writing knights and noble ladies in the courtly epic, thereby calling into question the established view of an illiterate laity. Similarly, the study reexamined the idea that people in the Middle Ages never read silently but rather always aloud or in a low voice and that the works of the epic poets were conveyed to the public only through performance at court.[3] In recent studies on the German illustrated epic manuscripts, scholars have developed a new understanding of the medieval culture of writing and image: medieval vernacular literature is no longer considered exclusively oral but rather as considerably scriptoral and iconic as well.[4] Medieval

images do not only take on the functions of visualizing, explicating, and commentating on the text, but rather, based on their portrayal of reading and writing and in their depictions of writing media such as writing tablets, scrolls, codices, and letters, they are also part of a media culture that includes both the clergy and the laity. Drawing on my recent collection, dissemination, and evaluation of references to scenes of reading and writing as well as references to books and letters in courtly epics of the Middle Ages, I examine the extent to which forms of scriptoral communication find expression in the manuscript illustrations of the vernacular epic as well.

Heinrich von Veldeke and the Tradition of the Classical Epic

The origin of the courtly epic in the High Middle Ages is marked by Heinrich von Veldeke, whose representation of a poetics of writing is documented in particularly concentrated form in the epilogue of his *Eneasroman* (a Middle High German version of the *Aeneid*).[5] This epilogue includes references to scriptoral sources, to Vergil and the *Roman d'Eneas*, to the stylization of the poet as *poeta litteratus*, to the adventurous story of the theft of a book, and to Countess Margarete von Kleve, a courtly lady who is interested in reading (352, 38–40). Motifs of writing pervade the text itself as well; among these motifs, the epitaphs on the graves of Dido (80, 10–15), of Pallas (225, 18–23), and of Camilla (254, 16–26) deserve special attention. Furthermore, on the narrative level, various characters are represented as literate, such as the priest Chores, who is both a scholar and a knight (243, 18–27), or Japyx, who is skilled in the art of healing and is characterized as learned (314, 7), or the sibyl whom Eneas encounters with a book in her hand before he sets off on his journey to Hades (85, 8–9).

The scene with the sibyl reading (l. 84, 20 ff.) is illustrated in the upper register of images on folio 21r of the Berlin manuscript of the *Eneasroman* (Ms. Germ. fol. 282), which was written in the first or second decade of the thirteenth century and is decorated with 136 miniatures on 71 pages of pictures (figure 5.1).[6] The ancient seer sits in her temple, in which an altar with a candle can be found, and she is reading from an open book, the text of which has been functionalized to direct the reception of the image, since it fulfills the task of introducing the sibyl to the reading viewer: "Here sits the sibyl, the soothsayer of such diabolical nature" [Hie sizzet sibille. div wis / saginne also tivelichen getan], while Eneas holds a banderole in his hand that refers to the dialogue: "My lady, I must travel to the underworld; on the way there, I will be protected if you accompany me" [Frowe ih schol ze helle uarn / da hin schol mih iwer gelæitte bewarn]. Banderoles constitute a distinct form of the thematization of literacy in the Berlin codex; the artists

5.1 Heinrich von Veldeke, *Eneasroman*; Berlin, Staatsbibliothek zu Berlin—
Preußischer Kulturbesitz, Ms. Germ. fol. 282, fol. 21r. The sibyl reading.

have frequently presented them in nonlinear, curved, or winding paths of
text that postulate a deciphering act of reading requiring the reader to
either turn the text or his or her head.[7]

In the *Eneasroman* of Heinrich von Veldeke, fictional letters also play an
essential role in the repertoire of pragmatic writing. Of importance, for
example, is the conspiratorial letter by Amata (125, 36–40), who is doing
her utmost to prevent the marriage of her daughter Lavine to Eneas
because she would prefer to have Turnus as her son-in-law, and the letter
that Lavine delivers to Eneas by having an archer shoot it to him (286, 14 ff.)
is also of crucial significance to the plot. In the Berlin manuscript, in the
upper portion of the image on folio 71r, one can see Lavine surrounded by
references to literacy and writing. In her left hand is the letter and in her
right hand a quill, as she sits in front of a writing desk with inkpots and
extra quills. In an adaptation of 286, 24–26, the epistolary salutation
directed at Eneas is retained, and it can be read on the document, which
appears as a written banderole: "Lavine the Princess sends Eneas devotion
and affection" [Lauine div chvniginne. enbv / tet enee dienist vnd minne],
while the lower segment of the image on folio 71r depicts Lavine present-
ing an archer with an arrow around which she has wound the letter to
Eneas (287, 32 ff.). The text of the banderole in Lavine's hand reads: "If you
would like to have my eternal gratitude, shoot this arrow down to those
who are at the moat" [wil dv iemer lon von mir haben. / schivoz di strale
vnder di in dem graben], and the banderole of the archer presents us with
the following pair of verses: "That would be dangerous for me, for we have
a ceasefire and peace" [Daz wǽre mir angistlîch zetvon. / wan iz ist fride vnd
svon]. Corresponding to the verses following 289, 19, Lavine and the archer
can be seen in the upper segment of the illustration on folio 71v as they
watch Eneas inspecting the arrow, while the lower segment of the illustration,
which corresponds to the verses following 291, 25, conveys the impression
that reading the love letter causes Eneas to forget his hunger. The use of arrows
as a means of transporting letters proves to be a dominant motif in a miniature
in the Manesse song manuscript (Heidelberg, UB, Cod. pal. germ. 848,
fol. 169v) as well, this time in the context of the author's portrait depicting
Lord Rubin: the poet is about to use a crossbow to shoot a letter up to the
window of the castle; the letter is intended for the lady who is standing in
the central arch.[8]

Heinrich von Veldeke's *Eneasroman* belongs to the genre of the classical
epic that was cultivated in the late Middle Ages by various authors in the
"humanistic" education tradition. Written communication also plays a sig-
nificant role in a work that may be based on Byzantine sources, Konrad
Fleck's courtly epic *Flore und Blanscheflur* ("Flore and Blanscheflur") com-
posed around 1220, in which the protagonists write each other childlike

love letters early on (ll. 2286–91).[9] In the illustrated Heidelberg paper manuscript (Cod. pal. germ. 362), which was fashioned in Lauber's workshop (1430–1440), one finds a relevant miniature, albeit only at the very end (fol. 201v).[10] It illustrates the delivery of a sealed letter reporting the death of Flore's father (l. 7649 ff.), and above it, a corresponding titulus for the picture or the chapter reads: "Thus, two knights came to Flore from his country and said to him that his father the king was dead, and he and Blanscheflur wept miserably" [Also zwene ritter zu Flore koment us sime lande und ime seitten daz sin vatter der kunig tot wer und er unde Blanscheflur sere weintent].

The genre of the classical epic is also taken up by Konrad von Würzburg when he innovatively adapts the legend of the Trojan War in his *Trojanischer Krieg* ("Trojan War"), which is based on the *Estoire de Troie* by Benoît de Sainte-Maure as well as on other Latin texts (*Ilias latina*, perhaps also *Dares and Dictys*).[11] In codices of this work, which is rich in writing motifs,[12] miniatures also reflect forms of pragmatic writing, such as in the Berlin manuscript (Staatsbibliothek, Berlin, Ms. germ. fol. 1), which was produced in Lauber's workshop around 1430–1440, and which pictorially records the delivery of a letter with a red seal (l. 18102 ff.) on folio 174v; the titulus provides this commentary: "Thus, the Greeks went to the troops and gave the two counts the answer that they would have to repeat to Priam" [Also die kriechen z[ů] rate gingent vnd den zwein grafen ein antwurte geben das sy priamo wider solten sagen uf; die zwein grafen = Antenor and Anchises].[13]

Finally, the classical epic *Apollonius von Tyrland* ("Apollonius of Tyre") by Heinrich von Neustadt provides us with numerous textual references to forms of scriptoral communication: an epitaph (ll. 15511–25), a "letter" (ll. 1987–2050), and a magical piece of paper (ll. 6969–73); the illustrations from the manuscript tradition express a connection to scriptorality as well.[14] Thus, in the Gotha manuscript (Cod. chart. A 689), which predates 1420 and which is decorated with 128 colored pen-and-ink drawings that are considerably more recent than the body of the text, one finds a miniature before verse 2074 at the lower end of the left column that refers to the account of Apollonius acting as a messenger and delivering three letters of proposal with promises of various wedding gifts to the Princess Lucina, who is being courted by three counts; he then receives from her a letter of reply that he is to deliver to her father. The illustration depicts Apollonius with a crown on his head and a piece of paper in his hand as well as Lucina, also crowned, with a wax diptych in the one hand and a pen in the other (fol. 16r).

An image can also be found after verse 14402 in the middle of the left column (fol. 113v) that depicts the delivery of a letter: Apollonius is seen with a letter in his hand, and in front of him is Cleopacras, the messenger of the jealous queen Diamena. Another illustration preceding verse 18188

depicts the pope, wearing a crown topped by a cross, placing a crown on the head of Apollonius, who is on bended knee before him. Beside the pope, one catches sight of a lectern and a book lying open on it, displaying graphically simulated notes; in front of this, three choirboys with red caps can be seen (fol. 141v).

Wolfram von Eschenbach and His Followers

In the epic works of Wolfram von Eschenbach, whose supposed "illiteracy" can justifiably be doubted, one comes across the most varied expressions of literacy and writing, such as the fictional discovery of a book in the story of Kyot in *Parzival* (453, 11–454, 23), an inscription on the Grail king's sword (490, 18–24), an epitaph on the helmet of the deceased Gahmuret (107, 29–108, 28), the mysterious writing on the Grail stone (470, 21–29), various letters from Gahmuret (55, 21–56, 20), Gawan (625, 12–626, 8), Gramoflanz (710, 5–715, 30), and Feirefiz (785, 27–30), as well as the exceptional inscription on the hound's leash in *Titurel* (stanzas 139–45).[15]

The Vienna codex (Österreichische Nationalbibliothek, Cod. ser. nov. 2643), which emerged from the Prague workshop of King Wenceslas IV in the year 1387, conveys a portrait of Wolfram von Eschenbach in which he is depicted as having been schooled in writing. This codex contains all three adaptations of the *Willehalm* material: *Arabel*, the prelude to Willehalm by Ulrich von dem Türlin, Wolfram's *Willehalm*, and Ulrich von Türheim's *Rennewart*. In this magnificent manuscript, one illustration in the *Rennewart* section on folio 313r stands out in particular; it represents Wolfram von Eschenbach as a literate poet: in the initial "O" of a digression in which Ulrich von Türheim calls on his role model with the words "O masterful artist Wolfram" [O Kvnstericher wolfram] (l. 21711), one can see the poet, depicted with a penknife and a quill, sitting at a desk in front of an open book containing illegible marks suggesting letters (figure 5.2).[16]

As is often the case with medieval manuscripts, books also appear in a liturgical context in the *Parzival* tradition. This is, in fact, demonstrated by a Munich codex from the first half of the thirteenth century (Bayerische Staatsbibliothek, Cgm. 19), which contains three miniatures on folio 50v appearing one above the other in a column next to the text. In the lower left, in the depiction of Feirefiz's baptism (817, 8 ff.), a tonsured cleric is holding his right hand over the baptismal candidate while, at the same time, he is holding a large book, a missal, in his left hand. Among the people schooled in writing who appear in *Parzival*, we also find the layman Trevrizent, who is in possession of books (459, 21–22) and who states: "Although I may be a layman, I have read what is reported in the true books, and I can also write" [doch ich ein leie waere / der wâren buoche

5.2 Ulrich von Türheim, *Rennewart*; Vienna, Österreichische Nationalbibliothek, Cod. ser. nov. 2643, fol. 313r. Wolfram von Eschenbach.

maere / kund ich lesen unde schrîben] (462, 11–13). Corresponding to the text, one sees Parzival astride his steed in one of the miniatures in the n manuscript (Heidelberg, UB, Cod. pal. germ. 339, fol. 335r), which was produced in the middle of the fifteenth century in Lauber's workshop; near Parzival is Trevrizent, who is clasping an open book with empty pages and standing in front of a church—whether this is the psalter mentioned in verse 460, 25 remains open.[17]

In the *Willehalm* cycle of the Cod. Vind. 2670, which originated in 1320, an illustration appears in Ulrich von dem Türlin's prelude to *Willehalm*, the titulus of which announces: "Here, the margrave sends the messengers away to his friends" [Hie sendet der Markeis di / poten enwech zv seinen

freunten].[18] The illustration iconically represents the margrave sending out
messengers (l. CXCVII, 1 ff.; fol. 38va): the lower portion of the two-level
miniature depicts a writing scene, while in the upper portion, one can see
the messenger receiving the letter.[19] It is interesting to note that the
prologue of Ulrich's prelude to *Willehalm* is decorated with an acrostic:
MEISTER VLRICH VON DEM TVRLIN HAT MIH GEMACHET
[Master Ulrich von dem Türlin made me] (fol. 2ra, l. 26 ff.), thereby
suggesting that the epic is directed at a reading public.

 The Kassel *Willehalm* codex (Landesbibliothek und Murhardsche
Bibliothek, 2° Ms. poet. et roman. 1), commissioned in 1334 by Landgrave
Heinrich II of Hessen, is particularly rich in pictorial concretizations of
written communication.[20] This codex contains several illustrations displaying
symbols of writing in Ulrich's prelude to *Willehalm*: in the prologue (l. I, 1 ff.),
a portrait of a scribe or an author sitting in front of a desk and displaying an
open book containing the beginning of the work (l. 1) is located at the
lower edge of the page inside the end of the initial, virtually in contact with
a *drôlerie* (fol. 1v); there is also a scene depicting Willehalm, followed by
three men, as he hands the knight Kunal a letter to his brother Bertram in
Oranse telling of his successful return home (l. CXCVII, 1 ff.; fol. 44r).
Further, one finds an illustration of the delivery of the letter in Oranse
(l. CCI, 1 ff.; fol. 44v); and finally, a scene depicts the pope, who is supposed
to baptize Arabel, as he sits with a miter and a missal in his hand (l. CCXLVIII,
1 ff.; fol. 55r).

 The sumptuous Vienna manuscript (Österreichische Nationalbibliothek
Cod. ser. nov. 2643), which immortalizes Wolfram as a poet schooled in
writing, also contains two portraits of the author Ulrich von Türheim.
These portraits are integrated into the initials of the preliminary and clos-
ing prayers (fols. 161r, 421r), and they depict the poet kneeling in prayer.
The illustration at the end of the literary work that combines the portrait
of the author and the dedication depicts Ulrich in front of a desk with an
open book as he beseeches his audience to intercede for his spiritual salva-
tion, as can be gathered from the following verses in the miniature: "This is
the end of the book.[21] I am sending this book via messengers to those who
will listen to it or read it so that they may ask God to save my soul" [Hie hat
ditz buch ein ende. / ditz buch zu boten ich sende / an sie die ez horen oder
lesen, / daz sie mir bitende wesen / der sele heiles hin zu got] (ll. 36509–13).
It is appropriate for this literary work, the *Rennewart*, that Ulrich von
Türheim is introduced as an author who has a good knowledge of books,
for in *Rennewart*, forms of writing are thematized many times on the fic-
tional level, for example, the inscription on the belt that Gyburc presents to
her spouse at their farewell (ll. 33662–74) or King Loys's letter that
Willehalm reads (ll. 34387–94).

One also finds illustrations with elements of writing in the manuscript tradition of the *Jüngere Titurel* ("Later Titurel"), whose author was thought in the Middle Ages to have been Wolfram.[22] Within the context of this study, the Dietrichstein manuscript, which was produced around 1425 and which can be found today in the Bayerische Staatsbibliothek (Cgm. 8470), deserves particular attention, for this manuscript is decorated with eighty-five miniatures of high aesthetic quality executed by an Italian or by an artist who was familiar with Italian Renaissance painting. In addition to the standardized scenes of the delivery of letters, this codex contains an exquisite miniature on folio 164r that depicts Schionatulander presenting Sigune with the ominous hound's leash, one of the props of destiny, so to speak.[23] In this case, the leash carries an Italian inscription, only the end of which can be deciphered (stanzas after 1184): ". . .ma vule(?) amor, ma la speranza."

The manuscript traditions of Wolfram's *Parzival* and the *Jüngere Titurel* not only contain miniatures with signs of writing, but in the illustrations of other Arthurian epics, one can also find pictorial elements that betray a clear interest in "cultural technologies" of reading and writing as well. A manuscript of the *Lanzelet* of Ulrich von Zatzikhoven (Heidelberg, UB, Cod. pal. germ. 371), written in an Alsatian workshop in 1420, presents us at the beginning with a picture of the author writing at a lectern and wearing a pair of glasses on his nose (fol. 2r).[24] In one of the miniatures in the Manesse manuscript, that is, the one on folio 311v displaying a portrait of Lord Alram von Gresten, a courtly lady, who is apparently able to read, is holding an open codex in her left hand—one can read the initial verses of Ulrich von Zatzikhoven's *Lanzelet* on the two visible pages of the open book—and pointing with her right hand from the book to the poet sitting beside her.

The thirteenth-century Arthurian romance *Wigamur*, which has come down to us anonymously and which has survived in an illustrated manuscript with sixty-seven pen-and-ink drawings (Wolfenbüttel, HAB, Cod. Guelf. 51.2 Aug. 4⁰) from the second half of the fifteenth century, also offers the viewer images of the scriptoral transmission of messages: the forty-ninth miniature (fol. 100r) depicts a messenger delivering a letter to King Paltriot (l. 3580 ff.), and the sixtieth illumination (fol. 120v) represents the royal couple Wigamur and Dulciflor receiving a letter (l. 4727 ff.).[25]

Forms of scriptoral communication in the courtly epic *Lohengrin*, written between 1283 and 1286, must finally also be taken into account; here, writing is expressed on the textual level in a very succinct manner, in that the protagonist wears a helmet with a crown decorated with an inscription (l. 5337 ff.).[26] In the Heidelberg manuscript (Heidelberg, UB, Cod. pal. germ. 345) of this work, which was produced in the Hennfflin workshop around 1457 and which also contains *Friedrich von Schwaben* (fols. 182r–379r), various pages with writing motifs can be found among the ninety-eight

color illustrations. These motifs are distributed equally between religious ceremonies with liturgical books (fol. 25v, l. 1050 ff.; 36r, l. 1550 ff.; 48r, l. 2010 ff.; 81r, l. 3250 ff.) and the delivery of letters (fol. 34v, l. 1489 ff.; 64r, l. 2600 ff.; 72v, l. 2903; 87r ff., l. 3510 ff.).

Gottfried von Strassburg and Other Adapters of the Tristan Material

In his prologue to *Tristan*, Gottfried von Strassburg develops a literary-aesthetic program based solidly upon literacy by referring, among other things, to scriptoral pretexts and reporting that he investigated the literary sources of his poem (ll. 147–72).[27] It is significant that even lay characters in his courtly epic are described as having a good knowledge of reading and writing; Tristan and Isolde, for example, write each other love letters (ll. 16281–83, 16301–02). The inscription on the crystal bed in the allegorically interpreted grotto of courtly love ("Minnegrotte"), which forms the core of the courtly epic (ll. 16716–23), underlines the significance of writing in this work.[28] It is thus not surprising that the erudite poet, who may have attained a master's degree at one of the French universities, is represented in his authorial portrait in the Manesse codex as *homo litteratus*: In the pictorial tradition of the teaching scene (*magister cum discipulis*), the miniature on folio 364r depicts the master in a group of men; he can be distinguished by his wax diptych, the attribute of the scholar. Bligger von Steinach, probably Bligger II (1152–1209), who is mentioned in the excursus on literature in *Tristan* (ll. 4691–4722) and who is attested as the author of a lost verse epic entitled *Umbehanc* ("The Blanket"), is also introduced in the Manesse manuscript (fol. 182v) *in actu*, as he dictates to his scribe.

Gottfried's *Tristan* has been iconicized in the most various of materials, media, and forms; here, however, we are interested only in the manuscript illustrations.[29] In the Munich *Tristan* (Bayerische Staatsbibliothek, Cgm. 51), which was furnished with fifteen images in an Alsatian workshop around 1240, the illuminator portrayed the burial of Tristan's father Riwalin (l. 1689 ff.) in the lower register of the image on folio 11v.[30] Riwalin is being lifted from a bier into a sarcophagus, and in the hollow of the sarcophagus, one can read a worn inscription: "May the One who created heaven and earth care for him all of his days, and may [his days] be entrusted to Him with confidence in His benevolence" [der himel vnd erde geschaffen hat Er plege siner tagerat (?) / vnd laze si im bevolhen sin vf die gnade sin].[31] In the background of the burial scene, one can discern figures, and among these is also a priest holding a missal in his hand—an image that often accompanies liturgical events of this type in epic manuscripts, even when there is no textual reference to such a figure.

Besides the image of the funeral, the codex also contains an additional scene in which a sacred book appears, for on folio 15v, the upper register of the illumination illustrates a priest baptizing Tristan (l. 1963 ff.) while behind him a second cleric holds a large book in front of his chest (figure 5.3). In the middle section of the illumination, which shows Tristan's education in the arts, one can see the protagonist at the left, surrounded by three boys; with his finger, he follows the text of a book that lies open before him on a three-legged lectern (l. 2092 ff.). In the codex opened before him, the Latin words "beatus vir deus (?). . .veni sancte spiritus reple" can be read over an earlier, different text—apparently, it is a palimpsest.[32] The pictorial scene on folio 82v also presents us with a sacred book in the hands of a cleric as an integral part of a liturgical ceremony; in the central portion of the illustration, it shows Isolde accused of adultery before the court at *Carliûne* (l. 15632 ff.): on the left margin of the illustration, a bishop with a miter is standing behind Marke; the bishop is holding a liturgical book in his covered hands and pressing it to his breast.

The Munich codex preserves Ulrich von Türheim's continuation of *Tristan* immediately following Gottfried's poem. Ulrich von Türheim composed this work for Konrad Schenk von Winterstetten (d. 1243), the *Reichsministeriale*.[33] In this portion of the manuscript, the scene pictured in the lower section of the illustration on folio 107v also exhibits a writing motif in the center of the image in the form of a (no longer legible) inscription on the sarcophagi of the lovers, above which a rosebush and a grapevine are growing intertwined (l. 3695 ff.).[34]

In his continuation of Gottfried's work, Ulrich von Türheim was influenced by Eilhart von Oberg's *Tristrant und Isalde*, in which Tristan, while living in the woods, sends a hermit's letter to King Marke (ll. 4974–5113).[35] The Cod. pal. germ. 346 of the University Library of Heidelberg preserves Eilhart's work; it was produced between 1465 and 1475, and it is furnished with ninety-one pen-and-ink drawings. In this codex, a miniature depicting the hermit at a high desk, writing the letter to the king for Tristan and Isolde, appears on folio 89v, and on folio 90v, Tristan is iconically visualized throwing the letter into the royal chamber through a window in the wall. Finally, the end of Eilhart's verse epic is marked by an illustration of the lovers' grave on folio 174r: the gravestone, out of which a rosebush and a grapevine are growing intertwined, is engraved with a bilingual inscription in Latin and German: "Anno Domini MCCCIII—†Ars Dem Got Genedig."

Rudolf von Ems

Rudolf von Ems was an erudite producer of texts who moved easily between discourses on writing and who apparently aspired to the image of

84

5.3 Gottfried von Strassburg, *Tristan*; Munich, Bayerische Staatsbibliothek, Cgm. 51, fol. 15v. *Above*, the baptism of Tristan (a cleric with a book); in the *center*, Tristan reading a book on a three-legged stand.

poeta litteratus. Characteristically, several authorial portraits of him have been preserved, and among these is what is probably the oldest portrait of an epic poet writing in German, found in the Werningerode manuscript of the *Weltchronik* ("World Chronicle," Cgm. 8345, fol. 1r).

The illuminated manuscripts of Rudolf's *Alexander* afford us with several miniatures that contain references to writing; the exchange of letters has been a part of versions of this material since antiquity.[36] In the Brussels manuscript of the epic (Bibliothèque Royale, ms. 18232), which originated in Lauber's workshop around 1430–1440, one finds on folio 111v a picturesque depiction of the Babylonians as they receive their fiefs in the form of scrolls from Alexander the Conqueror following the surrender of their city (l. 13296 ff.).[37] In a Munich manuscript from the first half of the fifteenth century (Cgm. 203), which also originated in Lauber's workshop, a portrait of the author can be found before the text begins; the portrait represents the inspired poet in front of a writing desk with an open book (fol. 2r).[38]

Rudolf's *Barlaam und Josaphat* ("Barlaam and Josaphat") is a legend which tells of the Indian prince Josaphat, who, against the will of his pagan father Avenner, converts to Christianity and is baptized by the monk Barlaam.[39] In the end, not only Josaphat's father but also the pagan astrologer Nachor and the diabolical sorcerer Theudas renounce their idolatrous religion. The Lauber manuscript of *Barlaam*, which dates from 1469 (Los Angeles, Paul Getty Museum, Sammlung Ludwig: Ms. Ludwig XV 9 [83.MR. 179]), is, as the following list demonstrates, truly a treasure trove of images thematizing writing, images that are, in part, independent from the text.

45r: Barlaam with a book in his monk's hermitage in the woods (inscription: "A monk passes the time singing and reading in his cell in the woods" [Ein münch vertribet sin ziet / Mit singen vnd lesen inn siner zellen im walde]; ll. 1413–15: "When he was in his cell, he sang and read there for the sake of God according to priestly custom" [dô er in sîner zelle was, / durch got dâ sanc unde las / nâch priesterlîchem rehte]).

64v: The tree of Jesse, with Joachim and Anne as a symbol of the Immaculate Conception; Anne with an opened book on her lap (inscription: "This is the tree of Jesse, of which the saints prophesy and through which the holy Scriptures have been fulfilled" [Dis ist die ruote Yesse von der die heiligen wyssagen und die heiligen geschrift erfüllet worden ist]; l. 2531 ff.).

159v: The baptism of Josaphat, a cleric with an open book (l. 6612 ff.).

162v: Barlaam, with a book on his lap, instructs Josaphat in the true faith (inscription: "How Barlaam instructed the young prince Josaphat in his palace in faith and in the Christian way of life so that he would be

baptized" [Wie Barlaam dem jungen künige Josaphat in sinem balast fürseite den glouben vnd kristeliche ordenung er zum touffe käm]).

165r: Josaphat with a cross in front of the baptismal font, next to him, a tonsured cleric with a book and a censer (l. 6834 ff.).

191v: The astrologer Nachor with an opened book (ll. 7955–57: "There was Nachor inside, reading books of magic; his knowledge of magic was great" [dâ Nachor inne was, / an zouberlîchen buochen las / zouberliste grôze]).

214v: Josaphat, Avenner, and Nachor, etc. take part in a scholarly competition; two scholars with open books (l. 8942 ff.).

219v: Scholars, one of whom holds an open book (l. 9139 ff.).

223r: Josaphat, Avenner, and the pagan scholars see the sun god above the clouds with a scepter and a book.

231r: The same observers see the personified image of the planet Saturn with a book.

235r: The magician Theudas with an opened book.

241r: Theudas with an open book; Vulcan with a hammer on a cloud.

281r: Theudas with the Devil and an open book of spells (ll. 11931–37: "Theudas left from there when the decision was made. When he arrived at his cave after that, he took up his books of spells: then, using his magic, the Devil's excellent servant conjured up a demon. . ." [Von dannen huop sich Thêodas, / dô der rât gevrumet was. / als er in sîn hol dô kam, / sîniu zouberbuoch er nam: / des tiuvels werder dienestman / mit sînem zouber dô gewan / einen tiuvel. . .]).

310v: Theudas burns his books of spells in front of Josaphat's eyes (ll. 13281–86: "When old Theudas was brought into the faith, he hurried quickly from that place to his cave in the woods. He burned whatever books of spells he found there immediately" [Dô der alte Thêodas / brâht an den gelouben was, / er gâhte dannen balde / in sîn hol in dem walde. / swaz er dâ zouberbuoche vant. / diu verbranter sâ zehant]).[40]

Rudolf's *Willehalm von Orlens*, which contains an acrostic at the beginning of each book as a reference to literacy, repeatedly tells of an exchange of letters between Willehalm and the English princess Amelie.[41] Indeed, with its many inserted letters, the poem even approaches the modern genre of the epistolary novel.[42] For this reason, it is not surprising that scenes of epistolary communication, in which the messenger Pitipas generally plays an important role, can often be found in the illustrated manuscripts of the work as well.

In Munich manuscript Cgm. 63 (Bayerische Staatsbibliothek), which presumably originated in Zurich around 1270–1280, one finds not only a portrait of the author, namely, the poet who is dictating to a scribe, but also a series of epistolary scenes (fols. 49r, 53r, 60r, 64v); these will, however, not

be discussed here at any great length, since a detailed monograph has already been written on the subject of this manuscript.[43]

In the Heidelberg manuscript (Cod. pal. germ. 323), which dates from the years 1413 to 1416, one finds an illustration of dictation on folio 3r: an author can be seen as he dictates to a scribe who is sitting on a chair with an opened book on his lap and holding a quill in his hand, while on folio 37v, one finds a funeral scene, and integrated into the scene is a server with a processional cross and a book. Finally, on folio 159r, one sees Pitipas delivering a letter from Amelie to Willehalm; at the bottom of the previous page (158v), an explanatory titulus precedes the image: "Here, Pitipas will offer the lord a letter, and Lord Wilhelm will take counsel with his servant" [Hier sol Pittipas dem herren einen brieff bieten vnt sol herr Wilhelm zu rate gon mit seinem diener].

Similar configurations of a media-oriented iconography can be recognized in the illustrations of a manuscript from the Regional Library of Württemberg (Württembergische Landesbibliothek, Stuttgart, HB XIII 2) as well. This manuscript was produced in 1419, and its inventory of images includes 109 slightly colored pen-and-ink drawings: Willehalm receives his fief in the form of a scroll (fol. 65v), Pitipas delivers Willehalm a letter from Amelie (fol. 130r), Willehalm accepts a letter from Pitipas (fol. 154r), Willehalm writes a reply to Amelie in the presence of Pitipas (fol. 159r), Pitipas delivers a letter (fol. 160v), Pitipas brings Amelie a letter (fol. 174r), Pitipas gives Willehalm a message (fol. 175r), Willehalm receives a message from Amelie (fol. 232r), and King Amilot hands a message to Count Morant (fol. 235v).

In another manuscript of the text held in the Germanic National Museum of Nuremberg that was compiled around 1441 (Germanisches Nationalmuseum Nürnberg, Hs. 998), folio 225v presents us with an illustration in two horizontal registers: in the upper register, Pitipas delivers a sealed letter to Willehalm, who is riding, and in the lower register, Willehalm is reading the letter on horseback (figure 5.4). On 227r, an additional scene depicting the delivery of a letter at the side of a tournament can be seen; using the means of painting, this image portrays Willehalm in full armor as he hands Pitipas a letter, and on the outside of this letter, writing is visible. On 231r, the messenger delivers another letter to Willehalm as he is at table, and again, the letter displays writing on the outside. The depiction of a massive tournament with the delivery of a letter on folio 233r concludes the sequence of messenger scenes containing references to writing.[44] Clearly, the accumulation of images in manuscripts such as these, which thematize writing in general and epistolography in particular, suggest that the entire work engages in a discourse on writing, for the narratology of the work is developed further by means of the narrative quality of these images.

5.4 Rudolf von Ems, *Willehalm von Orlens*; Nuremberg, Germanisches
Nationalmuseum, Hs. 998, fol. 225v. *Top*, Pitipas delivers a letter to Willehalm;
bottom, Willehalm reading.

Conclusion

Now that the relevant pictorial material has been disseminated, explicated,
and organized, the following discussion will summarize our findings in terms
of more comprehensive perspectives and will also draw several conclusions.

The first thing that should be emphasized is that the miniatures that
thematize writing in the manuscripts of vernacular epics present us with
various writing media such as the book and the letter. At the same time, the
production of writing is reflected technologically in writing tools, such as
ink pots, quills, and razors, as well as in pieces of furniture, such as writing

desks and chairs. In addition to this, one also finds reading implements such as glasses (for example, Ulrich von Zatzikhoven).

Writing itself appears in the miniatures in various forms: as tituli; as banderoles, which often exhibit curved or even arabesque lines; in the depictions of opened books, which often cite the beginning of the work that is illustrated; writing is often graphically simulated, or even appears as musical notation (for example, Heinrich von Neustadt); and finally, it appears as inscriptions on physical artifacts such as a sarcophagus (for example, Eilhart von Oberg). Tituli are significant in that they integrate the images into the body of the text; the tituli and the chapter headings are sometimes identical, thereby according the image a tectonic significance. The manner in which chapter headings and lists of chapters function as a means of organizing and stabilizing the text, a phenomenon that is already prevalent in Old High German biblical epics, has yet to be investigated extensively in the context of the manuscripts of Middle High German epics. This aspect of these epics is not generally taken into consideration in editions either, and it is in urgent need of more thorough clarification.

In the manuscripts of the courtly epics discussed here, references to writing appear in a broad range of pictorial types, among which the following stand out: the authorial portrait that contains attributes of literacy and learning (for example, Rudolf von Ems); the liturgical scene, especially the baptism and the funeral, with a cleric in assistance holding a book (for example, Wolfram von Eschenbach, *Parzival*); the reading scene (for example, Rudolf von Ems, *Willehalm von Orlens*) as well as the writing scene (for example, Eilhart von Oberg).

Messenger scenes with documents appear often in the illustrations, particularly in those of the Lauber manuscripts; this corresponds in part to the structural significance of the fictional letters that are either mentioned or inserted into the text of the courtly epics.[45] Iconographically, three types can be differentiated: first, the writer sends a letter, handing it to a messenger; second, the addressee receives the letter from the messenger's hands; and third, the letter is delivered by another means, this being depicted in a particularly spectacular manner in the *Eneasroman* in which the letter is shot with an arrow. While writing can sometimes be seen on the outside of the letters (Rudolf von Ems, *Willehalm von Orlens*), this is generally an exception. Seals depicted in the illustrations make it clear in many cases whether the letters are still sealed or have already been opened. In the courtly epics, scenes of letter writing (for example, Heinrich von Veldeke) and letter reading (for example, Rudolf von Ems, *Willehalm von Orlens*), as well as scenes of sending and receiving letters generally involve laypeople.

In the cases where inserted letters have characterized the structure of the work in a profound manner, the back and forth of the correspondence is

reflected in the corresponding series of miniatures as well (for example, Rudolf von Ems, *Willehalm von Orlens*). The increase in letter scenes in the courtly epic not only reveals an extensive interest in the epistolary dissemination of information but is also certainly connected with the development of the *ars dictandi* in the high and late Middle Ages as well.[46]

One encounters the delivery of letters as a sign of established writing in a lay society in the illustrations of the Manesse manuscript as well. These illustrations are linked to the names of certain authors, as the following overview demonstrates: in the miniature of Lord Burkhard von Hohenfels, the poet delivers a letter to a lady (fol. 110r); in Count Konrad von Kirchberg's image, the poet unfurls a scroll up to the height of a lady who grasps it with her left hand (fol. 24r); in the image of Lord Wilhelm von Heinzenburg, the poet delivers a letter and a gift to a woman kneeling before him (fol. 162v); in the illustration of Lord Leuthold von Seven, the poet, represented as a mounted falconer, hands the lady in the castle a letter (fol. 164v); and in the image of Der Von Wildonie, the poet, taking part in the hunt, delivers a letter to a lady that she, leaning down from the battlements, takes up with her right hand (fol. 201r).

Except for the miniatures that can be traced back to paradigms of religious iconography, the illustrations of the vernacular epic manuscripts, which were directed at a secular audience, clearly demonstrate that literacy, contrary to an old "prejudice," was obviously not limited to the clergy in the Middle Ages, rather, as the evidence from the medieval era suggests, many knights could read and write as well. I argue, therefore, that the miniatures reflect what is implied in the texts of the epics, namely, that from the perspective of the Middle Ages, knighthood and the ability to read and write are in no way mutually exclusive.

It is, however, entirely possible that some "fictional" or "semifictional" portrayals of written communication in the courtly epics do not find their way into the illuminations or that oral communications in the text are pictorially represented in later illustrated manuscripts as the receipt or delivery of documents. The following explanations can be offered for such reinterpretations of media: first, a messenger scene can be unambiguously marked as such by the illustration of a document so that no further "commentary" is necessary; second, it could be a case of simply adopting an iconographic pattern that is not represented in the text in the same way; and third, it is possible that a more advanced state of writing is documented in later illustrations. It must, however, be emphasized that it is particularly in early manuscripts of vernacular epic poetry that many examples of illustrations with references to writing can be found (for example, Heinrich von Veldeke, Gottfried von Strassburg). The medium of the letter is apparently accorded special interest as a component of courtly life and a means of telecommunication, inspiring

many illuminators or their patrons to depict or request depictions of messenger scenes (for example, *Wigamur*). In the private writing and silent reading of love letters (Rudolf von Ems, *Willehalm von Orlens*), the competence of laypeople in the realm of writing manifests itself in an especially pronounced manner. It seems that desire as an agent of innovative media processes is not only a phenomenon of the modern era.

Portraits of the author portray the secular producers of texts in various situational roles that are characterized by the relationship of the respective author to writing: as, for example, *auctor scribens, auctor dictans, auctor dedicans*, and *auctor legens*. They document a clear organization of the discourse on literary authorship into various aspects, a phenomenon that we encounter in intensified form in other genres of medieval literature as well, such as in the development of the illustrated encyclopedia.[47] Moreover, authorial portraits and frontispieces, as components of the exordium, are connected with the medieval *accessus ad auctores*, which, among other things, provide information about the author and the title of the particular literary work.[48]

Illustrations of the poets, like the equally visually prominent acrostics that are often tied to paratexts, aid in the determination of authorship and in the outlining of authorial roles. Based on their reference to the origin and production of writing, miniatures that are furnished with signals of writing mark a distinct level of reflection on media within the particular work, and therefore engage in a discourse on writing and literacy. The viewer is also drawn in by the illustrated epic manuscripts to reflect on writing. These texts intermixed with miniatures invite the viewer, on the one hand, to read discursively and, on the other hand, to view synoptically. Textual spaces open themselves up to the viewer for the production of intramental images, but there are also possibilities for the perception of extramental images that must then be transformed into texts. In the process of examining the manuscript, the viewer advances into the role of the reader on various levels, for he or she not only reads the linear verse text but also follows the twisting, delinearized banderoles in the images, and finally decodes the hidden iconic grammar, rhetoric, and semiotics of the images themselves.

Notes

Translated by Edward T. Potter.

1. See, for example, Manfred Günter Scholz, *Hören und Lesen: Studien zur primären Rezeption der Literatur im 12. und 13. Jahrhundert* (Wiesbaden: Steiner, 1980); Dennis H. Green, *Medieval Listening and Reading: The Primary Reception of German Literature, 800–1300* (Cambridge: Cambridge University Press, 1994); and Horst Wenzel, *Hören und Sehen, Schrift und Bild: Kultur und Gedächtnis im Mittelalter* (Munich: C.H. Beck, 1995).

2. See, for example, Ulrich Ernst, *Carmen figuratum: Geschichte des Figurengedichts von den antiken Ursprüngen bis zum Ausgang des Mittelalters* (Cologne: Böhlau, 1991).

3. Ulrich Ernst, "Formen der Schriftlichkeit im höfischen Roman des hohen und späten Mittelalters," *FSt* 31 (1997): 252–369; compare also Bianca van Melis-Spielkamp, *Pragmatische Schriftlichkeit in englischen arthurischen Romanzen* (Frankfurt am Main: Peter Lang, 1999).

4. See Hans Wegener, *Beschreibendes Verzeichnis der Miniaturen und des Initialschmuckes in den deutschen Handschriften bis 1500* (Leipzig: J.J. Weber, 1928); Wolfgang Stammler, "Bebilderte Epenhandschriften," in *Wort und Bild: Studien zu den Wechselbeziehungen zwischen Schrifttum und Bildkunst im Mittelalter*, ed. Wolfgang Stammler (Berlin: E. Schmidt, 1962), pp. 136–60; Stammler, "Epenillustration," in *Reallexikon zur deutschen Kunstgeschichte*, vol. 5 (Stuttgart: J.B. Metzler, 1967), cols. 810–57; Hella Frühmorgen-Voss, "Mittelhochdeutsche weltliche Literatur und ihre Illustration. Ein Beitrag zur Überlieferungsgeschichte," *DVjs* 43 (1969): 23–75; Frühmorgen-Voss, *Text und Illustration im Mittelalter: Aufsätze zu den Wechselbeziehungen zwischen Literatur und bildender Kunst*, ed. and with an introduction by Norbert H. Ott (Munich: C.H. Beck, 1975); Frühmorgen-Voss, *Katalog der deutschsprachigen illustrierten Handschriften des Mittelalters*, continued by Norbert H. Ott, 2 vols. (Munich: C.H. Beck, 1991 and 1996). I would like to take this opportunity to thank Norbert Ott (Munich, Bayerische Akademie der Wissenschaften) for his help and advice.

5. Heinrich von Veldeke, *Eneasroman*, ed. and trans. Dieter Kartschoke (Stuttgart: Reclam, 1986).

6. Heinrich von Veldeke, *Eneasroman: Die Berliner Bilderhandschrift mit Übersetzung und Kommentar*, ed. Hans Fromm (Frankfurt am Main: Deutscher Klassiker Verlag, 1992); Veldeke, *Eneas-Roman: Farbmicrofiche-Edition der Handschrift Wien, Österreichische Nationalbibliothek, Cod. 2861* (Munich: Edition H. Lengenfelder, 2000).

7. For more on the banderoles, see Karl Clausberg, "Spruchbandreden als Körpersprache im Berliner Äneïden-Manuskript," in *Künstlerischer Austausch—Artistic Exchange*, ed. Thomas W. Gaehtgens, vol. 2 (Berlin: Akademie-Verlag, 1992), pp. 345–55.

8. *Codex Manesse: Die Miniaturen der großen Heidelberger Liederhandschrift*, ed. and annotated by Ingo F. Walther (Frankfurt am Main: Insel, 1988), pp. 54 and 110–11.

9. Konrad Fleck, *Flore und Blanscheflur: eine Erzählung*, ed. Emil Sommer (Leipzig: Basse, 1846).

10. See Lieselotte E. Saurma-Jeltsch, *Spätformen mittelalterlicher Buchherstellung: Bilderhandschriften aus der Werkstatt Diebold Laubers in Hagenau*, 2 vols. (Wiesbaden: Reichert Verlag, 2001); Christoph Fasbender, "Hübsch gemolt—schlecht geschrieben? Kleine Anthologie der Lauber-Handschriften," *ZfdA* 131 (2002): 66–78.

11. Konrad von Würzburg, *Der Trojanerkrieg*, ed. Adelbert von Keller (1858; repr. Amsterdam: Rodopi, 1965).

12. Ernst, "Formen der Schriftlichkeit," pp. 280, 299, 303, 344, and 347.

13. Konrad von Würzburg, *Trojanerkrieg*, color microfiche edition, ed. Elisabeth Lienert, Codices illuminati medii aevi, 15 (Munich: Edition H. Lengenfelder, 1989).

14. Heinrich von Neustadt, *Apollonius von Tyrland: Nach der Gothaer Handschrift*, ed. Samuel Singer (Dublin: Weidmann, 1967).

15. Wolfram von Eschenbach, *Parzival*, based on the edition of Karl Lachmann, rev. and annotated by Eberhard Nellmann, trans. Dieter Kühn, 2 vols. (Frankfurt am Main: Deutscher Klassiker Verlag, 1994); Ulrich Ernst, "Kyot und Flegetanis in Wolframs *Parzival*: Fiktionaler Fundbericht und jüdisch-arabischer Kulturhintergrund," *Wirkendes Wort* 35 (1985): 176–95; Wolfram von Eschenbach, *Titurel: Lieder*, ed. and trans. Wolfgang Mohr (Göppingen: Kümmerle, 1978).

16. Ulrich von Türheim, *Rennewart*, ed. Alfred Hübner (1938; repr. Berlin: Weidmann, 1964); and see Norbert H. Ott, "Pictura docet: Zu Gebrauchssituation, Deutungsangebot und Appellcharakter ikonographischer Zeugnisse mittelalterlicher Literatur am Beispiel der Chanson de geste," in *Grundlagen des Verstehens mittelalterlicher Literatur: Literarische Texte und ihr historischer Erkenntniswert*, ed. Gerhard Hahn and Hedda Ragotzky (Stuttgart: Kröner, 1992), p. 201 [187–212]; Burghart Wachinger, "Wolfram von Eschenbach am Schreibpult," *WSt* 12 (1992): 9–14.

17. Wolfram von Eschenbach, *"Parzival": Die Bilder der illustrierten Handschriften*, ed. Bernd Schirok (Göppingen: Kümmerle, 1985), pp. 87 and 190. See *Parzival* 462, 11–12.

18. Ulrich von dem Türlin, *Willehalm*, ed. Samuel Singer (1893; repr. Hildesheim: G. Olms, 1990).

19. Wolfram von Eschenbach, *Willehalm*, with the prelude by Ulrich von dem Türlin and the sequel by Ulrich von Türheim, complete facsimile edition in the original format of the Codex Vindobonensis 2670 of the Österreichische Nationalbibliothek, commentary by Hedwig Heger (Graz: Adeva, 1974).

20. Robert Freyhan, *Die Illustrationen zum Casseler Willehalm-Codex* (Marburg: Verlag des Kunstgeschichtlichen Seminars, 1927), pp. 4 and 9–10; tables 2, 44, 45, and 56.

21. Joseph Krasa, *Die Handschriften König Wenzels IV* (Vienna: Forum, 1971), pp. 44–45, 59–60.

22. Albrecht von Scharfenberg, *Der Jüngere Titurel*, ed. Werner Wolf and Kurt Nyholm, 3 vols., DTM 45, 55/61, 73 (Berlin: Akademie-Verlag, 1955–1984).

23. *Monumenta Codicum Manu Scriptorum: An Exhibition Catalogue of Manuscripts of the 6th to the 17th Centuries* (New York: H. P. Kraus, 1974), pp. 83 and 143.

24. Ulrich von Zatzikhoven, *Lanzelet*, ed. and trans. Wolfgang Spiewok, Wodan 71 (Greifswald: Reineke, 1997); and see Hans Wegener, *Beschreibendes Verzeichnis der deutschen Bilder-Handschriften des späten Mittelalters in der Heidelberger Universitäts-Bibliothek* (Leipzig: J. J. Weber, 1927), pp. 18–19, figure 18.

25. *Wigamur*, ed. Danielle Buschinger, GAG 320 (Göppingen: Kümmerle, 1987); and see Ingeborg Henderson, "Illustrationsprogramm und Text der

Wolfenbütteler *Wigamur*-Handschrift," in *"In hôhem prîse": A Festschrift in Honor of Ernst. S. Dick*, ed. Winder McConnell, GAG, 480 (Göppingen: Kümmerle, 1989), pp. 163–81.

26. *Lohengrin: Edition und Untersuchung*, ed. Thomas Cramer (Munich: W. Fink, 1971).

27. Gottfried von Strassburg, *Tristan*, vols. 1–3, ed. and trans. Rüdiger Krohn (Stuttgart: Reclam, 1980).

28. See Ulrich Ernst, "Gottfried von Straßburg in komparatistischer Sicht: Form und Funktion der Allegorese im Tristanepos," *Euphorion* 70 (1976): 1–72.

29. Doris Fouquet, *Wort und Bild in der mittelalterlichen Tristantradition* (Berlin: E. Schmidt, 1971).

30. Gottfried von Strassburg, in *Tristan und Isolde: Faksimile-Ausgabe des Cgm 51 der Bayerischen Staatsbibliothek, München*, ed. Ulrich Montag and Paul Gichtel (Stuttgart: Müller und Schindler, 1979).

31. Gottfried von Strassburg, *Tristan und Isolde*, Textband, pp. 103–04.

32. Gottfried von Strassburg, *Tristan und Isolde*, Textband, pp. 105–06.

33. Gottfried von Strassburg, *Das Tristan-Epos mit der Fortsetzung des Ulrich von Türheim; nach der Heidelberger Handschrift Cod. Pal. Germ. 360*, ed. Wolfgang Spiewok (Berlin: Akademie-Verlag, 1989).

34. Gottfried von Strassburg, *Tristan und Isolde*, Textband, pp. 139–40; the Brussels manuscript of Gottfried's *Tristan* (Bibliothèque royale, ms. 14697), which was made in Lauber's workshop around 1440, also thematizes various scriptoral motifs in its miniatures (fols. 43v, 131r, and 140v).

35. Eilhart von Oberg, *Tristrant und Isalde*, ed. and trans. Danielle Buschinger and Wolfgang Spiewok (Greifswald: Reineke, 1993).

36. Rudolf von Ems, *Alexander*, ed. Viktor Junk, 2 vols. (1928/29; repr. Darmstadt: Wissenschaftliche Buchgesellschaft, 1970).

37. *Katalog der deutschsprachigen illustrierten Handschriften*, vol. 1, pp. 102–04, figure 42. For further illustrations with references to writing in the Brussels manuscript, see David J.A. Ross, *Illustrated Medieval Alexander-Books in Germany and the Netherlands: A Study in Comparative Iconography* (Cambridge: Modern Humanities Research Association, 1971), figures 3 and 37.

38. *Katalog der deutschsprachigen illustrierten Handschriften*, vol. 1, pp. 104–05.

39. Rudolf von Ems, *Barlaam und Josaphat*, ed. Franz Pfeiffer (1843; repr. Berlin: W. de Gruyter, 1965). See Norbert H. Ott, "Anmerkungen zur Barlaam-Ikonographie: Rudolfs von Ems *Barlaam und Josaphat* in Malibu und die Bildtradition des Barlaam-Stoffes," in *Die Begegnung des Westens mit dem Osten*, ed. Odilo Engels and Peter Schreiner (Sigmaringen: J. Thorbecke, 1993), pp. 365–85.

40. See Euw and Plotzek, *Die Handschriften der Sammlung Ludwig*, vol. 4, pp. 256–66, figures 189–220.

41. Rudolf von Ems, *Willehalm von Orlens*, ed. Viktor Junk (1905; repr. Dublin: Weidmann, 1967).

42. Ems, *Willehalm von Orlens*, ll. 6232–335, 6827–950, 7535–7619, 8015–91, 8204–8317, 8528–67, 8759–79.

43. Erika Weigele-Ismael, *Rudolf von Ems: "Wilhelm von Orlens"; Studien zur Ausstattung und zur Ikonographie einer illustrierten deutschen Epenhandschrift des 13. Jahrhunderts am Beispiel des Cgm 63 der Bayerischen Staatsbibliothek München* (Frankfurt am Main: Peter Lang, 1997).

44. Similar scenes of the delivery of letters (fols. 198v, 208v, 253v, 293r) can be found in the manuscript from Den Haag (Koninkl. Bibl. Cod. 71 J 54), which was compiled around 1450.

45. Many textual references can be found in the volume edited by Horst Wenzel, *Gespräche—Boten—Briefe: Körpergedächtnis und Schriftgedächtnis im Mittelalter* (Berlin: E. Schmidt, 1997).

46. See Franz Josef Worstbrock, "Ars dictaminis, Ars dictandi," in *Reallexikon der deutschen Literaturwissenschaft*, vol. 1, ed. Klaus Weimar et al. (Berlin: de Gruyter, 1997), pp. 138–41.

47. See Christel Meier, "Ecce auctor: Beiträge zur Ikonographie literarischer Urheberschaft im Mittelalter," *FSt* 34 (2000): 338–92; Ursula Peters, "Autorbilder in volkssprachigen Handschriften des Mittelalters: Eine Problemskizze," *ZfdPh* 119 (2000): 321–68.

48. Douglas Kelly, "Accessus ad auctores," in *Historisches Wörterbuch der Rhetorik*, vol. 1 (Tübingen: Niemeyer, 1992), cols. 28–36.

PART THREE

RETHINKING MANUSCRIPT CULTURE

CHAPTER 6

THE FLUID TEXT: OBSERVATIONS ON THE HISTORY OF TRANSMISSION AND TEXTUAL CRITICISM OF THE THIRTEENTH-CENTURY COURTLY EPIC

Joachim Bumke

Preliminary Remarks

The object of this study is the manuscript history of the courtly epic in the thirteenth century. The methods of dealing with these medieval texts passed down to us in written form have been, up until the present day, characterized by a form of textual criticism, which is based on the work of Karl Lachmann and which derived its methodological foundation by transposing terms and conceptions of texts from classical philology and biblical philology onto vernacular texts. In the last several decades, the legitimacy of such procedures has been called into question for a broad range of medieval literary texts.[1] Only the courtly epic (which was, from the very beginning, of central significance in the formulation of this methodology of textual criticism) has, until now, been exempted from this, with the exception of research on the *Nibelungenlied*, which occupies a special position within the textual historical tradition. The aim of this chapter is to reconsider the premises of textual criticism and the manuscript tradition for the courtly epic as well. I proceed from the premise that there can be no objective method of treating texts that is valid for all periods and all cultures, but rather that texts fixed in writing must be interpreted as cultural artifacts characterized by the historical conditions of their period. For the courtly epic of the thirteenth century, this means that the specific conditions of the manuscript

tradition—especially the fact that these texts were intended for a nobility still living to a large extent without writing—must be considered in order to understand the history of textual transmission.

Behind these observations stands the conviction that it cannot be in the interest of medieval German studies to emphasize an opposition between traditional philology on the one hand and innovative approaches informed by more modern literary-theoretical concepts on the other. What matters, I believe, is that scholars devoting themselves mainly to textual questions and those dedicated more to questions about the formation of categories and the problems of comprehension should remain in scholarly dialogue with one another because, on the one hand, the methods and goals of philological work must always be analyzed and defined anew, and the standards for this work can only be derived from the knowledge and assumptions of one's own time; and, on the other hand, the application and testing of new theories on the literary texts passed down to us are indispensable for literary studies.

The Extant Texts and Their Interpretation in Traditional Textual Criticism

In his critical editions of Hartmann von Aue's *Iwein* (1827) and the works of Wolfram von Eschenbach (1833), Lachmann blazed a philological trail for German studies. Even today, one cites Lachmann's editions of Hartmann's *Iwein* and Wolfram's *Parzival*. In particular, the *Iwein* edition (the second edition from 1843) was long considered to be "the model of a critical edition," and it had "the most enormous influence on the development of editing techniques."[2] Later studies of the manuscript tradition of *Iwein*, prompted by Hermann Paul, led, however, to the realization that the classic goal of textual criticism, that is, the reconstruction of the original wording of the text, cannot be achieved in the case of *Iwein* because, in the textual tradition of *Iwein*—as Zwieržina wrote—"the variants are wildly divergent" and the manuscripts do not allow themselves to be placed within the structure of a clear stemma.[3]

Iwein is not an exception. It is the case with most of the courtly epics coming down to us in the form of multiple manuscripts that scholars have not been able to reach a consensus regarding the original form of the text. This becomes especially clear when one examines Gottfried von Strassburg's *Tristan*. For *Tristan*, it has also been impossible "to tidily construct a stemma of the manuscript tradition," because the relationship of the manuscripts to one another is "particularly unclear."[4] The reason for this lack of clarity is always the same: the relationship of the manuscripts to one another cannot be ascertained because the correspondences between

the manuscripts often change in an unexpected manner, so that one must speak of an "extensive intermingling of the manuscript tradition."[5] Scholars of textual criticism speak of "hybrid manuscripts" and have determined that most of the manuscripts of the epics, especially the older manuscripts originating in the thirteenth century, are hybrid.

Traditional textual criticism provides only one answer to the question of how hybrid manuscripts came into being: they are the result of contamination. Contamination occurs when "a scribe used several sources."[6] In the textual history of the courtly epic, one finds, as Karl Stackmann established, "a contaminated manuscript tradition in the vast majority of cases."[7] The term *contamination* is taken from classical philology. Contamination presupposes that: (1) several manuscripts of the same text were available at one scriptorium, and that (2) the scribes had "what would seem to be an almost philological" attitude toward the text, that they were concerned about the "correct" text and, because of this, did not spare themselves the trouble of comparing several manuscripts with one another and collating them.[8] Such an attitude toward texts did indeed exist in the Middle Ages, especially when dealing with the Holy Scriptures and the Roman classics. In isolated cases, it is also possible that a vernacular epic text was treated "philologically."

The unambiguous cases of contaminated epic manuscripts are, however, of a different type: it was not out of concern for the genuine text but rather because a source was incomplete or no longer available that a second manuscript was occasionally consulted. A review of the available material leads one to the conclusion that neither of the required conditions for contamination was present in the case of the German-language epic texts of the thirteenth century. Even if one were to succeed in proving with certainty philological contamination in isolated cases, this would not provide an explanation for all the texts that have come down to us, for, given the great number of hybrid texts in existence, one would have to conclude that contamination was a common practice, and that is, given the cultural historical conditions, out of the question.

The Research Situation

Before one attempts to offer a different explanation of the phenomena mentioned above, it is necessary to ask to what extent a detailed discussion of such questions can lay claim to literary historical relevance. It seems to me to be characteristic of current scholarship that a small number of medievalists concern themselves with issues of textual criticism and the history of transmission, while a majority, for whom literary problems in a narrower sense stand at the forefront, refer in their work to the extant texts only in passing. The major works of the period around 1200 are still being

cited using editions that were made in the nineteenth century, even though the principles of structuring these texts have been recognized as inadequate or uncertain in these editions. The situation is even worse for the works for which no editions have been legitimated by scholarly tradition. Today, Veldeke's *Eneit* is most often cited from Ludwig Ettmüller's edition (Leipzig: Göschen, 1852), although the philological defects of this edition are well known, and Gottfried's *Tristan* is cited either from Marold's edition (3rd ed., Berlin: de Gruyter, 1969) or Ranke's edition (Berlin: Weidmannsche Buchhandlung, 1930). However, if it is immaterial for the interpretation of *Tristan* which edition is used as one's basis, then there no longer seems to be any essential correlation between philological and interpretative work.

One should, however, keep in mind that this situation is especially pronounced in the realm of the courtly epic. Things already appear to be completely different when one examines courtly lyric poetry.[9] Today, no one interpreting Walther von der Vogelweide's or Neidhart's songs would simply take the critical editions by Lachmann and Haupt as a basis for study and assume that there was no further need to take the manuscript tradition into account. Outside the realm of courtly literature, the research situation is even more uncompromising. It is primarily to the credit of Kurt Ruh, whose critical works on the history of the transmission of religious prose raised awareness of this problem, that the vernacular literature of the Middle Ages can only be understood as a phenomenon of manuscript transmission and that the "manuscript history of medieval texts" can be understood "as a methodological approach to an expanded conception of literary history."[10] The circumstances are basically no different for the courtly epic. Most of the courtly epics have been so poorly handed down to us that the use of textual-critical methods must be ruled out. The epics of the period before 1200 have, for the most part, been preserved for us only in fragments or exist only in the form of later adaptations. We also possess so few manuscripts of numerous thirteenth-century epics that the reconstruction of the originals cannot even be attempted. One is left with the surprising observation that, based on the state of the manuscript tradition, only ten or twelve texts meet the requirements necessary for the application of the Lachmannian method that was intended to serve as the methodological foundation of the entire field of study. These few works are, however, of particular significance, not only because of their artistic quality but also because the conditions under which vernacular texts were produced and disseminated in the Middle Ages can be gauged particularly well based on the more extensive manuscript tradition of these works.

That modern interpretive research refers to the research in textual criticism so rarely is likely a response to the fact that textual criticism has not produced reliable results in evaluating the various pieces of textual

evidence. If one follows which arguments are used to justify which reading is "better" and which is "worse," then one must often ask what is to be gained from results attained in this manner. The alternative of using only the old critical editions cannot, however, be recommended. An example: no interpretation of *Iwein* neglects to mention Laudine's kneeling before her husband at the end of the work as weighty evidence of Hartmann's interpretation of the relationship between the genders and the issue of marriage; and scholars ascribe even more significance to this gesture as it relates to the meaning of the poetic work, since Hartmann has gone beyond his French source in this scene. Laudine's falling to her knees can be found in Lachmann's critical edition of *Iwein*, as well as in all other editions of *Iwein*, although it is not explicitly stated in these editions that this portion of the text has only come down to us in the manuscripts B, a, and d, and that according to the premises of textual criticism, it must be "a later addition" to Hartmann's text.[11] Clearly, interpretations that take no notice of this manuscript tradition display serious methodological defects. This example and others tell us that, for the courtly epic, we must preserve the connection between textual criticism and interpretation.

Parallel Versions of Courtly Epics

I believe that we may find the explanation for the numerous hybrid texts, if they are not to be explained as the result of frequent contamination, in a phenomenon of manuscript transmission that scholars have been aware of for a long time, yet which has received little attention. Most of the courtly epics of the twelfth and thirteenth centuries have come down to us in several versions. For example, a very early "Upper German variant," of Veldeke's *Eneit* is attested by the manuscripts B and M as well as by the oldest fragments.[12] Similarly, since the discovery of new portions of the Wolfenbüttel fragments, scholars have suspected the existence of another version of Hartmann's *Erec* that differs from the other *Erec* manuscripts in its greater similarity to Hartmann's French source. Likewise, the oldest *Iwein* manuscripts, A and B, represent two different versions, which diverge considerably in both their form and their content. The manuscript tradition of *Parzival* is divided, as Lachmann had already noted, into the two groups ★D and ★G, which are textually "of equal value."[13] Two different thirteenth-century versions of Wolfram's *Titurel* fragments are also known to exist, represented by the manuscripts G and HM. The oldest manuscript of Gottfried's *Tristan*, the Munich manuscript M, contains an abridged version of the text in which, among other things, the allegorical interpretation of the love grotto ("Minnegrotte") is missing. There is also a shorter version of Herbort von Fritzlar's *Liet von Troie* that has been preserved in the

Skokloster fragments. There are even four different versions of the *Nibelungenklage*, the sequel to the *Nibelungenlied*, in existence.[14] The epics that have come down to us in more numerous manuscripts present the same picture. Especially pronounced are the various versions of the text in the manuscript tradition of the *Jüngere Titurel*.

Scholars of textual criticism have rarely dealt with the problem of the parallel versions of the epics. Actually, according to these scholars, there should not be any early parallel versions of courtly epics in existence at all. If original texts stand at the beginning of the manuscript tradition of epics, then there can only have ever been one fully adequate version of the text. Within the context of textual criticism, other versions must be viewed as faulty distortions of the original. For this reason, when multiple versions were in existence, textual critics have considered it their task to prove that only one version was "genuine" and that the others were distortions of the "genuine" text. Where this explanation failed, they explained that it was probable that both versions could be traced back to the author himself, that is, that there had been two originals. One must take into account both possibilities. There were, in fact, early adaptations of epics: the *C version of the *Nibelungenlied* is one example. In general, however, early parallel versions and later adaptations can be clearly distinguished from one another. Given the conditions under which courtly epics were written and disseminated, it is not only possible but also probable that a good number of authors produced different versions of their works. Up until now, however, no one has succeeded in proving with any certainty that the multiple versions of any particular courtly epic were an author's variants. For this reason, it is advisable to put aside the question of how the various versions of the epics came into being—this question cannot be answered with any certainty, anyway—and to devote oneself to the task of, first of all, describing the versions precisely and of considering how one should deal with them.[15] It is helpful that, in other areas of medieval literature, the existence of multiple versions of texts has long been observed and has, in part, already been the subject of a fair amount of research. One finds multiple versions not only of religious, didactic, historiographic, specialist, and legal texts, but also of courtly literature: for example, the Dietrich epic, the short verse narratives and humorous narratives (*Schwänke*), as well as courtly lyric poetry. Multiple versions are indeed a sign of the medieval, and above all, the vernacular, manuscript tradition. One may assume that the various textual manifestations spring from the same root and elucidate one another. It is, however, also a fact that parallel versions occur in various literary genres in various ways; we are therefore faced with the task, first of all, of describing the extant texts individually and then, once we have done that, of comparing

them with one another. In the present essay, I am concerned only with the parallel versions of courtly epics.

I speak of versions when an epic occurs in several divergent forms that correspond to one another literally to such an extent that one can speak of one and the same work but which, however, differ from one another in the form of the extant text and/or in the sequence of the text and/or in the formulations within the text so strongly that the differences cannot have come into being coincidentally. Rather, it becomes evident that the divergence is due to varied intentions with respect to the formulation and structuring of the text. Different versions are always obvious; if they are not obvious, it must remain open whether or not we are indeed dealing with different versions. Versions are defined positively by means of the extant texts and the formulations that are particular to them. This differentiates versions from the manuscript groups with which traditional textual criticism works: these groups can only be defined negatively by means of the errors that are common to them compared with the original. The study of versions is always a study of the work itself, which often makes itself available to us only in the form of a manuscript version. Textual criticism, on the other hand, only ever deals with the elements of the text that are not particular to the work itself but which have come into being secondarily during the process of transmission.

In dealing with versions, one is confronted with the problem that all of the terms used to describe the differences between texts have been influenced by the conventional view of textual criticism. When one speaks of *abridgments* or *expansions*, of *rearrangements* or *displacements*, of *additions* or *omissions*, of *text replacement* or *reformulations*, one already suggests a definite direction of change, and implicit in these terms is the concept of primary and secondary textual passages. It is crucial that scholars develop a different descriptive model for parallel versions of epics.

The textual differences between parallel versions can be described in terms of *variation*. Epic variation can refer to the slightest changes to the text, to "an alternation between interchangeable or similar spellings, sounds, forms, parts of words, words, phrases."[16] These forms of variation are not specific to a particular version: they can be found everywhere in the transmission of manuscripts, even between unrelated manuscripts. Characteristic for the differences between the versions are the more pronounced forms of variation, which can range from a different formulation of the same statement to new narrative elements. There are versions of epics that differ from one another mainly in the textual form, yet, on the other hand, correspond in the formulations used, and others that are widely divergent in their formulations yet barely differ from one another in the scope of the text. In the

case of relatively slight variation, one should verify whether or not different versions are really involved. The most pronounced variation that I am aware of in the history of the transmission of thirteenth-century epics can be found in the *B and *C versions of the *Nibelungenklage*. Each of these versions diverges from the other in every other line, each possesses a different textual structure (in *C, the text is divided into *âventiuren*; in *B, it is not), and each exhibits several hundred lines that belong only to that particular version.

The Fluid Text

The phenomenon of epic variation, which manifests itself in the existence of parallel versions, cannot be comprehended adequately using the methods of traditional textual criticism, which can be defined as the "study of errors."[17] Epic variation is a sign of the fundamental fluidity of medieval texts that has already been observed by various scholars. Regarding the French *fabliaux*, Jean Rychner spoke of a "tradition vivante"; Paul Zumthor coined the term *mouvance*; Joachim Heinzle noted a "structural openness of the texts" with regard to the German Dietrich epic.[18] Most closely related to the epic variation mentioned here is the concept that Bernard Cerquiglini called *variance*, which he elucidated using, among other things, passages from courtly epics.[19] Cerquiglini also established that the written transmission of works in the Middle Ages did not "produce" variants but rather that variation is the "principle" of medieval writing.[20] In fact, we must start from a different concept of text when dealing with medieval literature, particularly with the vernacular literature, than we would for the modern period. We must expect to be confronted with fluid, malleable texts that can be changed without the changes being viewed as distortions. Medieval texts were not at first fixed and then subsequently modified; instead, the "text" is, from the very beginning, a variable entity.

In the ninth book of *Parzival*, the hero learns from Trevrizent the words of the redemptive question that they were expecting from him in Munsalvâsche: "hêrre, wie stêt iwer nôt?" [Sire, how is your ailment?] (484, 27). Then, when Parzival poses the question at the end of the poem, he asks: "ôheim, waz wirret dier?" [Uncle, what ails you?] (795, 29). Neither of these formulations corresponds to the other, not even in one single word, yet it is nonetheless the same question, and both formulations are "correct." The fluidity of the texts manifests itself not only in variant formulations but also in variants within the subject matter. On an illustrated page of the G manuscript of *Parzival*, one can see Parzival riding toward his wife Condwiramurs, who is riding toward him on a horse with both sons in her arms. However, the text narrates that Parzival finds his wife sleeping in

a tent when he arrives at the Plimizôl (800, 1 5–17). Here, the pictorial narrative indeed attains the quality of an independent version of the text, since the same scene is played out differently in the picture than it is in the text, although it is the same scene. The comparison of the language of the text with the language of the illustrations proves to be instructive in other places as well.

The scholarship of the most recent decades has taught us that communication and the transmission of meaning were structured in a fundamentally different manner in the preliterate society of the Middle Ages than they have been in modern literate society. Communication in the Middle Ages was not primarily dependent upon the ability to abstract but instead functioned considerably via sensory perception. The term *orality*, as the most common counterpart of *literacy*, is directed at the fundamental significance of speaking and of the voice as the medium for the transmission of meaning. In the Middle Ages, visual powers were considered equally important— actively as gaze and vision, passively as the visibility of courtly culture—as was the multifaceted sphere of the production and transmission of meaning through gesture and the movement of the body. The phenomenon of the *fluid* text is to be understood against this cultural-historical background, which, as far as many details are concerned, is still in need of more in-depth and precise investigation. This is, to a large extent, well known; in this essay, however, we are concretely concerned with a new view of the manuscript history of the courtly epic.

Forms of Vernacular Writing

Joseph Bédier, the great critic of Lachmannian textual philology, made the observation that, in most of the manuscript trees that the textual critics of the Lachmann school drew in order to diagram the relationships among the extant manuscripts, the lower branches, which represent the later manuscript tradition, possess a great degree of evidence pointing to connections between the manuscripts but that these relationships become less and less clear the further up one goes toward the "original."[21] This observation led Bédier, justifiably, to ask the crucial question of whether stemma diagrams can adequately represent the relationships within the manuscript tradition of vernacular literature at all. By observing that the evidence of textual interrelationships in the older period of the transmission history of the epics differs from that of the later period, Bédier addresses an important phenomenon of manuscript history. Indeed, one can make the same observation in the manuscript history of almost all of the epics: that the more recent manuscripts can be arranged unproblematically into groups, whereas a great deal of uncertainty exists about the classification of the older manuscripts and fragments. Everywhere, the great controversies of textual

criticism concerned the question of the relationship between the main branches of the manuscript tradition—branches that had already developed when these texts were first written down—to one another and to the presupposed original. Scholars have not found it sufficiently surprising that the manuscript tradition of the epics presents us with the same situation everywhere: an early splitting-up into two or more groups (depicted in the stemma as branches) and later, further branches only developing within the old main branches. If one organizes the manuscript tradition of the epics into groups not according to errors, but according to versions, then the findings are rather different. For most of the epics, we possess early multiple versions whose relationship to the "original" cannot be definitively ascertained by using the methods of traditional textual criticism. In many cases, the "original" remains indistinct or disappears completely, since one is unable to trace one's way back to an original text through the versions. Instead of an author-text, we can, for the most part, speak only of versions that approach or are close to the author. The transmission of the text that is closest to the author is characterized by a high degree of variability. The early multiple versions attest that even the text that was close to the author was still so fluid in its written form that different formulations were able to develop. This is not as surprising as it might seem upon initial consideration. Based on the prevailing orality of courtly literary practices, one would expect to encounter partial texts, multiple versions, and varying situations of oral presentation and written composition in the early phase of the manuscript tradition. In this context, textual variants, which found their way into the older manuscripts in the form of independent versions or hybrid texts, could easily have developed. Indeed, one can explain the existence of early hybrid texts by considering the fluidity of textual production and transmission in this period. Unfortunately, we can no longer determine what part the authors may have played in the production of hybrid texts, or alternatively, to what extent variants did not develop until the texts were copied.

We are confronted with a completely different situation when we examine the later manuscript transmission of the epics starting at the end of the thirteenth century. After the initial phase, in which variations were developed in close temporal proximity to the author, there is very little variation in the epics. Instead, the later manuscript transmission demonstrates an astonishing consistency. The early versions of epics that developed in close proximity to the author can, in most cases, be followed in the epics' transmission over hundreds of years, often until the text ceases to be transmitted in the fifteenth or sixteenth centuries. This means that the later manuscripts were compiled in an environment in which the conception of the text had changed; this new conception of the text distanced itself considerably from its original variability, moving instead toward the modern

notion of word-for-word literality. Scholars have not yet sufficiently taken
into consideration this process of fixing or stabilizing vernacular texts. If
one looks into the cultural-historical background of this development, he
or she finds a striking similarity to the phenomenon described by Malcolm B.
Parkes and by Richard H. and Mary A. Rouse as "new attitudes to the
page."[22] They have observed that the practice of writing underwent a decisive
shift in the twelfth and thirteenth centuries, and they have demonstrated
that this process began in the early scholastic education centers in the
twelfth century and reached its first peak in the scholastic writing culture of
the thirteenth century. This process exhibits the rationalization of forms of
writing. The new writing techniques of compiling, glossing, commenting,
registering, indexing, alphabetizing, and the like, increasingly took on the
functions and replaced the skills that the memory had performed previously.
Scholars have to investigate further the ways in which the new conception
of the text affected the written page in manuscripts containing poetic
works.[23] When poetic works were written down, we can expect that there
was a concern not only with making the text rational and accessible but also
with using techniques of decoration and labeling. I suspect that the process
described by Parkes and Rouse also found its way into vernacular manu-
scripts as well. The German epic manuscripts begin to appear around 1200.
The oldest manuscripts are, without exception, small in format and unre-
markable in layout and in decoration. In the course of the thirteenth century,
however, the appearance of the epic manuscripts is conspicuously trans-
formed: the format becomes larger, the margins become wider, the use of
two columns becomes the rule, and new forms of textual labeling become
evident. Setting off each single line of a poem proves to be an especially
appropriate form of textual representation for the rhymed couplets of the
epics. In order to structure the text, initials were used; these were often of
varying sizes and designs so that larger sections could be distinguished from
smaller sections.[24] For the manuscript user, a wealth of visible cues emanated
from the arrangement and structuring of the pages. These cues made the
texts easier for the user to access; it could even be said that these cues made
the use of texts possible in the first place. The thoroughly rational and aes-
thetic arrangement of the pages attests to a new conception of the text that,
I suspect, has a cultural parallel in the simultaneous stabilization of the
word. Toward the end of the thirteenth century, there was a drive in
Germany to put things into writing on a scale that, until then, had been
unimaginable. In this period, the number of epic manuscripts that have
been preserved increases many times over. The first extensive collections of
lyric poetry, the first manuscript anthologies of short epics, the first German
devotional books, the first great collections of legends, the first extensive
collections of sermons, and many more all stem from this period. This is the

same period in which numerous chanceries switched over to German as the written language, which resulted in the number of German-language documents increasing a hundredfold within a few years. It is in the same period that town council books, town charters, guild regulations, contracts, land registers, property treatises, and legal treatises begin to be written down on a larger scale. The educational-historical and organizational preconditions necessary for this development have not yet been clarified sufficiently. For this reason, for the time being, one can only conjecture that the transformation of the conception of the text that manifests itself in the manuscript history of the courtly epic is best viewed within the medieval context of changes in the practice of writing.

Conclusions

Kurt Ruh has called for the supplementation or the replacement of traditional textual criticism by a scholarly approach that takes manuscript transmission into account.[25] For the courtly epic, the description of variation within the corpus of manuscripts should become one of the main tasks of philologists. In addition to this, scholars must develop new forms of editing. Up until now, only one scholar has attempted to issue different versions of an epic in the form of a parallel edition. But Anton Edzardi's 1875 edition of the *Nibelungenklage* failed because of its own inadequacies. Versions of a text that are equal in value deserve to be presented in a form that accords them equal value.[26] The parallel printing of two (or more) versions of a text makes it, on the one hand, difficult to use as an edition, but, on the other, forces scholars to take the manuscript transmission into consideration when interpreting the text. When we interpret Hartmann's *Iwein*, we are, in reality, interpreting version A or version B of *Iwein* without being able to say in what relationship the versions stand to the author-text. For this reason, one should no longer speak of Hartmann's relationship to his French source, but rather of the way in which Chrétien's text is adapted in the various versions. We know nothing at all about Hartmann's views on marriage; we can only examine the depiction of marriage in *Iwein* A or in *Iwein* B. Taking epic variation into consideration will perhaps once again direct attention more heavily toward the linguistic-stylistic form of the texts; this could only be beneficial in the interpretation of these works.

Notes

Translated by Edward T. Potter.
This essay was previously published in German as "Der unfeste Text: Überlegungen zur Überlieferungsgeschichte und Textkritik der höfischen Epik

im 13. Jahrhundert," in *Aufführung und Schrift in Mittelalter und Früher Neuzeit*, ed. Jan-Dirk Müller (Stuttgart: Metzler, 1996), pp. 118–29.

1. Rüdiger Schnell, "Was ist neu an der 'New Philology'? Zum Diskussionstand in der germanistischen Mediävistik," in *Alte und neue Philologie*, ed. Martin-Dietrich Gleßgen and Franz Lebsanft (Tübingen: Niemeyer, 1997), pp. 61–95; Karl Stackmann, "Neue Philologie?" in *Modernes Mittelalter: Neue Bilder einer populären Epoche*, ed. Joachim Heinzle (Frankfurt: Insel, 1994), pp. 398–424; Helmut Tervooren and Horst Wenzel, eds., *Philologie als Textwissenschaft: Alte und neue Horizonte* (Berlin: Erich Schmidt, 1997; Sonderheft).

2. Hendricus Sparnaay, *Karl Lachmann als Germanist* (Bern: A. Francke, 1948), p. 79.

3. Hermann Paul, "Über das gegenseitige Verhältnis der Handschriften von Hartmanns *Iwein*," *PBB* 1 (1874): 288–401; Konrad Zwieržina, "Allerlei *Iwein*kritik," *ZfdA* 40 (1896): 225 [225–42]: "die varianten wirr durcheinander gehen."

4. Friedrich Ranke, "Vorwort," in Gottfried von Strassburg, *Tristan und Isold: In Auswahl*, ed. Friedrich Ranke (Bern: A. Francke, 1946), p. 3; Hans Fromm, "Stemma und Schreibnorm: Bemerkungen anläßlich der *Kindheit Jesu* des Konrad von Fußesbrunnen," in *Mediaevalia litteraria: Festschrift für Helmut de Boor zum 80. Geburtstag*, ed. Ursula Henning and Herbert Kolb (München: C.H. Beck, 1971), p. 199 [193–210].

5. Hans Steinger, "Nachwort," in Hartmann von Aue, *Iwein*, ed. Hans Steinger (Leipzig: Reclam, 1933), p. 282.

6. Hartmut Erbse, "Überlieferungsgeschichte der griechischen klassischen und hellenistischen Literatur," in *Geschichte der Textüberlieferung der antiken und mittelalterlichen Literatur*, vol. 1, ed. Herbert Hunger (Zurich: Atlantis Verlag, 1961), p. 210 [207–83].

7. Karl Stackmann, "Mittlealterliche Texte als Aufgabe," in *Festschrift für Jost Trier zum 70. Geburtstag*, ed. William Foerste and Karl-Heinz Borck (Cologne: Böhlau, 1964), p. 249 [240–67].

8. Friedrich Ranke, *Die Überlieferung von Gottfrieds "Tristan"* (Darmstadt: Wissenschaftliche Buchgesellschaft, 1974), p. 157.

9. Werner Besche and Helmut Tervooren, eds., *Überlieferungs-, Editions- und Interpretationsfragen zur mittelhochdeutschen Lyrik* (Berlin: Bielefeld, 1985); Günther Schweikle, *Minnesang* (Stuttgart: Metzler, 1989), pp. 23–33; Franz-Josef Holznagel, *Wege in die Schriftlichkeit: Untersuchungen und Materialien zur Überlieferung der mitelhochdeutschen Lyrik* (Tüblingen: Francke, 1995).

10. Kurt Ruh, "Überlieferungsgeschichte mittelalterlicher Texte als methodischer Ansatz zu einer erweiterten Konzeption von Literaturgeschichte," in *Überlieferungsgeschichtliche Prosaforschung: Beiträge der Würzburger Forschergruppe zur Methode und Auswertung*, ed. Kurt Ruh (Tübingen: Niemeyer, 1985), pp. 262–72.

11. Ludwig Wolff, in Hartmann von Aue, *Iwein*, vol. 2, 7th rev. edn. ed. Georg F. Benecke and Karl Lachmann (Berlin: de Gruyter, 1968), p. 219.

12. Gabriele Schieb and Theodor Frings, "Einleitung," in Henric van Veldeken, *Eneide*, vol. 1, ed. Gabriele Schieb and Theodor Frings, DTM 58 (Berlin: Akademie-Verlag, 1964), p. xxxvi [ix–cix].

13. Karl Lachmann, "Vorrede," in *Wolfram von Eschenbach*, ed. Karl Lachmann (Berlin: G. Reimer, 1833), p. vi.

14. See Joachim Bumke, *Die vier Fassungen der Nibelungenklage: Untersuchungen zur Überlieferungsgeschichte und Textkritik der höfischen Epik im 13. Jahrhundert* (Berlin: de Gruyter, 1996).

15. New approaches to this problem are offered by Peter Strohschneider, "Höfische Romane in Kurzfassungen: Stichworte zu einem unbeachteten Aufgabenfeld," *ZfdA* 131.4 (2002): 409–35; Nikolaus Henkel, "Kurzfassungen höfischer Erzähltexte als editorische Herausforderung," *editio* 6 (1992): 1–11; Henkel, "Kurzfassungen höfischer Erzähldichtung im 13./14. Jahrhundert: Überlegungen zum Verhältnis von Textgeschichte und literarischer Interessenbildung," in *Literarische Interessenbildung im Mittelalter: DFG-Symposion 1991*, ed. Joachim Heinzle (Stuttgart: Metzler, 1993), pp. 39–59.

16. Stackmann, "Mittelalterliche Texte," pp. 257–58.

17. Stackmann, "Mittelalterliche Texte," p. 256.

18. Jean Rychner, *Contribution à l'étude des fabliaux: Variantes, remaniements, dégradations*, vol. 1 (Neuchâtel: Faculté des lettres, 1960), p. 43; Paul Zumthor, *Essai de poétique médiévale* (Paris: Éditions du Seuil, 1972), p. 507; Joachim Heinzle, *Mittelhochdeutsche Dietrichepik: Untersuchungen zur Tradierungsweise, Überlieferungskritik und Gattungsgeschichte später Heldendichtung* (Munich: Artemis Verlag, 1978), p. 231.

19. Bernard Cerquiglini, *Eloge de la variante: Histoire critique de la philologie* (Paris: Éditions du Seuil, 1989), p. 54.

20. Cerquiglini, *Eloge de la variante*, p. 111: "L'écriture médiévale ne produit pas des variantes, elle est variance."

21. Joseph Bédier, "La tradition manuscrit du Lai de l'ombre: Réflexions sur l'art d'éditer les anciens textes," *Romania* 54 (1928): 356 [161–96, 321–56].

22. Malcolm B. Parkes, "The Influence of the Concepts of Ordinatio and Compilatio on the Development of the Book," in *Medieval Learning and Literature: Essays Presented to Richard William Hunt*, ed. Jonathan J.G. Alexander and Margaret T. Gibson (Oxford: Clarendon Press, 1976), pp. 115–41; Richard H. and Mary A. Rouse, "*Statim invenire*: Schools, Preachers, and New Attitudes to the Page," in *Renaissance and Renewal in the Twelfth Century*, ed. Robert L. Benson and Giles Constable (Cambridge, MA: Harvard University Press, 1982), pp. 201–25.

23. Carol Symes, "The Appearance of Early Vernacular Plays: Forms, Functions, and the Future of Medieval Theater," *Speculum* 77 (2002): 778–831.

24. See Nigel F. Palmer, "Kapitel und Buch: Zu den Gliederungsprinzipien mittelalterlicher Bücher," *FSt* 23 (1989): 43–88; Palmer, "Von der Paläographie zur Literaturwissenschaft: Anläßlich von Karin Schneider, Gotische Schriften in deutscher Sprache, Bd. I," *PBB* 113 (1991): 212–50;

Barbara Frank, "Zur Entwicklung der graphischen Präsentation mittelalter-
licher Texte," *Osnabrücker Beiträge zur Sprachtheorie* 47 (1993): 60–81.

25. Kurt Ruh, "Votum für eine überlieferungskritische Editionspraxis," in
*Probleme der Edition mittel- und neulateinischer Texte: Kolloquium der deutschen
Forschungsgemeinschaft, Bonn, 26.–28. Februar 1973*, ed. Ludwig Hödl and
Dieter Wuttke (Boppard: Boldt, 1978), pp. 35–40.

26. In the new edition of the *Jüngere Titurel* by Wolf and Nyholm, the first
version, as the critical text, fills the largest portion of the pages, whereas the
second version, in the form of a small copy of the manuscript, is placed
underneath it. This does not seem to me to be a form of presentation that is
worthy of imitating. *Albrechts von Scharfenberg Jüngerer Titurel*, vols. 1–2/2, ed.
Werner Wolf (Berlin: Akademie-Verlag, 1955–1968), vols. 3/1–3/2, ed. Kurt
Nyholm (Berlin: Akademie-Verlag, 1985–1992). There are parallel editions
of different versions of rhymed narrative (for example, Erich Gierach's
edition of *Arme Heinrich* [Heidelberg: Winter, 1913]), lyrical poems,
religious plays (for example, Hans-Jürgen Linke, ed., *Die deutschen
Weltgerichtsspiele des späten Mittelalters* [Tübingen: Francke, 2002]), and other
texts. Of particular note is the extensive parallel edition of the Hessian
Passion plays by Johannes Janota of which three volumes have already
appeared (Tübingen: Niemeyer, 1996–2003).

CHAPTER 7

IMAGES AT THE INTERFACE: ORALITY,
LITERACY, AND THE PICTORIALIZATION
OF THE ROLAND MATERIAL

James A. Rushing, Jr.

The legend of Roland is one of the most frequently pictorialized
nonbiblical stories in the Middle Ages, as the enormous body of images
cataloged by Lejeune and Stiennon testifies.[1] It is thus perhaps a little
surprising that the two texts that, more than any others, define the material
for both medieval and modern minds—the Old French *Chanson de Roland*
and the Latin *Pseudo-Turpin*—are barely touched by pictorial traditions.[2]
Why is the Roland material, so popular in a variety of verbal and visual
traditions, virtually never pictorialized in direct association with its most
primary texts? If not in association with these texts, under what circum-
stances *is* the Roland material adapted into the visual arts? Can any answer
be offered other than the idiosyncrasies of manuscript makers and artists,
and the chances of survival?

In the following, I show that reasons can be offered that not only explain
certain broad trends in the pictorialization of the Roland material but also
suggest important general trends in the pictorialization of medieval literary
materials and in the role of images in medieval culture.

A brief sketch of the broader situation is required. When the study of
relationships between "texts and pictures," "words and images," or, to put it
perhaps more precisely, between verbal and visual manifestations of narrative
materials in medieval culture moves beyond the examination of individual
works and adopts a more global perspective, one of the most obvious facts
that it must endeavor to explain is this: what we might call the frequency of

pictorialization varies enormously. Some literary materials, such as the Tristan story, are pictorialized early and often, others, such as the German bridal quest narratives, never or only very late in the Middle Ages.[3] In some cases, the frequency of pictorialization of a particular subject varies depending on the visual genre or upon the literary genre with which images are associated. For example, the heroic epic is illustrated in its book forms seldomly and late, while certain motifs from the same genre appear in the monumental arts fairly early and fairly often.[4]

Which factors affect the frequency of pictorialization, both across subject matters and, within subject matters, across genres or other categories? A full answer will obviously require the study of many subject matters. But the consideration of one important subject matter—the legend of Roland (and to some extent the whole related complex of legends around Charlemagne)— may perhaps allow us to approach an answer, or at least a model for answering this essential question.

In general terms, the answer that I will propose is that the frequency with which a material is pictorialized may be explicable in terms of certain basic cultural oppositions or axes of medieval culture. To a great extent, these oppositions or axes were perceived and defined by medieval people themselves, at least by medieval intellectuals, and I can delineate some of the most important ones by briefly discussing three medieval loci: the first two rather well known to medievalists, the third perhaps somewhat less famous. I begin with the well-known letter from Pope Gregory the Great to Bishop Serenus of Marseille, written in October of the year 600, in which Gregory profoundly influenced the discussion of the relationship between words and images for the next 1,404 years, and counting.

> Nam quod legentibus scriptura, hoc idiotis praestat pictura cernentibus, quia in ignorantes vident, quod sequi debeant, in ipsa legunt qui litteras nesciunt; unde praecipue gentibus pro lectione pictura est.[5]
>
> [For what writing offers to those who read, the picture offers to the illiterate who look at it, since in it the ignorant see what they ought to follow, in it they read, who do not know letters; whence especially for the common people, the picture stands in place of the reading.]

This passage is often discussed as evidence for how medieval intellectuals thought about images,[6] but here I want to stress how Gregory takes for granted the division of all people into the literate ("legentibus") and the illiterate, the "idiotis" or "ignorantes"—who are assumed to be identical with the "gentibus," the common people, the lay people. This distinction between the learned literate and the illiterate laity was generally taken for granted throughout the Middle Ages, and though we know it to be a factual

oversimplification, it certainly reflects medieval reality, as well as showing something essential about the way medieval intellectuals thought about their own place in society. For Gregory, of course, there was no literacy but Latin literacy. But even long after Late Antiquity had evolved into the Middle Ages and vernacular literacy had arisen, the paradigmatic opposition continued to be that of clerical Latin literacy versus lay vernacular illiteracy.[7]

Related to this opposition was the one reflected in Alcuin's famous letter to the bishop of Lindisfarne, written in 797:

> Verba Dei legantur in sacerdotali convivio. Ibi decet lectorem audire, non citharistam; sermones patrum, non carmina gentilium. Quid Hinieldus cum Christo? Angusta est domus: utrosque tenere non poterit.[8]
>
> [The word of God is to be read in the priests' dining room. There one ought to listen to the reader, not the harpist, to the sermons of the fathers, not the songs of the people. What has Ingeld to do with Christ? The house are narrow, and there is not room to have both.][9]

Here, again, a complex reality is reduced to a simple opposition: all texts and discourses are either "the words of the fathers," read by a reader, or "the songs of the people," sung by a "harpist." And it is clear that the former are written, important, and true, while the latter is oral, unimportant, and untrue.

This opposition of true and untrue, finally, is embodied in two passages from the *Kaiserchronik*, written in German by a cleric from Regensburg in the 1140s:

> Nv ist leider in disen ziten.
> ein gewoneheit witen
> manege erdenchent in luge.
> vñ v.gen si zesamen.
> mit scophelichen worten.
> nv vŏreht ich uil harte.
> daz div sele darumbe brinne.
> [. . .]
> Swer nu welle bewåren.
> daz Dietrich Ezzelen sahe.
> der haize daz boch uŏrtragen.
> do der chunicc Ezzel zeouene wart begraben.
> dar nach stunt iz vŏr war.
> driv unt fiersich iar.
> Daz dieterich wart geborn.[10]
>
> [Now unfortunately in these times a habit is widespread: many people think up lies and put them together with minstrel's words. Now I fear very strongly that the soul will therefore burn: it is without God's love.
> [. . .]

Whoever wants to claim that Dietrich saw Etzel, let him have this book brought out (or read aloud). For when King Etzel was buried in Ofen, it was truly thirty-four years before Dietrich was born.][11]

Here we have two diametrically opposed modes of thought: the cleric's history, in which precise dates are recorded in books, and the history of heroic song, in which oral traditions conflate and elaborate and make what we would call fiction or legend out of dimly remembered historical and quasihistorical figures. But the cleric does not call the heroic epic "fiction" or "legend," he calls it "lies."[12]

We thus have a set of parallel, linked or related oppositions or axes: written/oral, Latin/vernacular, true/untrue, important/trivial. The history of medieval literature, indeed of medieval artistic culture, is among other things a history of these oppositions and their eventual blurrings, mergings, and blendings, and I will suggest in the following that the frequency of the pictorialization of various subject matters can be explained in terms of these oppositions. More precisely, my working hypothesis is that literary materials are most frequently pictorialized at the interface of the Latin/written/clerical with the vernacular/oral/lay.

The legend of Roncesvalles would appear to be a paradigmatic case for the study of these and related axes of medieval cultural diversity, since it is developed, as far back as we can trace it, on both sides of the medieval cultural divide. In the early twelfth century, we have the *Chanson de Roland*, which, though written, clearly belongs to the oral episteme, and on the other side we have the *Pseudo-Turpin*, a clerical Latin text. Before these, in the "silent" centuries between the battle of Roncesvalles in 778 and the emergence of the extant epic traditions, we have, on the one hand, a few rather brief mentions of the event in Latin chronicles and biographies; on the other, some evidence, in onomastics and in the (admittedly later) account that a Norman minstrel sang of Roland during the battle of Hastings in 1066, for the continuous existence of an oral tradition. But it is not necessary, here, to enter into the debate, now more than a century old, about the origin of the *Chanson de Roland*.[13] It should suffice to observe, as I will discuss in more detail in a moment, that in the early twelfth century, the Roland legend has emerged in textual traditions on both sides of the cultural divide, in the Latin text usually referred to as the *Pseudo-Turpin* (around 1130–1140), and in the Old French text known today as the *Chanson de Roland* (around 1100), as well as in a clearly attested tradition of oral performance by minstrels.[14] During the same period, the material begins to appear in the visual arts (earliest securely identifiable Roland art works about 1120).

One of the most striking facts about the pictorial traditions surrounding the legend of Roland is that the *Chanson de Roland* itself, in a reasonably

narrow sense, is never illustrated. This parallels the situation of the *Nibelungenlied*, which is not illustrated until the fifteenth century, and then only once.[15] What the two works have in common is that they belong more to the oral than to the literate sphere. And the conclusion that suggests itself is that such works (also, for example, the *Spielmannsepen* and the Dietrich epics) are not generally made into illustrated books, though "oral" materials, including the story of Sigurd/Sigfried, Arthur, and, of course, Roland himself, do find visual manifestations in the monumental arts. Indeed, this dearth of illustration in *Roland* manuscripts is itself probably evidence that the work was *perceived* as belonging more to the oral than the literate sphere.

In saying that the *Chanson de Roland* belongs to the oral sphere, I certainly do not mean that the poem is an oral formulaic composition or any sort of transcription of an oral poem or that the *Roland* as we know it is the written record of an oral poem of epic length. I agree with Taylor's recent argument that the "Song of Roland" never existed, in the sense of a 4,000 line oral epic.[16] The *geste que Turoldus declinet* (roughly "the tale that Turoldus tells," although the meaning is debated) was surely composed in writing by a writer.[17] The *Roland* is not even as clearly "pseudo-oral" as the *Hildebrandslied* or the *Nibelungenlied*: it begins with no such obvious indicators of orality or the pretense of orality as "ik gihorte dat seggen" [I have heard it said] (v. 1); or "uns ist in alten mæren wunders vil geseit" [We are told in old stories of many wondrous things] (v. 1); or even *Beowulf*'s resoundingly oral "Hwaet" [Listen] (v. 1).[18] Despite all this, it does appear safe to assert that what we now call the *Chanson de Roland* did belong to what we might call an oral mode or an oral episteme. This is, in fact, clear from the beginning of the poem, despite the lack of clear pointers to oral performance or aural reception. The French poem begins not only *in medias res*, but also with an assumption that the audience is thoroughly familiar with the main characters. "Carles li reis, nostre emper<er>e magnes, / Set anz tuz pleins ad estét en Espaigne" [Charles the king, our great emperor, / Has been full seven years in Spain] (vv. 1–2). The definite article implies that the person named is known to the discursants, while the possessive adjective indicates a national or tribal connection of the king to the audience. And the second line is phrased in such a way as to suggest that the audience knows perfectly well that Charles spent time in Spain: there is no introduction, no explanation. Whether or not this actually reflects the conditions of twelfth-century performance and reception is beside the point. The *Roland* presents itself as having the same kind of relationship to its audience as an oral poem would have, as being the type of poem in which "the referential force. . .derives largely from its focusing upon the contact between the people bodily and together present at the performance."[19] "We"—the singer and the audience—share with the people *in* the tale "*the* king," "*our* emperor."[20]

Even though the *Chanson de Roland* appears to belong to the oral or quasi-oral episteme, its most famous manuscript probably belongs to the cleric's world, the world of the written text. This is the Oxford manuscript, Digby 23, a codex combining the *Roland* with as scholarly a text as can readily be imagined, a glossed Latin translation of Plato's *Timaeus*.[21] Digby 23 has often been somewhat romantically discussed as a "minstrel's manuscript." But Taylor has recently drawn on older work to argue convincingly that Digby 23 is much more likely to be the product of a clerical environment.[22] A scholar's copy of a pseudo-oral poem? That is probably the combination least likely to be illustrated, and indeed the *Roland* text in Digby 23 is remarkably plain.[23]

Similarly, the Latin version of the Roland material, the so-called *Pseudo-Turpin*, is virtually never illustrated, and even the exceptions to this statement tell us something about the circumstances under which medieval texts are accompanied by pictures. The illustration of Latin books in the Middle Ages is a vast field, and any generalization here would be premature; however, it appears that scholars' books are illustrated quite rarely. In the case of the *Aeneid*, for example, only a handful of the enormous number of medieval manuscripts are illustrated, and the manuscripts of less exalted Latin narratives, such as the Trojan stories of Dares and Dictys or the *Ilias Latina*, virtually never contain pictures.[24] The *Pseudo-Turpin*, in what is clearly at least close to 140 manuscripts,[25] appears to have been illustrated only four times.[26] All four extant miniature cycles are closely related; the oldest is that of the Codex Calixtinus, made in the 1120s–1140s. Two of the others (A and VA) are obvious copies of the text and pictures of C (although not all pictures are included in A).[27] The status of the other (S) is not so clear, as it follows the iconography of C rather closely, though somewhat different in format and strikingly different in style, and its *Pseudo-Turpin* text is a different version altogether.[28] All three copies or near-copies seem to have been made in Santiago around 1325.[29] Thus, it may be argued that the decision to illustrate this text was really only made once, for the Codex Calixtinus itself, and that is what we will focus on here.

Why is this manuscript illustrated, while the overwhelming majority of *Pseudo-Turpin* manuscripts is not? Because it was made for the shrine of Saint James in Santiago, one of the most popular pilgrimage sites of the Middle Ages, and as such surely one of the ideal medieval locations for interaction between clerical and lay culture, the quite literal interface of the learned and the lay. As Stones has pointed out, saints' shrines frequently possessed illustrated saints' lives,[30] but, although the Codex Calixtinus may owe its illustrated existence to this tradition, it is exceedingly atypical, for it contains no *vita* of St. James and no cycle of St. James miniatures; instead, it devotes its illuminations primarily to Charlemagne and Turpin. However,

since the very preservation and dissemination of the Roland story is associated with the pilgrimage route to Santiago de Compostela, which led across the pass at Roncesvalles, it is perhaps not surprising that the illustrations focus on Turpin and Charlemagne as Christian warriors in the particular service of St. James. But what does it signify that of the other 135 or so *Pseudo-Turpin* manuscripts, none is illustrated? The suggestion to be put forward here is that, while the *Pseudo-Turpin* qua text was a book for the learned, the literate, and was thus virtually never illustrated, the connection of the Codex Calixtinus to the "interface" site of the pilgrimage church prompted its illustration.

Though the *Chanson de Roland* in the narrow sense is never illustrated, and the *Pseudo-Turpin*, despite an enormous number of manuscripts, only rarely illuminated, when either of these texts is translated into a different language or adopted into a different genre, the frequency with which the material is illustrated rises dramatically. For example, when the *Chanson de Roland* is transformed or translated into new forms and/or languages, it begins to be illustrated, though only sparingly. The late thirteenth-century manuscript known as V7 contains a portrait of Charlemagne in an initial; the manuscript V4 has one historiated initial with Ganelon and Marsile.[31] What these two (barely) illuminated manuscripts have in common is that their texts are a sort of translation, from pure French into Franco-Venetian; one, the text of V7 is additionally transformed from assonant verse to rhyme. V4 is assonant, but late, either late thirteenth century or fourteenth century.[32] They represent transformations of the *Roland*, not the *Roland* in the narrow sense. And when the transformation into another genre is more complete, the frequency of illustration increases much more dramatically. The *Chanson d'Aspremont* and the *Girart de Vienne*, just to mention thirteenth-century examples, survive in a number of illuminated manuscripts.[33] The illustrations of the German adaptation of the *Chanson de Roland* will be discussed shortly.

Just as the transformations and adaptations of the *Chanson de Roland* are rather frequently illustrated, so are the vernacular translations of the *Pseudo-Turpin*. For example, the version attributed to Master Jehan or Johannes exists in some twenty-two manuscripts, of which five are illustrated.[34] That number provides a nice comparison to the frequency with which the Latin *Pseudo-Turpin* is illustrated: we have four illuminated codices among some 139 Latin manuscripts (about 2.9 percent) versus five illustrated books among some 22 Jehan manuscripts (22.7 percent). Moreover, one of these—the early fourteenth-century manuscript now in Florence—is quite lavishly illustrated, with thirteen paintings in the *Roland* part alone.[35] The illustration frequency is similar for the French *Pseudo-Turpin* version known as Saintonge/Poitou, though the overall numbers are smaller: of five

manuscripts, one is illuminated (20 percent).[36] Much work remains to be
done on the illuminated vernacular *Pseudo-Turpin* manuscripts, but it is clear
that they are illustrated far more often than the Latin *Pseudo-Turpin*.[37]

To get beyond the statistics and explore more fully the dynamics of the
transition from one language and one mode or episteme to another, let us
consider in somewhat more detail the case of the first German adaptation
of the *Chanson de Roland*, the *Rolandslied* of Pfaffe Chuonrat or Konrad,
written about 1170, apparently for Heinrich der Löwe (Henry the Lion,
Duke of Saxony).[38]

In contrast to the *Chanson de Roland*, the German *Rolandslied* certainly
desires itself to be regarded as a highly literary text. The beginning of
Konrad's poem stands in particularly sharp contrast to the beginning of the
Roland. The French narrator begins, as noted above, not only in the middle
of the action, but also with the assumption that Charlemagne is so well
known as to need no introduction—in other words, with the pseudo-oral
narrator's assumption that the characters, the narrator, and the audience all
belong to the same community. The German narrator, on the other hand,
announces that he will speak of "eineme turlichem man, / wie er daz gotes
riche gewan / daz ist Karl der cheiser" [a noble man, / how he won God's
kingdom / that is Charles the emperor] (vv. 9–10).[39] Charles must first be
introduced with an indefinite article as a noble man who won the kingdom
of God, then identified as the Emperor Charles.[40] But his identity is still not
fully established. The poet continues "Karl der was Pipines sun" (v. 17), thus
locating Charles in a genealogy that further explains his identity. Finally,
nothing is taken for granted about Charles's sojourn in Spain. Konrad goes
on at some length about the reasons for the Spanish war, relating how an
angel appeared to Charles in a dream, urging him to go into Spain and fight
the infidel. But this *ab ovo* beginning of the narrative is not the beginning
of Konrad's text. Konrad begins with a prayer to the "Schephare allir dinge, /
cheiser allir chunin-|ge" [creator of all things, emperor above all kings]
(vv. 1–2)—a prayer that God should send him true knowledge, and help
him write the truth and avoid lies. Here is not only a truth claim that
Konrad's audience has to have taken quite seriously, but also a claim of a
high degree of literariness, for Konrad's prayer is directly analogous to the
invocations of the muses with which pagan authors—in particular, no
doubt, Virgil—began epics. Thus, the German *Rolandslied* demands at the
outset to be regarded as both historical and salvific truth and also as literature.
These demands are renewed in Konrad's epilogue, when he claims to have
translated the material first from French into Latin and only then into
German (vv. 9080–83). Whether or not this is in any way true, and what-
ever else it means or relates to, this claim certainly stresses the literariness,
the bookishness of the undertaking.[41]

In keeping with this vernacular bookishness, the *Rolandslied* seems to have been illustrated right from the beginning of its manuscript tradition. The only complete manuscript (Heidelberg, Universitätsbibliothek, cpg. 112), dating from around 1200, with its thirty-nine pen drawings, is one of the earliest illustrated German manuscripts.[42] The Strassburg manuscript, destroyed in the famous fire of 1870, also contained illustrations, and the two that have been preserved in copies very closely resemble the corresponding pictures in the Heidelberg manuscript. Finally, the Schwerin manuscript, a Saxon manuscript of before 1200,[43] also had spaces left for pictures, apparently for a cycle more or less identical with that in the Heidelberg codex. Some evidence suggests that S was made in a workshop that worked for Heinrich der Löwe himself.[44] All this fits very neatly with the findings of textual scholarship, which suggest that these three manuscripts are derived from a common ancestor (perhaps the archetype?). It thus appears extremely likely that an early and important, that is, much-copied manuscript of the *Rolandslied* was illustrated, and that the copyists were concerned to copy the pictures with the text. And this in turn suggests the very early desire, perhaps on the part of Konrad and/or Heinrich themselves, to mark the work as literary and true.[45]

The precise nature of the illustration program in the Heidelberg *Rolandslied* need not concern us further at the moment. The point here is that as the pseudo-oral text of the *Chanson de Roland* is transformed into the self-consciously literary text of the *Rolandslied*, the location of the text moves to the interface of the oral/vernacular with the literate/Latinate, to the interface of the song and the book, the word and the text. Likewise, the vernacularization of the Latin *Pseudo-Turpin* moves that text to the interface. And it is at that interface, not in the purely "oral" world of the *Roland*, and not in the purely literate world of the *Pseudo-Turpin*, that the Roland material is illustrated.

The most obvious concrete, physical interface of the two major medieval epistemes is the church building itself, with its plethora of above all monumental art works designed, as medieval theoreticians themselves always insisted, to connect the unlettered lay people with the sacred word of God. And thus, it is not surprising that the monumental arts of the church building were, early and often, the location in which the Roland material was made into images. Some of the earliest supposed appearances of Roland in art can only be identified with a great deal of wishful thinking,[46] and the number of appearances of Roland in monumental art may thus vary depending upon who is counting, but we do have, undeniably, quite a number of Rolands in stone and glass, and the like. To demonstrate the ways in which these works of art can be located at, or indeed can function as the interface between the oral and the literate, I would like to discuss two

images, one of which appears to draw uncommonly directly on the *Chanson de Roland* or on related oral traditions, the other of which is evidently based on the *Pseudo-Turpin* and other texts.

The first is the set of sculptures at Angoulême, from about 1120. Angoulême is in the heart of Roland country, on the pilgrimage route to Santiago. The Roland sculptures run along a lintel on the west facade, under an architrave with three apostles. In the first scene (figure 7.1), a Christian knight runs a lance through the body of a pagan knight, recognizable as a pagan by his round shield. This might seem a rather generic scene of combat between a Christian and a pagan, perhaps to be identified as representing the general idea of crusading, were it not for the fact that the lance pierces the body of the pagan, who has turned in the saddle, from side to side rather than from front to back. And this uncommon lancing, surely as unusual in the visual arts as it is in the verbal, may well serve to identify this scene not as a generic combat, nor even as a generalizable representation of a moment from the story of Roland, but specifically, as Lejeune and Stiennon have argued, as a response to a specific moment in the *Chanson de Roland*. In the combat between Turpin and Abîme, at line 1506, "Le cors li trenchet tres l'un costét qu'a l'altre" [He runs him through from one side to

7.1 Angoulême, Cathedrale of Saint-Pierre. Turpin kills Abîme.

7.2 Angoulême, Cathedrale of Saint-Pierre. Roland cuts off Marsile's hand.

the other].[47] The second scene (figure 7.2), too, may be closely identifiable
with a moment in the text: *Chanson de Roland*, line 1903, where Roland
cuts off Marsile's hand. Finally (figure 7.3), the wounded pagan flees back to
Saragossa, where he collapses in front of the city (laisse 186).

Lejeunne and Stiennon surely go too far in saying that the artist here "ne
créait pas selon sa fantaisie, il illustrait un texte" [did not create according to
his imagination, he illustrated a text]—if by "illustrates a text" one under-
stands an effort to reproduce precisely the details of a verbal narrative in a
visual one.[48] The details of the sculpture are not quite "correct," as Ross has
pointed out: "Abîme" is indeed twisted in the saddle, but his lower body,
starting about where the lance pierces him, faces more or less forward, as the
sword on his side indicates. "Roland" should not really be wearing a crown,
and his sword does not make contact with the arm it is supposed to cut
off.[49] To this, one can add that, in the text (1505), Turpin's lance shatters
Abîme's shield before passing through the pagan's body, and that detail is
omitted in the sculpture. Nonetheless, Ross goes too far in the other direc-
tion in claiming that these discrepancies make it impossible to identify the

7.3 Angoulême, Cathedrale of Saint-Pierre. Marsile collapses at Saragossa.

sculptures as a visual response to the Roland story.[50] Visual artists, even
when illustrating books, frequently do not reproduce every detail of a tex-
tual passage with pedantic accuracy. The sculptures at Angoulême clearly
reflect the idea of running a lance through an opponent from side to side,
of slicing off the hand of a fleeing foe, of a defeated pagan collapsing in front
of his city. These three scenes would not exactly illustrate the *Chanson de
Roland*, even if every detail was textually "correct," for the scenes do not
belong together in the *Chanson de Roland*'s plot.[51] But they do seem clearly
to represent a response to the Roland story as we know it from the *Chanson
de Roland*—whether the sculptors knew it from a text or from some sort of
oral tradition, either primary or secondary.[52] The tale of Roncesvalles,
coming as it does from the oral episteme, has here become "literature" of
a sort, has become *litteratura laicorum* of the same sort that saint's lives and
Scripture can become, in the monumental art of the church building, the
physical interface of the literate and the oral worlds.

In the Charlemagne window at Chartres, on the other hand, the visual
narrative is apparently based on three texts, mainly the *Pseudo-Turpin* and

the eleventh-century chronicle of Charlemagne's legendary Jerusalem crusade, the *Descriptio qualiter K.M. clavum et coronam Domini a Constantinopli Aquisgrani detulerit*, partly also the *Vita Sancti Aegido*.[53] Here, at least as far as the intent of the makers of the window is concerned, the action at the interface of the oral and the literate is surely that envisioned by Gregory: the learned, literate, clerical world makes images of its knowledge, so that the unlettered may "read" in the windows what the learned would read in the Latin texts. That is to say, the clerical minds behind the creation of the window probably knew the Latin texts and based the window on them. And certainly, viewers who knew the relevant texts could read the window in the same way that Maines reads it in his 1977 *Speculum* article, as a coherent narrative that zigzags up the three parallel columns of images from the bottom to the top of the window, telling the story told in the *Descriptio*, the *Pseudo-Turpin*, and the *Vita Sancti Aegido*. But an interface works in both directions, and the unlettered or less lettered viewer could surely read the window in other ways, less complex, and perhaps less complete, but nonetheless meaningful. For example, each column could be read independently from bottom to top, producing not a particular narrative about Charlemagne, but a series of episodes of knightly activity, involving combat with pagans, and culminating in each column in some sort of salvific moment—what might be an act of Communion in the left-hand column, the defeat of the pagan enemy in the center column, and the conversation with a saint in the right-hand column. In an even more general way, the images of the window can be viewed from bottom to top as a loose progression through various types of combat and prayer to a climactic victory over the pagan in the uppermost scene, confirmed and celebrated by the censing angels at the very top of the window. Surely an overall allegorical reading is possible for a viewer who does not follow the narrative in intricate detail: through a life of struggle, prayer, Communion, and perhaps martyrdom, one can achieve final victory over the pagan within. The point here is not to insist on any particular reading of the Charlemagne window, but only to show that it can be read in several ways, including the painstaking and deliberate construction of a text-based narrative, but also including much freer, much more independent readings. Precisely because the window can be read in multiple ways, it provides the perfect interface of the clerical world, in which history has precise chronologies and story-lines that can be verified in books, and the lay world, in which history is an oral tale, a little different at each telling, and capable of being made and remade in a variety of ways.

It is precisely this role as interface or intermediary between the literate and the oral epistemes that the visualizations of the Roland material appear to play. As long as the material is perceived as belonging to either the oral

or the literate world—the pseudo-oral *Chanson de Roland*, the obviously literary *Pseudo-Turpin*—it is not pictorialized. But when the material moves to or across the interface, the medieval cultural divide—when the *Pseudo-Turpin* is copied for a pilgrimage church or translated into French, when the *Chanson de Roland* is made "literary" in its German adaptation, when the oral material is adapted for the church or the literary is presented to the illiterate—then pictorializations are created. Whether the theory of "images at the interface" can explain the fates of materials other than the Roland story in the visual arts is a subject for further research; the theory certainly seems consistent with the way the Latin *Aeneid* is rarely illustrated in medieval codices, while the manuscripts of its vernacular adaptations are frequently illuminated. But certainly, as far as the Roland material is concerned, we may say, using Alcuin's words as shorthand for the literate and the oral epistemes, that images appear at the places where the reader and the harpist meet.[54]

Notes

This essay originated as a paper presented at the convention of the Northeast MLA in 1998; it is much revised and expanded here, but retains something of its oral or pseudo-oral origins, above all perhaps insofar as the notes and references endeavor to provide the necessary documentation for the argument here, not to incorporate exhaustively all possible literature.

1. Rita Lejeune and Jacques Stiennon, *La legende de Roland dans l'art du Moyen Âge*, 2 vols. (Brussels: Arcade, 1966).

2. *Chanson de Roland*, ed. Cesare Segre (Milan: Riccardo Ricciardi, 1971); Pseudo-Turpin, *Liber Sancti Jacobi: Codex Calixtinus*, ed. Walter Muir Whitehill (Santiago de Compostela: n.p., 1944); hereafter cited in the notes as *CdR* and *Ps-T.*

3. On the dearth of illustrations in the bridal quest texts, see Norbert H. Ott, "Pictura Docet: Zu Gebrauchsituation, Deutungsangebot und Appelcharakter ikonographischer Zeugnisse mittelalterlicher Literatur am Beispiel der Chansons de Geste," in *Grundlagen des Verstehens mittelalterlicher Literatur: Literarische Texte und ihr historischer Erkenntniswert*, ed. G. Hahn and H. Ragotzky (Stuttgart: Kröner, 1992), pp. 188–89 [187–212].

4. For example, the Franks Casket of ca. 700 depicts Wayland; scenes from the Sigurd/Sigfried legend are scattered through northern Europe; an Alsatian frieze of ca. 1145 depicts scenes from the Dietrich-Saga; and Arthur appears on an archivolt at Modena in the early twelfth century. On Wayland, Sigurd, and Dietrich, see Michael Curschmann, "Wort-Schrift-Bild: Zum Verhältnis von volksprachigem Schrifttum und bildender Kunst vom 12. bis zum 16. Jahrhundert," in *Mittelalter und frühe Neuzeit: Übergänge, Umbrüche und Neuansätze*, ed. Walter Haug (Tübingen: Niemeyer, 1999), pp. 383–85, with further references; on the Modena archivolt, most accessible is Roger

Sherman Loomis and Laura Hibbard Loomis, *Arthurian Legends in Medieval Art* (New York: Modern Language Association, 1938), pp. 32–36, figures 4–8, though some of the statements there are no longer tenable—better in many ways is Jeanne Fox-Friedmann, "Messianic Visions: Modena Cathedral and the Crusades," *Res* 25 (1994): 77–95.

5. Pope Gregory I, *Registrum Epistolarum*, MGH: Epistolarum 2, ed. Ludwig Hartmann (Berolini: Weidmann, 1899), p. 270.

6. See especially Michael Curschmann, "*Pictura laicorum litteratura?* Überlegungen zum Verhältnis von Bild und volkssprachlicher Schriftlichkeit im Hoch- und Spätmittelalter bis zum Codex Manesse," in *Pragmatische Schriftlichkeit im Mittelalter: Erscheinungsformen und Entwicklungsstufen*, ed. Hagen Keller, Klaus Grubmüller, and Nikolaus Staubach (Munich: Fink, 1992), 211–29; more briefly James A. Rushing, Jr., *Images of Adventure: Ywain in the Visual Arts* (Philadelphia: University of Pennsylvania Press, 1995), pp. 9–10.

7. Cf. Herbert Grundmann, "Litteratus-illitteratus: Der Wandel einer Bildungsnorm vom Altertum zum Mittelalter," *Archiv für Kulturgeschichte* 40 (1958): 45: "von *clerici litterati* und von *laici illitterati* ist seit dem 10. Jahrhundert allenthalben die Rede [. . .] und nur die Abweichung von diesen Gleichungen fällt auf" [from the tenth century on, references to literate clerics and illiterate laypeople are everywhere (. . .) and only exceptions to these associations are noted].

8. Alcuin, "Epistola 124," in MGH: Epistolae 4, Karolini Aevi 2, ed. Ernst Duemmler (Berlin: Weidmann, 1895), p. 183 [181–84].

9. Ingeld is a now little-known Germanic hero, whose story is told briefly in *Widsith* and alluded to in *Beowulf*. Alcuin's letter reflects, of course, not only the official opposition to the "songs of the people," but also the irrepressible interest of clerics in wordly literature. See Walter Haug, *Literaturtheorie im deutschen Mittelalter: Eine Einführung* (Darmstadt: Wissenschaftliche Buchgesellschaft, 1985), p. 25, n. 1. Around the same time that Alcuin was writing his letter, two monks at Fulda were so interested in the sort of songs that he condemned that they composed or copied one of their own, which we know as the *Hildebrandslied*.

10. *Die Kaiserchronik nach der aeltesten Handschrift des Stiftes Vorau*, ed. Joseph Diemer (Vienna: Braumüller, 1849), pp. 2 and 434.

11. The passage has recently been discussed by Michael Curschmann, "Dichter *alter maere*: Zur Prologstrophe des 'Nibelungenliedes' im Spannungsfeld von mündlicher Erzähltradition und laikaler Schriftkultur," in *Grundlagen des Verstehens mittelalterlicher Literatur: Literarische Texte und ihr historischer Erkenntniswert*, ed. Gerhard Hahn and Hedda Ragotzky (Stuttgart: Kroner, 1992), p. 58 [55–71].

12. The assumption that vernacular stories are untrue is not altered by the fact that some clerics, such as Thomasîn von Zerclaere, argued that the lying tales could contain valuable truths: "daz wâr man mit lüge kleit" [one clothes the truth in lies] (*Der wälsche Gast*, ed. Heinrich Rückert [1852; repr. Berlin: de Gruyter, 1965], v. 1126; cf. Rushing, *Images*, p. 7, and further references). Clerical attitudes toward what we would call fiction are, of course, more

complex than I suggest here, but the basic opposition between truth and untruth remains fundamental.

13. For a good overview of the debate, see T.D. Hemming, "Introduction," in *La Chanson de Roland: The Text of Frederick Whitehead Revised, with a New Introduction, Bibliography and Notes*, ed. T.D. Hemming (London: Bristol Classics Press, 1993), pp. xvi–xxv; on the song at Hastings, see Andrew Taylor, "Was There a Song of Roland?" *Speculum* 76 (2001): 28–29 [28–65].

14. On performances by minstrels, see Taylor, "Was There a Song of Roland?" [n. 14], pp. 53–59, with extensive further references.

15. That is the "Hundeshagen Codex" of about 1440 (Berlin, Staatsbibliothek, Ms. germ. fol. 855); the material is also illustrated in the "Heldenbuch Lienhard Scheubels" of 1480–1490 (Vienna, Österreichische Nationalbibliothek, Cod. 15478). For reproductions from both, see Michael Curschmann, "Nibelungenlied" (with "Bildkapitel" by Norbert H. Ott), in *Literaturlexikon: Autoren und Werke deutscher Sprache*, vol. 8, ed. Walther Killy (Gütersloh: Bertlesmann, 1990), pp. 389 and 391 [384–99].

16. Taylor, "Was There a Song of Roland?" [n. 14].

17. V. 4002: "the story that Turoldus tells" in the translation of Gerard J. Brault, *The Song of Roland: An Analytical Edition*, 2 vols. (University Park: Pennsylvania State University Press, 1978).

18. "Das Hildebrandslied," in *Althochdeutsches Lesebuch*, 15th edn. by Ernst A. Ebbinghaus, ed. Wilhelm Braune (Tübingen: Niemeyer, 1969), pp. 84–85; *Das Nibelungenlied*, 20th edn. by Helmut de Boor, ed. Karl Bartsch (Wiesbaden: Brockhaus, 1972); *Beowulf*, 3rd edn. ed. Friedrich Klaeber (Lexington, MA: D.C. Heath, 1950).

19. Paul Zumthor, "The Text and the Voice," *New Literary History* 16 (1984), p. 75; cf. David P. Sudermann, "*Hortus Temporum*: Beginning the Middle High German *Rolandslied*," *Modern Philology* 92 (1995): 434 [413–37].

20. Curtius and others (see notes in Brault, *Song of Roland*, 1:385) have argued that the beginning *in medias res* reflects a classical influence. But it is not the narrative structure so much as the discourse that marks the beginning as "oral."

21. See the reproductions in Taylor, "Was There a Song of Roland?" [n. 14], figures 2 and 3.

22. Taylor, "Was There a Song of Roland?" [n. 14], pp. 41–52.

23. The *Timaeus* does include diagrams, but then it is an entirely different kind of text.

24. The illustration of Latin texts, especially Virgil, does become more common in the fourteenth and especially the fifteenth centuries, above all in Italian humanist manuscripts, but that is a new and different phenomenon from what I am primarily discussing here. Medieval Virgil manuscripts are listed in Gian Carlo Alessio, "Medioevo: Tradizione Manoscritta," in *Enciclopedia Virgiliana*, vol. 4 (Rome: Istituto della Enciclopedia Italiana, 1987), pp. 433–43. The illustrations remain poorly studied: the one attempt at a comprehensive examination, though it is by no means complete, is Pierre Courcelle and Jeanne Courcelle, *Les manuscrits illustrés de l'Éneide du Xe au*

XVe siècle, vol. 2 of *Lecteurs païens et lecteurs chrétiens de l'Énéide* (Paris: Institut de France, 1984). For other classical works, medieval illustrations have attracted even less scholarly attention, but for a start, one can consult B. Munk Olsen, *L'Étude des Auteurs classiques latins aux XI^e et XII^e siècles* (Paris: Éditions du Centre Nationale de la Recherche Scientifique, 1982), who mentions even the most incidental illustration in the manuscript descriptions.

25. The textual traditions of the *Ps-T* are bewilderingly complex, and scholars often add to the confusion by regarding the Latin text and its vernacularizations as versions of the same thing, which is no doubt useful and appropriate for certain purposes, but not when one is trying to study differences in the illumination of Latin and vernacular manuscripts. The number of manuscripts clearly depends on who is counting and how one defines what one is counting. Hans-Wilhelm Klein, ed. and trans., *Die Chronik von Karl dem Großen und Roland: Der lateinische "Pseudo-Turpin" in den Handschriften aus Aachen und Andernach* (Munich: Fink, 1986), p. 12, notes the existence of "etwa 200 mehr oder weniger vollständige Hss" [about 200 more or less complete manuscripts]. Alison Stones, "The *Codex Calixtinus* and the Iconography of Charlemagne," in *Roland and Charlemagne in Europe: Essays on the Reception and Transformation of a Legend*, ed. Karen Pratt (London: King's College London Centre for Late Antique and Medieval Studies, 1996), p. 171 [169–203], refers to "over 200," but clearly includes both Latin and vernacular texts in this figure. My own effort to eliminate the translations and transformations (such as the incorporation of the *Ps-T* into the *Speculum Historiale* of Vincent of Beauvais) from the list of "plus de 300 manuscrits turpiniens" [more than 300 Turpinnian manuscripts] given by André de Mandach, *La Geste de Charlemagne et de Roland*, vol. 1 of *Naissance et Développement de la Chanson de Geste en Europe* (Geneva: Droz, 1961), pp. 389–92, produces a somewhat more modest count of 139 "pure" Latin *Ps-T* manuscripts, which matches the count in Adalbert Hämel, *Überlieferung und Bedeutung des Liber Sancti Jacobi und des Pseudo-Turpin* (Munich: Verlag Bayerischen Akademic der Wissenschaften, 1950), p. 7.

26. Here the count given in the scholarship does refer only to the Latin *Ps-T* in its own right, not to translations or transformations, which the iconographers treat separately. The statement that the Latin *Ps-T* is illustrated only four times is repeated throughout the scholarship (for example, Stones, "*Codex Callixtinus*" [n. 26], pp. 173 and 175; Lejeune and Stiennon, *La legende* [n. 2], p. 52).

27. "A" is British Library, Additional MS 12213; "VA" is Vatican, Biblioteca Apostolica Vaticana, Arch. S. Pietro C 128.

28. "S" is Salamanca, Biblioteca Universitaria 2631. On these manuscripts in general, see Lejeunne and Stiennon, *La legende*, pp. 31–60; Stones, "*Codex Calixtinus*" [n. 26]; and Alison Stones, "The Decoration and Illumination of the *Codex Calixtinus* at Santiago de Compostela," in *The "Codex Calixtinus" and the Shrine of St. James*, ed. John Williams and Alison Stones (Tübingen: Narr, 1992), pp. 137–84 [136–84].

29. Stones, "*Codex Calixtinus*" [n. 26], p. 174.

30. Stones, "Decorations" [n. 29], pp. 139–40; "*Codex Calixtinus*," p. 182. See also Margaret Alison Stones, "Le ms. Troyes 1905, le recueil et ses enluminures," in Wace, *La vie de sainte Marguerite*, ed. Hans-Erich Keller (Tübingen: Niemeyer, 1990), p. 186 [185–214]; Barbara Abou-el-Haj, *The Medieval Cult of Saints: Formations and Transformations* (Cambridge: Cambridge University Press, 1994), especially pp. 26–30.

31. Lejeune and Stiennon, *La legende* [n. 2] figure 159; these authors stress that neither picture depicts Roland (p. 209).

32. Late thirteenth: Lejeune and Stiennon, *La legende* [n. 2], p. 209; fourteenth, probably first half: Cesare Segre, "I Testi della Chanson de Roland," in *Chanson de Roland*, ed. Cesare Segre (Milan: Riccardo Ricciardi, 1971), p. xxxviii.

33. The *Chanson d'Aspremont*: three illustrated manuscripts, plus another with spaces left for miniatures; *Girart de Vienne*: two illuminated manuscripts (of five known). See Lejeune and Stiennon, *La legende* [n. 2], pp. 209–15.

34. André de Mandach, *La Geste de Charlemagne et de Roland*, vol. 1 of *Naissance et Développement de la Chanson de Geste en Europe* (Geneva: Droz, 1961), pp. 389–92. See also Ronald N. Walpole, ed., *The Old French Johannes Translation of the Pseudo-Turpin Chronicle: A Critical Edition* (Berkeley: University of California Press, 1976).

35. Biblioteca Medicea-Laurenziana, coll. 125 [= Ashburnham ms. 12] (Lejeune and Stiennon, *La legende* [n. 2], pp. 271–74, pl. XXXVII and figures 268–72). See also Walpole, *The Old French Johannes Translation*, p. 319 and photo on facing page. Paris, Bibliothèque Nationale fr. 573 is a mid-fifteenth-century copy of the Florence manuscript, but with fewer pictures (Lejeune and Stiennon, *La legende*, pp. 274–75, figures 273–77; Walpole, *The Old French Johannes Translation*, p. 339 and photo on facing page).

36. de Mandach, *La Geste*, pp. 370–71 (his category MC). See BN fr. 124, a thirteenth-century manuscript with one drawing at the beginning and two others in the margins (Lejeune and Stiennon, *La legende* [n. 2], p. 275).

37. Overall, I know of eight illustrated French *Ps-Ts* out of about thirty-eight total manuscripts (using de Mandach's lists [*La Geste*, pp. 304–98] for the overall total). To the illuminated manuscripts cataloged by Lejeune and Stiennon ([n. 2], pp. 271–75 in English version) must be added Chantilly, Musée Condé, MS 869; see Ronald N. Walpole, ed., *Le Turpin Français, Dit le Turpin I* (Toronto: University of Toronto Press, 1985), frontispiece.

38. On the date and patron, see above all Dieter Kartschoke, *Die Datierung des deutschen Rolandsliedes* (Stuttgart: Metzler, 1965), especially pp. 164–67.

39. Pfaffe Konrad, *Das Rolandslied des Pfaffen Konrad*, ed. Carl Wesle, second edition by Peter Wapnewski, ATB 69 (Tübingen: Niemeyer, 1967); cited in the notes hereafter as *Rl*.

40. Here the *Rl* has more in common with the *Ps-T* than either of them does with the *CdR*. Cf. the way the *Ps-T* introduces Charles as "Karoli magni, imperatoris Romanorum, Galliorum et Theutonicorum cetararumque gencium" (Pseudo-Turpin, *Liber Sancti Jacobi*, p. 302). For the argument that

Konrad did know and use the *Ps-T* as well as the *CdR*, see Cola Minis, "Der Pseudo-Turpin und das Rolandslied des Pfaffen Chunrat," *Mittellateinisches Jahrbuch* 2 (1965): 85–95.

41. See Ott, "Pictura Docet" [n. 4], p. 189.

42. On the Heidelberg manuscript (and those at Strassburg and Schwerin), see Lejeune and Stiennon, *La legende* [n. 2], pp. 111–38, figures 111–38. On the date, see Barbara Gutfleisch-Ziche, "Zur Überlieferung des deutschen 'Rolandliedes': Datierung und Lokalisierung der Handschriften nach ihren paläographischen und schreibsprachlichen Eigenschaften," *ZfdA* 125 (1996): 155 [142–86]; Karin Schneider, *Gotische Schriften in deutscher Sprache I: Vom späten 12. Jahrhundert bis um 1300; Textband* (Wiesbaden: Reichert), p. 80.

43. Gutfleisch-Ziche, "Zur Überlieferung" [n. 44], pp. 165–67 and 184.

44. Gutfleisch-Ziche, "Zur Überlieferung" [n. 44], p. 167.

45. Cf. Ott, "Pictura Docet" [n. 4], p. 189: by being illustrated, "die Handschriften des 'Rolandsliedes' [signalisieren]. . .von Anfang an das mit diesem Stoff verbundene Selbstbewußtsein des volkssprachlichen 'Staatsromans' und seinen Anspruch auf Literarizität." The specific interpretation of Konrad's text as "Staatsroman" (for which see Marianne Ott-Meimberg, *Kreuzzugsepos oder Staatsroman? Strukturen adliger Heilsversicherung im Deutschen "Rolandslied"* [Zürich: Artemis, 1980]) is not essential for the general thrust of Ott's argument about the importance of the pictures.

46. For example, the knights and hornblowers at Conques certainly *can* be seen as representing the Roland material, but nothing about them demands that they be seen that way, nor does there appear to be any evidence that they were conventionally associated with Roland in the Middle Ages. Nonetheless, Lejeune and Stiennon, *La legende* [n. 2], p. 70, still want to regard them as the beginning of Roland iconography, a moment at which the work of art does not interpret the text, but the text interprets the work of art. With this sort of argument, we might identify any fighter of pagans, or any warrior with a horn, as Roland, and D.J.A. Ross, "The Iconography of Roland," *Medium Aevum* 27 (1968): 46 [46–65], is rightly more emphatic than Lejeune and Stiennon in rejecting the Conques figures as having anything to do with Roland. Similarly, the frescos at Santa Maria Cosmedin in Rome, accepted by Lejeune and Stiennon, *La legende*, pp. 43–50, and others as representing scenes from the life of Charlemagne are actually to be identified as scenes from the book of Ezekiel, as convincingly demonstrated by Ian Short, "Le Pape Calixte II, Charlemagne et les Fresques de Santa Maria in Cosmedin," *Cahiers de Civilisation médiévale* 13 (1970): 229–38 (for agreement: Stones, "Decoration" [n. 29], p. 141, n. 14).

47. The translation here is Brault's (v. 1667).

48. Lejeune and Stiennon, *La legende*, p. 333.

49. Ross, "Iconography" [n. 48].

50. Ross, "Iconography" [n. 48], p. 48.

51. On this point, cf. Curschmann, "Wort-Schrift-Bild" [n. 5], p. 384.

52. The sculptures clearly represent the *CdR* tradition, not the *Ps-T*, where these things do not happen this way.

53. Clark Maines, "The Charlemagne Window at Chartres Cathedral: New Considerations on Text and Image," *Speculum* 52 (1977): 803–04 [801–23]. On the window, in addition to Maines, see generally Lejeune and Stiennon, *La legende* [n. 2], pp. 192–99, plates VII–XVIII, figure 153.

54. This theory of "images at the interface" does not so much contradict as perhaps enhance Ott's argument that the *chansons de geste* are pictorialized early, often, and lavishly because of their importance as *Staatsromane* and their public value as representative art ("Pictura Docet" [n. 4], pp. 188–90) and Curschmann's elaborate demonstrations of the importance of the visual arts in the creation and development of vernacular literature in the Middle Ages (most comprehensively in "Wort—Schrift—Bild" [n. 5]). What I think the "interface" theory adds to the accounts of Ott and Curschmann is a fuller explanation of why images play such *different* roles in different genres and different literary materials.

CHAPTER 8

VISUALIZING PERFORMANCE?
MUSIC, WORD, AND MANUSCRIPT

Volker Mertens

Nisi enim ab homine memoria teneantur soni, pereunt, quia scribi non possunt.
—Isidor, *Etymologiae,* Lib. XX, cap. III, 15

[If sounds are not retained in the memory of men, they perish, because they cannot be
written down.]

My essay deals primarily with the musical notation of German
vernacular literature, focusing on the relationship between writing
and sound. In the context of this essay, the term *writing* refers not only to the
written text but also to graphics in general. In other words, *writing* refers to
the musical notation and the layout of the page, as well as the verbal text
itself. While modern editors normally concern themselves only with the
verbal text, this chapter argues that all three components, music, word, and
manuscript, comprise a visual whole that reflects the reality of the *work.* The
visual components of a musical manuscript refer to the writer's and reader's
memories and to the singer/performer's sensorial (visual and acoustic)
realization of the *work.* I use the term *realization* rather than *performance*
because the latter implies that there is a *work* existing independent of the
body of the singer—this is not the case with the phenomena dealt with
here. The concept of *work* as an entity that is prior and superior to the trans-
mitted *text* draws on the distinction made by Paul Zumthor in his seminal

study of 1987, a distinction that has been taken up less frequently than his now ubiquitous concept of *performance*.[1]

Zumthor's distinction allows me to consider the phenomena of vocality, that is, voice and writing, in the transmission of literature, that have been discussed frequently in recent scholarship. I consciously avoid the term *orality*, because it is connected with the oral production (not reproduction) of literature, which plays no significant role here, apart from the influence of an oral tradition on the concept of verbal or musical identity in written transcription. Public and private reading will also have to be taken into account, insofar as it is possible to say anything conclusive about this form of reception.

The aim of this chapter is to examine the data provided by manuscripts on the status of an imagined or concrete *realization* of the works in question. In order to achieve this, it is necessary to discuss the systems of musical notation and, especially when no notation is given, the layout of poetic texts, for example, the separation and marking of lines and stanzas by initials or *littera notabilior*, with respect to a possible vocal realization.[2]

In Western musical culture, we are accustomed to systems of notation that use the spatial analog as opposed to instrumental tabulature or purely symbolic notations, such as letters of the alphabet. Only recently has the complex Western staff notation been challenged by composers, such as Roman Haubenstock-Ramati or Earle Brown, who have modified and transformed traditional notation. Medieval notational systems are frequently regarded as deficient precursors to modern notation and, even by music historians, studied with the aim of "deciphering" the notation and "transcribing" it into a modern "readable" form.

Modern notation may provide information about absolute pitch and meter, but it disregards the dimensions of color, tempo, and expression. In modern notation, these qualities are provided only as additional information and generally fall under the jurisdiction of the performer as part of the arrangement for an actual performance. In order to see what we can derive from medieval notation, we have to look at the origins and development of this notation. Since there are divergent theories of origin regarding neumes, I take into account here only those aspects that are relevant to the present study.

The origin, the date, and the derivation of neumes from written or visual systems are controversial issues.[3] Predating and coexisting with neumes was a system of punctuation (*positurae*) that indicated certain melodic formulae for singing the psalms and the liturgical prayers as *Collecta*, *Secreta*, and *Postcommunio*, which were sung in liturgical recitative (and thus different from such "songs" as *Introitus*, for example).[4] Even texts that were read in the chapter-house or the refectoria of monasteries, for example, the Benedictine Rule, are transmitted with *positurae*.[5]

Scholars generally agree that the notation of music in the form of neumes as a method of (self-)control and stabilization of the repertory supported the reform of liturgical music that occurred in connection with the general ecclesiastical reforms of Charlemagne; neumes meant norms. The oldest manuscripts that contain neumes are fairly small in format, and would neither have been used for realization by a choir nor by the cantor himself, because trained cantors would not have needed memory aids.[6] The manuscripts were instruments for securing the correct musical form of liturgical chant and were sources of reference similar to the late mastersinger (*Meistersinger*) manuscripts. The notation represented what was learned by *vox viva*, but it was not used for studying or teaching because it worked only in the context of a memorized repertory; it could not teach a new one.[7] Notker Balbulus, for example, wrote only the words of hymns on scrolls (*rotuli*) for the monks of his monastery. These words supported the singers' memory of what they had learned face to face (or voice to voice) from the cantor. Notker, therefore, wrote texts for preexisting tunes (with the exception of two melodies). This is supported by visual evidence from the beginning of the eleventh century—an image of Notker in which he is depicted writing down his sequence for Pentecost, *Sancte Spiritus assit nobis gratia*, shows him writing only the words.[8]

Neumes helped one to memorize an already familiar melody. Indeed, while the notation indicated certain characteristics, it did not indicate relative or absolute pitch nor the duration of single notes. The fact that pitch was generally regarded as important is indicated by other systems of notation that were developed to show absolute pitch (the alphabetical notation suggested by Hucbalt von Saint-Amand) and the distance between notes (Daseia-notation).[9] According to Hucbalt von Saint-Amand, neumes show speed, indicate when the sound should be a tremulation of the voice, and how the sounds are connected or separated, but not the pitch. This implies that it was considered more important to normalize what we would call the arrangement (phrasing, tempo relations, vocal colors) of a piece of music than the pitch or rhythm. The frequently quoted (fictitious) reports of the introduction of Gregorian chant in the Franconian Empire, of the incompetence of the Franks (Johannes Diaconus, Ademar von Chabannes), and of the malevolence of the Roman singers (Notker Balbulus) offer us an image of vocal inability. But in these descriptions, the Gauls failed in exactly those parameters of music that neumes tried to fix.[10] Notker Balbulus regarded even the existing notation as an insufficient method of indicating vocal peculiarities and suggested additional letters for volume, tempo, and special sound effects; for example, the letter F should indicate "the sound of gnashing the teeth," G "a sound of gargling in the throat," and O "a wide open mouth of the singer."[11]

Neumes are concerned with the meaning of the text, aiming at a partic-
ular realization and not at representing an abstract structure of the music.[12]
Two different traditions come together in this kind of notation. The first is
the tradition of punctuation: instructions for delivering a spoken text that
included accents were developed as a sophisticated system of *positurae* (*punc-
tus flexus* for a small pause, *punctus elevatus* for a medium pause in a larger
unit, and *punctus versus* for the ending of a sentence) and were subsequently
used for musical liturgical recitation.[13] These accents were associated with
certain melodic formulae of the traditional liturgical chant, comparable to
the *clausula* (ending formula) of the liturgical recitative. The oldest neumatic
notations show certain similarities with this system, and the fact that they
were used not only in liturgical manuscripts but also in classical texts makes
it plausible that one of the main sources of the neumes is this scholarly
system of *positurae* that goes back to antiquity.[14] But if the cantor's manual
gestures that guided the vocal realization of the choir's chants were the
single origin of the neumes, then it is difficult to explain the very early use
of neumes in secular texts. Gestures (cheironomy) could, however, have
been used to modify punctuation and supply new forms of punctuation.
Neumes were not a sudden invention, but part of a longer process that
involved some experimentation. In the thirteenth century, the systems of
positurae and of (at that time diastematic) neumes had developed in different
directions; the *positurae* were used to underline the meaning more than to
indicate a vocal realization. As Bonus of Florence wrote, "If we wish to vary
the points [punctuation] in our writing according to the manner of pro-
nunciation, it [the book] would look like an antiphonary."[15] But, despite
this ironic commentary, *positurae* could still identify certain melodic formu-
lae by differentiating liturgical recitative from proper chant.[16] An important
difference between punctuation signs and neumes is their position in
relation to the written words: the punctuation signs follow the words and
are related to the structure and the meaning of the sentence, whereas the
neumes are positioned above the words, thus forming a more intimate
connection between the vocal realization and the written text. Recently,
Levy has argued that cheironomy marks a synchronized visualization of the
chant, as opposed to merely indicating the different pauses, suitable for
transmitting the meaning. Cheironomy thus provided the general concept
of neumes, while *positurae* gave clues as to how to put it on parchment.

Neumes represented a form of notation of vocalization that not only
indicated the course of the melody by using the spatial metaphor high-low,
but also certain specific modes of voice production. Neumes could induce
a realization without a lengthy process of deciphering the symbols, as it is
the case with letter notation. Even in the ninth century, letter notation was
criticized because it was difficult to determine what the letters really meant.

Leo Treitler, who applied the categories symbolic, iconic, and indexical (Charles S. Pierce) to musical notation, regards neumes as "iconic" because they offer a formal equivalent to the course of the melody (see note 2). Certainly, the "iconic" content of the written neume is greater than that of the written letter, but Treitler overestimates this dimension of the neumes. A person without a fairly precise knowledge of the meaning of the neumes could not use them to prepare a vocal realization; at the very best, he would notice that the neumes indicated musical performance of a certain kind (for example, elaborated or simple). A medieval person would recognize that the written texts were not identical with the work—similar to a modern Christian who would not regard a hymn-book without musical notation as a simple prayer-book. The neumes visualize a realization that one recognized as the proper state of the work. In spite of their iconic dimension, neumes provide information only to the initiated regarding the style of the melody, its movement and expressive quality. Neumes do not represent "music" as an abstract entity, but a sensual, bodily realization of words and melody inextricably connected.[17] Only much later did people start to perceive words and music as two different dimensions of the work. The vocal realization is always taken for granted, even when verses or stanzas are transmitted without musical notation; the neumes offer only support for the memory, by reminding a performer visually of a performance. The actual realization could differ according to the school of training, as Johannes of Afflighem (twelfth century) shows when he depicts an ironic discourse of three singers trained by different teachers.[18] In general, however, neumes ask for a specific vocal realization. Whether this realization took place with the manuscript present is debatable. Only since the late tenth or eleventh century were liturgical books with neumes actually used in church, and most of the very precious manuscripts were rarely, if ever, put on the lectern during holy service. With the use of *synoptical* or marginal notation, which was common in the tenth and eleventh century, a fixed memorized realization of chant was indispensable.[19] The cantor or the officiating priests obviously knew the melodies by heart and used the neumes only as a memory aid, if they looked at them at all and did not only regard them as a part of an especially sumptuous layout of a manuscript, comparable to decorated initials or miniatures. It was appropriate for holy texts that a great amount of care went into the correction of the notation of melody, even if it was never meant to be used as a guide for singing. The books with neumes offered a more comprehensive visualization of the vocal existence of liturgy and so achieved a higher dignity.

Learning the melodies remained an oral process throughout the Middle Ages. Presumably the cantor (who was most likely the only one who understood neumes fully) studied new melodies after learning them, and

transmitted them to the singer by singing them to the monks (or nuns). Hildegard of Bingen's songs offer us an example. They are—in the context of the liturgical chant—unusual experiments of melodic structure and vocal range, although the method of vocal realization seems to have been the traditional one; the range of two octaves and a sixth only slightly exceeded the expectations of a trained voice, while two and a half octaves were still regarded as possible. The difficulty of Hildegard's songs lay in the extensive vocal training and long periods of memorization that they required, thereby underlining the elitist aspirations of the abbess herself and her convent. In their exceptional demands, the songs were closer to the singing of angels than the usual liturgical chant. Because of this singularity, Hildegard's songs did not enter the common repertory outside her convent, and even in the convent, they were probably executed only occasionally. The manuscript of these songs and other works that Hildegard sent to the monks of Villers (on their request) provided documentation but was not a performing manu-script, even though the musical notation was carried out with great care. The melodies could be studied and admired without vocal realization. Indeed, there is no trace of a reception of Hildegard's extraordinary vocal style. The Notre-Dame-polyphony, on the other hand, which differed even more from the usual practice, was soon taken up, imitated, and elaborated. For this innovative form of music, however, we have no manuscript before ca. 1250, so that one assumes that even polyphonic music was transmitted without written support.[20] The two beautifully executed manuscripts of Hildegard's songs are not meant to be used for performance (which involved learning and memorizing). Instead, they document Hildegard's claim to equal the greatest theologians and even to surpass them. By virtue of her divine visions, auditions, and songs, Hildegard places herself on the same level as Gregory the Great, the inventor of liturgical chant himself. The neumes do not visualize performance, but Hildegard's claim to greatness.

In the second part of this chapter, I examine a number of (mainly) ver-nacular manuscripts and focus on the visualization of musical realization. When neumes were used in vernacular manuscripts, they connected the vernacular texts with the sacred and the learned sphere, and with the practice of singers trained in liturgical chant. Only works that were related to this sphere would have been notated with neumes. To write down the music of the "obscene songs of the laity" (Otfried) was not only out of the question, but also probably not even possible, because these did not conform to the melodic and vocal qualities of liturgical chant. Even notating the living practice of chant proved to be difficult, since identical musical sequences were sometimes rendered differently in writing. The characteristic quality of vernacular poetry could not be captured by a system developed for a different style of music. Similarly, transcribing the music of other cultures by

using the notation of Western music proves to be hardly possible because certain peculiarities are impossible to record. This is true even for European folk music—when Bela Bartók transcribed previously recorded music from Transylvania, he unwittingly did it twice and these transcriptions differed in several details.[21] As mentioned earlier, even Notker Balbulus thought of adding special signs to traditional neumes in order to achieve a more complete graphic representation of his intended melodic style, perhaps because he adapted melodies from the vernacular repertory.

So it is not by misfortune that we have neumes neither for *Beowulf* nor for the *Hildebrandslied*. Even if both scribes had the ability to write neumes, the ways in which these texts were sung differed too markedly from liturgical recitative.[22] The *Hildebrandslied* is written down on the front and back of the first page of a Latin manuscript, and continued on the last page. The manuscript remained unbound for some time, so that it is controversial whether the poem's ending was ever written down at all. The scribe has partly compensated for the missing musical notation (which, may not even have been available in Fulda around 840/50) by using a caesura in the middle of each verse and a *punctus* as a punctuation sign that indicates the end of the verse; but not infrequently, the *punctus* is missing or appears elsewhere.[23] The scribe treated the text as a poem (and not as prose) and was aware of its form; he must have "heard" it at least in his mind. A person knowing the melody could have produced a vocal realization, but that was obviously not the intention of the scribe. He most likely prepared the *Hildebrandslied* for reading (with the melody in mind), understanding, and studying the moral implications of vernacular heroic poetry.

Musical notation, however, is found in two works with biblical content: the *Heliand* and Otfried of Weißenburg's *Evangelienbuch*. Generally speaking, the neumes place these two works in an ecclesiastical and scholarly context, removing them from the category of vernacular secular poetry. Only short passages have neumes, and their meaning is not obvious. Do the neumes give a model for the realization of the complete epic? This is unlikely because they do not appear at the beginning. Most likely they realize specific passages in a more elaborate style than the rest of the poem. The neumes would thus offer a sort of a festive mode that could be applied to other passages on certain occasions as well.

The neumes in the *Heliand* present a more difficult problem. They are on folio 5r of the Munich manuscript M (mid–ninth century) and cover verses 310b–13a. The form of the neumes is unusual, perhaps because the scribe had difficulty applying the (not yet well-developed) system to a vernacular work.[24] It is evident, however, that the signs indicate a musical realization and are not mere punctuation signs, because these would have been put after and not above the words.[25] The content of the passage is unremarkable: it

concerns the Jewish law that an illegitimate pregnancy be punished with expulsion and even death, and that Joseph, being wise and just, decides to send Mary away in secrecy. The neumes start at the second half of verse 310 and go to the first word of verse 313. Taeger assumes that these verses were meant as a model for the whole passage of the Annunciation up to the nativity.[26] This, he argues, is possible because the neumes are situated on the lower part of the right-hand page of the opened book, so that the singer would notice the neumes and adopt them, starting on the upper left-hand page. This is improbable, however, because no beginning is indicated by the neumes. The neumes do not offer a repetitive model, and the neumes over the last word *suido* (v. 313) do not lead back to the beginning of a line. So the singer would have to perform the feat of transforming the melody. The neumes do not indicate a simple recitative but instead a more elaborate melodic formula, connecting the *Heliand* with liturgical chant or, perhaps, with secular poetry—a vernacular heroic mode, similar to the presumed "Hildebrand's mode." In the first case, the passage in question might be used at the feast of St. Joseph (March 19) and refer to a well-known hymn melody. In the second case, the scribe might have tried to adapt the newly learned method of notation to a secular melody, but having found it difficult, resigned from it after a few lines. In both cases, however, the *Heliand* (or parts of it) would have been realized vocally not in a melodic style, repeating a single line, but in larger, strophic units. So the manuscript indicates a vocal realization in a fairly elaborate mode for at least part of the *Heliand*, even if the book would (and could) not have been used for an actual performance. The intrusion of secular forms of vocalization into sacred works is documented by the synod of Clovesho (England) in the year of 747: the priests are admonished not to "squeam" in church (*garriant*), and not to spoil the sacred words by "tragic sounds" (*tragico sono*) but to produce the simple and holy melodies.[27]

The passage in Otfried's *Evangelienbuch* seems to relate to a more specific situation of vocal realization. The neumes are regular ones, written down slightly later than the words. They are not part of the original layout. The scribe has also inserted some letters that indicate absolute pitch.[28] This passage may have been marked for a special occasion, as it is the beginning of the Annunciation scene. The melody is a two-line model and more elaborate than the one in the *Heliand*, marking the endings of line 1 and the caesura of line 2. Bielitz considers this to be a cantilena with a hymn- or sequence-type melody.[29] One could repeat this model and use it for a longer passage. This musical notation comes close to the neumes in texts by classical authors, including Horatius, *Carmina*, as well as Lucanus (parts of *Pharsalia*), Statius (passages of *Thebais*), Vergil (*Eclogues, Georgica, Aeneis*, several passages), and even Terentius (*Andria, Eunuchius*) and Boethius.[30] Christopher

Page has shown that the melody of the Boethian verses does not respect their meaning, so that it seems improbable that the epic poems were sung in their entirety according to the notated melodies. The passages with neumes were most likely sung at specific occasions (for example, at school), or, as Riou suggests, the passages in question were marked for more ornate delivery in a simple formulaic melodic context.[31] These possibilities do not exclude each other, but we cannot also rule out a selective vocal realization of the long epics. Andrew Taylor has suggested that this was probably generally the case with vernacular epics.[32] Perhaps Otfried's work was delivered in parts appropriate to the liturgical calendar. The passage with musical notation may have been sung at the feast of the Annunciation (March 25), not in the course of the Hours or Mass but, similar to Ratpert's *Galluslied*, in a less strictly regulated "paraliturgical" context. Even when there were local variants of the Hours, the language would have been Latin. Rarely vernacular versions of the Latin texts might be "performed" alternating with the original, but no independent texts in the vernacular were performed. In a church dedicated to the Annunciation of the Virgin, a sacred work in the vernacular would have enriched the holy service and proclaimed the universal importance of the incarnation of Christ.

Whether the vocal realization of the *Heliand* and the *Evangelienbuch* was completely musical has been debated. Bertau and Stephan assume that it was in the form of liturgical recitative, referring to the signs in the Codex Moguntinus, whereas Bielietz remains skeptical regarding the passages in the prefaces as relevant for the actual realization.[33] But we see a parallel in the French *chansons des saints*, and *chansons de geste*, where we have not only the statement of John of Grouchy but also melodies for the *Chanson d'Audigier* (in *Jeu de Robin et Marion*), the *Bataille d'Annezin* (melody *sine littera* after the text), *Aliscans* (*Roman de la Violette*), *Bevis d'Hampton* (Guiraut del Luc), and *Girart de Rouissilon* (Raimbaut de Vaqueiras).[34] A musical realization of the *chansons* must have been the norm, even if a realization with a speaking voice (or semispeaking voice, indicating pitch) cannot be ruled out. Several of the *chansons de saints* are transmitted in a way that indicates musical realization. The oldest text, the *Eulalia-Sequence*, has no musical notation, but is written down in bipartite verses with *littera notabilior* at the beginning of each verse and after the caesura, which is marked by a *punctus* as well, indicating a minor pause, so that it can be delivered like a psalm.[35] The scheme is: M—.M—M—.M—.

The same layout is used for the *Ludwigslied* that follows immediately. This makes it unlikely that the manuscript was intended for performance because a situation where Old French and Old High German were equally understood is hard to imagine. The layout probably signifies the vocal component of the text without indicating a specific melody. While the *Eulalia*

Sequence has a counterpart in the Latin part of the manuscript (the Eulalia legend on the recto side of the same page 141), the *Ludwigslied* remains isolated, so that the connection with a "postscriptive" musical realization is even less likely.

We have neumes for the first stanza of Clermont-Ferrand's *Passion* (516 vv.) from the early tenth century. For the *Chanson de St. Leger* (240 vv.) from the late tenth century, we have neumes only for the first line, which were probably intended to be repeated with a traditional modification of the ending in the last line of the stanza.

Of special importance is the *Te autem* trope from the late eleventh century, setting the liturgical formula *Te autem Domine, miserere nobis* that traditionally marks the end of a work when read or performed.[36] The stanzas have a relatively complicated melody: A B C D C E C D A F G D. We have three initial formulae (A, C, B) and four closing ones (B, D, E, F), while D serves as the ending of every fourth verse and so indicates a stanzaic structure. Chailley sees in the *Te autem* trope a final stanza common to several *chansons*, a *passe-partout*, that integrates different melodic models, and provides an elaborate ornamental ending. In any case, this trope indicates a musical realization of the *chansons de saints*, even when they are not transmitted with musical notation.

Among the shorter forms of poetry, we have two examples that predate 1100: the Cambridge Songs and the Old High German poem *Hirsch und Hinde*. Among the Cambridge Songs, we have four naming the tune or *modus* in the beginning: *Modus qui et Carelmanninc* (no. 5), *Modus Florum* (no. 15), *Modus Liebinc* (no. 14), and *Modus Ottinc* (no. 11); all these are transmitted in the Wolfenbüttel manuscript, too (Cod. 3610 Aug. 56.16). While we have no indication of the origin of the *modi*, the *Carelmanninc* is used a second time for a religious text, in Ekkehard's first sequence for the feast of St. Paul *Concurrite hoc populi* with the reference *Liddi Karlomannici*.[37] Presumably the *modi* came into existence with vernacular texts. Naming them in abbreviated form (*Liebinc, Ottinc*) would suffice to bring the melody back to memory. Only the *Modus Ottinc*, however, is transmitted with neumes in the Wolfenbüttel manuscript, and the reason for that is evident: the beginning of the song states that Otto's servants woke him up with this tune when his palace was in flames.[38] So it is a very special, life-saving melody that the scribe shows visibly that he knew. The notation intensifies the story and is not an instruction for performance, because a singer would have had to know the melody beforehand. The melody has its own history that is told in the poem, and its status led to its neumic notation.

The Old High German *Hirsch und Hinde* belongs to a similar model: a poem in the vernacular provides the formal and musical model for a religious poem in Latin. The secular love poem *Hirsch und Hinde* appears with

neumes on the upper margin of folio 15v of the Latin manuscript Brussels, Bibl. royale 8860–67, part 62. The vernacular poem serves as a model for a Latin hymn of nine stanzas: *Solve lingua*, destined for the feast of St. Peter and Paul (June 29) written down with neumes on the margins of folio 15v and 16r of the manuscript.[39] The melody is preserved in diastematic neumes in an eleventh-century Italian manuscript (Oxford, Bodleian MS Douce 222). The use of secular music for a sacred song is comparable to the use of the *Modus Carelmanninc*. The neumes over the German text indicate the provenance of the melody and are not to be seen as an invitation to sing the song; instead, they show that the scribe was aware of melodic origin of the Latin hymn. Schwab, however, believes that the secular dance-song was given a melody in the style of a hymn, or that at least the secular song would be performed together with the hymn that would eventually supplant it. I do not see any indication for this process either in the manuscript or in other documents.

The transmission of the poem *Übermuot diu alte* belongs in a similar context. We find it on a single leaf of a Latin manuscript, preserved as Clm 5249, 42a, together with a drawing of an allegorical tree, dated shortly after 1200. The neumes characterize it as singable, but do not invite a musical realization. They are part of a multimedia decoration of the manuscript, closely connected with the drawing. The *superbia* of the allegorical tree with vices and virtues gets a gloss in the form of the German text, which originated (like the moral and satirical songs of the *Carmina burana*) in clerical and learned circles and was not invented on the spot, as has been suggested.[40] Taking the song as an acrostical supplement of the drawing, the reader could sing it in his mind, as most probably the scribe did, when he wrote down the neumes. Drawings of trees like this are no rarity in Latin manuscripts.

The colored drawings in the manuscript of the *Carmina burana* aspire to a much higher level without aiming at the sumptuous decor of liturgical books.[41] They are inserted more or less randomly, referring to certain songs, and they give the manuscript a higher dignity. This is the case with the neumes, too; about thirty songs (with the exception of plays) are transmitted with melodies. There is no evident principle of selection regarding the distribution of neumes. In some cases, we have space left for neumes that were not provided (nos. 90, 99, stanzas 2–7, 110, 187), perhaps because the scribe did not memorize the melodies (in song no. 99, the neumes above stanza 1 would be sufficient). For several of the songs we have parallels with diastematic neumes, for the others we have to be content with general stylistic observations, for example, ornamental and melismatic style versus a more simple syllabic.[42] The many German stanzas seem to reflect a fashion of finishing a Latin song off with a German stanza as a supplement or

a comment. Only in certain cases are the German stanzas older than the
Latin ones: in nos. 152 and 166 (Reinmar), 168 (Neidhart), 169/151
(Walther), the Latin poems are contrafacta. In other cases, the German
stanza comments on the Latin poem (no. 147 [Reinmar], 150 [Morungen],
211 [Walther]). One could hardly regard the German stanzas as an indica-
tor of the melody because of their position at the end of the Latin poems;
they could, however, show what a learned author could do with the formal
and musical model. The manuscript is not intended for a performer and
would probably not serve for preparing a musical realization. In the clerical
sphere, one would read it privately or have a "convivial" realization in a small
circle without making use of the theatrical potential of the songs. A profes-
sional performer would most certainly sing the songs by heart and not from
a manuscript. The expert reader would sing the well-known melodies in his
mind and create a virtual performance, relishing the skills of the poets in
using the formal melodic models and/or contrasting the Latin and the
vernacular. The manuscript does not document a public musical realization,
but a possible "learned" use of poems in the vernacular as model, gloss, or
comment, all of which are common scholarly practice that were transferred
to German love-poetry and probably reflect a specific case and not a usual one.
It was possibly more of a performance in the mind than in the public.
The neumes demonstrate the comprehensive knowledge and ability of the
patron who ordered this collection.

Poetry in the vernacular was at first only written down in the context of
Latin poetry. There are no vernacular manuscripts before about 1270/75
(*Small Heidelberg Songbook*), but there must have been at least some small
song-books. We find a similar situation in Occitan and French: the earliest
troubadour and trouvère manuscripts date from ca. 1250.[43] The earliest
manuscripts with musical notation (Mss. R and G) are fifty years younger.
With the 250 and 1,700 songs, respectively, that these manuscripts contain,
we have a fairly broad musical transmission in diastematic neumes. In com-
parison, German manuscripts with music are less well preserved. Probably
the oldest exclusively German musical manuscript is the fragment of Ulrich
of Winterstetten's *Leich IV*.[44] It contains the versiculae A 13 und B 14: first
the text of the last two lines of A 13 and the first two of B 14, then text and
melody of A 13 lines 3–4 and B 14, 1–4.[45] B 14, 1–2 are identical with 3–4
except for the ending. The (not completely reliable) reproduction of the
manuscript (missing since about 1841) poses questions that are difficult to
answer: why was the text written down twice, once with and once without
the melody? And why were the versiculae 13 and 14 not separated?
Evidently the manuscript was carefully written, but the scribe must have
perceived the structure differently from modern philologists. Or does the
manuscript document a mode of performance, where alternating voices

split the versiculae, thus creating a tension between the melodic and metric structure and the realization? One could have used the manuscript for performance: after section B 14, there is some space and the new text (and music) began on the next page so that there was the opportunity to turn the page at the ceasura. The fragment was part of a manuscript that may have contained only Winterstetten's songs. His clerical education probably accounts for the unusually early transmission of his music.

Later manuscripts with musical notation are the Münster Fragment Z (one complete, four fragmentary melodies) and the Frankfurt Neidhart Fragment O, both inferior in decoration to the French manuscripts.[46] The relative scarcity of German music manuscripts is the result of the greater distance between clerical and secular scribes, so that there were few competent scribes and users. In the French manuscripts (and probably in the German ones, too), the melodies were notated from hearing, which meant that the scribe probably wrote down his own imagined realization. This points to a closer relation between the culture of performance and the culture of writing that existed in France, but not in Germany. Nevertheless, musical notation is relatively late in France as well, which can be explained by the fact, mentioned above, that the system of musical notation was invented for sacred songs and their tonal and expressive mode. Thus, the differing musical parameters of the secular love-poetry could be recorded only with difficulties, after one had adapted the notation to the melodies. The divergent notations of the same music in different manuscripts reflect different modes of adaptation (and different traditions of realization, as mentioned above). To reach codification on parchment, vernacular melodies had to pass the filter of a notational system that had been invented for an altogether different purpose. Accordingly, the scribes began to focus on a reciprocal process of adaptation that involved not only the notation but also the melodies themselves.[47] The same holds for the German manuscripts.

The manuscripts from the Romance and the German regions deal with poetry in a similar way: they write the stanzas separately but without setting off the lines (as is usual with epic poetry), so that they present visually the musical unit of the stanza. This visualization of the formal structure differs from modern editions, which usually separate the lines, whereas in the medieval manuscripts they are often not even divided by punctuation marks. The medieval presentation thus emphasizes the continuity against the caesurae, and the music that creates the internal divisions in the stanza seems to be "heard" by the scribe and the reader. As troubadour- and trouvère-manuscripts, neither Z nor O were performer-manuscripts, but instances of a process of thesaurization that encompassed not just the words but the music, too. Manuscript O was probably a Neidhart-compendium, whereas Z might have collected Walther and Reinmar, thereby collecting

the greatest musical poets of the time around 1200 (according to Gottfried von Strassburg). Their melodies must have been alive at the time of Z (1350) because they do not seem to be copied but written down from hearing. Z belongs to the group of manuscripts that not only indicate the beginning of each stanza, but also mark their internal structure (the two *Stollen* and the *Abgesang*) by letters in color and the lines by *litterae notabiliores*. Therefore, it is easy to adopt the music from the first stanza to the following ones. This "colormetric" disposition (here only for the "Palestine-song") is used in manuscripts from the north of Germany that belong to the group in the Jena manuscript.[48] This probably indicates a still vital tradition of musical realization in this region that was at least partly governed by princes practicing *Minnesang*.[49] From other regions we have only very few comparable manuscripts, such as the rotulus from Basel or the Neidhart manuscripts G and K.[50] Especially with Neidhart, the musical tradition lived on far into the fifteenth century, so that there is no reason to believe that melodies were only written down at the threshold of oblivion. This might be true of the troubadour manuscripts where we find empty staffs above the poems, suggesting that the melodies were lost, but in the Jena manuscript, missing melodies are a rare exception.

This manuscript documents a very high esteem for gnomic poetry (*Spruchdichtung*), which was regarded more highly than love-poetry in the middle of the thirteenth century because it offered ethical values, a perspective that lasted until the late eighteenth century. The size (large folio) and the decorative layout make evident that the manuscript served the purpose of showing the patron's cultural importance. To propose that the manuscript was used during a festive realization does not seem unreasonable when we compare it to sumptuous liturgical books that were kept in the church's treasury and shown at special occasions, such as Easter or Pentecost. The Jena manuscript begins with Walther von der Vogelweide's lay (*Leich*), a religious poem of especially high formal ambition, so that it could be seen as a fitting counterpart to the similarly ambitious liturgical books. It could be presented at festivities and put on a lectern during a vocal realization of poetry in order to show that secular song in the vernacular was given the honor of being preserved in such a magnificent book. Whereas the Manesse manuscript placed vernacular poetry in a noble context by opening with a miniature of Emperor Henry VI and thereby showing the splendorous past of singing, the Jena manuscript evokes the present: the realization of the songs in texts and music. The often quoted use of the songs as "courtly ceremonial action" finds here its apotheosis, at home mainly in the north of Germany with the singing princes.[51]

Among the songs that were written down in Latin manuscripts or in another foreign context, the most interesting is the Walther manuscript N.[52]

The song *Si wunderwol gemachet wîp* has neumes above the first line of the manuscript (= L 53, 1–2, without the last syllable *danch*); over the following lines, the scribe of the text has left space for neumes, but the person writing down the music obviously found the space too narrow, so that he stopped notation. The melody itself was clearly not important to him; perhaps he thought that indicating the highly decorative melismatic style of the music was sufficient, or perhaps he trusted the memory of the reader to furnish the rest of the melody. It would be erroneous to assume that melodies were characterized mainly by a certain style. In fact, there was a certain pride associated with the invention of new melodies. We recall the quotation "Kürenbergers wîse" [the manner of the Kürenberg poet] that suggests that melodies were highly individual and could be easily identified. This phenomenon is the foundation of meaningful contrafacta, such as Walther's "Palestine-song," or Jaufré Rudel's *Lanquan li jorn* with his allusion to the *amor de lonh* and the Holy Land in the original, or Walther's use of Reinmar's melody *Ich wirbe um allez daz ein man* in his own poem *Ein man verbiutet ane phliht* (L 111, 22). The mastersingers continued this tradition of developing and using individual recognizable melodies by giving them characteristic names.

The Munich Wolfram-manuscript G (before 1250) presents us with a special case: two of Wolfram von Eschenbach's dawn-songs (*Den morgenblick und Sine clawen*) are written down on the last page turned by ninety degrees.[53] The text is arranged in stanzas, each song should have started with a large initial, each stanza is marked by a *littera notabilior*. The lines are subdivided by punctuation marks (*punctus* and *punctus elevatus*) according to metrical and syntactic principles, for example, in the first song: "des muosen liehtiv ougen auer nazzen! si sprach 'owe tac. wilde vnd zam daz frawet sih din vnd siht dih gern!' " [Because of that her bright eyes had to fill will tears again. She said "Alas, day! The wild and the tame are pleased with you and like to see you"]. Here the rhymes *ougen* and *din* are not marked, but the syntactical divisions after *nazzen* and *gern* as well as *zam daz* are marked with the relative clause. Similar punctuation marks occur in the manuscripts of *Wigalois* and *Tristrant*, but they are related more to reading than singing. Here the textual notation distinguishes it from other texts in the manuscript (that is, *Parzival, Titurel*) and helps one to understand the song rather than to perform it. But as the stanza determines the songs' layout, their metrical-musical dimension is preserved. This manuscript, however, seems to hint at a transition from singing the songs in public (or privately) to reading them, possibly still with the melody of the stanzas in mind.

The miniatures of the Manesse manuscript offer us further evidence for this notion of "visualizing performance." In the course of an idealized knightly life, making music and singing play a very small role: talking,

reading, drinking, bathing, fighting, jousting, hunting, playing, and shopping are of at least equal importance. According to the Manesse manuscript, for Otto of Brandenburg, music was public representation, it was something to dance to for Hiltbolt of Schwangau, and it was accompanied solo recital for Heinrich Frauenlob, Reinmar the Fiddler, and the Chancellor. Making poetry is depicted in the manuscript under diverse circumstances—as an oral practice, as writing on tablets, and as sending a poem to a lady. Whether the empty "scrolls" signify the song or symbolize a poet's status is difficult to say; they are certainly symbolic and do not offer any insight into the vocal realization or the written transmission of poetry. Surprisingly, none of the miniatures depicts either a public or a private performance.[54] That scrolls were used by performers is documented by illustrations from the fifteenth century.

Scholars have recently discovered a single leaflet that was not part of a codex, but probably represents a performer's manuscript from around 1400, the Dießenhofen leaflet.[55] The melodies of its two songs are *sine littera* followed by the text organized in stanzas; it is difficult to adapt them to the text without knowing the melody by heart. The specific mode of notation could have been made for an instrumentalist, but most likely not for a professional musician because professionals would memorize their repertory.[56] Most likely the leaflet was a gift of love that could be used for making music together; its significance is as much a token as it is a sheet of music for performance. The fact that the leaflet had been folded several times suggests its use as a love token, and the musical notation is that of an amateur, not a professional performer. The relationship between the visual and the acoustic is ambiguous. Paramount is the dedicatory function that includes a symbolic performance; actual music-making is derivative. This fragment represents, in my view, the dedication of love songs with text and melody to a beloved person as a symbolic performance, and secondarily a performance that could be realized by the poet and his beloved making music together. In the Lochamer Song Book (1451–1453, Nuremberg), we find annotations that suggest a similar practice of dedicating a song and realizing it.[57]

From the same time and place, we have a very different manuscript, Neidhart c (1463?). While the Lochamer Song Book could be used for convivial music-making, the Neidhart manuscript would make this difficult. The forty-five melodies are written *sine littera* above the stanzas, each song opens with a red initial, the stanzas are separated, and the verses are marked by red virgulae, but often incorrectly. Only a person who already knew the melodies could use the manuscript for performance because the adaptation of the melodies to the texts is difficult. That Neidhart's melodies were still memorized in the fifteenth century is documented by a manuscript in Freiburg (Switzerland) in which the *Krechsenschwank* is notated with adiastematic neumes.[58]

While the stanzaic epic was generally realized with a singing voice, we have only one melody transmitted in connection with an epic text (a part of the *Eckenlied* stanza in the *Carmina burana*): the melody for Albrecht von Scharfenberg's *Jüngere Titurel* on the back side of the frontispiece in the Vienna manuscript A (Österreichische National Bibliothek, Cod. 2675) from around 1300, about one generation younger than the work itself.[59] The melody is written down with a text that has no parallel either in Wolfram's *Titurel* or in Albrecht's *Jüngere Titurel*. The text could be a document of the *Titurel* as a work in progress, as is made plausible by the manuscript tradition (versions H and M). We cannot determine with certainty whether the melody goes back to Wolfram, but it is probable that Wolfram had a melody in mind when composing the text of the work and the redactor(s) would have known it, up to Albrecht himself. It seems evident that the melody in A (written down slightly later than the text) should be used for realizing the work vocally; its position on the backside of the frontispiece enables the user to look at it simultaneously with the stanzas on the first page (1–15, 3). The stanzas were set separately and marked by a *littera notabilior*; the rhymes are marked by a punctus. So the manuscript could be used for performance, but the decoration indicates that it belonged to a wealthy patron rather than a professional performer. The fact that the melody is a later notation confirms this because a professional would have known it from memory. The melody would offer an imaginary vocal realization to the reader, such as silent or semisilent singing of the stanzas that would make the text more comprehensible. The manuscripts of the *Jüngere Titurel* generally separate the stanzas and mark the lines (mss. B and H) and even the caesurae (ms. B), the late manuscripts E and Y separate the lines (E) and even the half lines (Y), stanza and line remain the principle of organization (separation, *littera notabilior, punctus, virgulae*), even when the text is written continuously like prose. So a performance in stanzaic units consisting of distinct lines is always visualized.[60] Especially remarkable is manuscript G of Wolfram's *Titurel*: here we find a combination of lyric and epic layout: the stanzas are marked by a *littera notabilior* and the lines are set out separately, so that, when the melody is memorized, an imaginary vocal realization is possible.

The musical performance of the *chansons de geste* has already been dealt with, but there remains the question of the *Chanson de Roland* and the German *Song of Roland*. The Oxford manuscript of the former has the enigmatic *AOI* at the end of most of the lays (except the last one). It has been interpreted as an analog to the liturgical *seculorum.Amen* that was commonly written down as *EUOUAE*. So *AOI* could refer to *Alleluia* or *Pax vobis* and indicate a well-known melodic formula to be used to mark the ending of a lay. For the German *Song of Roland* we lack similar indications,

but the Heidelberg manuscript P marks the lays with red initials and the lines (written continuously) with a *punctus*, so that it could have been performed using a singular, recitativelike melody for each line and a *clausula* for the ending of a lay. However, when we regard the situation in France (discussed above), a repertory of several melodies for the beginning and ending seems more likely. Most likely performers did not present the epic works in full length but in parts, as is suggested by the passage in *Flamenca* (v. 596 ff.) or the Marner stanza (XV, 14).

Finally, there remains the open question on which part the manuscripts would have played in a "real performance." Andrew Taylor has discussed the "myth of the minstrel manuscript" and denied the existence and the necessity of it because he assumes a realization from memory.[61] This position has been extended to the courtly romances by Evelyn Birge Vitz who points to the almost inexhaustible capacity of human memory and the theatricality of the "performances," which would not allow the use of a book, even on a lectern.[62] This excessively theatrical realization is not proven, but in any case the question remains how the performer learned the work by heart. He learned it not by listening to other performers (as it is the case with truly oral poetry), but by making use of written texts. And even when a performance was very theatrical with a lot of proxemics and gesture, the book could have been "present" (in the hands of another person or on a lectern) as is the case with the liturgical book during the holy service, in order to demonstrate the authenticity of the realization. Even when singers or readers did not use a manuscript during a performance, it could be used to prepare the performance, for memorizing text and music, or to authenticate a performance by being exhibited during the vocal realization. The latter situation is especially feasible where religious texts were concerned. So when a lector or cantor "performed" a section of *Heliand* or Otfried's *Evangelienbuch*, he would have "the book" before him. The same can be assumed for the *Song of Roland* and the overly didactic *Jüngere Titurel*, too. With lyric texts, it would have been different: lyric poems were recited from memory, "by heart," as was especially appropriate for love songs. Manuscripts (like the *Carmina burana* codex) could be used for preparing a realization, but one has to take into account the role of private reading: at first in monastic and learned circles, it started to become a secular practice beginning in the thirteenth century.[63] Thus, the transmission of Latin poems with music (*Carmina burana*, Cambridge songs) started at a much earlier date than of poems in the vernacular. It is not clear whether songbooks were in use prior to the great collections: the repertoires of professional singers like Gedrut/Geltar could have been written down as a preparatory measure for a planned encyclopedic collection.[64] Most manuscripts, however, were probably used for a "realization" of the texts and their music that

involved semisilent singing while reading a book or imitating a "performance" in low key for a small circle of listeners. There would have been transitional modes between a public virtuoso performance and "silent" reading, as is indicated in Jean Renart's *Guillame de Dôle*, which indicates several possibilities from singing to oneself to a festive performance, even if these possibilities are the result of literary stylization.[65] Lyric poetry seems to have been transmitted primarily orally up to the middle of the thirteenth century, at least as far as its music is concerned. This is suggested by the fact that contrafacta use the melodies of older songs in a fairly loose way, while melodies after 1250 are taken over "literally." This does not exclude the existence of single leaves containing songs as a dedication; on the contrary, they could well be the origin of written transmission. These could be read in private, like love-letters, as Eneas does with the letter sent to him by Lavine in Heinrich of Veldeke's *Eneas* and its French model, the *Roman d'Eneas*. A late example of such a "love-song-letter" might be the Dießenhofen leaflet.

The notation of melodies has a symbolic function among others; it adds to the dignity of the text, the book, and finally the patron. The social and cultural implications of notation are not to be underestimated. When music is notated, it shows that the patron could organize and appreciate it, and it symbolizes a public performance of great splendor.[66] But this evocation of performance (which is no longer apparent in the Manesse miniatures) has its less public reality: it gives the experienced reader the opportunity to imagine, or to recall a performance and to renew it in his memory.

Musical notations visualize the vocal realization of literature as its normal form of existence, even while they reflect a no longer extant tradition of performance. Public performance declined because the situations in which it could be practiced no longer existed. The "deciphering" of a musical notation and the "transcription" into modern notation should not be our first task, but the examination of the manuscripts with and without music for indications of possible vocal realization, either imaginary or real, according to its style (ornamental, recitative, dancelike), its formal structures (stanzaic epic, lay, canzone, oda continua), and its mode of delivery (reading, memorizing). By examining these manuscripts, we may gain a broader understanding of how the written and the vocal culture were intertwined in a predominantly "oral" society.

Notes

1. Paul Zumthor, *La Lettre et la Voix de la "Littérature" Médiévale* (Paris: Éd. du Seuil, 1987). See also Jan-Dirk Müller, *Minnesang und Literaturtheorie*, ed. Ute von Bloh and Armin Schulz (Tübingen: Niemeyer, 2001).

2. Malcolm B. Parkes, "Punctuation, of Pause and Effect," in *Medieval Eloquence*, ed. James J. Murphy (Berkeley: University of California Press, 1978), pp. 127–42.

3. See Max Haas, "Notation IV: Neumen," in *Die Musik in Geschichte und Gegenwart: Sachteil*, vol. 7, ed. Ludwig Finscher (Kassel: Bärenreiter, 1997), cols. 296–317; Leo Treitler, "The 'Unwritten' and 'Written Transmission' of Medieval Chant and the Start-up of Musical Notation," *Journal of Musicology* 10 (1992): 131–91; Treitler, "Reading and Singing: On the Genesis of Occidental Music Writing," *Early Music History* 4 (1984): 135–208; Treitler, "The Early History of Music Writing in the West," *Journal of the American Musicological Society* 35 (1982): 237–79; Kenneth Levy, "On the Origin of Neumes," *Early Music History* 7 (1987): 59–80; Michael Walter, *Grundlagen der Musik des Mittelalters: Schrift—Zeit—Raum* (Stuttgart: Metzler, 1994). One of the earliest musical notations is the Easter Trope *Psalle modulamini* from the first half of the ninth century (Clm. 9543, fol. 199v). See Hartmut Möller, "Die Prosula Psalle modulanina und ihre musikhistorische Bedeutung," in *La tradizione dei tropi liturgici*, ed. Claudio Leonardi (Spoleto: Centro Italiano di Studi sull'Alto Medioevo, 1990), pp. 279–96; Malcolm B. Parkes, *Pause and Effect: An Introduction to the History of Punctuation in the West* (Berkeley: University of California Press, 1993).

4. See Parkes, *Pause and Effect* (plate 19).

5. Parkes, *Pause and Effect* (plate 19). It is debatable whether the delivery changed from sung to spoken. In the late Middle Ages, the *Collatio ad mensam* was mostly delivered with a speaking voice; see Johannes Mayer, "Ämterbuch," ed. Sarah Glenn Demaris (in preparation), who comments that the reader should speak neither too low nor too high, neither too soft nor too loud.

6. Helmut Hucke, "Toward a New Historical View of Gregorian Chant," *Journal of the American Musicological Society* 33 (1980): 437–67.

7. See Michael Walter, "Sunt preterea multa quae conferri magis quam scribi oportet: Zur Materialität der Kommunikation im mittelalterlichen Gesangsunterricht," in *Schule und Schüler im Mittelalter*, ed. Martin Kintzinger (Köln: Böhlau, 1996), pp. 111–46, for the role of learning in the training of medieval monks choirs. There were about 600 melodies in the Gradual and over 2,000 in the Antiphonary to be memorized in the course of a decade of training.

8. See Heinrich Hüschen, "Notker Balbulus," in *Musik in Geschichte und Gegenwart: Sachteil*, vol. 9, ed. Ludwig Finscher (Kassel: Bärenreiter, 1997), cols. 1095–1699, plate 2, from Berlin StBPK Ms-theol. lat. IV 11 (1022–27). Only the melodies (!) are transmitted in St. Gallen, Stiftsbl., Cod. 484 (about 970), texts and melodies appear in the margins, Stiftsbl., Cod. 381 (about 1,000).

9. Hucbalt von Saint-Amand, *De harmonica Institutione*, ed. Andreas Straub (Regensburg: Bosse, 1989), p. 62, discussed frequently, for example, by Treitler, " 'Unwritten' and 'Written Transmission' "; Walter, "Sunt preterea multa."

10. See Joseph Dyer, "Schola cantorum," in *Musik in Geschichte und Gegenwart: Sachteil*, vol. 8, ed. Ludwig Finscher (Kassel: Bärenreiter, 1997), col. 1122 [1119–23].

11. Jacques Froger, "L'Epitre de Notker sur les 'lettres significatives,' " *Études Grégoriennes* 5 (1962): 23–71; even if Notker is ironically exaggerating, his letter shows a keen interest in coloring the human voice according to prescribed intentions and rules.

12. They could not be used for theoretical purposes or for polyphony; therefore, the Dasean notation was developed in the *Musica enchiriadis*; see Bruno Stäblein, *Schriftbild der einstimmigen Musik* (Leipzig:Verlag für Musik, 1975), p. 220.

13. See Parkes, *Pause and Effect*, already in Parkes, "Punctuation."

14. For an early example of neumes, see Paris, Bibl. nat. ms. fonds latin 8093, with Eugenius of Toledo, Draconius, and Ausonius from the middle of the ninth century. See Yves-Francois Riou, "Chronologie et provenance des manuscrits classiques latins neumés," *Revue d'Histoire des Textes* 21 (1991): 77–114.

15. Parkes "Punctuation," pp. 128–29.

16. Nigel Palmer, "Von der Paläographie zur Literaturwissenschaft," *PBB* 113 (1991): 235 [212–50].

17. Walter, *Grundlagen der Musik*, p. 82.

18. Cited by Christopher Page, "The Boethian Metrum," in *Boethius: His Life, Thoughts, and Influence*, ed. Margaret Gibson (Oxford: Blackwell, 1981), pp. 306–11.

19. See the plates in Andreas Haug, *Gesungene und schriftlich dargestellte Sequenz: Beobachtungen zum Schriftbild der ältesten ostfränkischen Sequenzenhandschriften* (Neuhausen: Hänssler, 1987).

20. Anna Maria Busse Berger, "Mnemotechnics and Notre Dame Polyphony," *Journal of Musicology* 14 (1996): 263–98, but this has been disputed; see Christian Kaden, " '[. . .] auf daß alle Sinne zugleich sich ergötzten, nicht nur das Gehör, sondern auch das Gesicht': Wahrnehmungsweisen mittelalterlicher Musik," in *Mittelalter: Neue Wege durch einen alten Kontinent*, ed. Jan-Dirk Müller and Horst Wenzel (Stuttgart: Hirzel, 1999), pp. 333–67.

21. Exhibition examples in the Bartók Museum in Budapest.

22. See Dietrich Hofmann, "Die Frage des musikalischen Vortrags der altgermanischen Stabreimdichtung in philologischer Sicht," *ZfdA* 92 (1963): 83–121; and Dietrich Hofmann and Ewald Jammers, "Zur Frage des Vortrags der altgermanischen Stabreimdichtung," *ZfdA* 94 (1965): 185–95. Cable's theory that one could derive the melody from the natural accentuation of the verses is questionable, because this would not allow a specific melody for each of the epics, for example, "Beowulf-mode" or a "Hildebrand's-mode." See Thomas Cable, *The Meter and Melody of Beowulf* (Urbana: University of Illinois Press, 1974).

23. See the facsimile in Hartmut Broszinski and Marc-Aeilko Aris, *Die Glossen zum Jakobusbrief aus dem Victor-Codex (Bonifatius 1) in der Hessischen Landesbibliothek zu Fulda* (Fulda: Bonifatius Verlag, 1996).

24. See the discussion in Mathias Bielitz, *Zum Bezeichneten der Neumen, insbesondere der Liqueszens: ein Hypothesenansatz zum Verhältnis von Musik und Sprache, zur diatonischen Rationalität, zur Bewegungs- und Raum-Analogie, zur*

Entstehung der Neumenschrift und zur Rezeption des Gregorianischen Chorals in Benevent (Neckargmünd: Männeles-Verlag, 1998).

25. See the facsimile in Burkhard Taeger, "Ein vergessener handschriftlicher Befund: die Neumen im Münchener Heliand," *ZfdA* 107 (1978): 184–93.

26. Taeger, "Ein vergessener handschriftlicher Befund."

27. Egon Werlich, *Der westgermanische Skop: Der Aufbau seiner Dichtung und seines Vortrages* (Diss., Münster, 1964), p. 297.

28. See Mathias Bielitz, *Musik als Unterhaltung: Beiträge zum Verständnis der wertungsgeschichtlichen Veränderungen in der Musik im 12. und 13. Jahrhundert*, vols. 1–4 (Neckargmünd: Männeles, 1998); and Bielitz, *Zum Bezeichneten der Neumen.*

29. See Bielitz, *Musik als Unterhaltung,* p. 65.

30. See Riou, "Chronologicie et provenance"; Page, "Boethium Metrum"; and see the facsimile in Stäblein, *Schriftbild,* plate 111, 4.

31. Riou, "Chronologicie et provenance."

32. See Andrew Taylor, "Was There a Song of Roland?" *Speculum* 76 (2001): 28–65; and Taylor, "The Myth of the Minstrel Manuscript" *Speculum* 66 (1991): 43–73.

33. The Codex merits a closer inspection; see Rainer Patzlaff, *Otfrid von Weißenburg und die mittelalterliche versus-Tradition* (Tübingen: Niemeyer, 1975) plate 14; James Ure, *The Benedictine Office: An Old English Text* (Edinburgh: Edinburgh University Press, 1975), pp. 83 ff., 53.

34. Johannes W.B. Zaal, *"A lei francesca" (Sainte Foy, v. 20): Ètude sur les Chansons du Saints Gallo-Romanes du XIe siècle* (Leiden: Brill, 1962); and see Jacques Chailley, "Études musicales sur la chanson de geste et ses origines," *Revue de musicologie* 85–88 (1948/50): 1–27; and Jan von der Veen, "Les Aspects musicaux des Chansons de Geste," *Neophilologus* 41 (1957): 82–100.

35. See plate 71 in Parkes, *Pause and Effect.*

36. See Friedrich Ohly, "Te autem domine miserere nobis," *DVjs* 47 (1973): 26–68; on the trope, see Chailley, "Études musicales."

37. Analecta hymnica 50, no. 208. See Karl Bartsch, *Die lateinischen Sequenzen des Mittelalters in musikalischer und rhythmischer Beziehung* (Rostock: Stiller, 1868), p. 157. A part of this *modus* was used in the sequence *De undecim milibus virginum* (ibid.).

38. The Cambridge manuscript is reproduced in Karl Breul, *The Cambridge Songs: A Goliard's Song Book of the XIth Century* (1915; repr. New York: AMS Press, 1973); for Wolfenbüttel see Edmond de Coussemaker, *Histoire de l'harmonie au Moyen Âge* (Paris, 1852; repr. Hildesheim: Olms, 1966), plate 8.

39. See Ute Schwab, "Das althochdeutsche Lied 'Hirsch und Hinde' in seiner lateinischen Umgebung," in *Latein und Volkssprache im deutschen Mittelalter, 1100–1500,* ed. Nikolaus Henkel and Nigel F. Palmer (Tübingen: Niemeyer, 1992), plate 1 [74–122].

40. See Elmar Mittler, ed., *Codex Manesse: Katalog zur Ausstellung vom 12. Juni bis 4. September 1988* (Heidelberg: Braus, 1988), p. 550.

41. See edition and commentary of Benedikt K. Vollmann, ed. *Carmina Burana* (Frankfurt am Main: Deutscher Klassiker, 1987).

42. See Walter Lipphardt, "Unbekannte Weisen zu den Carmina Burana," *Archiv für Musikwissenschaften* 12 (1955): 122–42; and Lipphardt, "Einige unbekannte Weisen zu den Carmina Burana aus der zweiten Hälfte des 12. Jahrhunderts," in *Festschrift Heinrich Besseler zum sechzigsten Geburtstag*, ed. Institut für Musikwissenschaft der Karl-Marx-Universität (Leipzig: Verlag für Musik, 1961), pp. 101–26; Michael Korth, ed. *Carmina Burana: Lateinisch-deutsch; Gesamtausgabe der mittelalterlichen Melodien mit den dazugehörigen Texten* (München: Heimeran Verlag, 1979).

43. John H. Marshall, *The Transmission of Troubadour Poetry* (London: Westfield College, 1975); Eduard Schwan, *Die altfranzösischen Liederhandschriften: ihr Verhältnis, ihre Entstehung und ihre Bestimmung* (Berlin: Weidmann, 1886); Theodore Karp, "The Trouvère Manuscript Tradition," in *Twenty-fifth Anniversary Festschrift of Queens College, New York*, ed. Albert Mell (New York: Queen's College Press, 1964), pp. 25–52.

44. See Hugo Kuhn, *Minnesangs Wende* (Tübingen: Niemeyer, 1967), plate 1. It was one parchment leaf in 8°, from the second half of the thirteenth century (?).

45. Carl von Kraus and Gisela Kornrumpf, eds., *Deutsche Liederdichter des 13. Jahrhunderts* (Tübingen: Niemeyer, 1978), p. 505 (no. 54).

46. The Münster Fragment is partially reproduced in Walther von der Vogelweide, *Die gesamte Überlieferung der Texte und Melodien: Abbildungen, Materialien, Melodietranskriptionen*, ed. Horst Brunner, Ulrich Müller, and Franz Viktor Spechtler (Göppingen: A. Kümmerle, 1977), plate 189; Mittler, *Codex Manesse*, pp. 575–76.

47. See Hans-Herbert Räkel, *Die musikalische Erscheinungsform der Trouvèrepoesie* (Bern: Haupt, 1977), p. 331.

48. See Franz J. Holznagel, *Wege in die Schriftlichkeit: Untersuchungen und Materialien zur Überlieferung der mittelhochdeutschen Lyrik* (Tübingen: Francke, 1995), pp. 36–37.

49. See Volker Mertens, "Kaiser und Spielmann. Vortragsrollen in der höfischen Lyirk," in *Höfische Literatur, Hofgesellschaft, höfische Lebensformen um 1200*, ed. Gert Kaiser and Jan-Dirk Müller (Düsseldorf: Droste, 1986), pp. 455–63.

50. See Martin Steinmann, "Das Basler Fragment einer Rolle mit mittelhochdeutscher Spruchdichtung," *ZfdA* 117 (1988): 296–310; Gisela Kornrumpf, "Konturen der Frauenlob-Überlieferung," *WSt* 10 (1988): 26–50.

51. Erich Kleinschmidt, "Minnesang als 'höfisches Zeremonialhandeln'," *Archiv für Kulturgeschichte* 58 (1976): 35–76.

52. See the list in Volker Mertens, "Ein neumiertes Minnelied aus Kremsmünster," *Beiträge zur weltlichen und geistlichen Lyrik des 13. bis 15. Jahrhunderts*, ed. Kurt Ruh and Werner Schröder (Berlin: Schmidt, 1973), pp. 71–72 [68–83]; and Walther von der and Vogelweide, ed. Brunner, plate 162.

53. See the facsimile in Peter Wapnewski, *Die Lyrik Wolframs von Eschenbach: Edition, Kommentar, Interpretation* (München: Beck, 1972).

54. Holznagel, *Wege in die Schriftlichkeit*, p. 73; See Franz H. Bäuml and Richard H. Rouse, "Roll and Codex: A New Manuscript Fragment of Reinmar von Zweter," *PBB* 105.2 (1983): 192–231; 317–30, in contrast to Michael

Curschmann, "Pictura laicorum litteratura? Überlegungen zum Verhältnis von Bild und volkssprachlicher Schriftlichkeit im Hoch- und Spätmittelalter bis zum Codex Manesse," in *Pragmatische Schriftlichkeit im Mittelalter,* ed. Hagen Keller (München: Fink, 1992), pp. 211–29.

55. Eckart Conrad Lutz, *Das Dießenhofener Liederblatt: ein Zeugnis späthöfischer Kultur* (Freiburg im Breisgau: Schillinger, 1994), p. 24; see the facsimile provided separately.

56. See Lutz, *Das Dießenhofener Liederblatt.*

57. Christoph Petzsch, *Das Lochamer Liederbuch* (München: Beck, 1967), especially "Die Beischriften."

58. Ms. L 24 (fr); see Helmut Lomnitzer, "Ein neuer Textzeuge zu Neidhart," in *Kritische Bewahrung: Beiträge zur deutschen Philologie; Festschrift für Werner Schröder zum 60. Geburtstag,* ed. Ernst-Joachim Schmidt (Berlin: Schmidt, 1974), pp. 335–43.

59. See Horst Brunner, "Strukturprobleme der Epenmelodien. Beiträge der Neustifter Tagung 1977 des Südtiroler Kulturinstituts," in *Deutsche Heldenepik in Tirol: König Laurin und Dietrich von Bern in der Dichtung des Mittelalters,* ed. Egon Kuhebacher (Bozen: Athesia, 1979), pp. 300–28; Mertens, "Zu Text und Melodie."

60. See the facsimiles in Joachim Heinzle, ed., *Wolfram von Eschenbach: Titurel; Abbildungen sämtlicher Handschriften mit einem Anhang zur Überlieferung des Textes im "Jüngeren Titurel"* (Göppingen: Kümmerle, 1973).

61. Taylor, "Myth of the Minstrel Manuscript."

62. Evelyn Birge Vitz, *Orality and Performance in Early French Romance* (Cambridge: D.S. Brewer, 1999).

63. See the discussion in Vitz, *Orality and Performance.*

64. See Holznagel, *Wege in die Schriftlichkeit: Gedrut* in A is partly identical with *Geltar* in C.

65. See Mertens, "Kaiser und Spielmann"; and the list in Maria V. Coldwell, "Guillaume de Dole and Medieval Romances with Musical Interpolations," *Musica Disciplina* 35 (1981): 55–86.

66. See Kleinschmidt, "Minnesang"; and Mertens, "Kaiser und Spielmann."

PART FOUR

SPIRITUAL VISIONS

CHAPTER 9

THE "VARIOUS WRITINGS OF HUMANITY":
JOHANNES TAULER ON HILDEGARD OF
BINGEN'S *LIBER SCIVIAS*

Jeffrey F. Hamburger

In his still unsurpassed study of English sermons of the later Middle Ages, published in 1933, G.R. Owst noted, "The contribution of English pre-Reformation preaching to this subject of pictures and statuary of the saints is in its way an interesting little contribution to the slender literature of the times dealing with early English Art, hitherto strangely neglected."[1] Seventy years later, the same could still be said, with no less emphasis, of German sermons of the pre-Reformation period. In this essay, I have no intention of attempting a premature overview of so vast a subject, especially when so much of the relevant material remains unpublished.[2] Instead, I will consider perhaps the most remarkable instance of a German sermon that takes an identifiable image as its point of departure. The sermon in question was delivered by Johannes Tauler (ca. 1300–1361) to the Dominican nuns of St. Gertrude in Cologne in 1339. At this time, Tauler, along with the rest of his community in Strasbourg, was just beginning a period of four years of exile in Basel as a result of an interdict imposed by Pope John XXII, who wished to punish Strasbourg's inhabitants for their loyalty to the emperor, Ludwig der Bayer.[3] Although the purpose of Tauler's trip to Cologne is unknown, it surely had something to do with the city's having been the seat of a Dominican Studium generale. Fully one-third of Tauler's sermon is devoted to a detailed discussion of an image in the convent's refectory. Given the paucity of such passages in sermons of any kind, an extended description of a specific image from the hand of a celebrated preacher is in

itself of extraordinary interest. Still more remarkable is that the image itself can be associated with a still more celebrated figure, none other than Hildegard of Bingen.[4] Strangest of all, however, is that, despite a veritable torrent of publications in recent years, culminating with those celebrating the nine-hundredth anniversary of Hildegard's birth, Tauler's interest in Hildegard has gone virtually unnoticed.[5]

Tauler's sermon, which is of unquestioned authenticity, leaves no doubt that the image in the nuns' refectory was a fairly exact copy of the miniature of God enthroned prefacing the first vision in Book I of the *Liber Scivias* (figure 9.1). All too predictably, nothing of the image or, for that matter, of the convent's buildings, survived; the entire complex was sold following secularization in 1802/03 and torn down in 1808.[6] Nonetheless, Tauler's sermon offers an extraordinary opportunity to observe a prominent medieval mystic interpreting an enigmatic image by one of the most inventive thinkers of the Middle Ages (and artists, assuming one accepts Hildegard's authorship of the images). At issue is more than simply an early episode in the reception of Hildegard's most celebrated work, which Tauler appears to have known, be it indirectly or directly from the earliest illustrated copy, the Rupertsberg Codex, formerly in Wiesbaden, but probably lost in World War II. His sermon offers a very personal and paradoxical reading of Hildegard in which he, a preacher of imagelessness (*Bildlosigkeit*), seeks to reconcile his mystical theology with the teachings of a prophetic visionary. Tauler links his insight to Hildegard's visionary powers, even as he tailors her prophecy, written some two hundred years earlier, to the requirements of the contemporary *cura monialium*, the pastoral care of nuns.

Sermons are but one significant category within a larger array of genres requiring performative reading that, at its most expansive, could be taken to include everything from meditation to certain forms of liturgical celebration. In manuscripts, in which words and images were literally bound together, the expectation or necessity of oral performance left its mark on the visual presentation of the page in the form of visual cues ranging from the earliest forms of punctuation—some of which are derived from musical neumes—to florid figural initials that invited the reader to incorporate the text and enact its meanings.[7] The text of a sermon was not always associated with an act of oral delivery, but, as Michael Camille has noted, throughout much of the Middle Ages text and image both remained "secondary representations, external to, but always referring back to, the spontaneous springs of speech."[8] Sometimes, however, as in the case of sermons, the speech in question was anything but spontaneous, even if a preacher's presence in the pulpit could lend the spoken word an unrivaled immediacy. Images, whether real or imagined, could structure speech, serving as mnemonic pegs on which a preacher could hang a series of points and, at the same

altam pfunditatem expofitionif libror̄.
ut p̄dixi fentenf. utribufq; receptif.de
egritudine me erigenf. ux opuf iftud.
decem annif confummanf. ad fmem
p̄dixi. Jn diebus autem heinrici
moguntini archiepi. 7 Conradi roma
norum regis 7 Cūnonif aħatif in
monte beati dysibodi pontificif.
fub papa Eugenio he uifiones 7 uerba
facta funt. Et dixi 7 fcpfi hec ñ fecundū
adinuentionē cordif mei aut ulluif ho/
minuf. fed ut ea in celeftib̄ uidi. audiui
7 pcepi p̄ fecreta mifteria di Et iterum
audiui uocem de celo michi dicentem.
Clama ḡ 7 fcribe fic.

Jncipiunt capitula libri scivias
sioplicis ho oi ḡ i s....
Capitula pime ufionis pime partis.
1. De fortitudine 7 ftabilitate et̄mitati
 regni dei.
ii. De timore domini.
iii. De hif qui paupes fp̄u funt.
iiii. Quod uirtutef a dō nemeantef. trinitef õm
 7 paupes fp̄u cuftodiunt.
v. Quod agnitiom di abfcondi ñ poffint
 ftudia actuum hominum.
vi. Salemon de eadem re.

9.1 Hildegard of Bingen, *Liber Scivias* (last third of twelfth century), Book I, Vision I (Abtei Eibingen, 1927–1933). Wiesbaden, Hessische Landesbibliothek, Hs. I, fol. 2r. Repro: Rheinisches Bildarchiv Köln.

time, make his words more memorable for his audience.[9] Rarely did the written text of a sermon provide the "script" for oral performance or provide an exact record of an oral delivery. In written, as opposed to spoken form, the sermon supplied either a model or a ready literary form, closely related to the treatise, tract, and pastoral letter, with which to convey a particular content.[10]

In any of these modes, sermons that refer to art, let alone expound on individual works, remain surprisingly rare.[11] The numbers dwindle further still when one excludes those sermons that confine themselves to either condemning the abuse of images or, by way of response, offering an apology in their defense.[12] In the early fifteenth century, Gerson, the chancellor of the University of Paris, compared a good sermon to a pious painting when he remarked that "good, saintly, and devout words, paintings and texts inspire devotion, as Pythagoras said," adding "that is why sermons are composed and images painted in churches."[13] The only unexpected part of this pronouncement is its attribution to the Greek philosopher. To judge from the sermons themselves, however (at least those that have been published), most medieval preachers were blind, not simply to the beauty, but also to the utility of the images that adorned the churches in which they preached (including the decoration of the chancels from which they spoke).[14] Some preachers, most notably, Bernardino of Siena, were celebrated for making use of what we might call "visual aids," in his case, a small panel bearing the monogram of Christ.[15] Representations of preachers (the majority of them Italian panels portraying canonized mendicants), including those of Bernardino, portray them preaching against the backdrop of church façades, but do not allow one to draw any conclusions as to what references they might have made to their surroundings.[16] Guided by the liturgical calendar, preachers took Scripture as their primary point of departure; it appears that visual images based on Scripture or legends were perceived as secondary in status, hardly worthy of extended exegesis in their own right. Images, most often Marian cult statues, make cameo appearances embedded in exempla, but not always in a positive light.[17] To the extent that preachers refer to images, it is primarily as illustrations or metaphors, verbal props to score points about unrelated matters. Thus, Bonaventure, preaching to nuns in France, apologizes for his imperfect command of the vernacular by comparing a well-ordered sermon, beautifully spoken, to the crystalline clarity of a well-designed stained-glass window.[18]

Despite the apparent indifference suggested by the sources, it would be mistaken to discount the significance of sermons for the study of medieval art. Research on the relationship between word and image in the Middle Ages inevitably focuses on illuminated manuscripts. Yet many of the canonical texts that address text-image relationships, beginning with Pope Gregory the Great's letter to Serenus of Marseille, take as their primary point of reference, not manuscripts, but monumental wall paintings (and later, statuary and stained-glass windows).[19] It was against this panoramic and often overpowering backdrop of monumental art that most medieval churchgoers took in whatever they could glean of the history of salvation by listening to sermons. In a manuscript, the association between text and image, although

open, is in some ways fixed (unless the manuscript undergoes alternations). In the case of wall paintings, however, the situation is potentially much more fluid and fleeting. Tituli and inscriptions provided a frame of reference and, at the same time, reminded illiterate viewers of the extent to which, in Herbert Kessler's words, "the mysteries of Christianity remained locked in words."[20] The integration of monumental images within liturgical rites provides one example of rituals that integrated the spoken word with visual images in repeatable, if not necessarily identical, performances.[21] In most instances, however, the link between monumental images and the spoken word was both variable (in that, depending on the occasion, the same speaker might have referred to a given image in different ways at different times) and evanescent (in that whatever impromptu references to images a preacher might have made have inevitably gone unrecorded). In the late Middle Ages, most preachers were itinerant: in sermons that circulated in written form, gestures toward specific works of art would have been both gratuitous and bewildering unless they involved images so generic in nature that any viewer would have been able to conjure them up in their imagination. All these factors conspire in accounting for what otherwise seems inexplicable, namely, the striking absence of references to specific works of art in the overwhelming majority of sermons that have come down to us.

From the thirteenth-century set of sermons formerly attributed to the St. Georgener Prediger comes a homily that conforms to this general pattern by seeking to defend the utility of all religious imagery rather than refer to a specific work of art.[22] The collection, which may be Cistercian in origin, gathers several bodies of sermons under one name derived from the provenance of a single manuscript and hence can more accurately be called the St. Georgen Sermons than attributed to an anonymous preacher from St. Georgen.[23] The sermon, which is part of the core corpus, appeals to Gregory the Great's dictum that images are the Bible of the illiterate, without, however, so much as mentioning the pope by name.[24] Of specific concern to the author, who wrote at least several generations before Tauler, most likely in the mid–thirteenth century, are narrative cycles of scenes from the lives of saints, a genre well attested in both manuscripts and wall paintings of the period.[25] One can easily imagine any particular performer of such a sermon gesturing to whatever images populated the space in which he happened to find himself.

Considerably less conventional, however, is the preacher's insistence on the equality of word and image as means of access to sanctity.[26] The sermon is entitled, "Von månger hande schrift der mentschait," a heading that can only loosely be translated as "Of the various writings of humanity."[27] The preacher's point of departure is Psalm 86.6: "Dominus narrabit in scripturis populorum," "The Lord shall tell in writing of peoples."[28] The preacher

translates this as "Got sol kúnden an der schrift den lúten" [The Lord shall proclaim to the peoples in writing (or according to Scripture)], a formulation that more explicitly invests God's writing, as opposed to his speaking voice, with the authority of revelation. The preacher elaborates that Scripture teaches us in two ways ("In zwo wis") about two topics: first, the best path to heaven ("an den rehten weg ze hýmelriche") and second, a good and proper life ("an rehtes leben"). Like the sun penetrating and clearing a fog, Scripture informs and enlightens all Christian folk ("die christenhait"), including the utterances of Christ ("dú hailig lere die úns Gottes sun lerte mit sin selbes munde"), and the teachings of the prophets, apostles, and saints, all of whom were inspired by the Holy Spirit ("den der hailig gaist kunte und lerte wie si die hailig cristenhait leren soltent"). Once again, the preacher gives priority to the written, rather than the spoken word. The inversion might seem to undercut the authority of his own voice, but it places him and, more important, the body of his text, in an authoritative succession of teachers. The sermon's somewhat unfelicitous formulation could be read as suggesting that even Christ merely mouths the inspired teachings of Scripture. More likely, the preacher wished to ascribe to his own writing the authority of biblical writ.

To the spoken and written word, the preacher then adds what he calls the "scripture of the laity" [der laýgen schrift], a literal translation of Gregory's "littera laicorum." In this context, *laity* means not simply those lacking clerical orders but anyone unable to read Latin.[29]

Our Lord has also given us another scripture, that is, the scripture of the laity, for there are many people who can't read what's written in books. God has therefore given them another form of writing, from which they learn how they should strive to enter heaven. This writing consists of the paintings of the saints in the churches, how they lived, and what they did through God, and what they suffered on his account. One does that, for example, through many things. One thing is that they should learn from the lives of the saints how they ought to hope and aspire to the heavenly kingdom, just as did the saints. The second thing is that they will be strengthened in their true faith in seeing what the saints suffered for their true faith. And the third thing is that when our heart is unsteady and unfortunately seldom at rest with itself, then the person [looking at the paintings] finds his heart in the images [sin hertze denne an dem gemålde vindet] as he looks at the things that are painted before him and then afterwards considers it inwardly [or by heart, "inwendig"]. So says the proverb: "I have found my heart" [cf. Ecclesiasticus 51:27]. Now note well: whatever a person finds must first have been lost. It often happens that a person who unfortunately loses his heart with vain thoughts, he should find it again in the paintings. The fourth thing that one learns from the lives of the saints is virtue and purity.

In this passage, which departs both from Gregory's original and many of the conventional commentaries on it, the preacher assimilates the pope's teaching to Augustine's theory of memory.[30] Evoking imagery of restoration usually employed in discussions of the recovery of the *imago Dei*, the sermon argues that pictures, especially scenes from saints' lives, have the capacity, not merely to instruct, but to stir the affections, displacing worldly images with the memory of the images originally implanted there at the moment of creation. In a process of displacement, a set of authorized material images, namely, the paintings on the wall, takes the place of a set of mental images that—so the sermon argues—have themselves usurped the place previously occupied by an uncorrupted, paradisiacal self.[31] The heart itself is imagined as a painted chamber; the task of the individual soul is to redecorate this interior in seemly fashion.[32] To look at the lives of the saints and to learn their lessons by heart is, in effect, to restore the imagination to its original purity and splendor.

In the end, however, the preacher declares the image of Christ's body the only book worth reading: "But above all paintings [úber allez gemålde] and above all images [úber ållú bilde] we should regard the image of the suffering of our beloved lord" [únsers lieben herren marter bilde].[33] At this critical juncture, the preacher does not, as one might expect, direct the reader neither to some place beyond representation, nor even to the body of Christ. Instead, he directs his or her attention to a representation of Christ's body, in accordance with the unspoken notion that Christ himself is the perfect image of the invisible Father. In keeping with his previous argument, the preacher characterizes Christ's image ("bilde") ambiguously: as a recollected image of Christ's suffering and, no less, a visual representation of Christ's Passion.[34]

The rest of the sermon consists of eight lessons or readings ("leccen") to be drawn from this exemplary representation, which the preacher simultaneously characterizes as a text, written by Christ for his followers on the parchment of his body ("acht leccen, di er úns vor hat geschriben an sim hailgen libe").[35] To ensure that the reader does not lose sight of word or image, but rather maintains their essential equivalence, each of the eight lessons links a specific moment during Christ's crucifixion to a short passage from Scripture, for the most part, words spoken by or to Christ on the cross. For example, the first lesson links Christ's nudity (representing his Poverty of Spirit) with Matt. 5:3 ("Blessed are the poor in spirit, for theirs is the kingdom of heaven"), the third, his forgiving the repentant thief (representing his mercy) with Luke 23:42–43 ("Lord, remember me when thou shalt come into they kingdom, and Jesus said to him: Amen I say to thee, this day thou shalt be with me in paradise"), the fifth, his sunken head (representing his pious obedience) with Luke 23:46 ("Father, into thy hands

I commend my spirit"), and the eighth and last, long prayer ("lang gebet"), with Christ's supposedly having recited praying one hundred and fifty verses from the psalms (prayer) while nailed to the cross.[36] In keeping with Christ's two natures, Word and flesh, the sermon insists on the equality of text and image with remarkable consistency. Having argued for the essential equality of these two forms of divinely inspired "writing," the sermon concludes by providing a set-piece devotional exercise that requires of the reader a combination of recitation and visualization.

Tauler's sermon is considerably more complex in the demands that it makes of its audience, initially, the Dominican sisters of St. Gertrude, but, eventually, by virtue of its dissemination, a broader public that included men as well as women and members of the laity as well as members of various orders. Of the thirty-five extant manuscripts that include the sermon, none can be traced to the library of St. Gertrude itself, although it is known that the community once possessed copies of the text.[37] The nuns clearly had firsthand familiarity with the images to which Tauler refers; he speaks of those things that "wart der edelen creaturen S. Hiltgart geoffenbart under vil minneklichen dingen, und stet also in S. Hiltgarten buche gemolet und och in unser swester reventor zwei kleine bildelin," those things that "were revealed to the noble creature St. Hildegard among many other blessed things, and which are painted in St. Hildegard's book and also two little images in our sisters' refectory."[38] The precision with which the Dominican describes Hildegard's paintings (which Tauler, contrary to some modern scholars, attributes directly to her) leaves no doubt that, at a minimum, he knew both the text and the illustrations to Book I of the *Scivias*. His familiarity might have been limited to what he had seen in the refectory (assuming he had gained access to the enclosed parts of the convent, which was by no means unlikely). But that would leave unexplained his knowledge of the accompanying text, which is too long to have accompanied the images in the form of an extended caption or titulus. A derivation from an unillustrated copy of Hildegard's text can be ruled out on the basis of details described by Tauler that are found only in the accompanying illustration. Similar considerations rule out Tauler's having drawn on Gebeno von Eberbach's *Pentachronicon*, a compilation of Hildegard's works that circulated widely and that included portions of the *Scivias*, but none, however, of Book I.[39] Less clear is how the maker of the image in the refectory, be it one of the nuns or an artist working for one of their patrons, would have gained access to the exemplar, or how the exemplar, if it was indeed the Rupertsberg Codex, was transmitted to the artist. It is easy enough to posit the existence of copies, but far more difficult to make a convincing case for their existence. In all likelihood, both Tauler and whoever commissioned and made the copies in Cologne had somehow managed to gain access to

the famous Rupertsberg Codex, in the fourteenth century still housed at Hildegard's abbey, where it must have acquired a certain celebrity status (although surely less so than today). The only other possibility—tantalizing but exceedingly unlikely—is that Tauler and the nuns had access to a virtually identical but otherwise unrecorded copy that circulated in the Rhineland in the fourteenth century.

Tauler describes Hildegard's painting at considerable length, not simply to underpin his explanation of their meaning, but also to make his exposition comprehensible to subsequent readers who would not have had the benefit of seeing the image first hand.[40] From Tauler's characterization, it is impossible to say just what form the picture took. Tauler's description of the copy as "two little images" [zwei kleine bildelin] initially suggests two small miniatures or drawings, akin to the *Nonnenarbeiten* (devotional drawings) popular among Dominican nuns.[41] From the ensuing text, however, it emerges that by *bilde* Tauler, following Hildegard, means not free-standing, independent images, but rather "figures," in keeping with one meaning of the Latin *imago*, which, when it referred to a work of pictorial art, meant, above all else, a likeness or "portrait" of a holy personage. Although the figures (*imagines*) themselves—both of them personifications—may have been small, the image incorporating them might have been larger, just as in the illustration to Hildegard's *Liber Scivias*, the figures take up only a small portion of the pictorial space (figure 9.1). Given the communal character of the refectory, where sermons such as Tauler's may well have been read out to the nuns during their meals, one can imagine either a wall painting, large enough to be visible at a distance, or, no less likely, a wall-hanging, perhaps an embroidery.[42] Less likely, if not altogether implausible, is that Hildegard's *Scivias* itself provided material for refectory readings, in which case the images on the walls would have provided the perfect accompaniment.[43]

Virtually nothing is known about the decoration of refectories in Dominican cloisters north of the Alps.[44] In Italy, murals of the Last Supper were predictably popular, but refectories could also include complex diagrammatic imagery akin to that found in contemporary sermons, for example, as found in the refectory of Santa Croce in Florence, where around 1350 Taddeo Gaddi placed a monumental *lignum vitae* immediately above the Last Supper below.[45] At St. Gertrude's, another possibility that cannot be excluded is a panel painting. None of these media would have been out of place in the convent, from which images of various kinds are attested, including stained-glass windows of the late thirteenth century, a fragment of an altarpiece, dated ca. 1470 attributed to the circle of the Master of the Legend of St. George, and, most interesting, a devotional panel measuring 73.5 × 59 cm, also dated ca. 1470, which combines an allegory of the *imitatio Christi* with scenes of the martyrdom of saints, some

of them with names such as Wisdom (Sophia), Faith, Hope, and Charity
that could easily have been mistaken for personifications despite their status
as real Christian martyrs (figure 9.2).[46] The lines dividing the living, the
dead, and figures of spiritual allegory are blurred still further in the central
scene, in which two nuns, identified as Purity ("Reynicheit") and Willing

9.2 Mary mourning the Crucifixion, the martyrdom of the Maccabees, Christ
greeting Purity and Willing Poverty, the rescue of a drowning monk, Sophia at the
execution of her daughters, Faith, Hope, and Charity. Panel from St. Gertrude's,
Cologne (ca. 1470), 73.5 × 59 cm., Cologne, Wallraf-Richartz-Museum, Inv.-Nr.
340–42.

Poverty ("Woyllich armoyt")—the latter also figuring prominently in Tauler's sermon and Hildegard's vision—carry a cross toward the portal of a convent, where the resurrected Christ greets them with words borrowed from the Song of Songs: "komt in mynen wyngart" [Come into my vineyard].[47] Above Christ's head stand two statues of the convent's patron saints, Thomas Aquinas and Gertrude of Nivelles. Although much later in date than the image to which Tauler refers, the panel is consistent with the sermon in at least two respects: its reverence for holy women of a bygone era and its extensive use of personifications, a relative rarity in devotional painting of the period.

Tauler's discussion of the *Liber Scivias* occupies the final third of the sermon, in which Hildegard, whom he regards as a saint, is invoked as an authority by way of exemplifying the preceding argument. Tauler's commentary on Hildegard represents more than a coda or tailpiece: his entire exposition is governed by an iconographic imagination of a peculiarly paradoxical sort, in keeping with the *Bildlosigkeit* (imagelessness) that constituted a major theme within Rhenish mysticism.[48] In another sermon, Tauler, who also cites Gregory the Great, maintains that even "the slightest little image willingly retained" [ein ieklich biltlin mit willen besessen] will cost one time in purgatory.[49] Yet his sermon on Hildegard, whom he reveres and respects, is laced with implicit and explicit references to imagery of all kinds, pictorial and imagined. His entire sermon is haunted by images, be it in a positive sense, by their presence, to which he responds, in the form of his commentary, or, conversely, in a negative sense, by their absence, for which he calls from the very beginning. Tauler's images collapse in on and contradict themselves, offering a medieval model of deconstruction based on the dictates of negative theology.[50] More than rhetorical flourishes, the paradoxical images that structure his sermon constitute its very subject matter.

That Tauler, who consistently proclaimed the importance of inwardness and indifference to images, should comment so expansively on a work of art captures the contradiction in a nutshell. The theme of interiority, which for nuns within enclosure would have taken on added significance, is present right at the beginning of the sermon, which glosses Luke 19:5: "In domo tua oportet me manere" [For today I must abide at thy house]. In the Gospels, Christ addresses these words to Zaccheus, who climbed into a sycamore tree ("sycomorus") on account of his small stature so as to see better the Savior as he enters the city of Jericho. In the end, however, Zaccheus must descend if he is to receive the Savior in his house. Tauler selects this passage from the liturgy for the consecration of a church to commemorate the consecration of the cathedral of Cologne.[51] The house to which he applies the words from Luke is, first of all, the church itself, in which the reader is invited to abide. More important, however, the church

(*ecclesia*) provides an analogy for the individual soul (*anima*), which, like Zaccheus, needs to come down from her perch into order to allow Christ in.[52] Christ's entry into Jericho anticipates his entry into Jerusalem. In like fashion, Zaccheus's descent from the tree at Christ's behest anticipates the descent of the heavenly Jerusalem as the bride of the Lamb (Rev. 21:2–3: "And I saw the holy city, new Jerusalem, coming down out of heaven from God, prepared as a bride adorned for her husband").[53] Tauler does not spell out the implicit connection between these two passages, but the continuation of Revelation underscores his true theme: "Behold, the dwelling of God is with men" (Rev. 21:4). Tauler declares: "and as I said yesterday: all expressions and activities of the holy church, they all indicate the inward person [den innewendigen menschen] in whom in truth the consecration of the church and a true renewal should take place without interruption."[54] This turning inward and spiritualization of sacred history are constant features of Tauler's thought; elsewhere, in a Christmas sermon, he argues that for God to be born in the soul, "a reversal must necessarily take place," "there must be a definite introversion, a gathering up, an inward recollection of faculties without any dispersal, for in unity lies strength."[55]

In keeping with his negation of vision, Tauler links descent with introspection, a looking inward and away from the world. In characterizing the mystical path as an inward turn, rather than an upward process of elevation and ascent, Tauler proves that he is a faithful follower of a tradition that has its origins in Augustine.[56] Taking up the idea, so central to Christian doctrine, that in order to ascend one must first descend, Tauler invites his readers to embark on a process of progressive withdrawal. To this end, Tauler recommends "bodily exercises" [lipliche ubunge] for those who can manage them:

> The consecration of a church means as much as a renewal. As soon as this renewal take places, nature denies itself and is repressed in all its adhesions and attachments [in aller kleblicheit und anhenglicheit] in which it finds itself, be it friends or relatives, and all those things in nature that happen to come from outside must henceforth be done away, and also all those things in which nature takes pleasure with all her senses or powers, in all her ways and works [wisen und werken]. For this, bodily exercises, such as fasting and vigils, are good and useful, if the constitution is able to bear them.[57]

Like Zaccheus, the soul must act against its natural instincts and come down from its vantage point in order to enter into Christ's true house, namely, heaven. Tauler's turn inward is not entirely Augustinian, however. According to the church father, the turn inward allows man to reflect on the image in which he was made, itself a reflection of the Trinity. Yet in Tauler's scheme, which depends heavily on the teaching of Meister Eckhart, interiority is inimicable to any kind of imagery. To enter into oneself is not to embark on

a voyage of self-discovery, but rather to seek a kind of erasure or nothingness. Suppression of the senses is the goal, a systematic shutting down of any kind of interaction with the outside world:[58]

> Children [Kinder], you do not notice how covertly and secretly nature seeks its own and takes great pleasure there where one is accustomed to relieve nature [or "take care of necessities"]. The rational man should energetically assume mastery over the bodily man. This must be pursued with perseverance. At first, this hurts very much: to die to all higher desires for food, drink, seeing [sehende], hearing, going, staying, words and works [an worten und an werken].

Tauler's imagery conjures up the traditional battle between body and spirit, but presents it less in terms of combat than cooperation, the subordination of lower to higher.[59] It is not the "spiritual man" but the "vernúnftige mensche," the "rational person," his higher powers, that should master the body and its desires.[60]

There is undoubtedly something paradoxical about a sermon that begins by asking its audience to strip itself of sensory impressions of all kinds, only to conclude by appealing to the authority of images associate with a celebrated visionary. It is as if Tauler, despite his call to his audience to dismiss images, nonetheless sees Hildegard's "figures"—be it in their written or painted form—as vehicles that provide access to the visionary experience that ostensibly stands behind them. In effect, Tauler grants Hildegard's prophetic visions the same authority as Scripture, then vests himself in that authority. In this respect, Tauler follows Hildegard's lead; she glosses the "transcript" of her visions line by line in the manner of scriptural commentary. But Tauler's rhetorical strategy suggests more than indifference to images. There is no reason to think that Tauler was hostile to images, let alone an advocate of iconoclasm. At issue is not whether, but how images should be perceived. And on this subject, too, Tauler is not silent. Like Eckhart before him, Tauler uses the process of perception as a metaphor for the experience of mystical union. In a sermon for Christmas, Tauler compares the process of mystical union to the process by which the eye perceives an image on the wall:

> For if two are to become one, one must be passive, whereas the other must act. If, for instance, my eye is to receive an image on the wall, or anything whatever, it must first be free from other images; for if there remained an image of color, it could not receive another. . . .In short, whatever should receive must first be empty, passive, and free.[61]

Tauler's sermon on Hildegard's image could be read as invitation to enact this metaphor of mystical experience. One must empty oneself of outward images in order to make room for the kind of inner vision of which he regards Hildegard's *Scivias* an acceptable and authoritative exemplar.

Tauler's definition of mystical union in terms of the mechanics of perception is no idle analogy. The vision of God represented the summit of Christian aspirations. Tauler's understanding of empirical perception goes a long way to defining the core of his religious philosophy.[62] A comparison with Meister Eckhart is instructive. Eckhart states: "An eye is nobler in itself than an eye that is painted on a wall."[63] Eckhart's choice of image is hardly coincidental; the eye he has in mind is none other than the all-seeing eye of God.[64] The disembodied eye also stands for the intellect that, in striving for union with God, comes to see all. Elsewhere, Eckhart states: "The eye with which I see God is the same eye with which God sees me: my eye and God's eye are one eye, one seeing, one knowing and one love."[65] In keeping with the Neoplatonist underpinnings of his thought, Eckhart characterizes the eye's activity primarily (although not exclusively) in terms of extromission, that is, the notion that the eye grasps the object of perception by emitting an effluent, variously characterized as a "visual fire" or "ray," that coalesces with sunlight before extending toward the object of perception.[66] Eckhart's theory of vision is notably at odds with theories current in his day, which, whatever the differences among them, were predicated on the idea of intromission, that is, of rays emanating from the object somehow imprinting themselves on the mind through the medium of the eye. Heinrich Seuse ("Henry Suso," ca. 1295–1366) also characterized mystical sight as an inversion of empirical vision. To see Christ—"to be freed from the forms of creatures, formed with Christ, and transformed in the Godhead"—"the eye should not look outward unless it carries images forth."[67] Insisting on a systematic, step-by-step short-circuiting of the imaginative process, Seuse instructs his readers to "close your sense to all forms you encounter. Free yourself from everything your external judgment chooses, which binds your will and causes pleasure to your memory."[68] In contrast, Tauler proposes a variant of the passivity that makes his theology open to the charge of quietism. The mind must make itself a blank slate so that God, to use the terminology of the St. Georgener Prediger, may write upon it, in images as well as words.

Spiritual poverty and passivity, *gelossenheit* (hardly translatable simply as "composure") are the themes that link Tauler's spirituality to Hildegard's vision, as he reads it.[69] Hildegard's first vision opens with an evocation of the blinding light of the Godhead: "I saw a great mountain the color of iron, and enthroned on it One of such great glory that it blinded my sight."[70] Tauler characteristically sets his sights lower, on the two little figures ("zwei kleine bildelin")—for which Hildegard uses the term *imago*—that stand at the foot of the mountain: Fear of the Lord and Poverty of Spirit.[71]

The first, she is wrapped in a blue garment and has no eyes on itself, and her garment, that is all completely full of eyes, and that means the holy fear

of God. But this isn't fear in the sense that you understand it; rather it is a persistent examination of the self by itself in all places and ways, in words and works. And it is therefore without a face and has no eyes, because she forgets herself, whether one loves or hates her, praises or scolds her. And she is without hands, for she stands free of all comforts in all ways, with proper calm and composure [gelossenheit].

Tauler's description does not depend on Hildegard's initial vision, which itemizes the attributes of the figures, without, however, assigning them any meaning.

Before him, at the foot of the mountain, stood an image full of eyes on all sides, in which, because of those eyes, I could discern no human form. In front of this image stood another, a child wearing a tunic of subdued color but white shoes, upon whose head such glory descended from the One enthroned upon that mountain that I could not look at its face. But from the One who sat enthroned upon that mountain many living sparks sprang forth, which flew very sweetly around the images. Also, I perceived in this mountain many little windows, in which appeared human heads, some of subdued colors, and some white.[72]

Instead, Tauler takes as his text Hildegard's subsequent commentary:

And before him at the foot of the mountain stands an image full of eyes on all sides. For the Fear of the Lord stands in God's presence with humility and gazes on the Kingdom of God, surrounded by the clarity of a good and just intention, exercising her zeal and stability among humans. And thus you can discern no human form in her on account of those eyes. For by the acute sight of her contemplation she counters all forgetfulness of God's justice, which people often feel in their mental tedium, so no inquiry by weak mortals eludes her vigilance.[73]

Tauler's reiteration of Hildegard is marked by significant differences. Hildegard's humble figure of contemplation bears little resemblance to the figure drawn by Tauler. Whereas Hildegard emphasizes *timor Dei* as a counter to forgetfulness of God's justice—the eyes signifying the watchfulness that guards against tedium—according to Tauler, the same figure represents *gelossenheit*. Instead of preventing others from forgetting themselves and God's mercy, Tauler's *timor Dei* fends off self-regard in a spirit of abnegation. Hildegard's figure is a Christian Argus, all eyes in the acuteness of her contemplation. According to Hildegard, one cannot discern the figure's human form on account of her being covered with eyes. According to Tauler, however, she has no eyes at all. Rather, it is her garment that is covered with eyes. Tauler also notes that the color of the garment is blue, a detail that

clearly was inspired by his inspection of the image, as Hildegard makes no mention of its color. In addition, Tauler remarks that the personification has no hands, an observation also based on the image, in which no hands are visible, and in which the eyes appear as if they had been applied to the exterior of the shroudlike cloth enveloping the figure from top to toe. Hildegard's figure, at least on the surface, is represented as a kind of overseer, standing outself the self and looking in ("exercising her zeal among humans"). In contrast, Tauler's equivalent stands for self-discipline, fending off any presumption of worth in word or deed or self-regard ("anemelicheit") from within. Tauler's handling of the second "image," the personification of Willing Poverty of Spirit, is marked by a similar combination of close observation of Hildegard's image and subtle departures from her text. Like the Fear of the Lord, Willing Poverty, in Tauler's characterization of her, is also without eyes and hence blind:

> And there was another standing nearby in a white dress with upheld hands, and both of them were barefoot, and the second one didn't have a head, for above this one stood the Godhead in a pure, clear gold, and it had no form of face other than a brilliant gold and signifies the unknowable Godhead. And this gold flowed down upon this image [bilde] on the place of the head, and the Godhead is its head. And the image signifies the true poverty of spirit whose head is God's own. This paleness of the dress means simplicity of the transformation [wandelunge], freedom from self-regard and free, pure "gelossenheit." They both stood with bare feet; that signifies the naked imitation of the true image of our Lord Jesus Christ.[74]

Compare this with Hildegard's interpretation of her own vision:

> And so before this image appears another image, that of a child, wearing a tunic of subdued color but white shoes. For when the Fear of the Lord leads, they who are poor in spirit follow; for the Fear of the Lord holds fast in humble devotion to the blessedness of poverty of spirit, which does not seek boasting or elation of heart, but loves simplicity and sobriety of mind, attributing its just works not to itself but to God in pale subjection, wearing, as it were, a tunic of subdued color and faithfully following the serene footsteps of the Son of God.[75]

Hildegard bases her characterization of Poverty of Spirit on a common ideal of imitation, according to which mankind should retrace the *vestigia* (literally, footsteps) or traces of Christ. For Hildegard, writing in the twelfth century, the traces in question are first and foremost the marks traced on the soul's interior at the moment of its creation *ad imaginem et similitudinem dei* (Gen. 1:26).[76] By the early fourteenth century, however, the concept of

following the naked Christ naked (*nudus nudum Christum sequi*) had been exteriorized in ways that Hildegard could hardly have imagined.[77] Dominican nuns, like those to whom Tauler preached at St. Gertrude's in Cologne, read about, even if they did not practice in person, gruesome and literal reenactments of Christ's Passion.[78] Complementing such accounts, contemporary images gave literal embodiment to the idea of Christ's *vestigia* in the form of bloody footsteps marking the road to Calvary (figure 9.3).[79] Tauler's insistence on "the naked imitation of the true image of our Lord Jesus Christ" [die blosse nachvolgunge des woren bildes unsers herren Jhesu Christi] must be read against the foil of this form of very corporeal devotion to the Passion. Tauler seeks to deemphasize the bodily conception of the *imitatio Christi* that had broad currency in the piety of Dominican nuns.[80] Elsewhere, he goes out of his way to gloss Christ's footsteps (*fuosspúren*) in spiritual terms: "And that is his justice: that one finds this in the true footsteps: in true, 'gelassen' hopelessness, in willing poverty of spirit, in suffering."[81] In his consecration sermon, the "nakedness" to which he refers takes on another meaning: beyond the divestiture of property and possessions, an inner nakedness, denuded of the mental images that connote attachment to worldly things, consistent with the Poverty of Spirit embodied by the personification.

Tauler largely ignores the figure of the enthroned Godhead above the two personifications, noting only in passing that "wan ob disem stat die gotheit in einem luteren klaren golde, und das enhat nút förmliches antlites deune ein luter gott und meint die unbekentliche gotheit" [above these (two) stands the Godhead in a pure, clear gold and it had no form of face other than a brilliant gold and signifies the unknowable Godhead].[82] Assuming that the image in the refectory somehow reproduced the whole of the image illustrating Hildegard's vision, Tauler's oversight must have been all the more striking, at least to the nuns to whom the sermon originally was delivered. Hildegard, in contrast, makes the outpouring of glory from the mountaintop integral to the meaning of the second personification: "Upon her head descends such glory from the One enthroned upon that mountain that you cannot look at her face; because He Who rules every created being imparts the power and strength of this blessedness by the great clarity of His visitation, and weak, mortal thought cannot grasp His purpose, since He Who possesses celestial riches submitted himself humbly to poverty."[83] In effect, Tauler decapitates the image, omitting almost entirely any discussion of the dominant winged divinity seated at its summit. Confronted with the direct vision of the ineffable divinity the mystic simply falls silent.

Confronted, however, on a daily basis with Hildegard's vision of the divinity, the nuns could hardly have failed to notice it. Nor is the divinity

9.3 *Arma Christi*. Bibliothèque Royale Albert Iᵉʳ, Brussels, Ms. 4459–70, fol. 152v.

absent from Tauler's vision: what merely seems absent asserts its presence in more subtle ways. In his transmutation of Hildegard's text, the "soft shadow" cast by her vision of "One of such great glory," which she compares to a "wing of wondrous breadth and length," figures elsewhere in the form of three pairs of allegorized wings. One can easily imagine this figuration to have taken on visible form in the tradition of medieval didactic diagrams and *carmina figurata*, picture poems.[84] Be this as it may, as always in medieval manuscripts, the layout of the text lends the written word itself the character of an image:

> Die einen veder das sint der tuben vederen.
> Die ander wandelunge die ist über die vederen des aren.
> Die dritte wandelunge die ist über die vederen der winde.
>
> [The first feathers are dove's feathers.
> The second act of walking is upon the feathers of the eagle.
> The third act of walking is upon the feathers of the winds.][85]

At first reading, Tauler's enumeration of the three pairs of wings appears to refer to the Trinity, with the dove figuring the Holy Spirit, the eagle, Christ, and the wind, the invisible Godhead.[86] His reference to the wings of the wind draws on cosmic diagrams that portray wind personifications as winged heads.[87] In essence, however, the passage constitutes a gloss on a verse from the Psalms. Referring to the sense impressions that hinder the soul in its approach to the divinity, Tauler declares: "Once you have put these obstacles of nature [hindernisse der naturen] behind you, you will experience what is written in the Psalter (Ps. 103:3): 'qui ponas nubem ascensum tuum, qui ambulas super pennas ventorum,' who makest the clouds thy chariot: who walkest upon the wings of the winds."[88] He glosses this passage with the words, "Als der mensche die irdensche meinunge getôtet hat, so setzet Got sine stat uf" [When a man has killed his earthly desires (literally "mind-set," "meinunge"), then God imposes his own dwelling place].[89]

Tauler's gloss in the form of a verbal image that nonetheless contains reminiscences of visual iconography brings to mind the "Roman images" increasingly popular among his generation of mendicant preachers.[90] More likely, however, he had in mind a common type of schoolbook diagram of older provenance that allegorized the wings and feathers of the cherub in order to fix and make memorable an ordering of the virtues required for the salvation of the soul (figure 9.4). Certainly his readers would have had no difficulty in calling to mind such an image. Based on illustrations to Ps.–Alanus de Insulis's *De sex aliis Cherubim*, the diagram was later adapted for incorporation into a set of didactic diagrams known as the *Speculum theologie*, which enjoyed wide circulation in schoolbooks and devotional

9.4 Diagram of cherub, appended to Petrus Comester, *Historia Scholastica*, Upper Rhine (late thirteenth century). Aarau, Kantonsbibliothek, Codex Ms. WettF 9, fol. 245v.

compendia.[91] In the late-thirteenth-century copy illustrated here, appended to a copy of Petrus Comestor's *Historia scholastica* from the library of the monastery of Wettingen, the delicately designed wings completely mask the bodiless angel, revealing only his face as a bright focal point of color at the center.[92]

As Mary Carruthers has pointed out, "Every medieval diagram is an open-ended one. . .an invitation to elaborate and recompose, not a prescriptive, 'objective' schematic."[93] The diagram of the cherub (or seraph) offers a signal example of the diagrammatic imagination in action. The feathered wings of birds and angels offered devotional authors an irresistible means for organizing, outlining, and (most important) implementing sets of otherwise easily confused concepts. For example, Jean Gerson (1363–1429), chancellor of the University of Paris, used Psalm 54:7 ("Who will give to me the wings of a dove") as his starting point in his treatise, *On Mystical Theology*, arguing that "in the image of the dove we can make meditations that are suitable for fear and to accompany hope."[94] Personifications of Fear and Love play a prominent role in a late-thirteenth-century anonymously authored set of meditations, "Die Fittiche der Seele" ("The Wings of the Soul"), in which the virtues inscribed on individual feathers are organized into groups that the text designates as "choirs."[95] Heinrich Seuse played off this same tradition of devotional practice when, in the Life of the Servant that forms the first part of the *Exemplar*, he describes a vision in which there appears to him the likeness of the crucified Christ in the form of a seraph (figure 9.5). The immediate model for Seuse's account is the stigmatization of St. Francis. Onto this base, however, Seuse grafts a diagram not unlike that employed by Tauler, consisting of three injunctions emblazoned across the three pairs of wings: On the two bottom wings was written: "Receive suffering willingly." On the middle ones: "Bear suffering patiently." On the top ones: "Learn to suffer on the model of Christ."[96] Devotional images derived from Seuse's text isolate the inscribed seraph, allowing their users to recapitulate his vision (figure 9.6). Closer to Tauler's procedure, devotional compendia compiled by Dominican nuns eliminate the drawing altogether, reducing it to a threefold injunction that nonetheless evokes the image from which it derives.[97]

Why Tauler should have lit on the image of the six-winged seraphim is not immediately clear. Hildegard's text refers only to "a great mountain the color of iron, and enthroned on it One of such great glory that it blinded my sight. On each side of him there extended a soft shadow, like a wing of wondrous breath and length."[98] Only in the lost manuscript of the *Scivias* (and presumably in the copy at St. Gertrude's) did the glory of God and the shadow it casts take on substance in the form of an enthroned, frontal figure, his right hand raised in blessing, with a jeweled book resting on his left knee

9.5 The Servant's Vision of the Seraph. Heinrich Seuse, *Exemplar*, Strasbourg (ca. 1370). Bibliothèque nat. et univ. de Strasbourg, Ms. 2929, fol. 65v. Photo: BNU.

and with two enormous outspread wings that echo the outline of the mountain and extend beyond the border, as if to suggest the power and plenitude of the emanation. As noted by Lieselotte Saurma-Jeltsch, the image evokes representations of Christ in Majesty, especially those found in

9.6 Crucifixion, Rhineland (late fifteenth century). Karlsruhe, Badische Landesbibliothek, S.931 m. Photo: Badische Landesbibliothek.

manuscripts of the early Middle Ages (figure 9.7).[99] In a testimony to the vitality of his iconographic imagination, Tauler sees through Hildegard's image to its probable source, a figure of Christ enthroned flanked by seraphim, and supplies their wings, in verbal form, to his readers so that they too can mount to the vision of God. It is apparently this familiar apocalyptic imagery, rather than Hildegard's image per se, that led Tauler to light upon the imagery

9.7 Christ in Majesty. Sacramentary of Charles the Bald, Ms. lat. 1141, Paris, Cliché Bibliothèque Nationale de France, fol. 6r. Photo: BNF.

of wings as the paradoxical link between the first part of his sermon, which focuses on the castigation of the senses, and the final section, which focuses on Hildegard's vision. What Tauler appears largely to overlook—the vision of the Godhead and Hildegard's description of it—turns out to be very prominently present, if only in appropriately disguised fashion, as a veiled evocation of the seraphim guarding the entrance to the Holy of Holies. Just

as the wings of the seraphim shelter the Holy of Holies and protect the *deus absconditus* from prying eyes, so too, the wings of the soul sketched by Tauler mark the point of transition from the visible to the invisible world to which Hildegard has access. In walking with the Lord on the three sets of wings, the nuns of St. Gertrude gain access with Hildegard to the interior of the tabernacle.

In keeping with the pictorial underpinnings of his larger exposition, Tauler's explanation of each pair of wings hinges on a concept of the image (*imago*) that is closely linked to the idea and practice of imitation (*imitatio*). The wings of the dove represent the pure who, in simplicity of spirit, follow the mild example of Christ ("nach volgent dem senftmv̊digen bilde vns herrin ihesu christi").[100] In keeping with exegesis and bestiary lore, the eagle signifies ascent, although Tauler, consistent with what has come before, is careful to define the eagle's upward flight as a turn inward, away from the senses:

> The second time, our Lord travels by means of eagle's wings. This eagle flies so high that one can no longer see him. This eagle is the person who with all his inner powers flies up into the heights, and the person who with all his ability [vermúgende] stretches his outer and inner self and flies into the high knowing and loving [die hôhi kennende und minnende] so that no sensory power can reach him. Our Lord travels on these wings.[101]

The eagle with which Tauler associates the upward flight of the soul was a traditional symbol of apotheosis and resurrection.[102] At the same, however, it serves to identify the contemplative with John the Evangelist, the model visionary, theologian, and preacher who was regarded by many Dominicans as the embodiment of their order's mission.[103] The Evangelist's attribute marks the opening of John's Gospel in an Upper Rhenish Dominican gradual painted in part in Tauler's lifetime, ascending to his resting place on the breast of Christ, a configuration reminiscent of the sculptural images of John sleeping on Christ's breast at the Last Supper that were especially popular among Dominican nuns (figure 9.8).[104]

In his explanation of the first, as of the second set of wings, Tauler maintains a close link between the linked terms *imago*, *imitatio*, *imaginatio*, and *imago Dei*. This language of formation (*Bildung* in modern German) continues to find a place in the exposition of the third set, but in a context that ultimately insists on the abandonment of all images:

> On the third occasion, he [the Lord] wanders on the wings of the wind. The wind is very fast and agile: "you do not know whence it comes or where it goes." This wind is the most inward of persons [innewendigoste mensche], the hidden, highest person in the image of God [gotbildige], in God's likeness [gotformige], who is so completely above all powers of comprehension and

9.8 John the Evangelist as witness to the union of the Logos with Christ. Gradual, Upper Rhine (Alsace? ca. 1300), with later additions. Nuremberg, Germanisches Nationalmuseum, Ms. 21897, fol. 146r. Photo: Germanisches Nationalmuseum.

everything that reason is unable to reach it with her works. It transcends [über triffet] all senses. This inward person flies back to his origin, into his uncreated being, and there becomes a light in the light. In this light all the natural lights and poured in lights [die in gegossen liechter—a reference to

oil lamps?] that ever shone under this light are extinguished, becoming like a darkness. In the same way as the clear sun shines, so this light blinds the illumination of the stars that now stand so beautifully in the sky as they did last night, but the great light of the sun has obliterated them. Thus, the light that shines here in this ground darkens and overwhelms all created lights that ever shone and becomes as clear in the ground that it becomes overpowering for the soul, so that the light that shines on him appears as a darkness from the overpowering effect of the light, which is unfathomable to it and to all creatures. For all the perception of all creatures holds itself up to this light as the eye of the swallow holds itself against the brilliant sun. And if you wanted to stare into the wheel of the sun with your weak eyes, then your vision will appear as a darkness due to the overpowering light and the weakness of the eye.[105]

Shot through with oxymorons that evoke the ineffable, this eloquent exposition of the negative way expresses the ultimate paradox: that what is most inward in man ("der aller innewendigoste mensche") is, at the same time, the highest, most hidden, and most Godlike ("der verborgene oberste gotbildige gotformige mensche"). Tauler takes up this contradiction in terms in Sermon 39, in which he states simply: "ie tieffer, ie hôher; wan hoch und tief ist do ein" [the deeper, the higher, for there high and low are one].[106] Tauler's formulation ("der. . .gotbildige gotformige mensche") echoes the enigmatic language of Gen. 1:26, according to which God made mankind "in his image and his likeness." Man's likeness to God, however, is only to be found in recognition of the most profound unlikeness (*ungelichkeit*).[107] In effect, Tauler translates the classic doctrine of man created in God's image into terms derived from the apophatic theology of the Pseudo-Dionysius. Vision culminates in blindness, images in invisibility, and likeness in dissimilarity.

Having unmasked the search for God as a process of introversion, Tauler returns to his point of departure, Jesus' summons to Zaccheus to come down from his tree: "For today I must abide at thy house." Zaccheus's fruitless ascent of the sycamore at the gate to Jericho stands as one further oxymoron. In this instance, ascent and descent represent the unexpected conjunction of opposites. In the context of other didactic texts with which the nuns of St. Gertrude were surely familiar, Tauler's call to descend, rather than ascend, must have come as something of a shock.[108] Entire genres of pastoral literature were predicated on the principle of elevation, captured in images of ascent, be it of ladders or of trees.[109] "Praedicare est arborisare" [to preach is to make trees] declared Maurice of Leiden, reflecting the commonplace character of arboreal imagery in medieval sermons as both mnemonic device and rhetorical instrument.[110] Writing in the early fourteenth century, a contemporary of Tauler's, the Dominican Jacobus de Fusignano (died ca. 1329), wrote that "it should be known that the practice of preaching is similar to a tree."[111] Tauler's sermon defies this practice, or at least deliberately stands it on its head.

Tauler rewrites the scriptural account of Zaccheus's encounter with Christ in order to make it conform to his own particular purposes. Reminding his audience that the account of the episode in Luke 19 formed part of the liturgy for the feast of a consecration of a church, Tauler asks: "what did he [Zaccheus] do? He climbed up a barren fig tree" [einen dúrren figbowawm].[112] As noted by Corin in his edition of Tauler's sermons, Luke 19:1–4 makes no mention of a fig tree.[113] Instead, it refers to a sycamore ("et praecurrens ascendit in arborem sycomorum"). The fig tree is grafted from other places in the Gospels, most notably Matt. 21:19 ("And seeing a certain fig tree [ficus] by the way side, he [Jesus] came to it, and found nothing on it but leaves only, and he saith to it: May no fruit grow on thee henceforward for ever. And immediately the fig tree withered away") and Matt. 24:32 ("And from the fig tree learn a parable: When the branch thereof is now tender, and the leaves come forth, you know that summer is nigh").[114] Tauler's substitution of the barren fig tree represents anything but confusion on his part.[115] It figures, first of all, the sterility of the world and all its pursuits.[116] Man also wishes to see God, but feels himself too small. So, like Zaccheus, he gives away his worldly goods: "Man does the same thing. He then desires to see who has brought about all this wonder and turmoil in him, but for that he is too short and too small. What should he then do? He should climb up the barren fig tree; by that is meant everything that we have previously discussed—the mortification of the senses and nature and the life of the inward-turning person, whereupon God reveals himself, as you well heard."[117] In most commentaries, the barrenness of the fig tree was associated with the dead letter of Jewish law.[118] In Tauler's reading, the tree's sterility stands for the same Poverty of Spirit praised by Hildegard in the *Scivias*. How ironic, then, that immediately prior to his discussion of Hildegard, Tauler mentions book learning as an example of worldliness.[119]

In Tauler's reading, the conflation of the sycamore and the fig does not simply serve a crabbed allegory. In addition to a figure of fruitlessness, the fig tree reminds the reader of a subsequent, more significant set of entrances: first, that of Christ into Jerusalem, at whose gate Christ cursed the fig tree, and second, the entry of all his faithful followers into the Heavenly Jerusalem, of which the church whose consecration his sermon celebrates is the image on this earth. In casting his sermon as an invitation to enter into the church with Christ, Tauler places his text in a tradition of liturgically rooted exegesis. The last words of the sermon point in this direction; paraphrasing the passage from Scripture with which he began, Tauler concludes: "denne ich mus von not 'hodie'—das ist ewig 'hodie'—sin in dime hus; hút ist heil geschehen disem huse" [For today—that is the eternal today—I have to be in your house; today salvation is come to this house].[120] Tauler closes by blessing the community of St. Gertrude, just as Christ blessed the home of Zaccheus.

In preaching from and with images, Tauler identifies himself with Hildegard, the visionary to whom the Godhead enthroned on mountain cries out, saying, "O human, who are fragile dust of the earth and ashes of ashes! Cry out and speak of the origin of pure salvation until those people are instructed, who, though they see the inmost contents of the Scriptures, do not wish to tell them or preach them, because they are lukewarm or sluggish in serving God's justice."[121] Tauler likewise laments about those who take pride in being "Lesemeister," masters of school learning, rather than living as "Lebemeister," that is, exemplars of the good, Christian life.[122] In preaching humility, Tauler, nonetheless, identifies himself with the prophetess, enjoining the Godhead:

> Unlock for them the enclosure of mysteries that they, timid as they are, conceal in a hidden and fruitless field. Burst forth into a fountain of abundance and overflow with mystical knowledge, until they who now think you contemptible because of Eve's transgression are stirred up by the flood of your irrigation. For you have received profound insight not from humans, but from the lofty and tremendous Judge on high, where this calmness will shine strongly with glorious light among the shining ones.[123]

Indeed, Tauler concludes by assuming the place of Christ, calling to his audience as Christ called to Zaccheus: " 'Make haste and come down.' You must come down, you shouldn't take any account of all of this, but come down here in your sheer nothingness, good for nothing, capable of nothing [nút towawgen noch vermúgen], thus must I come today into your house."[124] In the end, the soul must content itself with nothing: but nothing now understood as everything that, by necessity, remains ineffable.[125]

According to the anonymous author of the sermon in the St. Georgen collection, God makes himself and his works known to mankind in two forms of writing: words and images. He goes on to say that the only higher form of revelation is the image of Christ's body. Although unspoken, the parallel to Christ's two natures is self-evident: Christ as Logos and Christ as flesh. Yet the preacher's formulation implicitly recognizes that humanity has no direct access either to Christ's speech or to his body (he makes no mention of the Eucharist). Instead, Christ's followers are left with representations of word and body in the form of script and image: the same pairing with which Hildegard's *Liber Scivias* confronted her readers.

Tauler's sermon on Hildegard of Bingen wrestles with a similar dilemma, despite manifest differences (not least, its incomparably greater rhetorical and theological sophistication). For Tauler, as for Hildegard, the written word and the painted image serve as complementary substitutes for the immediacy of speech and vision. The relationship between text and image, however, is

anything but straightforward or self-evident. Tauler wrestles with Hildegard, just as he does with the visual culture of his contemporaries: the images that haunt his text, far from providing fixed points of reference and meaning, testify to the vitality and transformative power of his iconographic imagination. Tauler's sermon strikes the modern reader as an unusual commentary on an image. More important, however, his sermon stands as a reminder that for Tauler as for the nuns to whom he spoke, the visualization of texts, understood as invitations to see, was as integral to the practice of the contemplative life as was the reading of images. At issue was the relationship of the inner and the outer eye. As a commentary on Hildegard's *Liber Scivias* and its illustration, Tauler's sermon makes this appeal to vision especially compelling, even for readers who did not have the benefit of having Hildegard's image before their eyes.

In closing his sermon, Tauler recognizes that full presence necessarily awaits eternity—the "ewig 'hodie' " or "eternal present" that he invokes at the end of his text. In the meantime, however, he must reconcile himself to living in the realm of representation: "Know that whatever nature does always has some stain [flecken] and is not yet completely pure. And one should call God down: that is, to a complete denial and rejection of nature in all ways in which one inwardly possesses any quality [eigenschaft] of it."[126] It may not be the highest praise one can imagine, but images, as Tauler sees them, represent both "stains" of humanity and traces of divinity.[127] This—the paradoxical place of images in imageless devotion—is the one oxymoron his sermon leaves unresolved.

Notes

My thanks to Beverley Kienzle and Nigel Palmer for incisive comments on various drafts of this essay, as well as to the participants in the Medieval Seminar at Harvard and a workshop organized by Profs. Drs. Ursula Peters and Hans-Joachim Ziegeler of the Institut für deutsche Sprache und Literatur, University of Cologne, for their many useful suggestions.

1. Gerald R. Owst, *Literature and the Pulpit in Medieval England: A Neglected Chapter in the History of English Letters & of the English People* (Cambridge: Cambridge University Press, 1933), p. 137. See also Helen Leith Spencer, *English Preaching in the Late Middle Ages* (Oxford: Clarendon Press, 1993).

2. The corpus of German-language sermons in manuscripts in the Staatsbibliothek, Berlin, ed. Volker Mertens and Hans-Jochen Schiewer, forthcoming from Niemeyer, Tübingen, should help remedy the situation.

3. Louise Gnädinger, *Johannes Tauler: Lebenswelt und mystische Lehre* (Munich: C.H. Beck, 1993), pp. 30–39.

4. For the purpose of this essay, I set aside the thorny issue of whether Hildegard herself had a hand in the images illustrating the *Scivias*, especially as Tauler

accepts their authenticity. For arguments in favor of Hildegard's participation in their creation, see Madeline Caviness, "Hildegard as the Designer of the Illustrations to Her Works," in *Hildegard of Bingen: The Context of Her Thought and Art* (London: Warburg Institute, 1998), pp. 29–62. For opposing arguments, see Lieselotte Saurma-Jeltsch, *Die Miniaturen im "Liber Scivias" der Hildegard von Bingen: Die Wucht der Vision und die Ordnung der Bilder* (Wiesbaden: Ludwig Reichert, 1998). For a judicious discussion of the state of the question, see Klaus Niehr, review of Saurma-Jeltsch, *ZfdA* 129 (2000): 215–22.

5. With the notable exception of Leonard P. Hindsley, "Rhenish Confluences: Hildegard and the Fourteenth-Century Dominicans," in *Hildegard of Bingen: A Book of Essays*, ed. Maud Burnett McInerney (New York: Garland, 1998), pp. 179–83 [177–90], who also discusses two other sermons by Tauler that refer to Hildegard and who raises questions very different from those explored in this essay. Alois M. Haas, *Nim din selbes war: Studien zur Lehre von der Selbsterkenntnis bei Meister Eckhart, Johannes Tauler und Heinrich Seuse* (Fribourg: Universitätsverlag, 1971), p. 102, n. 74; and Gnädinger, *Johannes Tauler*, p. 277, comment briefly on Tauler's treatment of Hildegard. Oliver Davies, *Meister Eckhart: Mystical Theologian* (London: SPCK, 1991), pp. 51–59, suggests that Meister Eckhart may have known Hildegard of Bingen's writings.

6. See Jutta Prieur, *Das Kölner Dominikanerinnenkloster St. Gertrud am Neumarkt* (Cologne: dme-Verlag, 1983); and Ulrike Bergmann, "St. Gertrud," in *Colonia Romanica: Jahrbuch des Fördervereins Romanische Kirchen Köln e.V*, 10/1–2 (1995): 1:173–76.

7. See P. Clemoes, *Liturgical Influence on Punctuation in Late Old English and Early Middle English Manuscripts* (Binghamton, NY: CEMERS, 1980); Malcolm B. Parkes, *Pause and Effect: An Introduction to the History of Punctuation in the West* (Aldershot, Hants: Scolar Press, 1992); Paul H. Saenger, *Space between Words: The Origins of Silent Reading* (Stanford, CA: Stanford University Press, 1997); and Laura Kendrick, *Animating the Letter: The Figurative Embodiment of Writing from Late Antiquity to the Renaissance* (Columbus, OH: Ohio State University Press, 1999).

8. Michael Camille, "Seeing and Reading: Some Visual Implications of Medieval Literacy and Illiteracy," *Art History* 8 (1985): 32 [26–49]. Horst Wenzel, *Hören und Sehen, Schrift und Bild: Kultur und Gedächtnis im Mittelalter* (Munich: C.H. Beck, 1995), surprisingly has nothing to say about sermons, not even in his section "Die Manifestation Gottes für das Ohr—die Kirche als akustischer Raum," pp. 105–06.

9. A subject not treated at length in Mary Carruthers, *The Book of Memory: A Study of Memory in Medieval Culture* (Cambridge: Cambridge University Press, 1990); or Carruthers, *The Craft of Thought: Meditation, Rhetoric, and the Making of Images, 400–1200* (Cambridge: Cambridge University Press, 1998), both of which deal primarily with earlier medieval material.

10. For consideration of these issues, see Kurt Ruh, *Kleine Schriften II: Scholastik und Mystik im Spätmittelalter*, ed. Volker Mertens (Berlin: de Gruyter, 1984), pp. 296–301: "Mit der graduell gestuften Authentizitätsfrage ist die Frage des

gesprochenen Wortes verbunden. Predigtsprache sei lebendige, gesprochene Sprache, an diese Gleichung wollten vor allem Sprachwissenschaftler glauben. Die Gleichung ist falsch." I was unable to consult Rüdiger Schnell, "Von der Rede zur Schrift: Konstituierung von Autorität in Predigt und Predigtüberlieferung," in *The Construction of Textual Authority in German Literature of the Medieval and Early Modern Periods,* ed. James F. Poag and Claire Baldwin (Chapel Hill: University of North Carolina Press, 2001), 91–134. The various contributors to Beverly Mayne Kienzle, ed., *The Sermon,* Typologie des sources du Moyen Age occidental, fasc. 81–83 (Turnhout: Brepols, 2000), pp. 861–961, provide extensive discussion of the relationship of oral and written in medieval preaching.

11. See Beryl Smalley, *English Friars and Antiquity in the Early Fourteenth Century* (Oxford: Basil Blackwell, 1960), pp. 166–67 and 179; Nicole Bériou, "De la lecture aux épousailles: Le rôle des images dans la communication de la Parole de Dieu au XIIIe siècle," *Cristianesimo nella storia* 14 (1993): 535–68; and Bériou, *L'avènement des maîtres de la Parole: La prédication à Paris au XIIIe siècle,* 2 vols. (Paris: Institut d'Études Augustiniennes, 1998), p. 1:603: "les images. . .ne servent pas ici plus au'ailleurs à illustrer l'enseignement des prédicateurs. Tout au plus sont-elles, comme les sculptures et les vitraux, des lieux de mémoire dont les prédicateurs ne s'occupent guère. La seule image qui a du prix à leurs yeux, au point que leur parole consent à s'effacter devant elle, est l'image du Christ crucifié, 'livre' des simples gens." For a somewhat less pessimistic assessment, see Hervé Martin, "L'imagerie religieuse dans quelques sermons des predicateurs français du XVe siècle," *Poznansasskie Towarzystwo Przyjaciól Nauk: Sprawozdania Wydzialu Nauk o Sztuce* 109 (1991): 145–49; and Miriam Gill, "Preaching and Image: Sermons and Wall Paintings in Later Medieval England," in *Preacher, Sermon, and Audience in the Middle Ages,* ed. Carol Muessig (Leiden: Brill, 2002), pp. 155–80, which appeared after the completion of this essay. One sermon by Eudes of Châteauroux has become a touchstone in art-historical scholarship; see Jeffrey F. Hamburger, "Medieval Studies and Medieval Art History," in *The Past and Future of Medieval Studies,* ed. John van Engen (Notre Dame, IN: University of Notre Dame Press, 1993), pp. 383–400; and Wolfgang Kemp, *The Narratives of Gothic Stained Glass,* trans. Caroline D. Saltzwedel (Cambridge: Cambridge University Press, 1997), pp. 71 and 80. See also Beverly M. Kienzle, "Medieval Sermons and Their Performance: Theory and Record," in *The Medieval Sermon,* ed. Carolyn A. Muessig (Leiden: Brill, 2001). I am grateful to Prof. Kienzle for sharing a copy of her essay with me prior to its publication. Baxandall has matched sermons to images in *Painting and Experience in Fifteenth-Century Italy* (Oxford: Clarendon Press, 1972), pp. 60–71; and *The Limewood Sculpture of Germany* (New Haven, CT: Yale University Press, 1980), but remains sensitive to the potential pitfalls of the enterprise; see Baxandall, "Pictorially Enforced Signification: St. Antonius, Fra Angelico, and the Annunciation," in *Hülle und Fülle: Festschrift für Tilmann Buddensieg,* ed. Andreas Beyer, Vittorio Lampugnani, and Gunter Schweikhart (Alfter: Verlag und Datenbank fur Geisteswissenschaften, 1993), pp. 31–39.

THE "VARIOUS WRITINGS OF HUMANITY"

12. Most of the sermons discussed by Owst, *Literature and the Pulpit*, fall into either of these two categories, as do those condemning what some preachers perceived as sartorial or other, related forms of excessive adornment, be it of books or bodies. For examples from the sermons by Berthold von Regensburg, see Helma Reimöller, "Ökonomik, Kleidung und Geschlecht: Ein stadtbürgerlicher Beitrag zum Haushaltsdiskurs im Spätmittelalter," in *Lustgarten und Dämonenpein: Konzepte von Weiblichkeit in Mittelalter und der Frühen Neuzeit*, ed. Annette Kuhn and Bea Lundt (Dortmund: Edition Ebersbach, 1997), p. 91.

13. "Contre le Roman de la Rose," in *Œuvres complètes*, ed. Palémon Glorieux (Paris: Desclée, 1996), quoted by Brigitte Buettner, "Profane Illuminations, Secular Illusions: Manuscripts in Late Medieval Courtly Society," *Art Bulletin* 74 (1992): 75–90, n. 67.

14. See, for example, Karl Halbauer, *Predigtstühl: Die spätgotischen Kanzeln im württembergischen Neckargebiet* (Stuttgart: Kohlhammer, 1997); and Götz Adriani, *Der mittelalterliche Predigtort und seine Ausstattung* (Diss., Tübingen, 1966).

15. See Daniel Arasse, "Iconographie et évolution spirituelle: La tablète de saint Bernardin de Sienne," *Revue d'histoire de la spiritualité* 50 (1974): 433–56; Enzo Carli, "Luoghi ed opere d'arte senesi nella prediche de Bernardino del 1427," in *Bernardino predicatore nella società del suo tempo* (Todi: Presso l'Accademia Tudertina, 1976), pp. 153–82; and Ephrem. Longpré, "S. Bernadin de Sienne et le nom de Jésus," *Archivum Franciscanum Historicum* 28, 29, 30 (1935–1938): 443–76, 443–77, and 170–92. For related imagery in a German panel painting and preaching practice, see Robert Suckale and Lothar Hennig, *Der Bußprediger Capestrano auf dem Domplatz in Bamberg: Ein Bamberger Tafel um 1470/74* (Bamberg: Historisches Museum, 1989). For a broader category of what might be called catechetical imagery in public settings, see Ruth Slenczka, *Lehrhafte Bildtafeln in spätmittelalterlichen Kirchen* (Cologne: Böhlau, 1998).

16. For rare representations of Dominican preachers, see the manuscripts reproduced in Walter Simons, Guido Jan Bral, Jan Caudron, and Johan Bockstaele, *Het Pand: Acht Eeuwen Geschiedenis van het oud Dominicanenklooster te Gent* (Tielt: Lannoo, 1991), p. 10; and Jeffrey F. Hamburger, *The Visual and the Visionary: Art and Female Spirituality in Late Medieval Germany* (New York: Zone Books, 1998), pp. 19–20 and color plate 1. For the Italian images, see the essays by Roberto Rusconi, "Le pouvoir de la parole: Répresentation des prédicateurs dans l'art de la Renaissance en Italie," in *La Parole du prédicateur, Ve-XVe siècle* (Nice: Centre d'Études Médiévales, 1997), pp. 445–56; "I 'falsi credentes'; Nell'iconografia della predicazione (Secoli XIII–XV)," in *Cristianità ed Europa. Miscellanea di Studi in onore di Luigi Prosdocimi*, 2 vols. ed. Cesare Alzati (Rome: Herder, 1994), pp. 1: 313–37; and "The Preacher Saint in Late Medieval Italian Art," in *Preacher, Sermon, and Audience*, pp. 181–202.

17. See, for example Jacques le Goff, "Le roi, la Vierge et les images. Le manuscrit des *Cantigas de Santa Maria* d'Alphonsa X de Castille," in *Rituels: Mélanges Offerts à Pierre-Marie Guy, O.P.*, ed. P. de Clerck and Éric Palazzo (Paris: Le Cerf, 1990), pp. 385–92; and Gabriela Signori, "Marienbilder im

Vergleich: Marianische Wunderbücher zwischen Weltklerus, städtischer
Ständevielfalt und ländlichen Subsistenzproblemen (10–13. Jahrhundert),"
in *Maria, Abbild oder Vorbild? Zur Sozialgeschichte mittelalterlicher Marienverehrung*,
ed. Hedwig Röckelein, Claudia Opitz, and Dieter R. Bauer (Tübingen:
Edition diskord, 1990), pp. 58–90.

18. Bériou, *L'avènement*, p. 1:231. For a study of the ordering of stained glass, see
 Kemp, *Narratives of Gothic Stained Glass*.

19. See Herbert L. Kessler, *Studies in Pictorial Narrative* (London: Pindar Press,
 1994); and Kessler, *Old St. Peter's and Church Decoration in Medieval Italy*
 (Spoleto: Centro italiano di studi sull'alto medioevo, 2002).

20. See Herbert L. Kessler, "Pictorial Narrative and Church Mission in Sixth-
 Century Gaul," in *Pictorial Narrative in Antiquity and the Middle Ages*, ed.
 Herbert L. Kessler and Marianne S. Simpson (Washington, DC: National
 Gallery of Art, 1985), p. 88 [75–91].

21. See, in general, Staale Sinding-Larsen, *Iconography and Ritual: A Study of
 Analytical Perspectives* (Oslo: Universitetsforlaget As, 1984).

22. To the best of my knowledge, the sermon has never been subjected to
 searching analysis. It is mentioned in passing by Michael Curschmann,
 "Wort—Schrift—Bild: Zum Verhältnis von volksprachigem Schrifttum und
 bildender Kunst vom 12. bis zum 16. Jahrhundert," in *Mittelalter und frühe
 Neuzeit: Übergänge, Umbrüche und Neuansätze*, ed. Walter Haug (Tubingen:
 Niemeyer, 1999), p. 439 [379–470]. A short essay on the sermon by Niklaus
 Largier will be included in the *New History of German Literature*, ed. David
 Wellbery et al., section no. 32.

23. See Ruh, *Kleine Schriften II*, pp. 308–12; and Wolfgang Frühwald,
 "St. Georgener Prediger," in *Die deutsche Literatur des Mittelalters: Verfasserlexikon*
 (henceforth VL), vol. 2, 2nd edn. (Berlin: de Gruyter, 1978–), pp. 1207–13.
 The sermon is number 58 in Karl Rieder, ed., *Der sogenannte St. Georgener
 Prediger aus der Freiburger und aus der Karlsruhe Handschriften* (Berlin: Weidmann,
 1908). Rieder's edition is part of the "core" group still attributed to the
 St. Georgener Prediger. The remaining sermons are now assigned to a separate
 figure named the "Schweizer Prediger." For German sermons, including the St.
 Georgen collection, see Hans-Jochen Schiewer, "German Sermons in the
 Middle Ages," in *The Sermon*, pp. 861–961. I was not able to consult Karl-Otto
 Seidel, *Die St. Georgener Predigten: Untersuchungen zur Überlieferungsgeschichte*
 (Tübingen: Niemeyer, forthcoming).

24. See Celia Chazelle, "Pictures, Books, and the Illiterate: Pope Gregory's
 Letters to Serenus of Marseilles," *Word & Image* 6 (1990): 138–53; Lawrence
 Duggan, "Was Art Really the 'Book of the Illiterate'?" *Word & Image*
 5 (1989): 227–51; and Jean-Claude Schmitt, "Ériture et image: Les avatars
 médiévaux du modèle grégorien," in *Théories et pratiques de l'écriture au
 Moyen Age: Actes du Colloque, Palais du Luxembourg-Sénat, 5 et 6 mars 1987*,
 ed. E. Baumgartner and C. Marchello-Nizia (Paris-Nanterre: Centre de
 Recherches du Département de Français de Paris X, 1988), pp. 119–53.

25. For illustrated manuscripts of saints' lives, see most recently Cynthia Hahn,
 Portrayed on the Heart: Narrative Effect in Pictorial Lives of Saints from the Tenth

through the Thirteenth Century (Berkeley: University of California Press, 2001). For narrative cycles of saints' lives in Rhenish wall painting of the period, see Jürgen Michler, *Gotische Wandmalerei am Bodensee* (Friedrichshafen: Gessler, 1992).

26. In seeming contradiction to a point made by Bériou, "De la lecture aux épousailles," p. 551, in characterizing French sermons of the period: "Jamais, non plus, les prédicateurs ne reconnaissent aux images une quelconque valeur d'autorité, commes ils le font par exemple pour les textes liturgiques."

27. Rieder, *St. Georgener Prediger*, p. 248. All translations from all texts are mine, unless otherwise noted, with the exception of the Vulgate, in which case I employ the Douai-Reims Bible.

28. The Vulgate reads "in scripturis populorum."

29. See the studies by Georg Steer, "Der Laie als Anreger und Adressat deutscher Prosaliteratur im 14. Jahrhundert," in *Zur deutschen Literatur und Sprache des 14. Jahrhunderts*, ed. Walter Haug, Timothy R. Jackson, and Johannes Janota (Heidelberg: Winter, 1983), pp. 354–67, and "Die Stellung des 'Laien' im Schrifttum des Straßburger Gottesfreundes Rulman Merswin und der deutschen Dominikanermystiker des 14. Jahrhunderts," in *Literatur und Laienbildung im Spätmittelalter und in der Reformationszeit: Symposion Wolfenbüttel 1981*, ed. Ludger Grenzmann and Karl Stackmann (Stuttgart: J.B. Metzler, 1984), pp. 643–60.

30. For Augustinian elements in Gregory's teaching on images, see Chazelle, "Pictures, Books."

31. For the house as an image of interiority in Tauler, see Gnädinger, *Johannes Tauler*, pp. 143–44; and Jeffrey F. Hamburger, *Nuns as Artists: The Visual Culture of a Medieval Convent* (Berkeley: University of California Press, 1996).

32. See Hamburger, *Visual and Visionary*, chapter 8 (" 'On the Little Bed of Jesus': Pictorial Piety and Monastic Reform").

33. Rieder, *St. Georgener Prediger*, p. 249, ll. 7–9.

34. Cf. Frank O. Schuppisser, "Schauen mit den Augen des Herzens: Zur Methodik der spätmittelalterlichen Passionsmeditation, besonders in der *Devotio moderna* und bei den Augustinern," in *Die Passion Christi in Literatur und Kunst des Spätmittelalters*, ed. Walter Haug and Burghart Wachinger (Tübingen: Niemeyer, 1993), pp. 169–210.

35. Rieder, *St. Georgener Prediger*, p. 249, ll. 8–9.

36. Rieder, *St. Georgener Prediger*, pp. 249–54.

37. For the copying of Tauler's works at St. Gertrude's, see Gnädinger, *Johannes Tauler*, pp. 113–14; and Johannes Gottfried Mayer, *Die "Vulgata"-Fassung der Predigten Johannes Taulers: Von der handschriftlichen Überlieferung des 14. Jahrhunderts bis zu den ersten Drucken* (Würzburg: Königshausen & Neumann, 1999).

38. Ferdinand Vetter, ed., *Die Predigten Taulers aus der Engelberger und der Freiburger Handschrift sowie aus Schmidts Abschriften der ehemaligen Strassburger Handschriften* (1910; repr. Frankfurt am Main: Weidmann, 1968), p. 379, ll. 15–17: "stet also in S. Hiltgarten buche gemolet und och in unser swester reventor zwei kleine bildelin." Although Vetter's edition remains the touchstone in Tauler studies, it must be consulted in conjunction with Corin's, which reproduces

a manuscript written in a Cologne dialect that may well be closer to Tauler's original and often offers more coherent readings. See Adolphe L. Corin, ed., *Sermons de J. Tauler et autres écrits mystiques*, Bibliothèque de la Faculté de philosophie et lettres de l'Université de Liège, fasc. 33 and 42, 2 vols. (Liege: H.Vaillant-Carmanne, 1924–1929).

39. For Gebeno, see Christel Meier, "*Nostris temporibus necessaria*: Wege und Stationen der mittelalterlichen Hildegard-Rezeption," in *Architectura poetica: Festschrift für Johannes Rathofer zum 65. Geburtstag*, ed. Ulrich Ernst and Bernhard Sowinski (Cologne: Böhlau, 1990), pp. 307–26. For Hildegard's reception in the later Middle Ages, see also Kathryn Kerby-Fulton, "Hildegard and the Male Reader: A Study in Insular Reception," in *Prophets Abroad: The Reception of Continental Holy Women in Late Medieval England*, ed. Rosalynn Voaden (Woodbridge, Suffolk: D.S. Brewer, 1996), pp. 1–18; Barbara Newman, "Seherin—Prophetin—Mystikerin: Hildegard-Bilder in der hagiographischen Tradition," in *Hildegard von Bingen, Prophetin durch die Zeiten: Zum 900. Gebertstag*, ed. Edeltraud Forster et al. (Freiburg: Herder, 1998), pp. 126–52; and Marc-Aeilko Aris, *Hildegard bei den Kartäusern: Beobachtungen zur handschriftlichen Überlieferung der Werke Hildegards von Bingen im Spätmittelalter* (Trier: Paulinus Verlag, 1999).

40. As noted by Corin, ed., *Sermons de J. Tauler*, p. 225, n. 1, the manner in which Tauler refers to the paintings in the refectory suggests that the sermon was not ultimately intended for the nuns alone.

41. For *Nonnenarbeiten*, see Hamburger, *Nuns as Artists*.

42. For the use of sermon readings in refectories, see Burkhard Hasebrink, "Tischlesung und Bildungskultur im Nürnberger Katharinenkloster: Ein Beitrag zu ihrer Rekonstruktion," in *Schule und Schüler im Mittelalter: Beiträge zur europäischen Bildungsgeschichte des 9. bis 15. Jahrhunderts*, ed. Martin Kintzinger, Sönke Lorenz, and Michael Walter (Cologne: Böhlau, 1996), pp. 187–216. Gerard I. Lieftinck, *De Middelnederlandsche Tauler-Handschriften* (Groningen: J.B. Wolters, 1936), pp. 174–84, entertains the possibility that Tauler refers to an illustrated manuscript of Hildegard's *Scivias*, possibly even the Rupertsberg Codex itself. Tauler's way of referring to the images, however, as being painted both "in Hildegard's book *and* in our sisters' refectory" (emphasis added) [stet also in S. Hiltgarten buche gemolet und och in unser swester reventor zwei kleine bildelin] would seem to rule out this rather far-fetched possibility.

43. What little is known of the library of St. Gertrude's makes it seem rather unlikely that the nuns could have understood readings in Latin; see Sigrid Krämer, *Handschriftenerbe des deutschen Mittelalters*, Mittelalterliche Bibliothekskataloge Deutschlands und der Schweiz, Ergängzungsband I, vol. 2 (Munich: C.H. Beck, 1989), pp. 420–21.

44. For one example, see *Seligenthal: Zisterzienserinnenabtei, 1232–1982; Beiträge zur Geschichte des Klosters* (Landshut: Zisterzienserinnenabtei, 1982), pp. 61–64, and figures. 39–40, where the surviving decoration includes a Holy Face and a Coronation of the Virgin, both fourteenth century.

45. For decorative programs in Italian refectories, see Creighton Gilbert, "Last Suppers and Their Refectories," in *The Pursuit of Holiness in Late Medieval*

and Renaissance Religion, ed. Heiko A. Oberman and Charles Trinkhaus (Leiden: Brill, 1974), pp. 371–407; and Stefanie F. Ohlig, *Florentiner Refektorien: Form, Funktion und die Programme ihrer Fresken* (Egelsbach: Dr. Hänsel-Hohenhausen Verlag, 2000).

46. Prieur, *Das Kölner Dominikanerinnenkloster*, pp. 162–68; and Bergmann, "St. Gertrud."

47. For further discussion of this panel, see Marion Opitz, "Die Sophiengruppe im Schnütgen-Museum: Der Sophien-Kult und seine Verbreitung im 15. Jahrhundert," *Kölner Museums-Bulletin* 2 (1995): 29 [19–30]. For related motifs, see Volker Mertens, "Kreuztragende Minne," VL, vol. 5, pp. 376–79; and Wolfgang Augustyn, "Passio Christi est metitandi tibi: Zwei Bildzeugnisse spätmittelalterliche Passionsbetrachtung," in *Die Passion Christi*, p. 226, n. 48 [211–40].

48. In addition to Niklaus Largier's contribution to this volume, see Wolfgang Wackernagel, *Ymagine denudari: Éthique de l'image et metaphysique de l'abstraction chez Maître Eckhart* (Paris: Vrin, 1991); and Mauritius Wilde, *Das neue Bild vom Gottesbild: Bild und Theologie bei Meister Eckhart* (Fribourg: Universitätsverlag, 2000). In at least one other instance (sermon 5, Vetter, ed., *Die Predigten Taulers*, p. 15, ll. 16–22), Tauler discusses a work of art, in this instance a sculptural group of Christ and St. John the Evangelist; see Gnädinger, *Johannes Tauler*, pp. 295–96.

49. Vetter, ed., *Die Predigten Taulers*, p. 222, l. 24–32 (sermon 49): "Dar uf sprach S. Gregorius,. . .den sol man scherphen und wetzen an die starke bibende verborgene urteil Gotz und an die swinden gerechtikeit, der einen gedank nút ungeurteilt enlot, es si ein ieklich biltlin mit willen besessen; das mus mit unlidelichem vegfúr ab geleit werden, e man iemer fúr Got kome." For this passage, see Haas, *Nim din selbes war*, pp. 105–07.

50. See, for example, Niklaus Largier, "Repräsentation und Negativität: Mesiter Eckharts Kritik als Dekonstruktion," in *Contemplata aliis tradere: Studien zum Verhältnis von Literatur und Spiritualität*, ed. Claudia Brinker et al. (Bern: Lang, 1995), pp. 371–90.

51. Luke 19:5–6 is an antiphon for the office for the consecration of a church.

52. For the relationship of Tauler's sermons to the liturgy, see Joachim Theisen, "Tauler und die Liturgie," in *Deutsche Mystik im abendländischen Zusammenhang: Neue erschlossene Texte, neue methodische Ansätze, neue theoretische Konzepte, Kolloquium Kloster Fischingen*, ed. Walter Haug and Wolfram Schneider-Lastin (Tübingen: Niemeyer, 2000), pp. 409–23. For Tauler's ecclesiology, see Adolf Hoffmann, "Taulers Lehre von der Kirche," in *Johannes Tauler, ein deutscher Mystiker: Gedenkschrift zum 600. Todestag*, ed. Ephrem Filthaut (Essen: Hans Driewer Verlag, 1961), pp. 232–46.

53. For this distinctive aspect of Tauler's thought, see Gnädinger, *Johannes Tauler*, pp. 251–61 ("Mystik des Sinkens").

54. Vetter, ed., *Die Predigten Taulers*, p. 377, ll. 2–6: "und als ich gesteren seite: alle wise und ubunge der heiligen kilchen die wiset alles uf den innewendigen menschen, da in der warheit kilwin und ein wor vernúwunge solte sin ane underlos." For this "Verinnerlichung der Heilsgeschichte," which is a consistent feature of Tauler's teaching, see Alois M. Haas, *Sermo mysticus: Studien zu*

198
JEFFREY F. HAMBURGER

Theologie und Sprache der deutschen Mystik (Freiburg: Universitätsverlag, 1979), pp. 264–65.

55. Vetter, ed., *Die Predigten Taulers*, p. 9, ll. 19–23 (sermon 1): "Entruwen, es mus von not ein widerlouf geschehen, sol dise geburt geborn werden, do mus ein kreftig inker geschehen, ein inholen, ein innewendig versammen aller krefte, der nidersten und der obersten, und do sol werden ein vereinunge von aller zerztrŏwunge, also alle vereinte ding sint kreftiger." Translation from Maria Schrady, *Johannes Tauler: Sermons* (New York: Paulist Press, 1985), p. 37.

56. See Jeffrey F. Hamburger, "Speculations on Speculation: Vision and Perception in the Theory and Practice of Mystical Devotions," in *Deutsche Mystik im abendländischen Zusammenhang*, pp. 368–79 [353–408].

57. Vetter, ed., *Die Predigten Taulers*, p. 377, ll. 9–15: "Kilwin meint als vil als ein vernúwunge. Do dise vernýwunge sol geschehen, do mus die nature ir selbes verlŏigenen und under getruket werden in aller kleblicheit und anhenglicheit do si sich an vint, es sin die frúnt oder di mogen, und alles das mus ze mole ab das von ussen in der nature zu gevallen ist, und alles das do di nature lust an nimet in allen iren sinnen oder kreften, in allen wisen und werken. Her zu ist lipliche ubunge gut und nútz, als vasten und wachen, ob es die nature erliden mag."

58. Vetter, ed., *Die Predigten Taulers*, p. 377, ll. 16–24: "Kinder, ir enmerkent nút wie verborgenlich und heimlich die nature das ir suchet und nimet do dicke lust da man wenet notdurft nemen. Der vernúnftige mensche der sol mit flisse meister sin über den vihelihen menschen. Dis mus mit flisse gesucht werden, Dis tut gar we mit dem ersten: ze sterbende allen den ungeordenten lústen, an spise, an tranke, an sehende, an hŏrende, gande, stande, an worten und an werken." In my translation, I follow the alternative reading proposed in *Johannes Tauler: Predigten*, ed. and trans. Georg Hoffmann, 2 vols. (Einsiedeln: Johannes Verlag, 1979), vol. 2, p. 524, n. 1, based on the text in Corin, ed., *Sermons de J. Tauler*, p. 220, l. 12.

59. On this group of texts, see Caroline W. Bynum, *The Resurrection of the Body in Western Christianity, 200–1336* (New York: Columbia University Press, 1995), pp. 326 and 328, who also argues "it seems to me that we do not have here real 'dualism' but rather a sense of self as psychosomatic unity."

60. Georg Hoffmann, *Johannes Tauler*, p. 524, translates as "Der geistige Mensch soll mit Eifer über den leiblichen Menschen herrschen." For the importance of "reason" as a category in Tauler's thought, see Haas, *Nim din selbes war*, pp. 93–94.

61. Vetter, ed., *Die Predigten Taulers*, p. 9, l. 34–p. 10, l. 3 (sermon 1): "Wan wenne zwei súllent eins werden, so mus sich daz eine halten lidende und daz ander wúrckende; sol min ouge enpfohen die bilde in der want oder waz es sehen sol, so mus es an ime selber blos sin aller bilde, wan hette es ein einig bilde in ime einiger varwen, so gesehe es niemer kein varwe. . . .so welich ding enpfohen sol, das mus itel, lidig und wan sin." Translation from Schrady, *Johannes Tauler*, p. 38.

62. For more general consideration of theories of vision in the Middle Ages, see David C. Lindberg, *Theories of Vision from Al-Kindi to Kepler* (Chicago: University of Chicago Press, 1976); and Lindberg, *La visione e lo sguardo nel*

Medio Eve/View and Vision in the Middle Ages, 2 vols. (Florence: SISMEL—Edizioni del Galluzzo, 1997).

63. Sermon 9; see Nikolaus Largier, ed., *Meister Eckhart: Werke I-II*, trans. Josef Quint, 2 vols. (Frankfurt: Deutscher Klassiker Verlag, 1993), vol. 1, p. 112, ll. 2–3: "Ein ouge ist edeler in im selber dan ein ouge, daz an eine want gemâlet ist."

64. For the eye of God, see Gudrun Schleusener-Eichholz, *Das Auge im Mittelalter*, 2 vols. (Munich: Fink, 1985), vol. 2, pp. 1076–110.

65. Sermon 12, a passage that drew his critics' ire, and which he, in turn, defended; see Largier, 1:148, ll. 31–34: "Daz ouge, dâ inne ich got sihe, daz ist daz selbe ouge, dâ inne mich got sihet; mîn ouge und gotes ouge daz ist éin ouge und éin gesiht und éin bekennen und éin minnen." For the English translation, see *Meister Eckhart: Sermons and Treatises*, ed. and trans. Maurice O'C. Walshe, 3 vols. (London: Watkins, 1981–1987), vol. 2, p. 87.

66. For Eckhart on vision, see Schleusner-Eichholtz, *Das Auge*, vol. 1, pp. 116–28; John E. Crean, "Mystical 'Schauen' in Meister Eckhart and Jan van Ruusbroec," *Monatshefte* 62 (1970): 37–44; and the commentary of Largier, *Meister Eckhart*, s.v. "Auge."

67. Karl Bihlmeyer, ed., *Heinrich Seuse: Deutsche Schriften* (Stuttgart: Kohlhammer, 1907), p. 168: "Ein gelassener mensch muss entbildet werden von der creatur, gebildet werden mit Cristo, und überbildet in der gotheit." Translation from Frank J. Tobin, ed. and trans. *Henry Suso: The Exemplar, with Two German Sermons* (New York: Paulist Press, 1989), p. 184.

68. Bihlmeyer, ed., *Heinrich Seuse*, p. 167, ll. 30–31 and p. 169, ll. 11–13: "Daz oge sol nút ussehens han, es hab denn ein ustragen der bilden. [. . .] Hab ein beschliessen der sinnen vor allen gegenwirtigen forman. Bis lidig alles dez, daz dú uslûgendú beschaidenhait us erwellet, daz den willen beheftet und der húgnúst wollust in trait." Translation from Tobin, *Henry Suso*, pp. 184–85.

69. For this aspect of Tauler's spirituality, see Gnädinger, *Johannes Tauler*, pp. 272–86.

70. All translations of the *Liber Scivias* are taken from Hildegard of Bingen, *Scivias*, trans. Mother Columba Hart and Jane Bishop (New York: Paulist Press, 1990).

71. Vetter, ed., *Die Predigten Taulers*, p. 379, ll. 17–24: "Das eine das ist in ein blo kleit gewunden und das enhat nút ŏgen an im selber, und sin kleit das ist alles vol ŏgen, und meinet das die heilige vorchte Gotz. Das enist alsoliche vorchte nút als ir vorchte heissent, sunder es ist ein flissig war nemen der mensche sin slebes in allen stetten und wisen, in worten, in werken, und ist dar umbe ante antlit und hat enkein ŏge, wan si vergisset ir selbes, ob man si minne oder hasse, lobe oder schelte, und es ist ane hende; wan si stet lidig aller annemlicheit in aller wise, in rechter gelossenheit." For Hildegard's text, consult *Hildegardis Scivias*, ed. Aldegundis Führkötter (Turnhout: Brepols, 1978), pp. 7–11.

72. Hildegard of Bingen, *Scivias*, p. 67.

73. Hildegard of Bingen, *Scivias*, p. 68.

74. Vetter, ed., *Die Predigten Taulers*, p. 379, ll. 24–34: "Und do stet ein anders bi in einem bleichen kleide mit uf gehaben henden, und stont alle beide barfus,

und dis enhat nút hoőbtes; wan ob disem stot die gotheit in einem luteren klaren golde, und das enhat nút fŏrmliches antlites denne ein luter golt und meint die unbekentliche gotheit, und dem fliessent clare under uf dis bilde in des hoŏbtes stat, und die gotheit die ist sin hŏbet, und meint das bilde das wore blosse armute des geistes des hŏbet ist Got eigen. Dise bleichet des kleides meinet einvaltigkeit der wandelunge und unannemlicheit und lidige lutere gelossenheit. Si stont alle beide mit blossen fůssen; das meint die blosse nachvolgunge des woren bildes unsers herren Jhesu Christi."

75. Hildegard of Bingen, *Scivias*, p. 68.

76. See Giles Constable, *Three Studies in Medieval Religious and Social Thought* (Cambridge: Cambridge University Press, 1995), pp. 143–48.

77. Giles Constable, "*Nudus nudum Christus sequi* and Parallel Formulas in the Twelfth Century: A Supplementary Dossier," in *Continuity and Discontinuity in Church History: Essays Presented to George Hunston Williams on the Occasion of His 65th Birthday*, ed. T. Forrester Church and Timothy George (Leiden: Brill, 1979), pp. 83–91.

78. See, for example, Wolfgang Böhme, ed. *Lerne leiden: Leidensbewältigung in der Mystik* (Karlsruhe: Verlagsdruckerei Gebr. Tron KG, 1985).

79. For the manuscript containing the image reproduced here, see A. Stracke, "Arnulf van Leuven, O. Cist. versus Gelukz. Herman Jozef, O. Praem," *Ons Geestelijk Erf* 24 (1950): 27–90.

80. For texts as responses the devotional practices of Dominican nuns, see Hamburger, "The Reformation of Vision," in *Visual and Visionary*, chapter 9 ("The Reformation of Vision"); and Otto Langer, *Mystische Erfahrung und spirituelle Theologie: Zu Meister Eckharts Auseinandersetzung mit der Frauenfrömmigkeit seiner Zeit* (Munich: Artemis, 1987).

81. Vetter, ed., *Die Predigten Taulers*, p. 364, ll. 7–9 (sermon 66): "Und das ist sine gerechtekeit das man dis vinde in den woren fuosspúren: in rechter gelossenre trostloskeit, in willingen armuote des geistes, in ellende." For Tauler's translations and applications of the term *vestigium*, see Antoinette Vogt-Terhorst, *Der bildliche Ausdruck in den Predigten Johann Taulers* (Breslau: M. & H. Marcus, 1920), p. 177.

82. Vetter, ed., *Die Predigten Taulers*, p. 379, ll. 26–27.

83. Hildegard of Bingen, *Scivias*, p. 68.

84. For the figuration of speech, see Dick Higgins, *Pattern Poetry: Guide to an Unknown Literature* (Albany: State University of New York Press, 1987); Dick Higgins, ed. "Pattern Poetry: A Symposium," special issue of *Visible Language* 20/1 (1986); and Ulrich Ernst, *Carmen figuratum: Geschichte des Figurengedichts von den antiken Ursprüngen bis zum Ausgang des Mittelalters* (Cologne: Böhlau, 1991).

85. Vetter, ed., *Die Predigten Taulers*, p. 377, ll. 31–33.

86. The three pairs of wings also serve as symbols of the threefold way, a common figure in mystical theology. See M. Engratis Kihm, "Die Drei-Wege-Lehre bei Tauler," in *Johannes Tauler, ein deutscher Mystiker*, pp. 268–300; and Vogt-Terhorst, *Der bildliche Ausdruck*, pp. 119–20.

87. See Thomas Raff, "Die Ikonographie der mittelalterlichen Windpersonifikationen," *Aachener Kunstblätter* 48 (1978–1979): 71–218.

88. Vetter, ed., *Die Predigten Taulers*, p. 377, ll. 25–28: "Als dise hindernisse der naturen ab sint, so geschicht dir als geschriben stet in dem salter: 'qui ponas nubem ascensum tuum, qui ambulas super pennas ventorum, der hat gesat in den wolken, dinen ufgang, der wandelt über den vederen der winde.' "

89. Vetter, ed., *Die Predigten Taulers*, p. 377, ll. 28–29.

90. See Smalley and Nigel Palmer, " 'Antiquitus depingebatur': The Roman Pictures of Death and Misfortune in the Ackermann aus Böhmen and Tkadlecek, and in the Writings of the English Classicizing Friars," *DVjs* 57 (1983): 171–239; and Palmer, "Das 'Exempelwerk der englischen Bettelmönche': Ein Gegenstück zu den 'Gesta Romanorum'?" in *Exempel und Exempelsammlungen*, ed. Walter Haug and Burghart Wachinger (Tübingen: Niemeyer, 1991), pp. 137–73.

91. See Lucy Freeman Sandler, *The Psalter of Robert De Lisle in the British Library* (London–Oxford: Harvey Miller, 1983), pp. 80–131. The second edition of Sandler's book, published in 2000, contains an expanded list of manuscripts. For diagrams incorporating inscribed wings, see Ernst, *Carmen figuratum*, pp. 58–63 and 95–96.

92. For the library of Wettingen, see Peter Högger, *Der Bezirk Baden III: das ehemalige Zisterzienserkloster Marisstella in Wettingen* (Basel: Wiese Verlag, 1998).

93. Carruthers, *Book of Memory*, p. 256.

94. *Jean Gerson: Early Works*, trans. and intro. Brian Patrick McGuire (New York: Paulist Press, 1998), p. 325

95. See Kurt Ruh, "Die Fittiche der Seele," Verfasserlexikon, 2nd ed., vol. 2, pp. 742–43, with references to other texts incorporating similar imagery. To the examples cited by Ruh can be added a treatise attributed to Nicholas of Strasbourg; see Franz Pfeiffer, *Deutsche Mystiker des vierzehnten Jahrhunderts*, 2 vols. (Leipzig: G. J. Göschen, 1845), vol. 1, pp. 348–61.

96. Bihlmeyer, ed., *Heinrich Seuse*, pp. 144–45: "Do sich der diner eins males hate zu got gekeret mit grossem ernste und bat, daz in lerti liden, do erschein im vor in einer geischlichen gesihte ein glichnús des gekrúzgeten Cristus in eines Serafins bilde, und daz selb engelschlich Seraphin hate VI vetchen, mit zwain vetchen bedacht es daz hobt, mit zwein die füsse, und mit zwein flog es. An den zwein niedresten vetchen stund geschriben: enpfah liden willeklich; and den mitelesten stund also: trag liden gedultekliich; and den obresten stund: lern liden cristförmklich."

97. For further commentary on these texts and images, see Jeffrey F. Hamburger, "La Bibliothèque d'Unterlinden et l'art de la formation spirituelle," in *Les dominicaines d'Unterlinden*, ed. Jeffrey F. Hamburger et al., 2 vols. (Colmar: Musée d'Unterlinden, 2000–2001), vol. 1, p. 147 and figure 28 [110–59], and vol. 2, p. 100 (cat. no. 137).

98. Hildegard of Bingen, *Scivias*, p. 67.

99. Saurma-Jeltsch, *Miniaturen im "Liber Scivias"*, pp. 33–37. For related imagery in illustrations to the Preface of the Mass in twelfth-century sacramentaries, see Beate Braun-Niehr, *Der Codex Vaticanus Rossianus 181: Studien zur Erfurter Buchmalerei um 1200* (Berlin: Gebr. Mann Verlag, 1996), pp. 59–66.

100. The text in Corin, ed., *Sermons de J. Tauler*, p. 221, ll. 9–14, is preferable here to that in Vetter, ed., *Die Predigten Taulers*, p. 378, ll. 1–5, where the term bilde is omitted: "Der tuben vederen das sint die luteren, die in heiliger einvaltigkeit stont sunder galle urteil und argwans und verkerendes alles des in anderen lúten ist, senftmûtig, stille und gûtig, die nach volgent dem senftmûtigen unserm herren Jhesu Christo. Úber dise vederen, úber al ir uf genge wandelt unser herre: begerunfe, minne und meinunge." Corin's edition reads: "Der dvben vederen daz sint die lvteren, die in heiliger eynveldicheit stent svnder gall v̊rteilis vnd argwanis vnd virkerins allis, des in anderen lvden ist, senftmvdich vnd stille vnd getwede, der navolgent dem senftmv̊digen bilde vns herrin ihesu christi. Vber disen vederne vnd vber alle iren vsgengen wandelt vns herin begervnge, monne vnd meinvnge."

101. Vetter, ed., *Die Predigten Taulers*, p. 378, ll. 4–12: "Zu dem anderen mole wandelt unser herre úber die vederen des aren. Diser are der flúget als hoch das man in nút gesehen enkan. Diser are das ist der mensche der mit allen sinen kreften innewendig uf flúget in die hôhi, und der mensche der sinen uswendigen und inwendigen menschen mit allem vermúgende uf spannet und flúget in die hôhi kennende und minnende, das einkein sinnelich kraft nút erlangen enmag. Uf den vederen wandelt unser herre." For eagle imagery elsewhere in Tauler's works, see Gnädinger, *Johannes Tauler*, p. 142, n. 46.

102. Liselotte Wehrhahn-Stauch, "Aquila-Resurrectio," *Zeitschrift des deutschen Vereins für Kunstwissenschaft* 21 (1967): 105–27.

103. See Martina Wehrli-Johns, "Das Selbstverständnis des Predigerordens im Graduale von Katharinenthal: Ein Beitrag zur Deutung der Christus-Johannes-Gruppe," in *Contemplata aliis tradere*, pp. 241–72; and, more generally, Jeffrey F. Hamburger, *St. John the Divine: The Deified Evangelist in Medieval Art and Theology* (Berkeley: University of California Press, 2002).

104. See Hanns Swarzenski, *Die lateinischen illuminierten Handschriften des dreizehnten Jahrhunderts in den Ländern am Rhein, Main und Donau*, 2 vols. (Berlin: Deutscher Verein für Kunstwissenschaft, 1936), vol. 1, pp. 53, 129–30 and figure 588; and *Codex Manesse: Katalog zur Ausstellung vom 12. Juni bis 2. Oktober 1988, Universitätsbibliothek Heidelberg*, ed. Elmar Mittler and Wilfried Werner (Heidelberg: Universitätsbibliothek, 1988), pp. 335–36.

105. Vetter, ed., *Die Predigten Taulers*, p. 378, ll. 13–32: "Zu dem dritten mole wandelt er uf den vederen der winde. Der wint der ist gar snel und behende: du enweist wannan er kumet oder war er wil. Diser wint ist der aller innewendigoste mensche, der verborgene oberste gotbildige gotformige mensche; der ist so gar úber alle verstentnisse und alles das dar in vernunft mit iren werken gelangen enmag. Es úber triffet alle sinne. Diser inwendiger mensche der wider flúget in sinen ursprung, in sin ungeschaffenheit und wirt do ein liecht in dem liechte. In disem liechte verlôschent etlicher mosse (si werdent als ein dúnsternisse) alle di natúrlichen liechter und die in gegossen liechter di under disem ie geluchtent. Ze gelicher wis als die klare sunne schinet, so verblendet si all die lúchtunge der sternen; die stant nu als schôn an dem himel als si hinacht taten; aber das grosse liecht der

sunnen das hat si geblendet. Also dis liecht das hie schinet in disen grunt, das verdúnstert und verblendet alle geschaffene liechter die ie geschinent, und wirt als klar in dem grunde das es dem geiste wirt als überswenkig das es engegen in schinet als ein dúnsternisse von überschwenklicheit des liechtes, wan es ime und allen creaturne unbegriflich ist. Wan aller crea-turen verstentnisse haltent sich engegen dem liechte als der swalwen ŏge sich haltet engengen der claren sunnen. Und ob du mit dinen kranken ŏgen woltest staren in das rat der sunnen, das schine dime gesichte als ein dúnsternisse von úber treffendem liechte und von krankheit des ŏgen."

106. Vetter, ed., *Die Predigten Taulers*, p. 162, l. 18, singled out for discussion by Walter Haug, "Johannes Taulers *Via negationis*," in *Die Passion Christi*, p. 88.

107. Haug, "Johannes Tauler," p. 87.

108. Tauler uses the more conventional climbing metaphor in sermon 57, which departs from Luke 18:10 ("duo homines ascenderunt in tem-plum"), Vetter, ed., *Die Predigten Taulers*, p. 271, ll. 16–20: "Ir súllent. . .uf den blŭjenden minneklichen bŏm klimmen des wirdigen lebens und des lidens unsers herren Jhesu Christi und in sine klarificierten wun-den und denne fúrbas uf klimmen uf den tolden siner hoher wirdiger gotheit."

109. For ladder imagery, see Christian Heck, *L'échelle céleste dans l'art du Moyen Âge: une image de la quête du ciel* (Paris: Flammarion, 1997). For tree imagery, especially as it relates to sermons, see Jeffrey F. Hamburger, *The Rothschild Canticles: Art and Mysticism in Flanders in the Rhineland ca. 1300* (New Haven, CT: Yale University Press, 1990), pp. 35–42.

110. Urs Kamber, *Arbor amoris, der Minnebaum: ein Pseudo-Bonaventura-Traktat herausgegeben nach lateinischen und deutschen Handschriften des XIV. und XV. Jahrhunderts* (Berlin: E. Schmidt, 1964), p. 70.

111. Kamber, *Arbor amoris*, pp. 68–73: "Sciendum quoque est, quod praedicatio videtur arbori similatur."

112. Vetter, ed., *Die Predigten Taulers*, p. 379, ll. 1–3: "Nu als man von diser kilwin liset von Zacheus das er unsern herren gerne hette gesehen; aber er was ze kurtz: was tet er? er clam uf einen dúrren fig b[ŏ]m."

113. Corin, ed., *Sermons de J. Tauler*, p. 224, n. 3. The conflation is also noted by Vogt-Terhorst, *Der bildliche Ausdruck*, p. 138.

114. For exegesis of these and related passages, see Stephen L. Wailes, *Medieval Allegories of Jesus' Parables* (Berkeley: University of California Press, 1987), pp. 167–72 and 220–25. For a rare illustration of Christ cursing the fig tree, see Freiburg, Universitätsbibliothek, Ms. 334, fol. 24r–v, an Alsatian manu-script illuminated ca. 1410, reproduced in Josef Hermann Beckmann and Ingeborg Schroth, *Deutsche Bilderbibeln aus dem späten Mittelalter: Handschrift 334 der Universitätsbibliothek Freiburg i.Bg. und M. 719–720 der Pierpont Morgan Library New York* (Constance: Thorbecke, 1960).

115. Tauler's reference to the barrenness of the fig tree would seem to preclude his simply having translated the Vulgate's sycomorus as feygenpawm or viecbom, both of which are attested in Lorenz Diefenbach, *Novum Glossarium Latino-Germanicum mediae et infimae aetatis: Beiträge zur wissenschaftlichen*

Kunde der neulateinischen und der germanischen Sprachen (1867; repr. Aalen: Scientia Verlag, 1997), p. 338.

116. For the iconography and symbolism of the fig tree in Christian art, see Oswald Goetz, *Der Feigenbaum in der religiösen Kunst des Abendlandes* (Berlin: Gebr. Mann, 1965). For similar interpretations of the sycamore of Luke as the barren fig tree, see the sermon for the dedication of a church by Absalon of Springersbach, PL 211, col. 225A: "Sed quae est arbor de qua jubetur descendere Zachaeus antequam recipiat Christum in domum suam? Ipsa est sycomorus, ficus videlicet fatua exuberans, cortice et foliis fructum ferens inutilem. Et significat hujus vitae delectationem ferentem ficus malas valde, ficus, inquam, voluptatis, corticem vanitatis et folia levitatis." That Tauler's reading of Zaccheus's descent from the sycamore/fig as a figure of humility and spiritual debasement is anything but conventional emerges if one compares it with the gloss on the same passage offered by Innocent III in PL 217, col. 445A–B: "Sycomorus est celsa, et, ut a quibusdam dicitur, ficus facua [*sic*—fatua]. Haec est sane crux Christi, quae ab infidelibus stultitia reputatur: 'Praedicamus, inquit Apostolus, Jesum Christum, et hunc crucifixum, Judaeis quidem scandalum, gentibus autem stultitiam' (1 Cor. 1). Hujus arboris ascensum alia quoque Scriptura proponit: 'Ascendam inquit, in palmam, et apprehendam fructus ejus' (Sg. 7). Palma, quae est signum victoriae, fidem crucis designat, de qua dicit Joannes: 'Haec est victoria, quae vincit mundum, fides nostra' (1 John 5). Quae comprehendit 'cum omnibus sanctis quae sit longitudo, latitudo, sublimitas, et profundum' (Eph. 3). Fructus hujus arboris est purpureus, succum habens sanguineum; quia fructus vitae, quae pependit in cruce, sanguinem suum pro nobis effudit." This is a much more common reading; cf. Aelred of Rievaulx in PL 145 col. 348: "Sycomorus quidem fatua ficus dicitur, per quam crux Christi manifestissime figuratur."

117. Vetter, ed., *Die Predigten Taulers*, p. 379, ll. 1–8: "also tut der mensche: er begert den ze sehende der dis wunder und dis gestúrne alles in im gemacht hat; aber dar zu ist der mensche ze kurtz und ze klein. Was sol er dar zu tun? Er sol uf klimmen uf den dúrren vig bǒm; das ist alles das do wir vor ab gesprochen haben, als sterben der sinnen und der nature und leben dem innewendigen menschen, do Got uf wandelt, als ir wol gehôrt hant."

118. See Jeffrey F. Hamburger, "Body vs. Book: The Trope of Visibility in Images of Christian-Jewish Polemic," in *Die Ästhetik des Unsichtbaren: Zum Verhältnis von Sichtbarkeit und Unsichtbarkeit in Kunst und Bildtheorie des Mittelalters und der Frühen Neuzeit*, ed. Thomas Lentes (Berlin: Reimer, 2004).

119. Vetter, ed., *Die Predigten Taulers*, p. 378, ll. 9–11: "Es dunket si ein raserige sin und ze mole ein affenheit, und so ist den wol als die licht zweihundert mark wert bucher habent und flisseklich lesent, und dunket es recht torheit sin."

120. Vetter, ed., *Die Predigten Taulers*, p. 380, ll. 16–17.

121. Hildegard of Bingen, *Scivias*, p. 67.

122. Vetter, ed., *Die Predigten Taulers*, p. 196, ll. 28–30: "Lieben kinder, die grossen pfaffen und die lesmeister die tispitierent weder bekentnisse merre und edeler si oder oder die minne. Aber wir wellen nu al hie sagen von den lebmeistern [. . .]"

123. Hildegard of Bingen, *Scivias*, p. 67.

124. Vetter, ed., *Die Predigten Taulers*, p. 380, ll. 5–8: " 'Ile und kum her nider.' Du must her ab; du ensolt von allem disem ein trahen nút halten. Denne gang her nider in din luter nicht, nút tŏgen noch vermúgen; so mus ich hútte komen in din hus."

125. For this aspect of Tauler's teaching, see Haas, *Nim din selbes war*, pp. 121–27 ("Der Mensch—ein Nichts").

126. Vetter, ed., *Die Predigten Taulers*, p. 380, ll. 13–16: "Wissest: was die nature wúrket, das hat alwegen etwas flecken, und es enist nút vollen luter, und dem ruffet Got her ab: das ist ein gantz verlŏigenen und ab gon der naturen in aller wise, do man dehein eigenschaft inne besitzet." For an interesting passage that speaks of music in terms of the abstraction of numbers "stained (*decolorantur*) by the corporeal matter of voices and moving things," see Bruce W. Holsinger, *Music, Body, and Desire in Medieval Culture: Hildegard of Bingen to Chaucer* (Stanford, CA: Stanford University Press, 2001), p. 4. Meinolf Schumacher, *Sündenschmutz und Herzenreinheit: Studien zur Metaphorik der Sünde in lateinischer und deutscher Literatur des Mittelalters* (Munich: Fink, 1996), provides an overarching study of a related semantic field.

127. For image as stain, see the comments of Georges Didi-Hubermann, "Puissance de la figure: Exégèse et visualité dans l'art chrétien," in *Encyclopedia Universalis: Symposium* (Paris: Encyclopaedia universalis France, 1990), p. 620 [608–21].

CHAPTER 10

SCRIPTURE, VISION, PERFORMANCE:
VISIONARY TEXTS AND MEDIEVAL
RELIGIOUS DRAMA

Niklaus Largier

"We are going to show you an image."—"Wy willen ju eyn bilde
gheven." This is how one of the late medieval northern German
Easter plays introduces the viewer and listener to the performance. The play
has been written down, as the manuscript tells us, in the year 1464 in
Redentin, but it testifies to a much older tradition of religious drama.[1] In a
similar way, the guiding voice of the "proclamator" informs the viewer and
listener at the beginning of a Passion play from Donaueschingen that the
upcoming performance is to be seen as "a series of beautiful devotional
images" [gar meng schön andächtig figur] that should be "contemplated" by
the viewer.[2] With these words, the play presents itself as a "figure," as an
"image" that has not only the function to stage the narrative "story" (*geschicht*)
of the Gospel and to instruct the viewers, but also to produce the effect of
a devotional image that should be "contemplated."[3]

As we will see, this evocation of the function of the play *as an image*
focuses on the reactions of the viewer in a very specific way. Seen as a series
of devotional images, the play produces what can be called a spiritual excite-
ment of the imagination. This state of spiritual excitement has to be under-
stood as the instance, the stage where desire, compassion, and devotion converge
in a moment of aroused, emotionally charged perception and a turn toward
the divine. Moreover, as I will show, the staging of narrative scenes from the
Gospel—and from apocryphal materials—in the shape of arousing images
defines the concept of faith and conversion in specific ways, transforming

the act of conversion into an emotional event that has its origin within the
logic and the structure of the visual display of the Gospel. Thus, *showing*
(*zeigen*)—the term used by the Easter play from Redentin—refers to the
production of an affective, emotional state through which the viewer is
absorbed by the things she sees and thus moved through conversion into the
state of faith. In being contemplated, the play is supposed to reenact time
and again the religious conversion of the viewer.[4]

The texts I mentioned above are only two examples of how religious
theatrical performance is defined during the Middle Ages. However, the two
examples are by no means exceptional. As I will argue, they can be seen as
quintessential types, as frames that let us understand how visual experience
is to be understood in the spiritual and theological context of the later
Middle Ages not only with regard to religious plays but also with regard to
the perception of the sacred space of the church and the visionary events
that happen within this space, in response to the pictorial display and the
liturgical performance of the story of the Gospel.

Both religious plays and visions offer answers to a strong tradition of
negative, apophatic theology that emphasizes the impossibility to name not
only the divine but also the hidden spiritual meaning of the Scriptures;
that is, the reconciliation with the divine and the resurrection of the flesh.
To illustrate this, I want to start with a glance at Mechthild of Magdeburg's
Flowing Light of the Godhead and at one of the famous visions of Hadewijch
of Antwerp. From there, I will return to the religious plays at the end of this
essay. In other words, I am going to discuss texts written by two pious
women who nevertheless did not belong to a religious order, and try to
work out an analogy between a characteristic element of their texts and
the way medieval religious plays usually present themselves.

Hadewijch's Vision

The vision I discuss below is very likely the most famous one in the book
of visions written by Hadewijch of Antwerp, a thirteenth-century beguine.
I am referring to the so-called seventh vision with its highly erotic moments
of an encounter between the beguine and Christ. Hadewijch's text and
her depiction of the encounter with the divine are not isolated cases. Her
vision can be compared to similar texts, for example, parts of Mechthild's of
Magdeburg's *Flowing Light of the Godhead*. It is very common—and indeed
correct—to look at both texts as religious allegories inspired by the language
of the Song of Songs and of its allegorical interpretation in exegetical texts
written by the church fathers. However, the visionary compositions from
the hands of the two beguines in the middle of the thirteenth century are
not to be seen as only a new form of exegesis of the Song of Songs or as

spiritual allegories of the encounter between the soul and God in a traditional fashion.[5] Rather, they are self-conscious plays enacting and staging the hidden meaning of the Gospel, interpreting the liturgy, establishing exegetical authority, and producing an actual experience of the spiritual meaning underlying the literal sense.[6] Thus, they perform the exegesis they intend in the form of dialogue and play, or, in other words, they enact in dramatic form what they consider to be the true meaning of the Gospel, that is, the encounter of the soul with the divine both in flesh and in spirit.

This is not only the case in the example of the vision quoted below or in the countless passages where Mechthild's and Hadewijch's texts construct allegorical plays staging vices and virtues or different powers of the soul in the tradition of medieval followers of Prudentius's *Psychomachia*.[7] It is also the case, to name just one example, where Mechthild offers an allegorical reading of the liturgy of the consecration of the virgins, transforming the personal reminiscence of a liturgical event into a play and hence translating the literal meaning into a spiritual experience.[8] A key moment in Hadewijch's and in Mechthild's visionary texts, namely, the reference to the liturgy and to the experience of certain elements of the daily celebration of the liturgy, is thus not only to be understood as a permanent allegoresis of the rite in the light of the beguine's personal experience of the divine, but also as an understanding of the liturgy that insists on the fact that the liturgy has to be seen as a form of performance and sacred play.[9] Both authors make it clear, as well, that the liturgical performance in the church produces certain types of spiritual experience, and that in their memory of the liturgical events, they look at them as playful enactments of the hidden meaning of the Scriptures. At the beginning of most theatrical scenes and allegories in Mechthild's and Hadewijch's texts, this means first of all the reminiscence and evocation of an emotional experience of incongruency between the promise of the Scriptures, that is, the mnemonic and prophetic quality of the text at the basis of the liturgical performance, and the unfulfilled desire of the nun or beguine to see the promise come true in the redemptive event of a real encounter with Christ. At the end of most of these theatrical scenes in their texts, the wish will be fulfilled through the encounter with the divine in the visionary event itself. As the two authors, together with many other late medieval documents, for example, the *Vitae sororum*, tell us time and again, the space of the church, the pictures in the church, the music, and the liturgy all evoke exactly this same experience of an emotional and spiritual tension, since both the space of the church and the liturgy are the place of the unfolding of the Scriptures in gestures, words, and images.[10]

From this point of view, the liturgical acts should not be seen to have only a representational and symbolic function but to produce an event that evokes the desire of the pious soul and responds to it in the form of a drama

that unfolds between the soul and God in the shape of the liturgy.[11] The allegorical mode that plays such an important role in Hadewijch's and Mechthild's texts has a very specific function. It mediates between the literal and the spiritual, creating a field of visualization that absorbs the representative aspects of the reading of the Scriptures and becomes the basis of a spiritualization of the written word in the sacred play. The spiritualization, the uncovering of the hidden meaning of the Scriptures, is nothing else than the enactment of this meaning in the dramatic encounter of the beguine with the divine, that is, the transformation of the liturgy into a dialogic scene. Usually, these encounters are depicted in terms inspired by the mysticism of the Song of Songs and enacted in the form of a series of playful events between the soul-bride and Christ-bridegroom.[12]

This pattern is most visible in one of the visions written by Hadewijch in the thirteenth century. Remembering a visionary experience while sitting in the church, she writes:

> On a certain Pentecost Sunday I had a vision at dawn. Matins were being sung in the church, and I was present. My heart and my veins and all my limbs trembled and quivered with eager desire and, as often occurred with me, such madness and fear beset my mind that it seemed to me I did not content my Beloved, and that my Beloved did not fulfill my desire, so that dying I must go mad, and going mad I must die. On that day my mind was beset so fearfully and so painfully by desirous love that all my separate limbs threatened to break, and all my separate veins were in travail. The longing in which I then was cannot be expressed by any language or any person I know; and everything I could say about it would be unheard-of to all those who never apprehended Love as something to work for with desire, and whom Love had never acknowledged as hers. I can say this about it: I desired to have full fruition of my Beloved, and to understand and taste him to the full. I desired that his Humanity should to the fullest extent be one in fruition with my humanity, and that mine then should hold its stand and be strong enough to enter into perfection until I content him, who is perfection itself, by purity and unity, and in all things to content him fully in every virtue. To that end I wished he might content me interiorly with his Godhead, in one spirit, and that for me he should be all that he is, without withholding anything from me. For above all the gifts that I ever longed for, I chose this gift: that I should give satisfaction in all great sufferings. For that is the most perfect satisfaction: to grow up in order to be God with God. For this demands suffering, pain, and misery, and living in great new grief of soul: but to let everything come and go without grief, and in this way to experience nothing else but sweet love, embraces, and kisses. In this sense I desired that God gave himself to me, so that I might content him. As my mind was thus beset with fear, I saw a great eagle flying toward me from the altar, and he said to me: "If you wish to attain oneness, make yourself ready!" I fell on my knees and my

heart beat fearfully, to worship the Beloved with oneness, according to his true dignity; that indeed was impossible for me, as I know well, and as God knows, always to my woe and to my grief. But the Eagle turned back and spoke: "Just and mighty Lord, now show your great power to unite your oneness in the manner of union with full possession!" Then the eagle turned round again and said to me: "He who has come, comes again; and to whatever place he never came, he comes not."

Then he came from the altar, showing himself as a Child; and that Child was in the same form as he was in his first three years. He turned toward me, in his right hand took from the ciborium his Body, and in his left hand took a chalice, which seemed to come from the altar, but I do not know where it came from. With that he came in the form and clothing of a Man, as he was on the day when he gave us his Body for the first time; looking like a Human Being and a Man, wonderful, and beautiful, and with glorious face, he came to me as humbly as anyone who wholly belongs to another. Then he gave himself to me in the shape of the Sacrament, in its outward form, as the custom is; and then he gave me to drink in form of the chalice, in form and taste, as the custom is. After that he came himself to me, took me entirely in his arms, and pressed me to him; and all my members felt his in full felicity, in accordance with the desire of my heart and my humanity. So I was outwardly satisfied and fully transported. Also then, for a short while, I had the strength to bear this; but soon, after a short time, I lost that manly beauty outwardly in the sight of his form. I saw him completely come to naught and so fade and all at once dissolve that I could no longer recognize or perceive him outside me, and I could no longer distinguish him within me. Then it was to me as if we were one without difference. It was thus: outwardly, to see, taste, feel, as one can outwardly taste, see, and feel in the reception of the outward Sacrament. So can the Beloved, with the loved one, each wholly receive the other in all full satisfaction of the sight, the hearing, and the passing away of the one in the other.

After that I remained in a passing away in my Beloved, so that I wholly melted away in him and nothing any longer remained to me of myself; and I was changed and taken up in the spirit, and there it was shown me concerning such hours.[13]

I quote this lengthy passage because it shows the ways in which the visionary event is embedded in a transition from the performance of the liturgy through a reference to allegorical symbols that finally leads to an experience of the divine.[14] The starting point is nothing else than a liturgical moment, Pentecost, and the singing of the matins on that day. This liturgical moment—Pentecost, the soul waiting for the arrival of the spirit, the singing that evokes the desire—leads to a description of the intensity and character of the beguine's wish for an encounter with the divine, quoting from the repertoire of mystical topoi inspired by the Song of Songs.

The description of her desire finally gives place to the act of communication, the play between her and the divine. An eagle, here as in many other cases, the allegorical figure of the spiritual messenger, prepares an encounter through which all the symbols of the communion in the Eucharist are transformed into the Real Presence of Christ. The liturgy that represents the text and its message—Pentecost as the moment when the spirit transforms the old world of the literal—has become the place where the hidden meaning of the Gospel—the union of Christ and the beguine—is being enacted in the visionary event. The *sensus mysticus*, the mystical sense of the Scriptures, takes shape in a performance that absorbs both the symbolic language of the liturgy and the desire of the beguine for oneness with Christ in a unifying event.

We certainly do not go wrong if we read this visionary text, the play between the soul and Christ, as Hadewijch's interpretation, as her enactment of the meaning of Pentecost. She refers to the liturgy, to the singing, to the conventional set of liturgical symbols. However, she does this in a very specific way, emphasizing a transition from word to flesh and from flesh to word, from the spiritual to the literal and from the literal to the spiritual. The spiritual desire evoked by the singing leads to the literal vision where the meaning of the liturgical symbols takes shape in the literal play between Christ and her. This literal encounter, the Real Presence in the flesh evoked by the symbolic language of the liturgy, finally disappears in the apophatic moment of pure spiritual unity that the text describes at the end where all the differences between inward and outward, literal and spiritual, word and flesh disappear. From the word and the singing, the soul moves through the conversion of word and flesh in the encounter with Christ to the spiritual sphere where there is nothing else than unity with the divine.

We might argue that the text tells us the story of the perfect absorption of the soul by the hidden and unspeakable meaning of the text, that is, the promised unity with the divine beyond the separation of word and flesh. However, the text tells us much more. It brings to our attention that this unity has its place *in via*, in time, nowhere else than in the performance that happens on the visionary stage—a visionary stage that superimposes itself upon the liturgy, emphasizing that the true meaning of the word is not to be found in its symbolic representation, but only in the performance where it becomes event. The transition from the liturgy—the singing, the reading of the word, the Eucharist—to the experience of the divine takes shape in the theater of the imagination. There, the visual enactment, the mise-en-scène of the meaning of the Scripture is linked to an emotional intensity of the experience that unfolds hand in hand with the visualization. This "living image," this *tableau vivant*, one might argue following Hadewijch's text, is the true exegesis and reading of the Scriptures and its representation in the

space of the church at Pentecost, the day when the Spirit was received by the apostles.

The vision, I want to argue, is an exemplary instance of such a type of reading, emphasizing the necessity of a performative enactment wherever the "hidden," "mystical," "spiritual" sense (*sensus absconditus, mysticus, spiritualis*) of the Scripture is at stake. From this point of view, and from the point of view of the audience of the visionary text, namely, the hypothetical community of nun and beguine readers, the vision is a didactic text as well. It guides and shapes the understanding of the faithful, starting with the situation of the listener in the church and moving on to the person who contemplates the word in the form of a visual allegory and a playful enactment. Thus, the listener in the church is transported from the allegorical meaning of the text—Christ being the bridegroom—into the realm of the event and enactment that absorbs both the listener and the meaning of the text in one event, that is, the real encounter of Christ and the soul as bride and bridegroom.

This, one might want to add, is the ideal model of reading that Hadewijch and Mechthild insist upon. It is, on a didactic level, the type of reading their texts try to produce since all of them intend to become examples, exemplary readings that show and fashion how one has to read and how one should understand the liturgical representation of the Scriptures. In this sense, the two beguines are to be seen as theological authors who propose a specific, possibly alternative hermeneutic practice with regard to the reading of the Scriptures. At its center is not the biblical text alone and its memorial presence in the liturgy, but the act of reading and liturgical performance as a repetition and a dialogic enactment where the remembering of the Scripture becomes experience of its hidden meaning, enactment of the *sensus mysticus*. This, in Mechthild's and Hadewijch's texts, is exemplary reading, that is, a model for reading where the visual, the image, and the play compensate for the ungraspable depth of the meaning of the Scriptures.

Medieval Religious Play

As we have seen, medieval religious plays often use the term *image* or *figure* to refer to the performance. This term, I would like to argue, is to be understood in the light of what we read in Hadewijch. In both cases, the visual compensates for a lack, for the apophatic character of the divine, for a finitude of human understanding, and leads the mind desiring to encounter the divine into a realm of spiritual enactment and "real presence."[15] This point is at stake in other plays as well. Hence, the Passion play of Villingen points out: "Because no man's reason / and no man's educated mind / and no man's mouth / can grasp and tell us really / how Christ fought in his life / and

how he suffered for us / this is why we present as a play in simplicity / his passion in all its shape / following the letter as good as we can" [Weil aber kains menschen verstand, / Auch kaines menschen gelehrte hand, / Wie auch durch aus kains menschen mundt / Begreiffen vnd erzellen kan im grundt, / Wie Christus im leben gstritten / Vnd was er für vns hab glitten, / Drumb wollen wir in ainfaltt / Den passion in aller gstalt / Dem buchstab nach mitt allem fleis / Auffs kürzst fürtragen in spils weus].[16] In other words, the play puts itself in the same position occupied by Hadewijch's vision. It responds to the inability to grasp the spiritual meaning of the Scriptures in positive terms, and it defines itself as leading to an understanding of the Scriptures beyond reason, gesture, and word. The "proclamator" of the Passion play from Donaueschingen points to the same fact when he mentions that the play consists of "many beautiful devotional images" [gar meng schön andächtig figur]. He also insists that it should be "contemplated in a silent manner," emphasizing the quality of the play that guides the mind toward a deeper understanding of the truth of the Scriptures. The play enacts by making visible what cannot be understood in words alone. However, it does not shift from one mode of representation, the word, to another one, the image. Rather, it brings to our attention that only the enactment itself can compensate for the lack of understanding.

The fact that this enactment focuses before anything else on an affective, emotional arousal means another parallel moment between Hadewijch's visionary play and the public religious drama. An instance where we can observe this best is the appearance of Mary Magdalene and her function in the Donaueschingen Passion play. The key moment when we first see Mary Magdalene is her conversion. This event is depicted in a most elaborate manner, introducing the viewer to a lively scene of luxurious entertainment and worldly opulence. The thought that this scene might be presented only as an antithesis to the following scene of conversion seems misleading. Rather, I would like to argue, it is an integral part of the understanding of conversion as it is enacted by the play. The production of an affective tension—Ingrid Kasten speaks of "Emotionalisierung"[17]—between the desire for luxurious pleasure and to follow Christ is not a tension between a mythical non-Christian or a pre-Christian world and a Christian model of conversion. Instead, the play presents and enacts conversion as a tension and drama within the world of affects itself. The viewer must pass through the images of the luxurious, he has to be affected by them and to transcend them in the same movement of emotional conversion that is exemplified by Mary Magdalene. As in Mechthild of Magdeburg's text, where she emphasizes that unity with the divine cannot be reached except by a radical submission to the world of images and to "Lucifer's tail," we are forced to go through an antagonistic stimulation of the affects here as well.[18]

It is only by going through the tension, by enacting the tension in allegorical, visionary, and theatrical images, that the viewer of the play understands without words what compassion and conversion—the exemplarity of Mary Magdalene—ultimately mean. This scene has no other purpose than to arouse the emotions of the viewer and to turn the emotions toward Christ.[19] In this way, the viewer is led "through images beyond images," through the playful enactment and the stimulation of the imagination beyond it.[20] This is the way in which the play redefines "conversion," not as a change of opinion but as a transformation that primarily affects and shapes the economy of the emotions. Comparable to Hadewijch's visionary text, the soul first is aroused by the desire to see, then gets excited by images, encounters the divine in playful figuration, and transcends the figurative in a final gesture of spiritualization. This is what "conversion" embodies if we understand it—as suggested by the play—in the light of the theatrical figure of Mary Magdalene.[21] Heinrich Seuse ("Henry Suso"), a Dominican author and mystic of the fourteenth century, confirms this reading by the way he makes use of the exemplarity of Mary Magdalene in one of his texts.[22] He refers to the medieval stories about Mary's life and the moments of her encounter with Christ as elements of an exemplary play that serve to arouse our imagination and to lead the arid heart into a state of emotional intensity. As he tells Elsbeth Stagel, the nun to whom he addressed his letters and treatises, the scenes function to stimulate the affective side of the soul, putting the soul into a state of intense desire, a desire that can then be directed toward the divine and that can transport the soul to the unknowable God. The use he makes of the stories about Mary Magdalene in this devotional exercise is exactly analogous to the theatrical scenes that we encounter in the plays. In Seuse's text, too, the image, its arousal of the imagination, and the affects caused by the visual and the playful enactment compensate for the apophatic character of the divine. Only the soul that gets aroused by looking at the scenes with Mary Magdalene can overcome the finitude of its desire to grasp the divine in positive terms and encounter God in an immediate, that is, at first emotional and imaginary and—ultimately—in the end intellectual and apophatic way.

The significance of Mary Magdalene in these dramatic scenes is characteristic since she embodies a specific understanding of conversion. Conversion, the texts and plays can be understood to argue, includes and presupposes the failure of reason and intellectual comprehension. Thus, conversion necessarily refers to a procedure that is able to compensate for this failure. It is this moment of compensation that the playful enactment of the story of the Passion in the Donaueschingen religious drama and the encounter of the beguine with the divine in Hadewijch's vision have in common. They both refer to a process—of conversion, of visionary union—where the

arousal of emotion and imagination compensates for the failure of reason to grasp the divine. In both cases, this process relies on the hermeneutic figure of thought that the play, the living image, enacts and performs what cannot be named directly, that is, the hidden spiritual meaning of the Scriptures. In both cases, too, the enactment means that the viewer or listener is absorbed by the hidden meaning of the text, that she is carried away—in case of the vision—or immediately affected by the event of conversion—in case of the dramatic scenes with Mary Magdalene.

One might want to argue—referring to Rainer Warning's study of medieval drama—that the religious play is characterized by a more archaic structure than the visionary event, and emphasize the "ambivalences of medieval religious drama" by pointing to the opposition of kerygma and myth, spiritual turn toward God and narrative context.[23] However, the material examined above suggests instead that the *myth*, that is, the pictorial narrative and the visual and dramatic artifact, is an integral part of the *kerygma* and that it has to be transformed by its own means to produce the spiritual event that the medieval authors are looking for. Only this form of embodiment makes the sense of the Scriptures fully present.[24] Both Hadewijch's visionary enactment and the religious play point to the *kerygma* as the underlying meaning of the Scriptures that cannot be represented, but which has its presence nevertheless nowhere else than in the enactment of the *myth*, that is, in the scriptural narratives that take shape as images, visions, and allegorical plays. In other words, the religious play—both in its visionary form and in its public performance—insists on the necessity of the visualization and of the arousal of the imagination as the instance where the spiritual meaning of the Scriptures is enacted—both in its originary form of conversion and its final form, the unity with the divine that annihilates all images.

Notes

1. For a recent discussion of medieval drama and the literature about it, see Jan-Dirk Müller, "Ritual, pararituelle Handlungen, Geistliches Spiel: Zum Verhältnis von Schrift und Performanz," in *Audiovisualität vor und nach Gutenberg*, ed. Horst Wenzel, Wolfried Seipel, and Gotthart Wunberg (Vienna: Kunsthistorisches Museum, 2001), pp. 63–71; Müller, "Mimesis und Ritual: Zum geistlichen Spiel des Mittelalters," in *Mimesis und Simulation: Festschrift Rainer Warning*, ed. Andreas Kablitz and Gerhard Neumann (Freiburg: Rombach, 1998), pp. 541–71; Müller, "Realpräsenz und Repräsentation: Zur Ausdifferenzierung von Theatralität und Geistlichem Spiel," in *Medieval Theatricality*, ed. Hans-Ulrich Gumbrecht (Stanford, CA: Stanford University Press, forthcoming); Rainer Warning, *The Ambivalences of Medieval Religious Drama*, trans. Steven Rendall (Stanford, CA: Stanford University Press, 2001),

first publication in German under the title *Funktion und Struktur: Die Ambivalenzen des geistlichen Spiels* (Munich: Wilhelm Fink, 1974); Gail McMurray Gibson, *The Theater of Devotion: East Anglian Drama and Society in the Late Middle Ages* (Chicago: University of Chicago Press, 1989).

2. Brigitta Schottmann, ed., *Das Redentiner Osterspiel* (Stuttgart: Philipp Reclam, 1975), p. 22; Eduard Hartl, ed., *Donaueschinger Passionsspiel* (Darmstadt: Wissenschaftliche Buchgesellschaft, 1966), p. 92. The terms used are *sen* or *betrachten*. The Donaueschinger play stresses *schowen, betrachten, schwigen* three times during the introductory lines spoken by the "proclamator."

3. An excellent analysis of the term *figura*, its use in the context of late medieval plays, and its connection with visual culture is to be found in Glenn Ehrstine, "Das figurierte Gedächtnis: *Figura*, Memoria und die Simultanbühne des deutschen Mittelalters," in *Text und Kultur*, ed. Ursula Peters (Stuttgart and Weimar: J.B. Metzler, 2001), pp. 415–37. In his analysis of several plays, Ehrstine emphasizes the importance of the "Andachtsfunktion von *figurae*." See also Ursula Schulze, "Formen der Repraesentatio im Geistlichen Spiel," in *Mittelalter und frühe Neuzeit: Übergänge, Umbrüche und Neuansätze*, ed. Walter Haug (Tübingen: Niemeyer, 1999), pp. 211–32. For an analysis of the link between plays and medieval iconography, see Anthonius H. Touber, "Das Donaueschinger Passionsspiel und die bildende Kunst," *DVjs* 52 (1978): 26–42. On devotional images, see Jeffrey F. Hamburger, *The Visual and the Visionary: Art and Female Spirituality in Late Medieval Germany* (New York: Zone Books, 1998), pp. 111–48; Niklaus Largier, "Der Körper der Schrift: Bild und Text am Beispiel einer Seuse-Handschrift des 15. Jahrhunderts," in *Mittelalter: Neue Wege durch einen alten Kontinent*, ed. Jan-Dirk Müller and Horst Wenzel (Stuttgart: Hirzel, 1999), pp. 241–71; Largier, "Jenseits des Begehrens—Diesseits der Schrift: Zur Topologie mystischer Erfahrung" *Paragrana* 7 (1998): 107–21.

4. This explains—and justifies—the "redundancy" some modern interpreters have criticized with regard to certain aspects of the play. Cf. Johan Nowé, "Wy willen ju eyn bilde gheven. Explizite und implizite Regieanweisungen als Grundlagen für Inszenierung und Aufführung des Redentiner Osterspiels," *Leuvense Bijdragen* 90 (2000): 325–58. Nowé writes: "Für den Spielverlauf bedeutet eine konsequente Anwendung der impliziten Regieanweisungen, dass ein beträchtlicher Teil des Haupttextes im Grunde redundant und verzögernd wirkt. Viele Aussagen enthalten ja bloss Erwähnungen von Begebenheiten, die schon durch die Inszenierung vermittelt werden und halten daher den Spielverlauf oft auf" (358). I don't understand the structure of the repetitive and seemingly redundant elements as a "Nachteil" (358). On the contrary, this reduplication is rather a principle of construction of the play. It enacts the tension between the narration and the dramatic performance, and points time and again to the fact that the spiritual transformation of the viewer is based on an actualization of the historical narrative through the play.

5. Cf. Bernard McGinn, ed. *Meister Eckhart and the Beguine Mystics: Hadewijch of Brabant, Mechthild of Magdeburg, and Marguerite Porete* (New York: Continuum,

1994); Amy Hollywood, *The Soul as Virgin Wife: Mechthild of Magdeburg, Marguerite Porete, and Meister Eckhart* (Notre Dame, IN: Notre Dame University Press, 1995).

6. Bernard McGinn, "The Four Female Evangelists of the Thirteenth Century: The Invention of Authority," in *Deutsche Mystik im abendländischen Zusammenhang: Neu erschlossene Texte, neue methodische Ansätze, neue theoretische Konzepte*, ed. Walter Haug and Wolfram Schneider-Lastin (Tübingen: Niemeyer, 2000), pp. 175–94.

7. Prudentius, *Works*, vol. 1, ed. H.J. Thomson (Cambridge, MA: Harvard University Press, 1969).

8. Mechthild of Magdeburg, *The Flowing Light of the Godhead*, trans. and introduced by Frank Tobin, preface by Margot Schmidt (New York: Paulist Press, 1998), pp. 63–64. See also Mechthild of Magdeburg, *Das fliessende Licht der Gottheit: nach der Einsiedler Handschrift in kritischem Vergleich mit der gesamten Überlieferung*, ed. Hans Neumann (München: Artemis Verlag, 1990).

9. For a discussion of the relation between medieval liturgy, social performance, and ritual, see Ingrid Kasten, "Ritual und Emotionalität: Zum geistlichen Spiel des Mittelalters," in *Literarisches Leben: Rollenentwürfe in der Literatur des Hoch- und Spätmittelalters, Festschrift für Volker Mertens zum 65. Geburtstag*, ed. Matthias Meyer and Hans-Jochen Schiewer (Tübingen: Niemeyer, 2002), pp. 335–59; C. Clifford Flanigan, Kathleen Ashley, and Pamela Sheingorn, "Liturgy as Social Performance: Expanding the Definitions," in *The Liturgy of the Medieval Church*, ed. Thomas J. Heffernan and E. Ann Matter (Kalamazoo, MI: Medieval Institute Publications, 2001), pp. 695–714.

10. Cf. Bruce W. Holsinger, *Music, Body, and Desire in Medieval Culture: Hildegard of Bingen to Chaucer* (Stanford, CA: Stanford University Press, 2001); and Jeffrey Hamburger's analysis in this volume of a sermon by Johannes Tauler and its references to visual material.

11. Cf. Johan Nowé, "Kult oder Drama? Zur Struktur einiger Osterspiele des deutschen Mittelalters," in *The Theatre in the Middle Ages*, ed. Herman Braet, Johan Nowé, and Gilbert Tournoy (Leuven: Leuven University Press, 1985), pp. 270–72 [269–313].

12. This transition from liturgy to playful enactment is similar to the transition from "Kult" to "Drama" analyzed by Johan Nowé on the basis of several plays. In both cases, we observe a growing distance from the liturgical rite, a move toward an increasingly independent narrative, and an attempt to construct a dramatic space of experience ("Kult oder Drama?" pp. 311–12).

13. Hadewijch, *The Complete Works*, ed. Columba Hart (New York: Paulist Press, 1980), pp. 280–82.

14. This movement is—not at all surprisingly—similar to the way in which Johan Tauler makes use of an image from Hildegard of Bingen's *Scivias* in one of his sermons. Cf. Jeffrey Hamburger's essay (chapter 9) in this volume.

15. Cf. Ehrstine, "Das figurierte Gedächtnis": "Die Grenze zwischen Anwesendem und Abwesendem im geistlichen Theater [. . .] war fliessend, was in der

Nähe zwischen Spiel und Liturgie sichtbar wird. Bei Fronleichnamsspielen war Christus durch das Sakrament tatsächlich gegenwärtig, und viele Aufführungen waren mit liturgischen Handlungen direkt verbunden. Ausserdem wurde oft für den Spielbesuch ein besonderer Ablass gewährt. Mit anderen Worten: das geistliche Spiel galt als Quelle des Heils und bot den Zuschauern eine Teilhabe an der Erlösungstat Christi, selbst wenn es ihn nicht leibhaft präsent machte wie bei der Messe" (p. 422).

16. Antje Knorr, ed., *Villinger Passion: literarhistorische Einordnung und erstmalige Herausgabe des Urtextes und der Überarbeitungen* (Göppingen: A. Kümmerle, 1976), p. 28, ll. 1–10.

17. Ingrid Kasten, "Ritual und Emotionalität," p. 348. In her essay, Kasten emphasizes the structure of participation and exclusion in view of the emotional constitution of a community through the play. Following her path of interpretation, I would like to argue that the "exclusion" itself is to be seen as an emotional drama that has to be enacted by the viewer in adopting both roles.

18. Mechthild of Magdeburg, *The Flowing Light*, p. 183.

19. Ursula Schulze, "Schmerz und Heiligkeit: Zur Performanz von *Passio* und *Compassio* in ausgewählten Passionsspieltexten (Mittelrheinisches, Frankfurter, Donaueschinger Spiel)," in *Forschungen zur deutschen Literatur des Spätmittelalters: Festschrift für Johannes Janota*, ed. Horst Brunner and Werner Williams-Krapp (Tübingen: Niemeyer, 2003), pp. 210–32. Cf. Ursula Schulze, "Formen der Repraesentatio," pp. 331–45.

20. Cf. Henry Suso, *The Exemplar, with Two German Sermons*, trans., ed., and introduced by Frank Tobin, preface by Bernard McGinn (New York: Paulist Press, 1989), pp. 174 and 203. See also Heinrich Seuse, *Deutsche Schriften*, ed. Karl Bihlmeyer (1907; repr. Frankfurt am Main: Minerva, 1961).

21. Cf. Elisabeth Pinto-Mathieu, *Marie-Madeleine dans la littérature du Moyen Age* (Paris: Beauchesne, 1997); Susan Haskins, *Mary Magdalen: Myth and Metaphor* (New York: HarperCollins, 1993).

22. Suso, *Exemplar*, pp. 134–35.

23. Warning, *Ambivalences*.

24. Cf. Ehrstine, "Das figurierte Gedächtnis," pp. 417–24.

PART FIVE

WORD, IMAGE, AND TECHNOLOGY

CHAPTER 11

THE *LOGOS* IN THE PRESS: CHRIST
IN THE WINE-PRESS AND THE
DISCOVERY OF PRINTING

Horst Wenzel

In recent years, questions regarding the relationships between texts and images have taken up a central position in cultural studies, as they have in literary studies, art history, history, and theology. One explanation for this interest is an iconic turn that has shifted the dominant medium from book to image.[1] Because of the recent developments and changes in information technology, scholars have become more attuned to the importance of primary audiovisual reception, such as hearing and seeing, to rituals and ceremonies, and to manifold combinations of text and image. This new audiovisual perspective is relevant to the study of cultural materials from before the Gutenberg era to the present.

In German Medieval Studies, it was long taken for granted that texts should be transmitted and disseminated in critical editions that might include an image of a folio from the manuscript or a miniature, but did not take into account the statement of imagery as such, let alone the correspondence to the text surrounding it. But our understanding of the medieval text has recently become much more complex. Scholars have begun to examine the diverse relationships between texts and images that vary depending on their intended use and the context of their compilation. This *variance* results in different versions of a text in which the relationship between word and image fluctuates.[2] The same phenomenon occurs in medieval frescos and tableaux. It is here that the interests of art and literary historians overlap: on the one hand, it is important to determine how

images were "read," and on the other, it is crucial to examine the ways in which literature was "visualized."

From the perspective of historians, this convergence corresponds to the nature of the sources themselves. According to medieval understanding, the world is perceived as a book (*liber naturae*) with every visible thing in it a sign that points beyond itself to the truth of God. Speech and images were both possible channels through which one could arrive at invisible truths through visible objects. In the modern period, by contrast, science separated speech and images so that the image was perceived as a representation while speech was considered a medium with which to reflect on that representation from a distance. Today, we regard speech and images as a complex and multifaceted symbiotic system of signs that creates meaning.[3] Most scholars working on word and image have been concerned with the role that images play in manuscripts, but equally fascinating are the inscriptions, banderoles, scrolls, and writing tablets portrayed in images. While this essay examines the iconography of the word in the medieval image, a history of words in images remains to be written.[4]

In this essay, I concentrate on a particularly rich iconographical tradition that appears in various contexts and guises: the image of Christ in the winepress. This image relates to various important religious tenets: disseminating the word of God, turning the mysterious wine of the Eucharist into Christ's blood, and establishing the Christian society as *corpus Christi mysticum*. This case study of a richly faceted iconographic representation offers insight into the history of communication and the highly complex notions of word and image in the religious culture of the Middle Ages. The parallels between the history of religion and the history of information technology have received little scholarly attention. Yet, information technology was essential to the Christian Church throughout the Middle Ages and into the modern period, since the church to a great extent determined and monopolized the Western Christian understanding of the world. Developments in information technology and shifts in media were, indeed, incorporated into the changing iconographic traditions of the church.

From the perspective of media theory, the images of Christ in the winepress discussed here represent the spreading of the *logos* and the reproduction of the single truth of God. The representation of the grape symbolizes the blessed land. The grape produces the mystical wine that is the medium of the *logos*. The *logos*, in turn, is disseminated by a communicative network and by the printing press. We will see that the technological breakthrough of the printing press, which in many ways signals the beginning of modernity, is effortlessly incorporated into the traditional theological discourses. Central to the issue of medium is the need to establish a system of communication throughout the Christian society (*communio*) by means of word and

image. The different manifestations of the image are compelling because they visually transform the sacred texts so dynamically and diversely that they overcome any tension between the traditional canon of the holy word and the historical dynamics of communication technology.

I draw here on Hartmut Winkler who comments that "the dynamic of the development of media has its origins in certain structures of desires and that the history of media follows describable sets of implicit utopias."[5] He further notes that "it remains open whether these are the desires of those who are actually instrumental in the processes, whether they can reach their consciousness, or whether they even need a human conduit; the concept of desire refers to the tension in the system rather than its subject presence."[6] Correspondingly, I interpret developments in information technology not so much as a response to social history or stages in the history of technology, but rather, following Winkler, I examine the fantasies and the imaginative precursors of these developments. These imaginings appear in images and metaphors before they ever appear as material objects.

Christ in the Wine-Press

The image of Christ in the wine-press points to the typological connections between the Old and the New Testament, that is, to the Old Testament as the figurative prehistory of Christ that has been superseded by the New Testament. The New Testament supersedes the Old Testament particularly in regard to the idea of transubstantiation as the condition for the development of a *communio* that joins the individual limbs of the Christian community into one collective body (*corpus Christi mysticum*). The point of departure is the Old Testament story of the discovery of Canaan (Num. 13). On God's order, Moses sends messengers to all the tribes to explore unobtrusively their surrounding lands.[7] As these explorers arrive in the valley of Eshcol, they cut a vine with a grape on it that is so heavy that two men must carry it on a pole. The explorers have fulfilled the goal of the enterprise, and their act symbolizes the discovery of the promised land, the ultimate goal (figure 11.1).

The vine and the grape become *signum* of the holy land and the *figura Christi*, because the tortured Christ nailed on the wooden cross bears testimony to the heavenly land of Jerusalem, which is promised to all believers. One of the men carrying the pole is old, the other young. These men symbolize the Old and New Testaments, which are also represented by *Synagoga* and *Ecclesia*. The vine that they carry is a precursor to the cross on which Christ is crucified, and the grape is a multivalent symbol that denotes Christ, the Eucharist, and the blood of Christ that flows down the cross at his crucifixion. Wine and blood are thus identified with the Eucharist.

11.1 The grape on the vine (Verdun Altar). *Der Verduner Altar: Das Emailwerk des Nikolaus von Verdun im Stift Klosterneuburg*, ed. Helmut Buschhausen, vol. 3/9 (Vienna: Edition Tusch, 1980), plate 27.

The image of Christ in the wine-press connects the representation of Christ with the chalice of the Last Supper, for it depicts Christ simultaneously as a pressed grape, and as a winemaker. The late medieval version of this image, which places the sacrifice of Christ at the center, is, however, not

the original interpretation. The original iconography draws on the image in Isaiah 63:3: "Torcular calcavi solus et de gentibus non est vir mecum / calcavi eos in furore meo et conculcavi eos in ira mea / et aspersus est sanguis eorum super vestimenta mea et omnia indumenta mea inquinavi" [I have trodden the wine-press alone; and of the people there was none with me: for I will tread them in mine anger, and trample them in my fury; and their blood shall be sprinkled upon my garments, and I will stain all my raiment]. Similarly, the book of Revelation, states: "et ipse calcat torcular vini furoris irae Dei omnipotentis" [and he treadeth the wine-press of the fierceness and wrath of Almighty God] (Rev. 19:15).

The action of working the wine-press stands primarily for the bloody harvest of God's final judgment (Rev. 14:18–20). But the early church fathers already interpreted the prophetic words in a typological manner as pertaining to the suffering savior, who was crushed like a grape in a wine-press, and whose blood becomes the Eucharistic drink.[8] Tertullian (shortly after 200) and Cyprian (d. 258) use the reference in Isaiah 63:1–6 as a prophecy in the Old Testament for the introduction of the sacrament of Holy Communion in the New Testament. In his commentary on the Song of Songs, Saint Hippolytus (d. 236) connects the story of the two messengers in Numbers 13:23 with the interpretation in the New Testament: "When the Bible says that they cut off a vine and a grape, which two men carried, then the vine is a symbol for the cross, and the grape, which hangs on the vine carried by two men, is a symbol for Jesus Christ, who was hung on a cross erected between two thieves."[9]

On stone crosses and bishops' staffs from the tenth, eleventh, and twelfth centuries, we find several instances of the motif of the grapevine used as a symbol of the crucified Christ.[10] Figure 11.2 is a late print from the seventeenth century that offers us a particularly striking example of this idea.[11] This print depicts Christ as a fruit-bearing grapevine. The verses that accompany the image tell us that "he is like the grape vine, just as he called himself" (John 15:5).[12] On the left, John the Baptist kneels with a stave and a banderole that reads "Ecce Agnus Dei." On the right we see Saint Stephen, and together they are represented as the most important of the Christian martyrs. The composition of the print underlines this message: The larger image of Christ in the center is framed by fourteen smaller saints' images that represent their martyrdom in the tradition of Christ. The twelve apostles are combined with St. Paul and the mother of God who appears as *mater dolorosa*. They are the grapes on the vine surrounding Christ (see John 15:4). Like Christ, they shed their blood for the Christian belief and the Christian community: "The vines that are rich with fruit are like Christ's apostles, who hang on Christ."[13]

The basic image of the wine-press that can be found from the twelfth century on picks up this allegorical representation of Christ as a grapevine

11.2 The spiritual grapevine of Lord Jesus. Nuremberg (mid–seventeenth century), copper plate by Paul Fürst. *Die Sammlung der Herzog August Bibliothek in Wolfenbüttel: kommentierte Ausgabe*, vol. 3, *Deutsche Illustrierte Flugblätter des 16. und 17. Jahrhunderts*, ed. Wolfgang Harms et al. (Tübingen: Niemeyer, 1989), figure 29, see also figure 30.

and connects the idea of the sacrifice with the notion of redemption. In this context, Rupert von Deutz (d. 1129) comments: "He worked the wine-press in that he gave himself for us; he was pressed like a grape in that under the weight of the cross, the wine flowed from his body as his spirit was exhaled. He also crushes himself, for through his suffering he separates the good from the evil, the former rewardingly, the latter punishingly, just like in the wine-press in which the wine is separated from the residue."[14] The image of Christ in the wine-press thus points to the eucharistic connection between blood and wine, to the act of reproducing and disseminating the *logos* that, in the Old Testament, was represented by the book and by the stone tablet containing the Commandments. These symbols, however, become superseded in the New Testament by the notion of transubstantia-tion from Christ's body into wine and the Eucharist. The hybridization of these motifs from the Old and New Testaments leads to the iconic layering of the complex and lengthy narration, which becomes reconceived as an image that combines theological content with the experiences of the laity. Ernst Wernicke noted already in 1887 that the connection between the cross and a wine-press is only possible if one envisions a particular kind of wine-press: "[I]nstead of the Eastern press in which slaves press the grapes with their feet (*calcatorium*), [one must consider] the more usual Western European press that functioned by means of a pressing device set into motion with a lever or a screw (*torcular*), in which the cross stands in place of the beam pressing on the grapes, and Christ takes the place of the pressed grapes."[15] In the late Middle Ages, we find many pictorial representations of this theme. I limit myself here to discussing two examples.

The first example is part of a panel altar from 1480 to 1490 (figure 11.3) currently housed in the Diözesanmuseum in Breslau/Wroclaw. The clean lines and surfaces of the image on the panel clearly depict the hybridization of cross and wine-press.[16] The image portrays Christ in a square container filled with grapes. He is depicted in a typical manner as if carrying the cross, but at the same time his feet and his right hand, which supports his left knee, indicate that he is actively trampling the grapes, as we saw in the book of Revelation. The central beam of the cross is also the crossbeam of the press and is fixed on the right to a wooden spindle, while it is weighted down on the left by a number of horizontal beams. Christ is both the subject and the object of the action. The blood from his wounds mixes with the grape juice. The pressed wine flows out of the container into a small chalice that hints at the sacrament of Holy Communion. The field of flowers in which the chalice is placed might suggest the motif of the *hortus conclusus*. The theme of the transubstantiation is clearly central, but it is dominated by the idea of the sacrifice.

230

11.3 Christ in the wine-press (ca. 1480/90), part of a panel altar (Breslau/ Wroclaw Diözesanmuseum).

Networks

In addition to the representation of Christ's suffering, contemporary images also visualize the Christian society that benefits from the power of the mystical blood. This may be seen in my second example (figure 11.4), which comes from an illuminated manuscript, the *Spiegel des lidens Christi* ("Mirror of Christ's Suffering") from the end of the fifteenth century (Kolmar, Stadtbibliothek, Cod. 306, fol. 1r). The text refers to Christ's suffering and then presents an interpretation of "Torcular calcavi solo" (in Isaiah), that leads to a commentary on the meaning of Christ's blood for the teaching of the sacraments:

IN disem buoch so vindest du / dz den menschen nút nützer / ist noch got genemer dene / das der mensche emptze- / klich betrachte dz grosse / vnsagberliche liden cristi / won dz ist als gross gewe- / sen dz wir lesent in der glos úber / ysaiam den propheten dz / die engel da uon wunder / nament also si sprachent / Quare rubrum est uestimentum tuum. worum- / be ist din kleide rot. vnd / dine kleider sint alz die / kleider dera (!) die da trettent / uff der trotten. Dz ist der / klare libe cristi der do gent- / zelich rote wart von sinem / Costberen bluote. Zuo der / frage antwurtet cristus / ihesus durch den prophe- / ten ysaiam vnd sprach:Torcular / calcaui solus. Ich han allein / getruket die trotten reht / alz er sprech. Ich bin allein / der gesin der da hat gelitten / den truke der trotten dz / ist die pin des heiligen / crútzes. won die selbe marter / vnd dz liden cristi ist ein / genuog tuon fúr die súnde / aller menschen vnd sin ver- / dienen ist in vns gegangen / won er sin nit bedorft. vnd / sin liden vnd sin verdienen / hat er in gegossen in die VII / heiligen sacrament. durh / die wir behalten werdent / als das wiset die nach / geschriben figure.[17]

[In this book, you will find that nothing is more useful to man or more pleasing to God than for man to examine eagerly the immense, indescribable suffering of Christ, for that was so immense, as we read in the gloss to the prophet Isaiah, that the angels themselves wondered as they spoke:"Quare rubrum est uestimentum tuum.Why is your clothing so red?" and "your clothing is like that of those who work the wine-press." That is the white body of Christ that was completely colored red with his precious blood. In answer to this question,Jesus Christ spoke through the prophet Isaiah and said, "*Torcular calcavi solus*. I alone worked the wine-press." He also said, "I alone suffered the crush of the wine-press, that is, the pain of the holy cross." For this martyr-dom and suffering of Christ means redemption for the sins of all mankind and his grace has transferred to us, for he was not in need of them himself. And he poured his suffering and his actions into the seven holy sacraments, through which we are redeemed, as the following representation shows.]

The text ends in a reference to the accompanying image: in the center of the image, there is a huge wine-press with Christ standing and crushing the

11.4 *Spiegel des lidens Christi* (end of fifteenth century). Kolmar, Stadtbibliothek, Cod. 306, fol. 1r.

grapes. Seven red lines flow from the opening of the trough in which the grapes are pressed. Each line leads to one of the seven sacraments: the Ordination of Priests, Baptism, Confession, Holy Communion, Marriage, Confirmation, and Extreme Unction.[18] The mystical wine appears as a eucharistic fluid that unifies all of the central stages of Christian life. This image is a representation of the church's mystical communication system, a system that incorporates all of Christian life from baptism to death over seven stations represented by the seven sacraments. All of these stations point to the spreading of the word (*logos*) that is connected to the sacrament. The empirical linear progression of the different stations in life and their sacramental elevation is represented systematically in the image in a manner that allows easy memorization. The persuasiveness of this system stems from the network portrayed between the different stations: the stream of mystical blood divides into pathways that unite all sacramental experience in the understanding that "sin verdienen ist in uns gegangen" [his grace has transferred to us]. Such a network suggests a closed system in the sense of a body or an institution, while pointing also to the possibilities of inclusion and the risk of exclusion: Christianity means to be part of a larger whole. In contrast to the text that lists the sacraments one by one, the image emphasizes the systematic nature of the Eucharist, that is, the unity that represents the liveliness of the church and points back to the source of all Christian life, Christ's sacrifice. The visualization of this mystical unity makes apparent that the human facility to recognize the symbolic and spiritual relies on mnemonically constructed "spaces for thought, experience, and comprehension, in which codes and forms, conventions, and revisions can be placed."[19] While the digital age attempts to reify this cultural technique, the medieval period takes for granted the necessity of mnemonic strategies.[20]

Similar to the miniature from the *Mirror*, a roughly contemporaneous miniature from a Seuse ("Suso") manuscript (Stiftsbibliothek Einsiedeln, Cod. 710, 322 fol. 106r) from around 1490 uses a red line to denote the path of grace and perfection. This red line represents the mystical circulation leading from the eternal God ("der ewigen gothait") and back again.[21] Indeed Diethelm notes, "If Christ's redemptive blood and the red line are interpreted together, then this line can, to a certain degree, be understood as an abstraction of this blood that flows through all the hearts/souls of God-loving creatures and ends finally in the symbol of divinity, only to flow out once again into the creatures in a kind of mystical circulation of blood."[22]

The need to visualize this mystical circulation combines spiritual thought with the construction of "technical" images, here with the creation of a network of channels that has a thoroughly anticipatory character. The assessment of the digital network as a "creator and memory, a mediator and

destroyer of artificial manifestations of mediality" is prefigured in much older "networks," and in their function of materially representing bodies or entities.[23] Mechthild of Hackeborn (1240/41 to 1298/99) imagines the connection of Jesus' heart with his beloved as a technical system of tubes like trumpets:"And she saw a trumpet go from the heart of the Lord to the heart of the soul and wind back again from the soul to God's heart, through which the praise of God was announced" (II 1, p. 136).[24] In a different passage, Mechthild mentions a golden channel that serves the soul to praise God (I 1, p. 8).[25] Gertrud of Helfta (d. 1301/2) makes a roughly contemporaneous reference to a divine channel through which God's mercy flows from the divine heart to the soul (III 26, 2; 30, 1; 66, 1).[26] One of Mechthild's other visions seems particularly reminiscent of the representation in the *Spiegel des lidens Christi:*"She saw a string go out from the Lord's heart into her soul with which she could lead all those who were close to her to God. The strings, however, referred to the love that God had poured, in appropriate quantity, into this blessed soul that allowed her to lead everyone to God through her good example and her teachings" (I 10, p. 33 ff.).[27]

Again and again, we encounter "technical fantasies" used to visualize the spiritual connection between God and man.[28] We are told of the "flow" of love or mercy through channels or tubes, and we are shown linear networks that vary in complexity.[29] The medium of the book also becomes incorporated into this technical image.[30] For example, the Lord speaks to Mechthild in one of her visions about the work that contains her spiritual experiences: "Everything that is written in this book has flowed out of my divine heart and flows back into it" (II, 43).[31] Similarly, in one of Gertrud of Helfta's mystical visions, Christ speaks to her as he holds a book that she has composed tight to his breast:"With the same effect with which I changed bread and wine at Mass and absolved all, [I make] with my divine blessing everything written in this book holy for all those who, on account of their purity and modest thought, wish to read it."[32] The transubstantiation from the body and blood of Christ to bread and wine is analogous here to the blessing of the word in the didactic process, the *logos* circulates and is consumed by the medium of the book.[33] This can be experienced in the representation of Christ in a book that appears in a variety of images in the twelfth and thirteenth centuries (figure 11.5).[34]

From the perspective of media history, the old medium thus gets preserved within the new. The voice, isolated and bound to Scripture, cannot maintain its abstractness but has to be reconciled with the body. However, the old medium is changed in this process, as we see in the metaphor of Christ as parchment. According to Caesarius of Heisterbach, the Christbook is produced in the Passion and inscribed with "Bene pellis eadem prius fuerat multiplici percussione pumicata, colaphis et sputis cretata,

11.5 God in the book. *Livres d'heures dit de Rohan*. Paris, Bibliothèque Nationale, lat. 9471, fol. 133 (ca. 1480).

arundine liniata [. . .]" [First his beautiful skin was glazed with many whippings, then it was lime washed with beatings and saliva, lined with lashings].[35] Just as the word has become flesh, the word in the book is also living and it circulates similarly to the mystical blood.

One finds the interchange between the book and the body, the book and the Christian corporation in numerous allegorical representations in the high and late Middle Ages that demonstrate the overlapping of old and new forms of communication, particularly in the period during which the dominant medium shifted from orality to writing. A similar overlapping occurs during the transition from manuscript culture to printed books.

Christ in the Printing Press

The representation of God in the book, with its long medieval tradition, suggests already the later understanding that the representation of Christ in the wine-press was an allegory for the book in the printing press. The printing process itself can be seen as a technology used for the dissemination of the word and a continuation of the dissemination or flow of the mystical blood. The miniature in the *Spiegel des lidens Christi* is from the end of the fifteenth century. It was, therefore, written shortly after Gutenberg was able to develop the printing press into a technology that then spread, in the second half of the fifteenth century, with incredible alacrity throughout Europe. The wine-press, as a technological medium from which the mystical blood flows and circulates, appears analogous to the technological medium of the printing press from which books containing the word of God circulate throughout the world. The title image of a Luther Bible from 1641 offers us visual evidence for this perceived connection between the two technologies (figure 11.6).

The page depicts a scene divided in three registers that concentrates on the distribution of the mystical blood by means of the wine-press, and on the dissemination of the word by means of the book. The vertical axis on the page connects the body of Christ in the wine-press in the upper register with the inscription of the title of the Luther Bible in the middle register and the open book in the center of the lower register. Wine-press, title inscription, and book are placed in relationship and refer iconographically to one another.

Christ appears alone in the wine-press, high up on the crest of a hill (Golgatha), that takes up a large part of the upper register. With a victory banner, he holds down a dragon that clutches a skeleton, thus pointing back to Adam and the Old Testament who have been overcome and superseded by Jesus Christ and the New Testament. The triumphant Christ thus signals victory over death and the devil. Above the enormous wine-press stand the words, "Heb: 13. v. 8 Jesus Christus gestern und heute und in alle Ewigkeit" [Heb. 13:8: Jesus Christ yesterday and today and in all eternity]. Under the wine-press and the symbols of evil, one can read, "Esa: 63. v. 3 Ich trette die Kelter alleine. Und ist niemandt unter den Völckern mit mir, darumb ist ihr

11.6 Title plate of the German Bible (1641). Heimo Reinitzer, *Biblia deutsch: Luthers Bibelübersetzung und ihre Tradition; Ausstellungskatalog der Herzog August Bibliothek zu Wolfenbüttel* (Hamburg: Wittig, 1983), p. 274.

Vermögen [*ihr Blut*] auff mein gewandt gesprützet" [Isa. 63:3: I alone work
the wine-press. And no one from among the people is with me, that is why
their wealth (blood) is sprayed on my clothing].[36] A fluid that one can inter-
pret as mystical blood, sprays out of Christ's wounds and the wine trough
into the group of people depicted in the upper and middle registers.[37] The
banderole in the upper left appears to be a commentary on this: "Zach:
9. v. 11 Du leßest [*lösest*] durchs Blut deines Bundes aus deine gefangene"
[Zech. 9:11: You are releasing your prisoners with the blood of your
covenant].[38] Similarly, the banderole in the upper right reads, "Heb: 9. v. 14
Wie viel mehr wird das Blut Christi unßer gewißen reinigen von den
todten wercken" [Heb. 9:14: How much more shall the blood of
Christ purge our conscience from dead works].[39] Like in the older images
of the wine-press, the mystical blood in this image is the medium of
redemption and freedom, it is the medium through which death can be
conquered.

To the right and left of the mountain, one can see a large crowd of
figures that are barely individualized watching Christ in the wine-press and
thereby taking part in his sacrifice (figure 11.6). Under them, in the middle
register, are more individualized and larger figures from the Old and New
Testaments. On the one hand (to the left), we see Adam, Eve, Moses, Isaac,
Aaron, and David; on the other (to the right), we see John, Paul, Peter, Mary
Magdalene, a toll collector, and a thief on the cross. They also stand and gaze
in the direction of Christ in the wine-press who dominates the background
of the image, and they are also oriented in the direction of the podium with
the tasseled cover that depicts the title of the Luther Bible:

BIBLIA
Das ist
Die gantze Heilige
Schrifft
Deutsch
D: Mart: Luth:
Mit Chur Sächsischen
Privilegio.
Gedruckt und verlegt zu Nürnberg
Durch Wolffgang Endter
Im Jahr 1641.

[Biblia. That is the complete Holy Scriptures. German. By Dr. Martin Luther
with the privilege of Electoral Saxony. Printed and published in Nuremberg
by Wolffgang Endter in the year 1641.]

The title is larger and broader than the whole wine-press. Luther's name
stands directly on the middle axis of the page and is therefore in a very
prominent position. Luther is inscribed here as the moderator of Christ, the

word of the Luther Bible as the medium of the living God who overcomes death. The inclusion of figures from the Old Testament into the community of believers indicates that all that was promised them is fulfilled in Christ. The promise is made to Adam and Eve and all of their children down to Noah, and to his children as well down to Abraham and to his children down to Christ "by which time this promise will be ever better renewed and explained by David and many prophets."[40]

The page thus depicts a relationship between the former era and its transcendence, in the promise and its fulfillment. It is the word of the Luther Bible, which is accessible to all: the sacrifice of Christ in the wine-press embodies the notion that the Christian community becomes one body with Christ and all saints. Luther himself writes, "just as the grapes, which by losing their form become a single communal wine and drink, so shall we be and so we are if we make correct use of this sacrament."[41]

The juxtaposition of Christ in the wine-press and the printed biblical word is continued in the lower register in which Christ returns as a teacher, pointing with the index finger of his right hand to the letters of an open book. The open book embodies the living word, and Christ himself is the teacher who makes the dissemination of the word possible. Luther writes with regard to this: "For everything in this Testament must live. For that reason he wrote it not using dead writing and seal, but using living words and signs."[42] On the left side of the book in the image, one can read, "Psalm 40. v. 8 Im Buch ist von mir geschrieben" [Ps. 40:8: in this book it is written about me]. On the right side, we see: "Johan. 5. v. 39 Suchet in der Schrift Dann die zeiget [zeuget] von mir" [John 5:39: Search in this book, for it is written of me]. Corresponding to the groups of figures in the upper register, the worldly and spiritual worthies dressed in contemporary clothing stand on Christ's left (our right), while we see the representatives of the people on his right. The inscription on the base of the podium reads in reference to this image: "Galat: 6. v. 16 Wie viel nach dießer Regel einhergehen, über die sey friede und Barmhertzigkeit" [Gal. 6:16: However many follow this rule, may they enjoy peace and mercy]. The tripartite distribution of these elements is not random, but rather captures testimonies to Christ as *logos* before, during, and after his lifetime.

The page's appeal, therefore, is directed, on the one hand, toward recognizing Christ in the writings and, on the other, to understanding that the mystical blood of Christ and the printed word of the Bible stand in for one another. Iconographically this connection is made through the representation of the wine-press trough, the title inscription, and the book. The typographical title inscription in the middle of the page appears as a medial modification of the mystical blood and creates the association with the printing press while providing the transition to the representation of Christ

as a preacher of the printed word. For a contemporary audience, the wine-press and printing press correspond overtly to one another, and the production of the Bible is understood as a printing process that reproduces the body of Christ, while simultaneously pointing to his sacrificial death and to his desire to disseminate the word. The wine trough represents in its function the compartment for the paper in the printing press from which the printed word flows, circulating through the Christian world. Through printing, that is, through an increased speed of reproduction, every person who is able to read becomes directly connected to the holy signs and thereby takes an active part in communicating within the Christian community (figure 11.7).

The flow of the mystical wine changes into the flow of printed words. The word *calcare* (to press the wine) is the same word used to characterize the

11.7 Printer at his printing press. Early representation of a printing workshop associated with José Baldius. Albert Kapr, *Johannes Gutenberg: Persönlichkeit und Leistung* (Munich: C.H. Beck, 1987), p. 132.

technique of printing (calcographia). Luther himself regards the "art of print-
ing as [God's] last and greatest gift" to mankind, given to fulfill the baptismal
order: "*Chalcographia est summum et postremum donum*, through which God
works. It is the last flame before the world is extinguished; it is, praised be the
Lord, at its end."[43] The spread of printed bibles made the word accessible to
each and every person. Through the unique medium of communication pro-
vided by the printing press, the word was no longer used exclusively, but
became available to all. The *Kölnische Chronik* ("Cologne Chronicle" [1499])
formulates its praise of the art of printing as praise to the Creator:

> God gave it to all people: to Laypeople who can read German, and to the edu-
> cated who need the Latin language, the monks and the nuns. Oh, how many
> prayers, how many uncountable revelations will be created by printed books.
> And how many worthy and blessed warnings are given in the sermons. And all
> that comes from the overwhelmingly noble art [. . .] comes from those who
> make printed books or help in their production in one way or another.[44]

Roughly contemporaneous to this title page (1641), Georg Philipp Harsdörffer
(1654/55) wrote with respect to printing that this recent art had arisen
from divine providence:

> Ist es nach dem Kaiserlichen Ausspruch Iustiniani, eine Göttliche Sache alles
> in dem Gedächtnuß behalten; so muß auch in dem Schreiben/ welches
> benebends der edlen Druckerkunst alles unser Wissen/ gleichsam in einem
> Schrein beschrancket/ etwas Göttliches enthalten seyn/ und ist nicht ohne
> sonderbare Vorsehung deß Höchsten/ berührt Druckerkunst/ in den letzten
> Zeiten hervor und empor gekommen/ in welchem sich/ nach deß Propheten
> Weissagung die Künste vermehren solten/ darzu nichts füglichers in Gebrauch
> gelangen können.[45]

> [If it is, in accordance with the words of Emperor Justinian, a divine quality
> to be able to keep everything in one's memory, then the process of writing
> must be inherently divine as, with the help of the art of printing, it protects
> all of our knowledge in one shrine. And is it not without any special inten-
> tion of the highest God that this art of printing has developed and risen up,
> in which, as the prophets announced, the arts shall increase. Nothing more
> suitable could be found to fulfill this.]

Immediately afterward, he continues that the art of printing as an art of fast
copying ("Kunst geschwinder Abschreibung") is so wonderful that one could
not have imagined it before its invention.[46] For that reason, it is necessary that
one be thankful for it and regard the art of printing as a merciful gift from God:

> Wann man von Anfang der Welt sollte Bücher gedruckt haben/ so würden
> derselbigen noch viel eine grossere Anzahl zu finden seyn: weil nemlich vor

Alters/ niemand als Könige und Fürsten Bücher abschreiben lassen können/ die man jetzund gedruckt umb gar geringes Geld erkauffen kann. Was man aber der Presse untergeben will/ daß muß man zuvor zu Papyr bringen/ und ist die Druckerey eine vielfältige geschwinde Abschreibung/ welche ihm keiner vor dieser Kunst Erfindung hätte einbilden mögen: daß wir Ursach haben Gott dem Herrn dafür herzlich zu dancken/ und solcher/ als einer Gnadengabe rechtmässig zu gebrauchen.[47]

[If one had printed books since the beginning of the world, then there would be many more of them today: earlier no one other than kings and princes could have books copied, books that one can now have printed and buy for little money. Whatever one wants to give to the press must be put down on paper beforehand, for printing is an art of fast copying that one could not have imagined before its discovery: for that reason we have cause to thank the Lord God heartily and to use it (this art) appropriately as a gift of grace.]

In a "Lobrede von Der Edlen Buchdruckerey" [praise of noble book-printing] that appeared in a 1654 pamphlet, this gratitude for the discovery of printing is given a nationalist twist and becomes a praise of German art and craft:

Uns Teutschen hat Gott geben
die Edle Druckerey/
Bey Der wir können leben
In seiner Gnade frey.
Klar lässt der Herr aussbreiten
Durch Sie sein wahres Wort/
Den Frommen auch bereiten
Den Weg zur Himmels Pfort.
Drauf können wir Uns trösten/
Und gwiß versichert seyn/
Daß wir mit Frewd und Lüsten
gehn in den Himmel ein.[48]

[God gave us Germans the noble art of printing through which we can live freely with his grace. Through it the Lord has the truth of his word announced and also has a gate to heaven prepared for the pious. We can comfort ourselves with that and be certain that we will enter into heaven with joy and benevolence.]

In this context, God's activities, which made printing an instrument of preaching, correspond to the images of the wine-press in which God himself pulls the level on the press in order to ensure the circulation of the eucharistic blood (figure 11.8).

11.8 God in the wine-press. Dürer workshop (ca. 1510). Ansbach, St. Gumbert, Schwanenritterordenskapelle ("Chapel of the Order of the Swan Knight").

Conclusion

The problem of visualizing the existence of Christian belief is central to the Christian iconography and manifests itself in the attempt to represent the circulation of blood and wine as the means for creating a mystical communal body. The intellectual models of Gertrud of Helfta or Mechthild of Hackeborn consider streams, channels, or tubes that function as communicative systems. The idea of such networks points to the creation of a collective body that, in turn, reflects the notion of the Christian *communio* as the basis for a closed communicative system. The technical fantasies of the mystics are fulfilled by the printing press insofar as it is understood as a machine used for the dissemination of the Holy Spirit. Christ's blood and his words are the primary guarantors for the livelihood of the Christian Church, which renews and sustains itself continually with the circulation of the mystical wine and the word. In this context, the printing press is incorporated seamlessly into religious iconography and symbolism as an art of copying that allows the circulation of the word and of God's grace to be increasingly sped up and intensified. In the transition to a literary society, the book becomes part of a complex information and communication technology that prefigures the future history of media but is also easily incorporated into the religious discourses of the Middle Ages and the Early Modern period.[49]

Notes

Translated by Kathryn Starkey.

1. Gottfried Boehm, ed., *Was ist ein Bild?* (Munich: W. Fink, 1995). See also Ferdinand Fellmann, "Innere Bilder im Licht des imagic turn," in *Bilder im Geiste: Zur kognitiven und erkenntnistheoretischen Funktion piktorialer Repräsentationen*, ed. Klaus Sachs-Hombach (Amsterdam: Rodopi, 1995), pp. 21–38; William J. Mitchell, *Picture Theory: Essays on Verbal and Visual Representation* (Chicago: University of Chicago Press, 1994).

2. Michael Curschmann, "Hören—Lesen—Sehen. Buch und Schriftlichkeit im Selbstverständnis der volkssprachlichen literarischen Kultur Deutschlands um 1200," in *PBB* 106 (1984): 218–57; Helmut Tervooren and Horst Wenzel, eds., "Philologie als Textwissenschaft: Alte und neue Horizonte," special edition of *ZfdPh* 116 (1997).

3. Sabine Groß, "Schrift—Bild: Die Zeit des Augen—Blicks," in *Zeit—Zeichen: Aufschübe und Interferenzen zwischen Endzeit und Echtzeit*, ed. G. Christoph Tholen and Michael O. Scholl (Weinheim: VCH, Acta Humaniora, 1990), pp. 231–46.

4. Horst Wenzel, "Die Verkündigung an Maria: Zur Visualisierung des Wortes in der Szene oder; Schriftgeschichte im Bild," in *Maria in der Welt: Marienverehrung im Kontext der Sozialgeschichte 10.–18. Jahrhundert*, ed. Claudia

Opitz et al. (Zürich: Chronos, 1993), pp. 23–52; Wenzel, "Die Schrift und das Heilige," in *Die Verschriftlichung der Welt: Bild, Schrift und Zahl im Mittelalter und in der frühen Neuzeit*, ed. Horst Wenzel, Wilfried Seipel, and Gotthart Wunberg (Vienna: Kunsthistorisches Museum, 2000), pp. 15–57.

5. "daß die Dynamik der Medienentwicklung in bestimmten Wunschstrukturen ihre Ursache hat und daß die Mediengeschichte beschreibbare stets implizite Utopien verfolgt." Hartmut Winkler, *Docuverse—Zur Medientheorie der Computer* (Regensburg: Boer, 1997), p. 17.

6. "Dabei wird zunächst offenbleiben müssen, ob dies die Wünsche der an den Prozessen konkret Beteiligten sind, ob sie deren Bewußtsein erreichen können, oder ob sie überhaupt einen menschlichen Träger verlangen; der Begriff des 'Wunsches' meint insofern eher die Systemspannung selbst als ihre subjektive Vergegenwärtigung." Winkler, *Docuverse*, p. 17.

7. "And they came unto the brook of Eshcol, and cut down from thence a branch with one cluster of grapes, and they bore it between two upon a staff; and they brought of the pomegranates and of the figs" (Num. 13:23).

8. For more detail, see Alois Thomas et al., *Die Darstellung Christi in der Kelter: Eine theologische und kulturhistorische Studie; Zugleich ein Beitrag zur Geschichte und Volkskunde des Weinbaus* (Düsseldorf: Schwann, 1936), pp. 53–67.

9. "Wenn die Schrift sagt: Sie schnitten dort eine Rebe und eine Weintraube ab, die sie zwischen zwei Männern trugen, so ist die Rebe das Sinnbild des Kreuzes, und die Weintraube, die an der Rebe hängt und zwischen zwei Männern getragen wird, ist das Sinnbild Jesu Christi, welcher am Kreuze aufgehängt ist, welches zwischen zwei Räubern steht." Hippolytus, *Cant. Cant.* 1, 13; cited from Thomas et al., *Darstellung Christi*, p. 55.

10. See also exhibit 02.03.09 (Stone cross in Rosovce), 21.03.01 (Holy Godehard's stave), 21.03.04 (bishop's stave of Holy Servatius) in *Europas Mitte um 1001: Katalog*, ed. Alfried Wieczorik and Hans-Martin Hinz (Stuttgart: Theiss, 2000).

11. "Der Geistliche Weinstock des Herrn Jesu," from Wolfgang Harms, ed., *Deutsche illustrierte Flugblätter des 16. und 17. Jahrhunderts: Die Sammlung der Herzog August Bibliothek in Wolfenbüttel; Kommentierte Ausgabe*, vols. 1–3, here vol. 3, *Theologica, Quodlibetica, Bibliographie, Personen- u. Sachregister*, ed. Harms et al. (Tübingen: Niemeyer, 1989), figure 29. See also vol. 2, *Historica*, 2nd edn., ed. Harms et al. (Tübingen: Niemeyer, 1997), figure 30.

12. "Ego sum vitis vos palmites / qui manet in me et ego in eo / hic fert fructum multum / quia sine me nihil potestis facere" [I am the vine, ye are the branches: He that abideth in me, and I in him, the same bringeth forth much fruit: for without me ye can do nothing] (John 15:5). Jochen Hörisch explains that this has to do with approaching and surpassing Dionysos, a process that is already manifest in the marriage at Cana. Jochen Hörisch, *Brot und Wein: Die Poesie des Abendmahls* (Frankfurt am Main: Suhrkamp, 1992), pp. 58–59.

13. Two explanatory stanzas appear on the bottom edge of the page:

Wem gleich ich Jesum doch, den meine Seele preiset? / Er ist dem Weinstock gleich, wie er sich selber heißet. / Der seine Reben hat, und

süssen Zucker Most, / Darinnen Safft und Krafft, der Seelentrost und Cost.

Den Reben, die am Stock mit reichen früchten prangen, / Sind seine Jünger gleich, die fast an Christo hangen, / Mit waarer Zuversicht und ungescheut der Noth, / Erzielen ihre Frücht auch mitten in den Tod.

See A. Weckwerth, "Einiges zur Darstellung des Reben-Christus," *Raggi* 8.1 (1968): 17–24.

14. Rupertus Tuit, *De trinitate et operibus ejus—In Isaia 2,29* (Migne, Patrologia Latina 167, col. 1357C), cited from Thomas, *Darstellung Christi*, pp. 62–63.

15. Wernicke writes: "statt der morgenländischen Kelter, in welcher die Trauben durch Sklaven mit den Füßen zertreten wurden (*calcatorium*), sich an die im Abendlande gewöhnlichere durch einen Hebel oder eine Schraube in Bewegung gesetzte Presse (*torcular*) hielt, wobei nun das Kreuz die Stelle des Preßbalkens, Christus aber die Stelle der zerpreßten Trauben einnehmen konnte." Ernst Wernicke, "Christus in der Kelter," *Christliches Kunstblatt für Kirche, Schule und Haus* 29 (1887): 38 [36–58]. On wineries and wine-presses, see Georg Schreiber, *Deutsche Weingeschichte: Der Wein in Volksleben, Kult und Wirtschaft* (Köln: Rheinland-Verlag, 1980). See also Regina Wunderer, *Weinbau und Weinbereitung im Mittelalter* (Bern: Peter Lang, 2001).

16. F. von Bassermann-Jordan, "Ein plastisches Kelterbild im Historischen Weinmuseum zu Speyer am Rhein," *Pfälzischen Museum* 29 (1912): 1–11.

17. Hans Vollmer, *Bibel und Gewerbe in alter Zeit: Kelter und Mühle zur Veranschaulichung kirchlicher Heilsvorstellungen,* Potsdam: n. p. (1937), p. 6.

18. Alfred Weckwerth, "Christus in der Kelter: Ursprung und Wandlungen eines Bildmotivs," *Beiträge zur Kunstgeschichte: Eine Festgabe für Heinz Rudolf Rosemann zum 9. Oktober 1960,* ed. Ernst Gulda (Munich: Deutscher Kunstverlag, 1960), p. 100 [95–108].

19. "Gedanken-, Erfahrungs- und Wahrnehmungsräume erfordert, in denen die Codes und Formen, Konventionen und Erneuerungen [. . .] plazierbar sind." Manfred Faßler, *Netzwerke: Einführung in die Netzstrukturen, Netzkulturen und verteilte Gesellschaftlichkeit* (Munich: W. Fink, 2001), p. 199.

20. Frances A. Yates, *The Art of Memory* (Chicago: University of Chicago Press, 1966).

21. I would like to thank Hildegard Elisabeth Keller for referring me to Seuse and to the miniature from the Codex Einsiedeln, and for verifying my reading of the image. The circulation passes through several stations: godliness without visual representation, the representation of godliness in the image (Triptychon), the Trinity, angel, human, figure of *ker* ("Kehre"—*conversio*), suffering female figure, figure of *ruewelis* (meditation), crucified Christ, figure of rapture, human soul within a spiritual person, figure of the highest *Entwerdens*, the Trinity, Triptychon, visual representation of godliness. Anna Margaretha Diethelm quotes, "Durch sin selbs unerstorben vichlichkeit hin zuo grosser loblichen heilikeit." Anna M. Diethelm, *Durch sin selbs unerstorben*

vichlichkeit hin zuo grosser loblichen heilikeit: Körperlichkeit in der Vita Heinrich Seuses (Bern: Peter Lang, 1988), pp. 244–45.

22. "Wird das erlösende Blut Christi und die rote Linie zusammengedeutet, so kann diese Linie in gewissem Maße als Abstraktion eben dieses Blutes verstanden werden, das als verbindendes Element durch alle Herzen/ Seelenfünklein der gottminnenden Figuren fließt und schließlich im Zeichen der Gottheit endet, um wieder von neuem in einer Art mystischem Blutkreislauf in die Geschöpfe auszufließen." Diethelm, *Körperlichkeit*, p. 214. On the codex and its content, see Hildegard Elisabeth Keller, *My Secret is Mine: Studies on Religion and Eros in the German Middle Ages* (Leuven: Peeters, 2000), especially chapter 4.

23. "Erzeuger und Speicher, Träger und Zerstörer künstlicher Körper der Medialität." Faßler, *Netzwerke*, p. 65.

24. Kurt Ruh, *Geschichte der abendländischen Mystik, Zweiter Band: Frauenmystik und Franziskanische Mystik der Frühzeit* (Munich: C.H. Beck, 1993), p. 312: "Und sie sah eine Trompete ausgehen vom Herzen des Herrn zum Herzen der Seele und wiederum von der Seele zum Herzen Gottes sich zurückwinden, wodurch der Lobpreis Gottes angekündigt war."

25. Ruh, *Frauenmystik*, p. 312.

26. Ruh, *Frauenmystik*, p. 323.

27. Ruh, *Frauenmystik*, p. 312.

28. Ruh, *Frauenmystik*, p. 323.

29. Horst Wenzel, "Die 'fließende' Rede und der 'gefrorene' Text: Metaphern im Spannungsfeld von Mündlichkeit und Schriftlichkeit," in *Knowledge, Science, and Literature in Early Modern Germany*, ed. Gerhild Scholz Williams and Stephan K. Schindler (Chapel Hill: University of North Carolina Press, 1996), pp. 93–117.

30. See also Albrecht Koschorke, *Körperströme und Schriftverkehr: Mediologie des 18. Jahrhunderts* (Munich: W. Fink, 1999). Unfortunately, he does not mention the relationship between the circulation of blood and of writing.

31. "Alles, was in diesem Buch geschrieben steht, ist aus meinem göttlichen Herzen geflossen und fließt in dieses zurück." Koschorke, *Körperströme*, p. 302.

32. Legatus V. 33, 27–30. Cited in Ruh, *Frauenmystik*, p. 317.

33. On the *Evangelium* as the incarnation of the *logos*, see Hildegard Elisabeth Keller, *Wort und Fleisch: Körperallegorien, mystische Spiritualität und Dichtung des St. Trudperter Hoheliedes im Horizont der Inkarnation* (Bern: Peter Lang, 1993), especially chapter 4.

34. Horst Wenzel, *Hören und Sehen—Schrift und Bild: Kultur und Gedächtnis im Mittelalter* (Munich: C.H. Beck, 1995).

35. Caesarii Heisterbacensis Monachi, "Dialogus miraculorum" (1851), VIII, 35. See Dieter Richter, "Die Allegorie der Pergamentbearbeitung: Beziehungen zwischen handwerklichen Vorgängen und der geistlichen Bildsprache des Mittelalters," in *Fachliteratur des Mittelalters: Festschrift Gerhard Eis*, ed. Gundolf Keil, Rainer Rudolf et al. (Stuttgart: Metzler, 1968), p. 88 [83–92]; Klaus Schreiner, " 'Wie Maria geleicht einem puch': Beiträge zur

Buchmetaphorik des hohen und späten Mittelalters," *Archiv für Geschichte des Buchwesens* 11 (1971): cols. 1437–64; Wenzel, *Hören und Sehen*, pp. 353–56; Urban Küsters, "Der lebendige Buchstabe: Christliche Tradition der Körperschaft im Mittelalter," in *Audiovisualität vor und nach Gutenberg: Zur Kulturgeschichte der medialen Umbrüche*, ed. Horst Wenzel, Wilfried Seipel, and Gotthart Wunberg (Vienna: Kunsthistorisches Museum, 2001), pp. 107–17.

36. See Isa. 63:2–4.

37. The pelican is often represented in sculpture and is well known to prefigure the Passion of Christ by sacrificing its blood for its children. The relationship between Christ's sacrifice and the sacrament of the Eucharist is documented in the motif of the well of mercy, or through the chalice with which Christ's blood is received by Ecclesia herself, or by an angel, Adam, or Mary Magdalene. See Friedrich Ohly, *Gesetz und Evangelium: Zur Typologie bei Luther und Lucas Cranach; Zum Blutstrahl der Gnade in der Kunst* (Münster: Aschendorff, 1985), p. 60.

38. "As for thee also, by the blood of your covenant I have sent forth thy prisoners out of the pit wherein is no water" (Zech. 9:11).

39. "For if the blood of bulls and of goats, and the ashes of an heifer, sprinkling the unclean, sanctifieth to the purifying of the flesh: How much more shall the blood of Christ, who through the eternal Spirit offered himself without spot to God, purge your conscience from dead works to serve the living God?" (Heb. 9:13–14).

40. "wie wol sie yn des durch David und vil propheten ymer baß und baß vornewet und vorkleret ist" ("Ein Sermon von dem neuen Testament, das ist von der heiligen Messe [1520]"), in *D. Martin Luthers Werke: Kritische Gesamtausgabe*, vol. 6 (Weimar: Böhlau, 1888), p. 357. Luther held fast to the idea of the presence of Christ in bread and wine and recognized a threat to this notion in the Catholic rite (Luther, "Vom Mißbrauch der Messe [1521]," in Luther, *Ausgewählte Schriften*, vol. 3, p. 118). He considered the practice of allowing only priests (until the second Vatican Council) to drink Christ's blood to be a ritual of exclusivity, and countered this with his understanding of Communion as a moment of unity and love for the whole Christian community: "darumb seyn all Christen man pfaffen, alle weyber pffeffyn, es sey junck oder alt, herr oder knecht, fraw oder magd, geleret oder leye" [Therefore all Christian men are priests, all women priestesses, young or old, Lord or servant, Lady or maid, cleric or layperson] (Luther, "Sermon von dem neuen Testament," in *D. Martin Luthers Werke*, vol. 6, p. 370). "Sie alle Alßo auch wir mit Christo yn dem sacrament voreyniget werden und mit allen heyligen eyngeleybet [. . .] alßo were er, das wir seynd, was unß antrifft, auch yhn und mehr dan unß antrifft" [They all become united with Christ in the sacrament and become a single body with all Saints (. . .) as if he were that which we are, as if that which touches us (. . .) touches him] (Luther, "Ein Sermon von dem hochwürdigen Sakrament des heiligen wahren Leichnams Christi [1519]," in *D. Martin Luthers Werke*, vol. 2, p. 748).

41. "Desselben gleychen auch die weyn kornlyn mit vorlust yhrer gestalt werden eyns gemeyn weyns und trancks leyb, Also sollen und seyn wir auch, so wir diß sacrament recht prauchen." Luther, "Sermon von dem hochwürdigen Sakrament," in *D. Martin Luthers Werke*, vol. 2, p. 748.

42. "dan es muß alles leben, was ynn disem testament ist, drumb hatt er es nit in todte schrifft und sigill, sondern lebemdinge wort und zeychen gesetzt, die man teglich widderumb handelt." Luther, "Sermon von dem neuen Testament," in *D. Martin Luthers Werke*, vol. 6, p. 359.

43. "*Chalcographia est summum et postremum donum*, durch welche Gott die Sache treibet. Es ist die letzte flamme vor dem ausleschen der welt." *D. Martin Luthers Werke*, vol. 2, *Tischreden*, p. 650. Luther's *Tischreden* regularly mix Latin and German.

44. "Gott hat sie allen Menschen gegeben: Den Laien, die Deutsch lesen können, den gelehrten Leuten, die die lateinische Sprache gebrauchen, den Mönchen und den Nonnen. Oh, wie viele Gebete, wie unzählig viele Offenbarungen werden aus den gedruckten Büchern geschöpft. Und wie viele köstliche und selige Mahnungen geschehen in den Predigten. Und das alles kommt aus der alles überragenden edlen kunst [. . .] kommt von denjenigen, die gedruckte Bücher machen oder bei ihrer Herstellung in der einen oder anderen Weise helfen." "Van der boychdrucker kunst. Cronica van der hilliger Stat va(n) Coelle(n)" (Cologne, 1499), cited from Michael Giesecke, *Der Buchdruck in der frühen Neuzeit: Eine historische Fallstudie über die Durchsetzung neuer Informations- und Kommunikationstechnologien; Mit einem Nachwort zur Taschenbuchausgabe 1998* (Frankfurt am Main: Suhrkamp, 1998), p. 160, and see also table 1, pp. 889–90. Giesecke also discusses the metaphor of flowing that he traces back to the notion of the well of divine wisdom: "Durch sein 'letztes Geschenk' erhielten die Menschen einen eigenen Brunnen, wurden von der göttlichen Wasserversorgung unabhängig. Sie können und müssen sich nun selbst versorgen [. . .]. Der Brunnen sprudelt von selbst, man muß ihn nur noch trinken" [As his last gift, mankind received its own well and became independent of God with respect to water. It must now take care of itself (. . .). The well flows on its own, one only has to drink from it] (pp. 162–63).

45. Georg Philipp Harsdörffer, *Der teutsche Secretarius: Titular u. Formularbuch*, vol. 2 (Hildesheim: G. Olms, 1971), Introduction, p. 15.

46. See Giesecke, *Buchdruck in der frühen Neuzeit*, p. 146, on "Lob der schnellen Vervielfältigung."

47. Giesecke, *Buchdruck in der frühen Neuzeit*, p. 15, and see further examples on pp. 159–67.

48. Harms, *Deutsche illustrierte Flugblätter*, vol. 1: *Ethica; Physica*, ed. Harms et al. (Tübingen: Niemeyer, 1985), p. 66a.

49. Giesecke, *Buchdruck in der frühen Neuzeit*, p. 167.

CHAPTER 12

FROM THE WORD OF GOD TO THE EMBLEM

Thomas Cramer

Scholars have often cited Pope Gregory's justification of images as wordless reading material for the laity, and although this justification was merely an assertion, it secured for art a relatively unchallenged existence for a millennium.[1] At the same time, Gregory's formulation established the primary status of the word and placed the image as a lower status source of knowledge.

This situation did not change even when theoreticians of the Renaissance, in the Paragone debate, endeavored to secure for art a position equal to that of literature: when Leonbattista Alberti refers to Apelles's *Calumnia* (handed down only verbally) as a paradigm for the power of images to make a moral statement, maintaining that, like books, they, too, can instruct people about good and evil, truth and falsehood, and can reform people by means of this instruction, he is using for art a category of judgment that has been derived from literature, and he can only substantiate this by translating the image into words by means of an allegorical interpretation, thereby implicitly demonstrating the more privileged status of the word.[2] Alberti's argumentation ultimately leads to the paradox that only an image that can be understood as an allegory and is therefore able to be verbalized through allegorical interpretation can lay claim to having equal status as a book. For painters, the price of admission to the *litterati* is (at least in theory) an extensive adaptation of art to the patterns of thought and patterns of interpretation of literature. Implicit in this is the subsumption of art under the primacy of the word.

Against this roughly sketched background, it is amazing and, indeed, unprecedented that, in the second half of the sixteenth century, the image literally pushes the word to the margins precisely in the place where the

word is irreplaceable and immutable: in the Bible, in which the word of God, according to the teachings of all the Christian churches, has become sacred Scripture. Between 1560 and 1579, at least four pictorial bibles appeared in the German-speaking territories; these are series of usually 150 to 170 woodcuts that narrate episodes mainly from the Old Testament and in which the few verses that have been added seem only to function as titles for the illustrations.[3] These magnificent works do not stand in any identifiable tradition. Neither the *Bibliae pauperum*, in which the arrangements of images created new, prefigurative interrelations of meaning between various parts of the Bible, nor the illustrations of the Lutheran translation of the Bible that came out of the Cranach workshop can be viewed as direct forerunners, although the pictorial bibles would hardly have been conceivable without the Cranach illustrations, nor the theoretical reflections on art that Luther employed in their justification.[4] Indeed, the path to these pictorial bibles led quite clearly from the bibles that were furnished increasingly opulently with illustrations and which promised the publishers a sizeable profit. It is one of the ironies of cultural history that the most consistent displacement of the word by the image takes place precisely within the context of the Protestant theology of the word, and that Luther himself paved the way for this development.

Reflected in this displacement are Christian notions about images, the perceived relationship of the image to the word, and the various strategies of justification that appear against the background of the triumph of printed pictures, which repeat what the lead-cast letter had achieved for the word one hundred years earlier. It is also possible to view the replacement of the word by the image as the result of a temporary fascination with the qualitatively stable reproducibility of a drawing.[5]

The biblical illustration seemed to be once and for all sanctioned by Luther's authority. It is known that his translations were illustrated from the very beginning: the *Septembertestament* of 1522 contains sixteen full-page woodcuts on the Apocalypse, and the 1523 translation of the Pentateuch contains eleven illustrations in equally large format.[6] In his reply to Andreas Bodenstein von Karlstadt, who, in his polemic *Von Abtuhung der Bylder* ("On the Elimination of Images"), had denounced the Gregorian justification of images as a papist strategy to dull people's minds, Luther defined the function of images briefly yet succinctly as "for the sake of memory and better comprehension" [umb gedechtnis und besser verstands willen], that is, as memory aids, and as a commentary on the text—a momentous formulation, since it presupposes that an image opens up dimensions of meaning in its interaction with the text, dimensions of meaning to which the text alone does not allow access.[7] Initially, however, Luther's justification and definition of the function of images remained theory. The first complete edition of all

the books of the Bible in Luther's translation was printed by Lufft in Wittenberg in 1534 and contained 117 images that were integrated into the text; these images could at best have functioned as memory aids, for they demonstrated no recognizable attempt to expand the context of meaning.[8] The images produce a doubling of the text by retelling it faithfully. Only the images of the Apocalypse that were imitations of the illustrations from the *Septembertestament* have an additional and independent interpretive potential.

> Vnd ich sahe das Weib sitzen auff einem rosinfarben Thier / das war vol Namen der lesterung / vnd hatte zehen Hörner. Vnd das Weib war bekleidet mit Scharlacken vnd Rosinfarb / vnd vbergüldet mit Gold vnd Edelsteinen vnd Perlen / vnd hatte einen gülden Becher in der Hand / vol Grewels vnd vnsauberkeit jrer Hurerey. Vnd an jrer Stirn geschrieben den Namen / das Geheimnis / Die grosse Babylon / die Mutter der hurerey vnd aller grewel auff Erden. (Rev. 17:3–5)
>
> [I saw a woman seated on a scarlet beast that was covered with blasphemous names, with (. . .) ten horns. The woman was wearing purple and scarlet and adorned with gold, precious stones, and pearls. She held in her hand a gold cup that was filled with the abominable and sordid deeds of her harlotry. On her forehead was written a name, which is a mystery, "Babylon the great, the mother of harlots and of the abominations of the earth."][9]

The figure of the Great Whore has been taken from the *Septembertestament*; she is wearing a papal tiara, thereby revealing her identity, which, according to the medieval etymological method, is already presented as a "mystery" in her name (*Babylon / Babst* [pope]). The homage of all the estates was kept as well. New additions, closely following the text, are: the angel and John as eyewitnesses and, most notably, the symbolic landscape with two trees side by side, one dead and the other turning green, as well as two church spires with a knob and a cross, which may be interpreted as the old and the new teachings.[10] This is an exceptional case in which the source provided the impetus for enriching the images with a greater potential for meaning. This example also makes all the more clear that the images, as a rule, serve the purpose of decoration and the enhancement of visual pleasure. Luther was apparently satisfied with the fact that the images would seldom invite the viewer to interpret them "for the sake of better comprehension" [umb bessern verstandts willen].

Even though theological arguments provided the pretext for the controversy over illustrating the Bible, it is evident that the discussions had their basis in the highly secular competition between printers or publishers. In 1561 in Frankfurt, Sigmund Feyerabend produced a two-volume edition of the Lutheran translation of the Bible.[11] This edition was opulently illustrated with 162 woodcuts by Virgil Solis, who was, at that time, the most sought-after

illustrator in Germany. In its format, its division of the volumes, and its illustrations, the edition is an enterprise clearly meant to compete with the first Wittenberg edition of the revised Lutheran text, which Hans Lufft had printed in two volumes in 1541, using the images from the earlier 1534 edition. The 1541 edition had been reprinted several times since then.[12] In contrast to the Wittenberg editions, Feyerabend's book refers to the illustrations even in the title. Virgil Solis's woodcuts have approximately the same format as those of the Wittenberg edition, and their relationship to the text is also comparable: they are repetitions of the verbal narrative in a graphic medium, and they provide little in the way of commentary or interpretation of the text. There is, however, one point in which the Frankfurt and the Wittenberg editions differ fundamentally: Solis's images are surrounded by broad frames with ornamental scrollwork, animals, satyrs, and plants. The effect created by this framing of the images is stunning: it delimits the image from the surrounding text and makes it independent in such a way that it demands the full attention of the observer as a self-contained work that is meaningful in and of itself. The illustration, which, according to Luther, was supposed to be a memory aid or an aid in comprehension, has become an autonomous image. In other words, the image does not direct one's attention toward the text; instead, it distracts one from the text.

Typically, this is where contemporary criticism began. The criticism stemmed from Christoph Walther, who was employed in Hans Lufft's Wittenberg printing office as an editor.[13] One therefore suspects that his criticism was, above all, a question of business interests. This does not, however, make the arguments any less informative, even though they may have been put forward with ulterior motives. Along with the meticulous listing of all the instances of philological carelessness and errors in the Feyerabend edition, Walther mentions the luxurious production and, in this context, the images. It goes without saying that he cannot raise any objections to the illustration in and of itself; rather, his criticism is directed at the method of presentation, that is, the framing.

> NAch dem Sigmund Feyerabend / Buchdrucker zu Frankford am Meien / Anno 1561. eine deudsche Biblia gros auff Median papier im Druck lies ausgehen / Vnd solche Biblia mit einer Vorrede trefflich sehr / aus geitz vnd neid / rhûmete. . .
>
> MIt solchem trefflichem rhûmen / hohmut vnd zunôtigen / ward ich / aus Christlicher Liebe vnd Eiuer / verursacht vnd bewegt / das ich solche Biblia durchaus besahe / vnd fand darin diese nachfolgende Mengel vnd Feil:
>
> ERstlich ist die Orthographia. . .durchaus nicht gehalten. . .
>
> ZVm andern / ist alles das jenige / was Lutherus kurtz vor seinem End gebessert vnd geendert / ausgelassen.

ZVm dritten / stehen lose Figuren drinnen mit Leisten verbremet. . .
vngewönliche Bilder vnd Phantastische Thier / Teufelsköpfe / Vhu /
Eulen. . .[14]

[After Sigmund Feyerabend (a) printer in Frankfurt am Main, published a
German Bible in large format on median format paper in the year 1561 and,
out of avarice and envy, extolled this Bible excessively in a foreword. . .
On the basis of such excessive praise, arrogance, and urging, I was, out of
Christian love and passion, moved and necessitated to take a look at this Bible
thoroughly, and (I) found the following omissions and errors in it:

First, the orthography is. . .not at all consistent. . .

Second, everything that Luther corrected and revised shortly before his
death has been omitted.

Third, there are meaningless figures framed by borders in it. . .unusual
pictures and fantastic animals, devils, heads, owls. . .]

In his use of the pejorative attribute "meaningless," Walther can certainly
not be referring to the content of the images, and he can hardly be refer-
ring to the method of representation. The images, according to Walther, are
thoughtlessly frivolous because of their frames, for their ornamentation
does not relate to the message conveyed by the text, and, in addition to this,
they raise the image to a unified aesthetic whole that is capable of existing
even independently of the text. In the Frankfurt edition, the image has
emerged from its function as an aid and has become an independent work;
as such, it competes with the word for attention.

With that, the first steps toward the marginalization of the text have been
taken; this marginalization was then consistently implemented in the picto-
rial bibles. That the result is problematic is demonstrated by the fact that
implicit or explicit attempts at justification, ranging from the stereotypical
formulation to elaborate theoretical reflections on art, are to be found in
every title or preface. The Gregorian argument authorizing the use of images,
which had never been used concerning Bible illustrations, was therefore
revived. Not only Karlstadt, who held images to be instruments of a papal
policy of stultification, would have been outraged, but also Luther, who
held a general extension of literacy to be desirable so that everyone would
be able to read the text of the sacred Scriptures, would have become appre-
hensive if he had read, in the foreword to Virgil Solis's pictorial Bible, that it
was created, among other reasons, "for the sake of simple Christians who
cannot read the Scriptures and nevertheless would like to do so; for them,
these figures will be, without doubt, all the more delightful and comforting
and will be the same as a Bible for laypeople" [vmb der einfeltigen Christen
willen / so die schrifft nicht lesen können / vnd dannoch lust vnnd
lieb darzu haben / denen werden diese Figuren ohn zweifel auch deste

lieblicher vnd tröstlicher / vnnd gleich als eine Leyen Bibell sein].[15] It was
for these "simple Christians" that Luther, in 1528, had penned the message:
"[T]hey shall leave the Word alone and not think about it" [das Wort sie
sollen lassen stan und kein Danck darzu haben].

The argument that the image is a book for laypeople is taken up again
twice, in prose and in verse, in Joß Amman's pictorial Bible, which, only
four years later, was also printed by Feyerabend.[16] The author of the preface
is Feyerabend himself. After he has, in a bold analogy, equated the decora-
tion of the Jewish Tabernacle "by divine command through Moses" [auß
Göttlichem befehl / durch Mosen] and the ornamentation of the Jerusalem
Temple "later by King Solomon, the wisest of all" [nachmals durch den aller
weisesten König Salomon] with the illustration of the Bible, he goes on to
affirm once again that the painters and illustrators undertook their efforts
"for the simple Christians who are well-disposed toward such holy Scriptures
and yet cannot read them" [von wegen der einfeltigen Christen / so zu
solchen heiligen Schrifften wol geneigt / vnd doch dieselbige nicht können
lesen].[17] In the dedication poem "To the Christian Reader" [An den
Christlichen Läser], the source is named:

> GRegorius der alt Scribent /
> Macht an eim ort ein solch Comment /
> Das die Bilder vnd das Gemäl /
> Der Leyen Bücher sind on fäl /
> Die auß denselben eben das
> Erlehrnen on groß arbeit / was
> Die Glehrten in den Schrifften fein
> Verfaßt hand durch des Buchstabs schein.[18]

[In one passage, Gregorius, the ancient writer, comments in such a way that
images and painting(s) are the unfailing books of the laypeople, who learn
from them, without great effort, precisely that which the scholars have written
in (their) fine writings (using) the appearance of the letter.]

Perhaps because citing the words of a pope was an awkward thing to do
in Protestant areas, or perhaps because confidence in the argument's ability
to carry weight was tenuous (generally, only members of the wealthy strata
of society would have been able to purchase these magnificent editions, and
these people would have known how to read and should have been able
to do without the aid of the images anyway)—in any case, in Feyerabend's
preface to Joß Amman's second pictorial Bible of 1579 (*Newe Biblische
Figuren* [1579]), he engages in an extensive defense of the book in the form
of a debate with the Gregorian quotation, reproduced for the first time in
the preface in its entirety, in which he equates Gregory's *idiotae* with "the
youth" [d(ie) Jugend]. In this manner, Feyerabend presents pictorial bibles as

primers for those who are not yet able to read (something that the pictorial bibles certainly were not), and one could therefore claim that the pictures led one to the actual reading of the Bible, and were therefore both useful and compatible with the Protestant theology of the word.

Darumb so haben vnsere Vorfahren / die lieben Alten / guter meynung erstlichen die Wunderthaten Gottes. . .zu mahlen / vnnd fein kůnstlich / mit lieblichem anschauwen / in Taffeln vnd Figuren / der Jugend nicht allein / sondern auch dem gemeinen Mann / vorzubilden jhnen fůrgenommen. Darnach haben sie auch die Wolthaten Gottes / als die Erschaffung der Welt vnd Creaturen. . .mit schônen wolgezierten vnd Kůnstlichen Bildnussen (welches doch nachmals bey vielen / gleich wie die ehrne Schlang Moysi / zum Mißbrauch vnd Abgôtterey gerahten) der Jugend vnd einfeltigen Leuten zu gutem fůr die Augen gestellet / daß jnen dieselbigen gleich wie ein gůlden GedenckRingk an eines Menschen Hand / môchten ein erinnerung im Hertzen vnd Gemůt seyn. . .Vnd ob wol / wie angezeigt / viel vnrahts nachmals darauß entstanden / vnd die Menschen durch falsche vnreyne Lehrer vnd Werckheiligen / die Bilder zu verehren / sie anzubetten / vnd fůr Gôtter oder Nothelffer zu halten / jåmmerlich sind verfůhret worden / so glaube vnd halte ichs doch gewißlich darfůr / daß es die lieben Alten / vnd Liebhaber Gôttlichs Worts / nicht bôser meynung oder superstitiosè gethan / oder daß sie darmit die Bilder anzubetten oder zu verehren haben lehren wôllen / Sondern daß die Bilder vnd das Gemåhlde der Jugend eine anreitzung weren / deß rechten Gottes vnd seiner Wunderwerck eyngedenck zu seyn. . .[19]

[For this reason, our ancestors, the worthy ancients, resolved with excellent intentions to paint the miracles of God first, and (they) illustrated (them) with exquisite artistry and in loving displays in painted panels and figures not only for the youth but also for the common man. After that, they also placed God's great deeds such as the creation of the world and of all living things. . .(in the form of) beautiful, well-decorated, and artistic portraits (which afterwards, of course, developed among many [people] into abuse and idolatry, just as [in the case of] the brazen serpent of Moses) before the eyes of the youth and the simple people for their betterment, so that these would be for them a reminder in their hearts and minds, similar to a golden ring that a person wears on the hand as a means of remembrance. . .And although, as was previously mentioned, much offensiveness developed from this afterwards and people were led wretchedly astray by false, impure teachers and miracle workers to worship the images and to pray to them and to consider them gods or saints who could give aid in times of need, nonetheless, I believe and consider it most certain that the worthy ancients and lovers of the divine Word did not do this with wicked intentions or out of superstition or that they wanted to teach (others) to pray to the images or to worship them; instead, (they did this) in order that the pictures and the paintings would be an incentive for the youth to be mindful of the true God and his wondrous miracles. . .]

The quotation from Gregory follows in its entirety.[20] The reference to the "beloved ancients" recalls an aesthetic experience that would have made it virtually impossible for someone living at the end of the sixteenth century to declare that the great artworks of antiquity as well as the works of Cranach, Dürer, Botticelli, or Titian, were simply the work of the devil. In this context, Feyerabend discovers new facets of the Gregorian justification and is able to claim that the danger of image-worship no longer exists. Instead, the image has, according to him, become something that induces and stimulates reflection. "In this manner, one can stimulate the youth, even today, with delightful figures and portraits to a great[er] desire for learning [and] contemplation" [Also kan man noch heutiges tags die Jugend mit lieblichen Figuren und Bildnussen darzu reitzen / daß sie. . .mit großem lust lehrnen nachforschung thun.][21] With this invitation to take the image as a point of departure in the search for meaning, the "figure" is implicitly being assigned an emblematic status. This will be examined more closely below.

Feyerabend takes his last and most powerful argument from the analogy between the graphic duplication of the image and the new possibilities for the dissemination and preservation of the word by means of the invention of moveable type. It is, according to Feyerabend, "worthy of pity" [wol zuerbarmen], that all the reports of the past that "had been composed in hand written books" [in geschriebenen Büchern sind verfasset gewesen] are lost, "not to mention the marvelous [hand]written books of the ancient teachers" [ich geschweige der herrlichen geschriebenen Bücher der alten Lehrer].

> Jetzunder aber können wir Gott dem HERRN nicht genugsam dancksagen / daß die ehrliche Kunst deß Buchdruckens an tag kommen ist. . . Darnach so sind noch andere herrliche und löbliche Künst mehr erfunden worden / als das abreissen vnd schneiden der Bilder vnd anderer Figuren.[22]
>
> [Now, however, we cannot give sufficient thanks to the Lord God that the honorable art of printing has come to light. . .After that, still other marvelous and praiseworthy arts were invented such as the copying and cutting of pictures and other illustrations.]

If the invention of moveable type represents, as it were, progress in the history of salvation, then the same must hold true for printed images.[23] Just as the word that is reproduced by means of print carries the same unchanging meaning in hundreds of copies, so, too, does the image that is multiplied by means of woodcuts or plates always guarantee the same message on the symbolic level. This, however, according to Feyerabend, is the precondition that is necessary for the image, and thus also for all symbolic art, to be accorded the same significance as the word as a bearer of truth. "Making an investigation" [nachforschung thun] within the image then becomes, in

comparison with the interpretation of the word, another, equally valid form of searching for the truth. The unchanging and reproducible nature of the image delivers the *pictura* of a symbolic image, particularly the emblem, from the role that Gregory accorded it, that is, to function as a lower grade *litteratura*. For this reason, the eloquent Johann Fischart speaks of the image perspicaciously as a "painted philosophy" [gemalt Philosophi] (see below).

Feyerabend perhaps owes his discovery of the emblematic structure as the means for establishing meaning in the pictorial Bible to Tobias Stimmer's pictorial Bible, which appeared in Basel three years previously and included verses by Johann Fischart.[24] This book transforms the biblical narratives consistently into emblems for the first time, presumably thanks to Fischart's intensive reflections on artistic and literary theory.[25]

In the 1564 text, the *Neuwe Biblische Figuren* ("New Biblical Figures"), emblematic structures play, if at all, only a rudimentary role in Feyerabend's foreword, in the typographical layout, and in the conception of the images. The concise summaries of the content, each in four Latin verses (above) and four German verses (below), are more like marginal commentaries on the dominant *pictura* than they are constitutive of a tripartite emblematic structure (figure 12.1). The images themselves are a faithful retelling of the biblical text, occasionally representing several events simultaneously; only rarely do they open up additional perspectives of meaning such as in the depiction of paradise, in which the snail, the unicorn, and the juxtaposition of ox and ass—prefigurative elements that had long been conventionalized—are used to foretell the stories of Mary and the birth of Christ.[26]

This changes in the 1579 edition. It becomes clearer that the illustrations are emblems when they are structured in a manner that is not motivated by the text but by something external to it: the eight verses of each of the summaries by Heinrich Peter Rebenstock are simply divided into two groups and placed, without any consideration for the ongoing text, half above and half below the small-format *pictura* framed in scrollwork (figure 12.2). This creates the semblance of a tripartite emblematic structure, and the letters and the image lay claim to an approximately equivalent amount of space on the page.

Here, we have a case of the apparently hasty, second-rate adoption of the practice of illustration that, in the case of Fischart and Stimmer, was the result of careful consideration and no doubt intensive collaboration between the writer and the artist.[27] In his detailed preface, Fischart develops a theory that accords the image its own interpretative significance that cannot be conveyed by other media, thereby demanding exceptional interpretative efforts from the observer.[28] The Gregorian justification has been retired; for Fischart, it is no longer even worthy of mention. The *illiteratus* is no longer the addressee of the image; the image is now directed at scholars and intellectuals, inviting them to make more and more intensive use of

GENESIS I.

Principio cœlum uacuum,terraśq́ iacentes,
Et pelagi immenſum condidit autor opus.

Hinc Lunæ Soliśq́ ignes,quibus emicet orbis,
Atque hominem fecit numinis eſſe typum.

Von anbegin ſchůff Gott der HERR/
Himmel vnd Erden/vnd das Meer/

Auch Sonn vnd Mon am Himmel hoch/
Zuletzt Adam/ſein Bildnuß nach.
A

12.1 Illustration from Genesis 1. Amman/Bocksperger, *Neuwe Biblische Figuren* (1564).

their critical reason. The artistry of the image is the instrument that provides a special type of access to the biblical narrative, a type of access that is unique to the image.

> Wan es sein künstlicheit legt an
> An die heilig Historisch gschicht,
> Nutzlich exempel und gedicht,
> Poetisch fünd, gmalt Poesi,
> Lehrbild und gmalt Philosophi,
> Welches zwar solche sachen sint,
> Das, je meh man nachsinnt und gründ,
> Je meh sie schärfen den verstand
> Und machen die sach bas bekant.[29]

[Since its artistry attracts (one) to the holy historical events, useful role models and stories, poetic inventions, painted poetry, teaching pictures, and painted philosophy, which, indeed, are such things that, the more one reflects

Genesis I. II.

Im Anfang schuff Gott vnser HERR
 Durch sein Wort Hümel/Erd vñ Meer/
Er hat auch nach der Bildnuß sein
 Auß Erden gmacht den Menschen fein.

In sechs Tagen vollend der HERR
 All seine Werck nach seim beger/
Am sibenden Tag ruhet Gott
 Befahl jn zu heilgen on spott.
 B Genesis

12.2 Illustration from Genesis 1. Amman/Rebenstock, *Neuwe Biblische Figuren* (1579).

(on them) and discovers, the more they sharpen one's intellect and make the
things better known.]

With these specifications, Fischart describes the emblematic image, although
he does not explicitly name it; he does, however, establish the context
immediately by referring to the art of hieroglyphics:

> Auch bzeugt solchs, das aus malens grund
> Die erst Egyptisch schrift entstund,
> All Weisheit und Theologi,
> Die Hieroglyphisch nanten sie.[30]

[This is also demonstrated by the fact that the first (form of) Egyptian writing
developed from painting. All wisdom and theology, they called it hieroglyphics.]

Fischart published his theory of the emblem five years later as the foreword
of Mathias Holtzwart's book of emblems, which was published by Fischart's
brother-in-law, Bernhard Jobin; the title bears Fischart's trademark in its
terminology.[31] He does not add anything considerably new to what he
wrote in the foreword to the biblical stories; he does, however, emphasize the
aspect of the mysterious quality that is never completely translatable by means
of allegory and that is characteristic of the emblem in the *pictura* and *scriptura*.
In order to characterize this situation, he uses a flood of terms that, taken
together, are more instructive than long descriptions. He speaks of mystery-
teaching paintings; instructive paintings; beautiful, instructive, deeply sought,
useful, and delightful opinions and warnings; painting-mysteries and concealed
instructive paintings; interpretative paintings or painting-interpretations; and
thought-signs.[32] The complete translatability of the image into words by
means of allegorical analysis that we found in Alberti is set here against a con-
ception of image and interpretation that allows the image to retain its "mys-
tery," the *concealed* lesson, which is why the reflection that it triggers is limitless.

"Because of its kept mystery" [Von wegen einhaltender Geheymnuß],
even the ornamentation becomes full of significance, "as this [is] apparent
every day in the scrollwork and compartments of the artists" [wie dann diß
noch täglich an der Maler Rollwercken vnd Compartamenten beschein-
lich].[33] Fischart is probably referring here to Tobias Stimmer's frames in the
biblical stories (see below).

By means of the mysteries that are inherent in it and that "occupy the
mind no less than those dark and unique secret scripts of the Egyptians and
Pythagoreans" [den Geist nicht weniger beschäftigen als jene dunklen und
einzigartigen Geheimschriften der Ägypter und Pythagoreer],[34] the emblem-
atic image denies the Gregorian formula once and for all: now the image is no
longer a literature of poorer quality for the *illitterati*; on the contrary, it is an

interpretative task that presupposes a great deal of knowledge and intellect and that is a never-ending invitation to engage with the objects and situations represented. Given this new assignment, the problem of the relationship of the image to the biblical text no longer arises. If the image is no longer a retelling of the text by nonverbal (less adequate) means, then there is no longer any question whether or under which circumstances it is permissible to allow the image to replace the word. The emblem is not in competition with the word; rather, it is a means of access to it. The emblem becomes a visual commentary on the text of the Bible as well as an instrument of biblical hermeneutics.

I have singled out several examples that elucidate how consistently and convincingly Fischart and Stimmer implemented this conception.[35] The book consists of 168 pages of both text and images that are structured in the tripartite emblematic schema (figure 12.3). Above the *pictura* is the *inscriptio* that denotes the (usually) theological topic under which the thing represented is to be subsumed but which is often not immediately decipherable and which is meant to serve as a stimulus for reflection: for example, why does Esau's sale of his birthright (Gen. 25) for a lentil dish prefigure the church led astray ("model of a false Church" [Vorbild falscher Kirch])?[36]

Under the *pictura* are five verses, the first four of which name the content of the image without completely merging with it and the fifth of which (usually) formulates a summarizing moral or religious aphorism.

Inscriptio, pictura, and *subscriptio* interlock into one unit by means of partially ornamental, partially figurative frames—on the whole, eight different frames are used in varying succession—that contain numerous symbolic references to themselves and often also to the framed *pictura.*

The *inscriptio* above the first *pictura* makes note of the symbolic nature of all creation and the resultant need for all of creation to be interpreted, an observation which, placed in this prominent position, is most certainly programmatic: "The delicacy of the creatures bears witness to the Creator's glory" [Der gschôpf zirlichait / zeugt des schôpfers herlichait].

The image, a paradisiacal landscape peacefully inhabited by land, air, and water animals, does not provide the impetus for reflection until one reads the subscriptio:

Am anfang schuf Got inn sechs Tagen
Luft / Himel / Erd / vnd was sie tragen:
All Thir vnd Vôgel / Fisch vnd Wild /
Lezlich den Menschen nach seim Bild:
Von seiner milt ist alls erfûllt.

[In the beginning, God created the air, the heavens, the earth, and everything that they bear in six days: all the animals and birds, fish and game, (and) finally, human beings in his image: Everything is full of his munificence.]

12.3 Illustration from Genesis 1. Stimmer/Fischart, *Künstliche Figuren* (1576).

All of the objects and living things named can be found in the image; only people are missing. The viewer who undertakes the search at last finds himself referred to himself.[37] The distance between the observer and the image is thereby removed. The viewer must understand himself as a component of precisely that creation which the image represents. He is not allowed to view Adam's role as an uninvolved spectator; rather, the viewer takes on this role himself. In this way, he is immediately, from the very first image

onwards—and this is surely meant programmatically as well—a participant in the biblical stories.

Tobias Stimmer plays the game of including the viewer in the image with great virtuosity. As a further example, I would like to cite the image of the drunken and exposed Noah.[38] The *subscriptio* is as follows:

Der Regenbogen ward Gots bund:
Cham plos sein Vater ligen fund /
Vnd deckt jn nicht / wie seine Brüder /
Verflucht ward er / zum Knecht ernidert:
Wer Eltern ehrt / den ehrt Got wider

[The rainbow became God's covenant: Ham found his father lying naked and did not cover him like his brothers; he was cursed and reduced to a slave: Whoever honors his parents will be honored by God in return.]

The sleeping Noah, lying in the foreground, is turned frontally toward the viewer. Ham, who is coming forward out of the background of the image, is, in contrast to the viewer, unable to see Noah's nakedness at all. The viewer is thereby placed in the role of the disrespectful wrongdoer and must suddenly ask himself whether and in what sense he is a Ham and has to reckon on the consequence that is formulated in the *inscriptio*: "The one who dishonored became dishonored" [Der Schånder wurd geschåndet]. In the interplay between *inscriptio*, *pictura*, *subscriptio*, and frame, the pages of the book become interlinked episodes in the history of salvation and correlations of meaning that extend beyond the individual image.

The image on folio A3v depicts the story of Cain and Abel. In the background, it simultaneously shows the burnt offering that was accepted and the burnt offering that was rejected. In the foreground lies Abel, struck dead and in the position of someone who has been crucified; Cain, shouldering a club, his face distorted with rage and his hair standing on end, bends over him. The first four verses of the *subscriptio* mention the facts briefly, and the last one says, unexpectedly and at first not really comprehensibly: "Cain's urge is the beginning of the church" [Cains trang / ist der Kirchen anfang]. The meaning of the sentence becomes clear when one reads the *inscriptio*: "The first martyr Abel" [Der Erst Martyrer Abel]. According to Christian teachings, "sanguis martyrum semen ecclesiae" [the blood of the martyrs is the seed of the church], so that, indeed, the first spilling of (martyrs') blood signifies the founding of the church. In various references, the border incorporates the Christian symbolism of blood, martyrdom, and the church as part of the context of the history of salvation. Eve, through whom death entered the world, stands on the left base of the frame; across from her on the right is an angel with the chalice, and who is holding a cross on her

shoulder as a counterpoint to Cain's club. In the left and right spandrels underneath, one sees the figure of the cross, a pelican feeding its young with its own blood, and a flower that has blossomed from the seed; two cherubs with the scepter of power and the palm branch of the martyrs are holding a heraldic cartouche bearing the monogram of Jesus, which forms the foundation of the image.

The key word *church* (*Kirche*) in the last verse of the *subscriptio* connects the symbolic image with the following one, which depicts the Great Flood and the saving ark. The *inscriptio* of this image reads: "To preserve the ship of the church" [Das Schyfflin der Kirchen erhalten]. Both images, as symbolic representations of the beginning and the continuance of the church, refer to each other. The last verse of the *subscriptio* summarizes the course of the history of salvation: "God's church and flock will last forever" [Gots Kirch vnd Schar / pleibt jmerdar]. The phases of the history of salvation, the Old and the New Testaments, are taken up in the frame: on the left, the figure flanking the image is Aaron (?), and under him, a putto can be found with the tablets of the Mosaic law; in the lower portion of the frame and to the right of that, the owl, the bird of darkness, can be seen. On the right, the figure flanking the image is Jesus, crowned with thorns (at the pillar for the scourging?). Under that is a putto with the cross, and left of him is the eaglet, which gains its eyesight by turning its eyes toward the bright light of the sun.

In the chronology of events and in its relationship to the text and to the frame, the following *pictura*, which depicts the animals as they board the ark, ought actually to have been interchanged with the previous one, which dramatically portrayed the Flood. This is, in any case, stated in the *inscriptio*: "The first punishment of the world by means of a watery disaster" [Die Erst Straf der Welt durch Wassers not]. In keeping with this theme, the frame thematizes the destruction of evil in the figures of David and Goliath as well as in three cherubs holding a cross, an anchor, and a burning heart: the virtues faith, hope, and charity. A sheaf of wheat and a sacrificial bowl with smoke being pressed downward in the lower left, and a lamb and a sacrificial bowl with smoke rising upward connect this illustration with the story of Cain and Abel by aligning the notion of purification by blood and water, with the idea of baptism by blood and water, thereby opening up yet another means of approaching the episode. It is entirely possible that the stock was accidentally transposed during printing. Within another context, I have, however, attempted to demonstrate that one may indeed suppose that such transpositions were intentional.[39] The effect here would be twofold: on the one hand, the search for meaning would be activated, for the viewer would be forced to page forward and backward through the book (which, at this point, becomes necessary anyway because of the pictorial reference to the

story of Cain and Abel), that is, the intellectual search is made manifest by means of a physical experience; on the other hand, one would find a further possible means of combining images and texts.

Finally, the number of the frames refers to the theme of baptism and to the history of salvation that manifests itself in the linking of the images. "The first punishment of the world by means of a watery disaster" [Die erst Straf der Welt durch Wassers not] is the last of eight images for which eight different frames were used. After that, the cycle of frames is repeated. Eight is the number of renewal, rebirth, and redemption. Eight people are saved in Noah's ark; baptism, the *sacramentum octavi*, which is prefigured in the Great Flood, is often performed over an octagonal basin. The frames, in both their number as well as in their cyclical repetition, represent the immutable framework of the history of salvation, and all of the images and the events represented in them refer, in all their diversity, to this framework in a unified manner.

This small number of examples, the details of which have not by any means been exhausted, should suffice. They demonstrate that Fischart's and Stimmer's biblical emblems, far from being simple pictorial retellings of biblical stories, instead invite one to reflect and to create a dense network of interrelationships of meaning. In this, they are an overdue answer to Gregory's dictum from almost exactly a thousand years before, an answer that redefines the relationship of the image to the biblical text according to the circumstances of the modern era, convincingly translating this reinterpretation into art.

Notes

Translated by Edward T. Potter.

1. "Aliud est enim picturam adorare, aliud picturae historiam, quid sit adorandum, addiscere. . .Idcirco enim pictura in ecclesiis adhibetur, ut hi, qui litteras nesciunt, saltem in parietibus videndo legant, quae legere in codicibus non valent" [It is one thing to worship an image, but (it is) something else to tell a story worthy of reverence with the aid of an image. . .For this reason, images should be placed in the churches so that the uneducated can at least, by viewing the walls, read what they can not understand in books.] Pope Gregory I, *Registrum Epistolarum, MGH: Epistolarum 2*, ed. Ludwig Hartmann (Berolini: Weidmann, 1899), p. 270.

2. Leonbattista Alberti, *De pictura*, ed. C. Grayson (Bari: G. Laterza, 1975), pp. 93–94. Cf. David Cast, *The Calumny of Apelles: A Study in the Humanist Tradition* (New Haven, CT: Yale University Press, 1981).

3. There are at least eight such pictorial bibles if one includes the often richly illustrated florilegia from the Bible (for example, *Hausbibel: Sprueche aus dem Alten und newen Testament, fuer die Jugend zusammen getragen. . .mit schoenen*

Figuren / Durch Andream Musculum [Erfurt: Dreher, 1569]). Because of their less extensive scope, numerous works can be considered precursors. One example of this is *Wolgerißnen und geschnidtnen Figuren auss der Bibel, Kaspar Scheit* (Lyon: Tornesius, 1554). In the period under discussion, the following must be considered a part of the core group of pictorial bibles: *Biblische Figuren des Alten vnd Newen Testaments / gantz künstlich gerissen. Durch den weitberhümpten Vergilium Solis zu Nürnberg* (Frankfurt: David Zöpfel, Johann Rasch, and Sigmund Feyerabend, 1560); *Neuwe Biblische Figuren deß Alten vnd Neuwen Testaments / geordnet vnd gestellt durch. . .Johan Bockspergern von Saltzburg / den jüngern / vnd nach gerissen mit sonderm fleiß durch. . .Joß Amman von Zfrych* (Frankfurt: Georg Rab, Sigmund Feyerabend, 1564); *Neue kuenstliche Figuren biblischer Historien / gruentlich von Tobia Stimmer gerissen: und zu Gotsfő rchtiger ergetzung andåchtiger Hertzen mit artigen Reimen begriffen durch J. F. G. M.* [Johann Fischart] (Basel: Thomas Gwarin, 1576; facsimile—Munich: Knorr and Hirth, 1923); *Newe Biblische Figuren Künstlich vnnd artig gerissen / durch. . .Joß Amman von Zürych / mit schónen Teutschen Reimen / welche den gantzen innhalt einer jeden Figur vnd Capitel kurtz begreiffen /. . .durch Herr Heinrich Peter Rebenstock / Pfarherr zu eschershaim* (Frankfurt: Sigmund Feyerabend, 1579).The boom in pictorial bibles remains constant throughout the entire seventeenth century; cf. Heimo Reinitzer, *Biblia deutsch: Luthers Bibelübersetzung und ihre Tradition* (Wolfenbüttel: Herzog August Bibliothek, 1983).

4. Thomas Cramer and Christian Klemm, ed., *Renaissance und Barock*, vol. 1 of *Bibliothek der Kunstliteratur* (Frankfurt: Deutscher Klassiker Verlag, 1995), pp. 36–41 and 656–59. On the history of the ban on images in general, see Micha Brumlik, *Schrift, Wort und Ikone: Wege aus dem Verbot der Bilder* (Frankfurt am Main: Fischer Taschenbuchverlag, 1994); Michael J. Rainer, ed., *Bilderverbot* (Münster: Lit, 1997); Eckhard Nordhofen, ed., *Bilderverbot: die Sichtbarkeit des Unsichtbaren* (Paderborn: Schöningh, 2001).

5. I investigate several aspects of this cluster of issues. A systematic history of the illustration of the Bible that makes use of the most recent Renaissance scholarship in art history has yet to be undertaken. The source book that yields the most material is still Reinitzer's *Biblia deutsch*. This work is referred to extensively in the following remarks. See Reinitzer also for further bibliographical references. A systematic study is available for the Netherlands: Barth A. Rosier, *The Bible in Print: Netherlandish Bible Illustration in the Sixteenth Century* (Leiden: Foleor, 1997).

6. On the *Septembertestament*, see Jaroslav Pelikan, *The Reformation of the Bible— The Bible of the Reformation*, catalog of the exhibition by Valerie R. Hotchkiss and David Price (New Haven, CT: Yale University Press; Dallas, TX: Bridwell Library, 1996), especially pp. 134–35, item 3.4.

7. Andreas Bodenstein, *Von Abtuhung*, in *Bibliothek der Kunstliteratur*, vol. 1, pp. 17–18: "Gregory, the pope, did not forget his papal nature and gave to images the honor which God gave to his Word and says that pictures are the books of the laypeople. Is that not a truly papal lesson and diabolical inspiration, that the flock of Christ can make use of forbidden and deceitful books

or examples. . .I recognize, however, why the popes placed such books [that is, images, Th. C.] before the laypeople. They realized that if they led their flock to the real books, their flea-market would not increase, and people would want to know what is divine and what is ungodly, what is right and what is wrong" [Gregorius, der Bapst, hat seiner bebstlicher art nit vergessen und den bildern die ehere geben, die got seinem wort geben hat, und spricht, das bildnis der Leien bucher seind. Ist nit das ein recht Bepstlich laher und teufelisch zugebung, das die scheflin Christi verboten und betrugliche bucher oder exempel mogen gebrauchen. . .Ich mercke aber, warumb die Bebst solich bucher [d.h. Bilder, Th. C] den Leien furgelegt haben. Sie haben vermerckt, wan sie die scheflein in die bucher furten, ihr grempelmarckt wurd nichst zunemen, und man wurt wellen wissen, was gotlich oder ungotlich, recht oder unrecht ist]. And see Luther's reply in Martin Luther, "Wider die himmlischen Propheten, von den Bildern und Sakrament," in *Bibliothek der Kunstliteratur*, vol. 1, p. 39 [39–41]. Luther refers to these images, which may be used as memory aids, as *Merkbilder.*"Aber die andern Bilder, da man allein sich drinne ersihet vergangener Geschicht und Sachen halben als in einem Spiegel, Das sind Spiegel Bilde, die verwerffen wir nicht, denn es sind nicht Bilder des Aberglaubens, [. . .] man setzet kein vertrawen drauff, sondern es sind Merkbilde." *D. Martin Luthers Werke: Kritische Gesamtausgabe; Unv. Nachdr. der Ausgabe Weimar, 1885–1985*, vol. 28 (Graz: Akademische Druck- u.Verlagsanstalt, 1969–1989), p. 677. See Joseph Leo Koerner, *The Moment of Self-Portraiture in German Renaissance Art* (Chicago: University of Chicago Press, 1993), especially pp. 363–410.

8. *Biblia / das ist / die gantze Heilige Schrifft Deudsch. Mart. Luth.Wittemberg. . . Hans Lufft*, 2 vols. (Wittenberg: Hans Lufft, 1534).

9. *The New American Bible: Translated from the Original Languages with Critical Use of All the Ancient Sources with the Revised Book of Psalms and the Revised New Testament* (Iowa Falls, IA: World Bible Publishers, 1987).

10. The text reads: "When I saw her I was greatly amazed. The angel said to me, 'Why are you amazed? I will explain to you the mystery of the woman' " (Rev. 17:6–7) [Vnd ich verwundert mich seer / da ich sie sahe. Vnd der Engel sprach zu mir / Warumb verwunderstu dich? Jch wil dir sagen das Geheimnis von dem Weibe. . .].

11. *Biblia. Das ist / Die gantze Heylige Schrifft / Teutsch. D. Mart. Luth. Sampt einem Register vnd schönen Figuren* (Frankfurt am Main: David Zöpfel, Johann Rasch, Sigmund Feyerabend, 1561).

12. *Biblia: das ist: die gantze Heilige Schrifft: Deudsch / Auffs New zugericht. D. Mart. Luth* (Wittenberg: Hans Lufft, 1541).

13. Christoph Walther, *Antwort Auff Sigmund Feyerabends vnd seiner Mitgesellschaft falsches angeben vnd Lügen. . .* (Wittenberg: Hans Lufft, 1571).

14. Walther, *Antwort*, fol. 1r.

15. *Biblische Figuren* (1560).

16. *Neuwe Biblische Figuren* (1564).

17. *Neuwe Biblische Figuren* (1564), fol. A2r, A2v.

18. *Neuwe Biblische Figuren* (1564), fol. A3v.

19. *Newe Biblische Figuren* (1579), fol. A4v f.
20. See n. 1.
21. *Newe Biblische Figuren* (1579), fol. A5v.
22. *Newe Biblische Figuren* (1579), fol. A6r.
23. On the invention of the printing press as a divine art, see Horst Wenzel's essay (chapter 11) in this volume.
24. *Neue Künstliche Figuren* (1576).
25. From the plethora of publications on emblematics, I will name only a few of the works that were the most substantially significant ones for my research project: Holger Homann, *Studien zur Emblematik des 16. Jahrhunderts* (Utrecht: Decker & Gumbert, 1971); Michael Bath, ed., *The Art of the Emblem: Essays in Honor of Karl Höltgen* (New York: AMS Press, 1993); Wolfgang Harms et al., eds., *SinnBilderWelten: Emblematische Medien in der Frühen Neuzeit* (Munich: Bayerische Staatsbibliothek, 1999); Ayers L. Bagley, ed., *The Telling Image: Explorations in the Emblem* (New York: AMS Press, 1996); Dieter Sulzer, *Traktate zur Emblematik: Studien zu einer Geschichte der Emblemtheorien* (St. Ingbert: W.J. Röhrig, 1992); Peter Daly, *Literature in the Light of the Emblem: Structural Parallels between the Emblem and Literature in the Sixteenth and Seventeenth Centuries*, 2nd edn. (Toronto: University of Toronto Press, 1998).
26. This combination can, among other places, also be found in the panel "Creation of the Animals" on the Grabow Altar by Master Bertram, ca. 1380, Kunsthalle Hamburg. For an interpretation of the image, see Reinitzer, *Biblia deutsch*, pp. 244–46.
27. There are many indications of haste and carelessness; for example, the transposition of Lot and Noah, probably triggered by the key word *drunkenness*, which should not have escaped even a superficial proofreader: "His wife remains standing as a pillar of salt. The daughters go with him from there, and Noah, out of drunkenness, sleeps with both of them afterwards" [Sein Weib zur Saltzseuln bleibet stan / Die Töchter mit jm dannen gan Welche Noah auß trunckenheit Hernach beschlafet alle beid] (fol. C1r).
28. Fischart, *Bibliothek der Kunstliteratur*, vol. 1, pp. 323–35. I am limiting myself here to the statements that have to do with the art of symbolic images. For the other aspects of art theory, particularly Fischart's analysis of the postulate of the imitation of nature, I recommend my commentary in *Bibliothek der Kunstliteratur*, vol. 1, pp. 771–80; and Thomas Cramer, "Aesopi Wolf. Überlegungen zum Verhältnis von Literatur und bildender Kunst im Spätmittelalter und in der frühen Neuzeit," in *Festschrift Walter Haug und Burghart Wachinger*, ed. Johannes Janota et al., vol. 2 (Tübingen: Niemeyer, 1992), pp. 955–66.
29. *Bibliothek der Kunstliteratur*, vol. 1, p. 327
30. *Bibliothek der Kunstliteratur*, vol. 1, pp. 327–28.
31. Mathias Holtzwart, *Emblematum Tyrocinia: mit einem Vorwort über Ursprung und Nutz der Emblematen von Johann Fischart und 72 Holzschnitten von Tobias Stimmer*, ed. Peter von Düffel and Klaus Schmidt (Stuttgart: Reclam, 1968).

32. "Geheymnußlehrigen Gemälen"; "Lehrgemäl"; "schöne lehrhafte Tieffgesuchte nutzliche vnd ergötzliche Meynungen vnd Manungen"; "Gemälsmysterien vnd verdeckten Lehrgemälen"; "Deutungsgemähl oder Gemäldeutnussen"; "Gedenckzeichen."

33. *Emblematvm Tyrocinia*, p. 10.

34. On the mysteries inherent to the emblematic image, see the classic study by Homann, *Studien zur Emblematik*, especially pp. 43–80. Johannes Sambuccus, "Emblemata cum aliquot nummis," cited in Homann, *Studien zur Emblematik*, p. 47.

35. For this, see Reinitzer, *Biblia deutsch*, pp. 250–53.

36. *Künstliche Figuren*, fol. C2v.

37. This idea was taken up by Jos Amann in the 1579 edition of *Newe Biblische Figuren*.

38. *Künstliche Figuren*, fol. B1r.

39. Thomas Cramer, "Fabel als emblematisches Rätsel: Vom Sinn der Illustrationen in den Fabelsammlungen von Posthius und Schopper, 1566; Ein Beitrag zur Kulturgeschichte des nichtlinearen Lesens," in *Audiovisualität vor und nach Gutenberg*, ed. Horst Wenzel et al. (Milano: Skira, 2001), pp. 133–57.

LIST OF CONTRIBUTORS

Joachim Bumke, Institute for Older German Literature (emeritus), University of Cologne. Joachim Bumke's interests include courtly culture, relationships between French and German medieval literature, patronage, and manuscripts. Among his numerous books are *The Concept of Knighthood in the Middle Ages* (trans. New York, 1982); *Geschichte der deutschen Literatur im hohen Mittelalter* (Munich, 1990); *Courtly Culture: Literature and Society in the High Middle Ages* (trans. Berkeley, 1991); *Die vier Fassungen der Nibelungenklage: Untersuchungen zur Überlieferungsgeschichte und Textkritik der höfischen Epik im 13. Jahrhundert* (Berlin, New York, 1996); *Wolfram von Eschenbach* (Stuttgart, 1997); and *Die Blutstropfen im Schnee: über Wahrnehmung und Erkenntnis im "Parzival" Wolframs von Eschenbach* (Tübingen, 2001).

Thomas Cramer, Professor, Institute for Literary Studies, Technical University of Berlin. Thomas Cramer works on high and late medieval literature, medieval aesthetics, lyric, and word and image. His books include *Geschichte der deutschen Literatur im späten Mittelalter* (Munich, 1990); and *"Waz hilfet âne sinne kunst?" Lyrik im 13. Jahrhundert Studien zu ihrer Ästhetik* (Berlin, 1998). His editions and translations of medieval texts include Hartmann von Aue's *Iwein* (Berlin, 1981) and *Erec* (Frankfurt am Main, 1972).

Ulrich Ernst, Department of Linguistics and Literature, University of Wuppertal. Ulrich Ernst is interested in visuality and poetics. His monographs include *Text als Figur. Visuelle Poesie von der Antike bis zur Moderne* (Weinheim, 1990); *Carmen figuratum. Geschichte des Figurengedichts von den antiken Ursprüngen bis zum Ausgang des Mittelalters* (Köln, 1991); and *Konkrete Poesie. Innovation und Tradition, Katalog zur Ausstellung in der Universitätsbibliothek* (Wuppertal, 1991).

Jeffrey F. Hamburger, Department of History of Art and Architecture, Harvard University. Jeffrey Hamburger's interests include medieval art, theology and mysticism, manuscript illumination and devotional imagery, and the visual culture of female monasticism. Among his books, which have won numerous awards, including the Jacques Barzun Prize in Cultural History, are *Nuns as Artists: The Visual Culture of a Medieval Convent* (Berkeley, 1996); *The Visual and the Visionary: Art and Female Spirituality in Late Medieval Germany* (New York, 1998); and *St. John the Divine: The Divinized Evangelist in Medieval Art and Theology* (Berkeley, 2002).

Niklaus Largier, Department of German, University of California, Berkeley. Niklaus Largier works on medieval mysticism, sexuality and the body, and medieval and

early modern visual culture. In addition to numerous essays, he has published the book *Lob der Peitsche: Eine Kulturgeschichte der Erregung* (Munich, 2001); and the edition and translation *Meister Eckhart* (Frankfurt am Main, 1993).

Volker Mertens, Institute for Older German Literature and Language, Free University, Berlin. Volker Mertens's interests include courtly and late medieval epic and lyric, German Arthurian romance, and sermons. His books includes *Das Predigtbuch des Priesters Konrad. Überlieferung, Gestalt, Gehalt und Texte* (Munich, 1971); *Laudine. Soziale Problematik im "Iwein" Hartmanns von Aue* (Berlin, 1978); and *Der deutsche Artusroman* (Stuttgart, 1988).

Jan-Dirk Müller, Institute for German Philology, University of Munich. Jan-Dirk Müller's interests include memory, gesture, performance, writing, and narrative strategy in medieval and late medieval literature. His books include *Gedechtnus: Literatur und Hofgesellschaft um Maximilian I* (Munich, 1982); *Wissen für den Hof: Der spätmittelalterliche Verschriftungsprozess am Beispiel Heidelberg im 15. Jahrhundert* (Munich, 1994); and *Spielregeln für den Untergang: die Welt des Nibelungenliedes* (Tübingen, 1998).

Norbert H. Ott, Bavarian State Archive, Munich. Norbert Ott's interests include secular and religious illustrated manuscripts. His books include *Exlibris: zur Geschichte ihrer Motive, ihrer Gestaltungsformen und ihrer Techniken* (Frankfurt am Main, 1967); and *Rechtspraxis und Heilgeschichte: zu Überlieferung, Ikonographie und Gebrauchssituation des deutschen "Belial"* (Munich, 1983), and he is continuing the work started by Hella Frühmorgen-Voss cataloging German illustrated manuscripts (*Katalog der deutschsprachigen illustrierten Handschriften des Mittelalters* [Munich, 1986–]).

James A. Rushing, Jr., Department of Foreign Languages and Literatures, Rutgers University, Camden. James Rushing has worked extensively on visual narratives of medieval German literature. He is the author of *Images of Adventure: Ywain in the Visual Arts* (Philadelphia, 1995) and numerous other publications on relationships between texts and images in the Middle Ages, as well as "a translation of Ava's New Testament narratives entitled *When the Old Law Passed Away* (Kalamazoo, 2003).

Kathryn Starkey, Department of Germanic Languages and Literatures, University of North Carolina at Chapel Hill. Kathryn Starkey's interests include word and image, material culture, language, performance, ritual, and the history of the book. She has published a number of articles on illustrated manuscripts and material culture, and her book is entitled *Reading the Medieval Book: Word, Image, and Performance in Wolfram von Eschenbach's "Willehalm"* (Notre Dame, 2004).

Haiko Wandhoff, Institute for German Literature, Humboldt University, Berlin. Haiko Wandhoff's research interests include high medieval courtly epic and lyric, word and image, ekphrasis, heraldry, printing and literary communication in the sixteenth century, and the theory and history of media and communication. He is the author of *Der epische Blick. Eine mediengeschichtliche Studie zur höfischen Literatur* (Berlin, 1996) and *Ekphrasis: Kunstbeschreibungen und virtuelle Räume in der Literatur des Mittelalters* (Berlin, 2003).

Horst Wenzel, Institute for German Literature, Humboldt University, Berlin. Horst Wenzel's interests include courtly culture, word and image, and media theory. He has co-edited numerous collections of essays including *Beweglichkeit der Bilder. Text und Imagination in den illustrierten Handschriften des "Welschen Gastes" von Thomasin von Zerclaere* (Cologne, 2002); and *Gutenberg und die Neue Welt* (Munich, 1994). His editorial work includes a microfiche edition of the *Welsche Gast* manuscript Hamilt. 675, Staatsbibliothek Berlin (Munich, 1998); and he is the author of *Frauendienst und Gottesdienst. Studien zur Minne-Ideologie* (Berlin, 1974) and *Hören und Sehen—Schrift und Bild. Kultur und Gedächtnis im Mittelalter* (Munich, 1995).

INDEX

CPSIA information can be obtained
at www.ICGtesting.com
Printed in the USA
LVHW041810251119
638462LV00006B/233/P